CATCHING THE WAVE

CONTEMPORARY ART AND ARTISTS IN CORNWALL

— FROM 1975 TO THE PRESENT DAY —

Tom Cross

Author of
The Shining Sands: Artists in Newlyn and St Ives 1880–1930
and
Painting the Warmth of the Sun: St Ives Artists 1939–1975

HALSGROVE

First published in Great Britain in 2002
Reprinted 2004
Copyright © 2002 Tom Cross

Copyright on reproduction of images in the book is the property of the artists who provided them for use.
Other photographs are from the author's collection or were taken specifically for use in this publication.
Copyright on all other photographs is individually credited.

The title for this work was inspired by the painting 'Catch A Wave' by Kurt Jackson.
The publisher acknowledges the artist's help with thanks.

British Library Cataloguing-in-Publication Data
A CIP record for this title is available from the British Library

ISBN 1 84114 207 7

HALSGROVE

Halsgrove House
Lower Moor Way
Tiverton, Devon EX16 6SS
Tel: 01884 243242
Fax: 01884 243325
email: sales@halsgrove.com
website: www.halsgrove.com

Printed and bound by D'Auria Industrie Grafiche Spa, Italy

CONTENTS

ACKNOWLEDGEMENTS

My thanks go to the artists whose names are found in these pages. This book has been prepared closely in collaboration with them. They have submitted to my interviews and commented upon my notes. They have allowed me to photograph them in their studios and they have produced illustrations of their recent work. Without their generous support this book could not have been written.

I would also like to thank a number of individuals who gave great help during the development of this book. These include Liz Knowles of the Newlyn Gallery; Kathy Watkins of the Penwith Gallery; Michael Tooby former Curator of the Tate St Ives, and the present staff of the Tate St Ives; Sheila Lanyon, Rose Hilton; Monica Wynter; Rowan James; Andrew Lanyon; the family of Roy Walker; Professor Alan Livingston, Principal of Falmouth School of Art and his staff; and Dr Roger Slack. I would also like to thank Patricia, my wife who has worked with me throughout, and my family and the many friends who have given their constructive support and encouragement throughout this project.

This book deals in the main with artists whose work is still developing and whose career is far from over. In his illuminating book, *The Italians,* Luigi Barzini talks about the difficulties he faced in writing about the peoples of his own land: 'It is notoriously easier to write about things and people one does not really know very well. One has fewer doubts. But to write about one's own country is a tortured enterprise. I knew too much. I saw too many trees. I sometimes could prove one thing or its contrary with equal ease'.

The same contrasts of familiarity or of ignorance have been apparent in writing this book. One's knowledge of art and artists is constantly changing. Reputations are as quickly unmade as they are painful to make. There are now very large numbers of artists working in Cornwall. Every village and fishing port has its dedicated group and galleries of all descriptions flourish to exhibit their work. In thanking the many artists who are included in this book one is conscious of those, who for reasons of space, could not be included.

The artists of Cornwall are now well provided with exhibition opportunities. In addition to the Tate St Ives and the major galleries of Newlyn and the Penwith, which are discussed in detail in these pages, there are many others that should be mentioned. These include the Royal Cornwall Museum, Truro; Penlee House Gallery and Museum, Penzance; and the Falmouth Art Gallery, all of which have their own fine collections of work by earlier artists in addition to showing the work of contemporary artists. There are also many commercial galleries in the county exhibiting and selling the work of present-day artists. St Ives is home to the largest number of these. The more established of them include the Wills Lane Gallery, the New Millennium Gallery, the Belgrave Gallery, and the Salt House Gallery. The Great Atlantic Map Works Gallery in St Just-in-Penwith and the Lemon Street Gallery in Truro must also be mentioned. Many of these have assisted in the preparation of this book.

PREFACE

IT'S ALL OVER

The deaths of three of the most important artists to be associated with St Ives occurred within the space of a few months in 1975. The painter Bryan Wynter died at his home at St Buryan, near Penzance on 11 February. Roger Hilton died on 23 February, a month before his sixty-fourth birthday, following a stroke. Barbara Hepworth died in her St Ives studio on 20 May. Each of these had made their own remarkable contribution to the unique tapestry of art which has become known as 'St Ives'.

The author can vividly remember the comment made by Terry Frost in 1975 that 'it was all over; St Ives is finished.' It certainly seemed so. Within a few months the author had moved from Reading where he had been teaching in the University Fine Art Department, to take up the position of Principal at Falmouth School of Art in Cornwall. It soon became clear that although there were many fine artists still working in and around St Ives, it was no longer a movement in the sense of shared ideals or identity. This book is an attempt to see St Ives with the benefit of twenty-five years hindsight, to assess the importance and value of the earlier years to the artists working in Cornwall today.

But what of the movement now known as 'St Ives'? In the swirling artistic movements of the little town, it is difficult to mark a particular time at which it is at its best. A central point would be in the late 1940s and 1950s when around the established figures of Ben Nicholson, Barbara Hepworth, and Bernard Leach there gathered a new generation, which included Peter Lanyon, John Wells, Terry Frost, Bryan Wynter, Patrick Heron and Roger Hilton.

In early years it was difficult to give a name to this group of artists. Denys val Baker, writer and editor of the *Cornish Review* tried to define the movement, writing in January 1959 he called it 'Britain's Art Colony by The Sea'. St Ives was not only a place, it was an idea, centred upon abstraction. In the 1950s St Ives became internationally recognised as a centre for the *avant-garde*. There was a series of landmarks, Corsham School of Art was a magnet that brought an extraordinary group of artists together as teachers. William Scott had made contact with the New York painters who were creating Abstract Expressionism, supported by a small group, which included from Cornwall, Peter Lanyon, Terry Frost and Patrick Heron. Paul Feiler, who was living and teaching in Bristol, was meeting the members of this group regularly and was alert to what was going on. He has a personal, if simplified, account of the important happenings of the 1950s in Cornwall. He relates this to the people who

came out of the conflict of the Second World War, with shared ambitions to do something worthwhile. Conflict had produced a positive desire to see what the world looked like in terms of painting and sculpture. To these people the Arts Council was a catalyst, bringing individuals together and giving official recognition.

St Ives was of course the centre. In St Ives you could walk into a pub or go to a party and see Rothko or Motherwell and eminent critics, American and British. At the time it all seemed natural but in retrospect it was an extraordinary and exciting period.

In talking of St Ives, David Lewis, one of the first curators of the Penwith Galleries recalls:

'Looking back, none of us were aware that these years were historic or unique. None of us realised that on this small Land's End peninsula called Penwith, jutting out into the Atlantic, with its ever-changing moods of earth and sea and sky, an evolution in the modern movement of art was taking place, the importance of which is only beginning to be realised forty years on.' (David Lewis 'St Ives, a Personal Memoir' 1947–55. Introduction to the catalogue of 'St Ives 1939–64' Tate Gallery 1985).

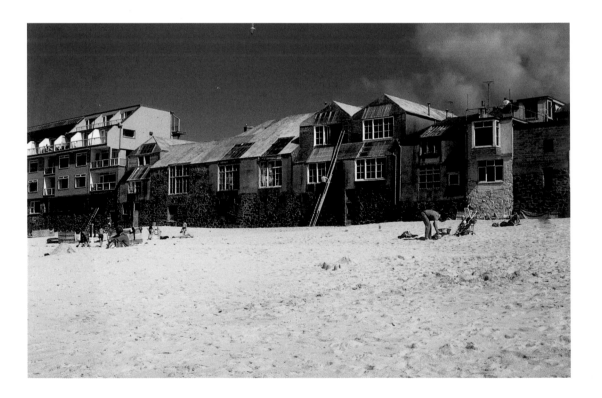

Studios on Porthmeor Beach, St Ives

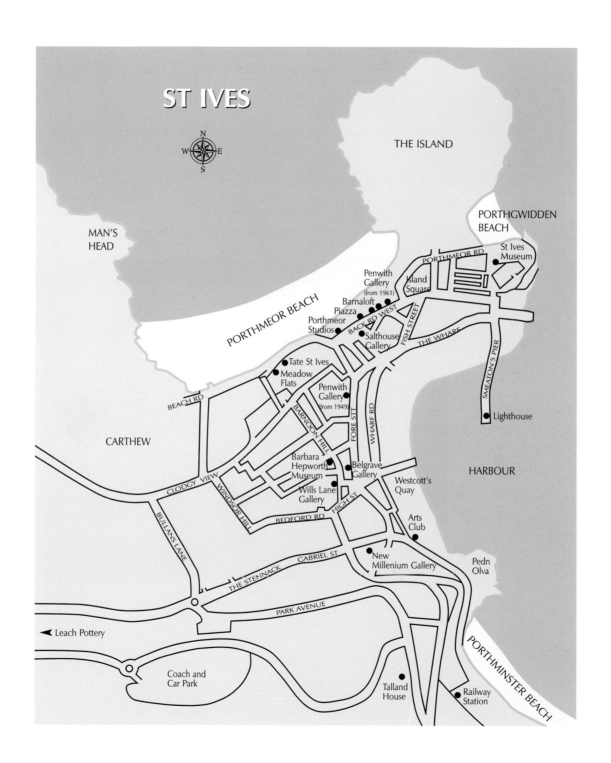

ST IVES

THE ISLAND

MAN'S HEAD

PORTHGWIDDEN BEACH

St Ives Museum

PORTHMEOR RD

Penwith Gallery (from 1961)

Island Square

Barnaloft

Piazza

PORTHMEOR BEACH

Porthmeor Studios

BACK RD WEST

FISH STREET

THE WHARF

Salthouse Gallery

SMEATON'S PIER

Tate St Ives

Meadow Flats

Penwith Gallery (from 1949)

BEACH RD

BARNOON HILL

FORE STT

WHARF RD

Lighthouse

CARTHEW

Barbara Hepworth Museum

Belgrave Gallery

Westcott's Quay

HARBOUR

CLODGY VIEW

WINDSOR HILL

Wills Lane Gallery

HIGH ST

BEDFORD RD

Arts Club

BULLANS LANE

GABRIEL ST

New Millenium Gallery

Pedn Olva

THE STENNACK

PARK AVENUE

◄ Leach Pottery

PORTHMINSTER BEACH

Coach and Car Park

Talland House

Railway Station

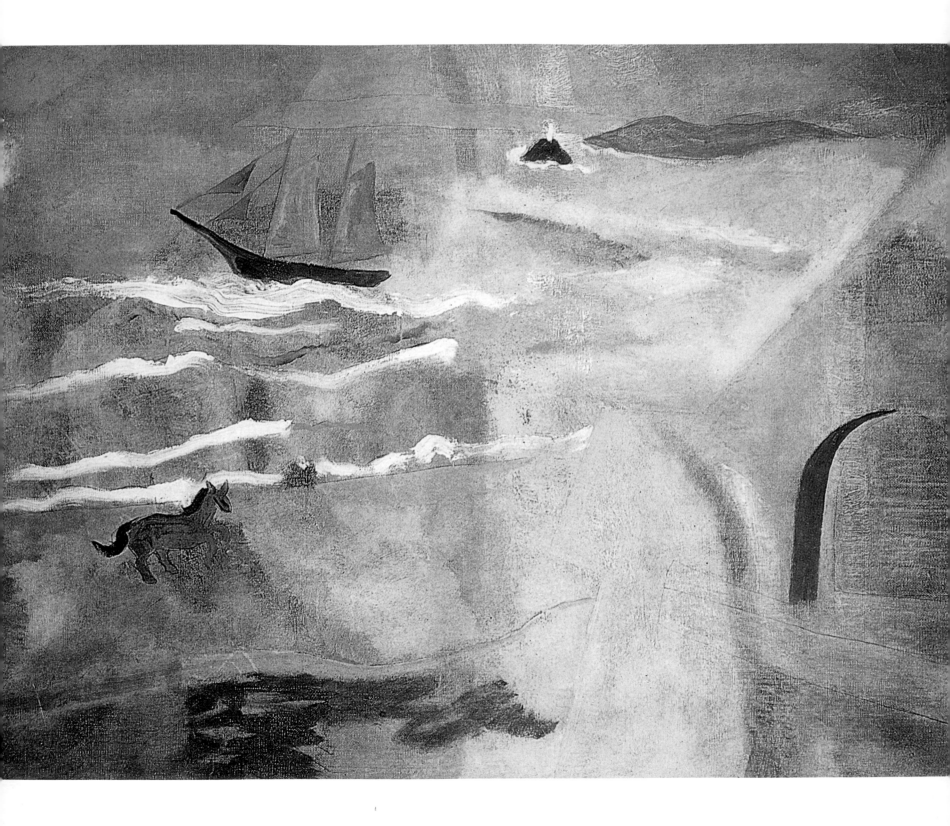

1

THE LONG SHADOWS

Cornwall is a county that has long been of interest to artists. Turner came in 1811 and his drawing of the town seen from the Stennack remains an accurate portrayal of the harbour and the huddle of cottages, surrounding the tower of St Ia Church. This visit was part of a coastal tour made by Turner which resulted in more than two hundred sketches in pencil, ink and colour. Some of these were developed for the publication *Picturesque Views of the Southern Coast of England*, published between 1814 and 1826. Others were re-worked over the years to become oil paintings or engravings. His work established the coast of Cornwall as a place of romantic legend and coloured the work of later artists.

Throughout the nineteenth-century Cornwall was regularly visited by artists who used it as a sketching ground, some took up residence for short periods and the exhibitions at the Royal Academy often contained views of the town of St Ives and the nearby landscape and the sea.

In the 1880s an important group of painters came to Newlyn and painted the figure in its working environment. The little town became, in the words of their leader Stanhope Forbes 'A centre for unflinching realism'. Others came later to the nearby Lamorna Valley and pursued a type of impressionism that was essentially English. Meanwhile St Ives, only nine miles away, attracted painters of the sea and the shore to its sun-filled coast. In the quiet years between the two World Wars St Ives became a substantial artists' colony. By the 1950s this had found a new high point as a major centre of international abstraction.

The visit of James McNeill Whistler to St Ives in the winter of 1885 drew considerable attention to the town. Whistler's visit was one of several that he made to coastal ports in preparation for an exhibition at Arthur Tooth's Gallery in Bond Street, London. It was a step in the restoration of his reputation that had been so seriously damaged following his court case with Ruskin in 1878. The work he did in St Ives was not in itself remarkable, a series of small panels mostly of Porthminster Beach depicting the sea in its various moods. His reputation was such that other artists were attracted to St Ives and within months of his visit the little town saw the beginning of a residential artists colony.

By 1888 an informal 'Artists' Club' was formed in St Ives by Louis Grier, an Australian painter. Two years later this became the St Ives Arts Club with permanent premises on Wescott's Quay. This Club continues to function in the same building to the present time. The artist members included Julius

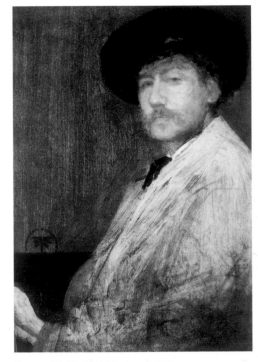

James McNeill Whistler, 1872

Opposite page:
BEN NICHOLSON
'Porthmeor Beach', 1928

oil on board, 40.5x58cm
City of Bristol Museum & Art Gallery

9

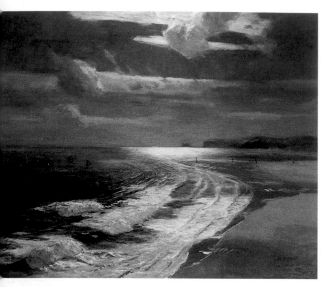

JULIUS OLSSON
'Silver Moonlight, St Ives Bay'

Tate Gallery

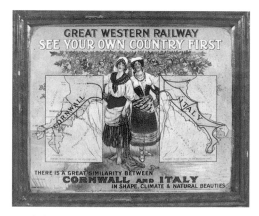

'Holiday Cornwall'
Great Western Railway Poster, 1912

Olsson, a romantic naturalist who became well known for his moonlight sea paintings, Adrian Stokes, one of the most promising landscape painters in Britain, described as 'a sensitive and glowing colourist', Arnesby Brown, Algernon Talmage and others. Their presence in the town attracted others and soon St Ives was seen as an artists colony, in the same way as those in France such as Pont Aven and Concarneau. The colony thus formed was remarkably international and drew artists from many countries: Americans, Australians and Scandinavians, such as the gifted Anders Zorn from Sweden. Artists also came from Finland and Germany.*

In these years up to the end of the nineteenth-century, Newlyn vied with St Ives as a major art centre. However the industrial changes that took place in Newlyn around the end of the century, changed it from a picturesque location to a major commercial fishing port and much less attractive to artists. St Ives remained the artistic centre for scattered groups in Newlyn and Lamorna.

The outbreak of war in 1914 brought inevitable change. The years of conflict were followed by a period of rapid social change, economic depression and high unemployment. For artists, sales were few; it became a matter of survival, living on private means supplemented by the attentions of a few patrons.

Slowly St Ives recovered its position and in the inter-war years it became a haven for a group of artists who described the harbour and the surrounding countryside in affectionate detail. This was 'holiday Cornwall', for in the years following the First World War the Cornish coast began to attract a new population of holidaymakers. For the first time the average wage earner received annual paid holiday and some now owned a private motor car and were able to take longer journeys in search of the sea and the sun.

New groups of artists were drawn to St Ives. Julius Olsson's School of Marine and Landscape Painting had made the town internationally known as a centre for marine painters, and students came from as far away as Canada and Australia. One of these was a Plymouth man, Borlase Smart (1881–1947) who came in 1913. At the outbreak of war in 1914 he served in France and took part in the terrible engagements of the Somme. Whilst being re-grouped, he met a fellow painter, Leonard Fuller, a portrait artist; each decided that on demobilisation, they would move to St Ives. Borlase Smart came in 1919 and worked in a converted fish loft overlooking Porthmeor beach. Leonard Fuller had to delay his move because of teaching commitments at Dulwich College, but in 1938 he formed The St Ives School of Painting which he ran until his death in 1973.

Another student of Julius Olsson was the painter John Park (1890–1962). He came to St Ives as a youth of nineteen from a large working-class family in Preston in Lancashire. Apart from a short period in Paris in 1906, where he was greatly impressed by the work of the French Impressionists, he was wholly taught by Olsson. Most of his working life was spent in St Ives and the harbour became his main subject. He captured the sparkle of sun and sea, the dancing fishing boats and the

*See *The Shining Sands*, Tom Cross pp 85–107.

colourful spectacle of the fishing port. His use of strong broken colour rivalled that of the French painters and he became a frequent exhibitor at the Royal Academy and with the artist societies in London. He also helped to form the St Ives Society of Artists in 1927, which for many years became the principal showing place in West Cornwall.

These artists were not considered to be *avant-garde*, but they were alert to the changes that were taking place in the world of art, and for the most part, sympathetic to them. Under their gentle guidance St Ives continued to be a place that welcomed artists. The St Ives Society of Artists had a handsome gallery, created by converting Julius Olsson's old studio overlooking Porthmeor Beach, and a membership of more than one hundred.

In March 1929, forty-one studios were open for the show days, and the newly established Arts Ball took place, with decorations and fancy dress. Work for the Royal Academy was taken to London in a specially hired railway carriage, at a charge of fifteen shillings per picture. The anonymous critic of the *St Ives Times* proudly announced:

> There is nothing eccentric about the art of the St Ives Colony. Cubism and such schools have not found their way down here yet. The art of St Ives is eminently sane and handsome... St Ives subjects are now views of popular beauty spots in and around St Ives, painted in quite strong colour and interspersed with evening views at dusk, twilight studies of the boats and harbour scenes. *(St Ives Times 1929, quoted in* The Shining Sands*, Tom Cross).*

A meeting took place in St Ives which was unnoticed at the time, but was later seen as a watershed in the history of modern art and of St Ives as an art colony. In the summer of 1928 two young painters, Ben Nicholson and Christopher Wood came to Cornwall. Nicholson and his wife Winifred were guests of friends, Marcus and Irene Brumwell, at their summer home at Pill Creek near Falmouth. On the second day of their stay the two young men were driven over to St Ives. Nicholson later recalled:

> This was an exciting day, for not only was it the first time I saw St Ives, but on the way back from Porthmeor Beach we passed an open door in Back Road West and through it saw some paintings of ships and houses on odd pieces of paper and cardboard nailed up all over the wall, with particularly large nails through the smallest ones. We knocked on the door and inside found Wallis, and the paintings we got from him then were the first he made.

The untutored fisherman **Alfred Wallis** (1855–1942), already in his seventies, had only recently begun to paint. At nine years old he had gone to sea, working as a cabin boy and cook, and at 18 he was making trips from Penzance to the fishing grounds of St John's, off Newfoundland. Without education, he taught himself to read and could write only with difficulty. At the age of twenty he married Susan Ward, twenty-one years older, who had already borne seventeen children. She had two more by Wallis, but both died in infancy. Within this extended family Wallis was more of a child than a parent. In 1890 he moved to St Ives, as a marine scrap merchant, known as 'Old Iron'. In 1912 he 'retired' to the little terraced house at 3 Back Road West, where he lived for the rest of his life and sold his home-

Showdays in St. Ives by E. W. Oldham. Two Newlyn RAs at St Ives View Day, c.1925
watercolour
private collection

Alfred Wallis' Marine Stores, St Ives, C.1900

author's collection

made ice cream to the holiday visitors. After Susan's death in 1922 Wallis began to paint, as he said 'for company'. He lived alone, a stubborn character with imagined grievances and suspicion. His 'Wireless voices', which he believed were devils, tried to draw him away from his belief in the Bible.

Wallis painted scenes from times past, boats sailing from St Ives harbour across a storm-tossed sea. He had his own systems of drawing and perspective. The largest objects in the painting would be those which were most important to him. He used few colours, usually from left over tins of boat paint given to him by fishermen – deep greens, blues and blacks, and the whitened transparency of the sea moving and tossing in his visionary world. He wrote to his friend and patron J.S. Ede: 'What I do mosley is what use To Bee out of my own memery what we may never see again as Things are altered all To gether Ther is nothin what Ever do not look like what it was sence I Can Rember.' (Letter to Ede, 6 April 1935). Wallis painted ships in the harbour and at sea. He painted the town of St Ives with his own small cottage prominent among the other houses and studios. He drew on his earlier memories of the sea, sailing between the icebergs off the coast of Newfoundland. All were displayed with a strong sense of pattern and design.

Why were these two young *avant-garde* artists fascinated by the work of this solitary friendless man? Christopher Wood wrote: 'All the great modern painters whom we may not quite understand are not trying to see things and paint them through the eyes and experience of a man of forty or fifty, or whatever they may be, but rather through the eyes of the smallest child...' They saw in Wallis' work, a direct creative energy expressed in the simplest means with the 'innocent eye' of the child, a search for a clearer form of emotional statement.

Christopher Wood, (1901–1930), was born in Liverpool, where he studied architecture briefly. It was Augustus John who recognised his talent and encouraged him to paint and who, In London, introduced him to other artists. Wood spent a period in Paris at the Acadèmie Julian and later at the Grande Chaumière. Young and highly impressionable, he formed a close friendship with a wealthy Chilian diplomat, Antonio de Ganderillas, who brought him into the international circle of artists and musicians surrounding Jean Cocteau. Much of his time was spent travelling in the Mediterranean, in Greece, Italy and North Africa, heady years in the company of the internationally famous. His meetings with Picasso and Cocteau were the most memorable, it was said that Cocteau introduced him to the use of opium. On Picasso's recommendation he worked on designs for Diaghilev and designed clothes for Molineaux.

CHRISTOPHER WOOD

'The Fisherman's Farewell'

(with portraits of Ben, Winnifred and Jake Nicholson)

private collection

Christopher Wood met Ben and Winifred Nicholson in London In 1926; they seemed to offer him the stability his restless life required, an austerity in accordance with their Christian Science beliefs. He stayed with them in their house in Cumberland and came with them to Cornwall, which held a special magic for Wood. After their meeting with Wallis, Nicholson and Wood moved to St Ives. Nicholson stayed for three weeks, Wood remained in St Ives and Mousehole, for about three months. He worked furiously but he was restless. 'I seem to live on the very edge of the world, but what an edge it is. I love this place and could stay here for ever if I had those around me for whom I care', he wrote to Winifred Nicholson.

In 1930 Wood had a successful exhibition with Ben Nicholson in Paris and then returned to Brittany. He was now entering the last stages of his personal tragedy. His addiction to opium had reached a critical point and in August he returned to England in a state of tormented delirium. After a brief and troubled meeting with his mother and sister on Salisbury station, he either fell or threw himself under the London train. He was twenty-nine years of age.

Ben Nicholson (1894–1982). Ben Nicholson's early background had placed him centrally in the progressive art circles of the time. His father, Sir William Nicholson, a painter of portraits and still-life, was a friend of Whistler, Sickert and Beerbohm. His mother, born Mabel Pryde, was also a painter, a granddaughter of the Earl of Carlisle, himself a patron of art and a Pre-Raphaelite painter. Rejecting this cultivated and sophisticated world, Ben Nicholson sought his own areas of interest and tested his own responses. His early training in art was limited to one year at the Slade School, London, in 1911. Following this he lived mostly out of England, for reasons of health, making extensive visits to Madeira and then to Pasadena, California. On the death of his mother in 1918 he returned to England. Soon after, he met Winifred Dacre, herself a painter of considerable talent and in 1920 they were married. Winters at Castagnole on the Italian border of Switzerland gave Ben Nicholson's landscape painting a Cézannesque purity of form. In the hills and farms around his wife's family home in Bankshead, Cumberland, he produced romantic paintings of intimacy and warmth. Visits to Paris between the years of 1920 and 1930 were a prominent part in the search for direction, as Winifred Nicholson described: 'years of inspiration – fizzing like a soda water bottle'.

In 1931, during a summer spent with Henry and Irena Moore, Nicholson formed a relationship with a young sculptor, Barbara Hepworth, then married to John Skeaping. In 1932 they travelled to France and met Picasso, Arp, Brancusi, and later Braque and Mondrian. In Nicholson's painting of 1933 '*St Remy, Provence*' three profiles appear which may be read as the likenesses of Ben and Barbara, while between is a third head of Winifred to whom he was still married. Nicholson remained fastidious and reserved, the rhythm of the studio of first importance – he refused interviews for the radio, film or television. In October 1934 triplets were born. (Ben and Barbara were married in November 1938).

In the following years Nicholson's work moved towards the extreme of abstraction. This period in Nicholson's life coincided with his close involvement with the artists identified with modernism in Paris and London. Nicholson responded to his meetings with Braque and Picasso in the early months of 1933 with a wealth of new painting in which the classic still-life forms were inscribed on a white, or sometimes black, ground interspersed with discs of colour. The modified forms of cubism which Nicholson made his own would provide him with a working repertoire for many years to come.

During the 1930s Nicholson's close acquaintance with the School of Paris brought new forms and a new confidence to his painting. As his work moved towards what he called 'freedom'; that is freedom from appearances or even references to the visual world, he produced paintings and carved reliefs of uncompromising purity, which rival the most extreme non-figurative work of Mondrian.

Ben Nicholson and Barbara Hepworth were accustomed to working within a group, they had long

BEN NICHOLSON
'St Remy, Provence', *1933*

oil on board, 170x93cm
Helen Sutherland

Ben Nicholson, 1933

author's collection

seen themselves as part of a small number of artists who would provide mutual support and encouragement in the face of an indifferent public. This was evident when, in 1931, Nicholson moved into 53 Parkhill Road in Hampstead. Barbara and Ben had adjacent studios in Parkhill Road. His neighbours included Henry Moore, Cecil Stevenson, an abstract artist from Leeds and a protégé of Nicholson. Paul Nash was nearby in Eldon Grove. The arrival in London of artists in flight from Hitler brought some of the most central figures of the modern movement to London; Walter Gropius, Mohaly Nagy, Marcel Breuer, Mies van der Rohe and Eric Mendelsohn, all lived for a time in Hampstead. Piet Mondrian lived from 1939 to 1941 in Parkhill Road. Naum Gabo came to Lawn Road, Hampstead, in 1938, and Herbert Read, who dubbed the group 'a nest of gentle artists' took No.3 Mall Studios.

During these years Nicholson was very active in the affairs of the 'Seven and Five Society' and was in regular contact with the most forward looking of the European artists in Paris – Arp, Brancusi, Helion, Braque and Calder. He was a member of the group 'Abstraction – Creation' and played an important part in the formation of 'Unit One'. He was included in the exhibition 'Abstract and Concrete' arranged by Nicolette Grey and a co-editor of the publication of *Circle*, a definitive proposition of the position of abstract art.

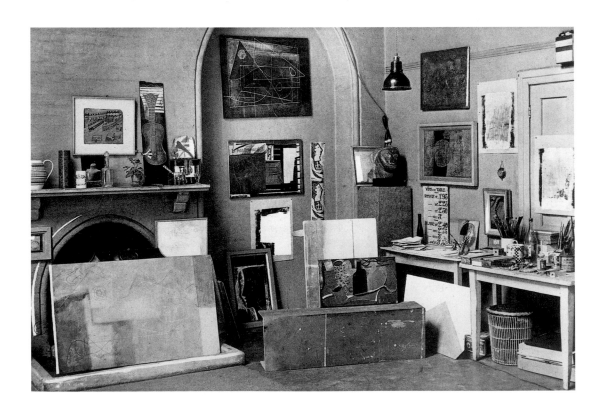

The Studio, Parkhill Road, 1933

author's collection

In August 1939, with war imminent, Nicholson, Hepworth and their five year old triplets came to Carbis Bay as guests of the painter and writer **Adrian Stokes** (1902–1973), author of *Colour and Form* (1932) and *Stones of Rimini* (1934) and his wife **Margaret Mellis**. As Hepworth said 'A glass-roofed studio in Hampstead was not the best place for three young children'. After Christmas the Nicholson's moved to a small house nearby, 'Dunluce' and were there for the period of the war. Stokes cared for Alfred Wallis from 1940, supplied him with paints and paid for his funeral. In 1946 Stokes returned to London after the break up of his marriage. He later moved to Switzerland.

The character of that time is reflected in the diaries of Margaret Mellis. She remembers the early years of the war when, for four months, she and Adrian, shared their house 'Little Park Owles' with Ben, Barbara, their triplets, nursemaid and cook:

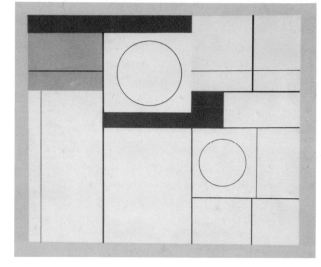

Ben Nicholson – Christmas card to Peter and Sheila Lanyon inscribed 'to Peter from Ben, Xmas 1939'

Shiela Lanyon

> *Ben never stopped working and if he wasn't actually painting or making reliefs he was writing letters to people who were interested in the movement. They might show works, buy them or write about them. When he wasn't doing that he was looking round St Ives for new people who might be interested. He had already begun to work towards what eventually became the Penwith Society in 1949. His aim was always to help people to do good work and get it shown and to stimulate a wider interest in modern art. He enjoyed manoeuvring people and arranging events.* (From 'St Ives' 1934–64 op.cit p.100).

For Ben the early war years were neither highly productive nor obviously adventurous. However with remarkable tenacity of purpose his work developed in new and unexpected directions. The poetry of the Cornish landscape became an essential ingredient in his painting: its light and colour, the variations of coast and sea, tin mine, tor, cottage and harbour – all enriched the sparseness of abstraction.

The group that had formed in Hampstead was necessarily dispersed at the outbreak of war, but from the remoteness of St Ives, Ben and Barbara managed to keep in touch with some of their closest associates by letter and occasional visits. Ben was always an energetic letter writer. In April 1941 Cyril Reddihough, a Yorkshire solicitor and one of Nicholson's principal patrons visited St Ives, as did Margaret Gardiner and Helen Sutherland, later that year Nicholson was back in London. He continued to exhibit as much as possible at the Lefevre Gallery and in mixed exhibitions in London and provincial galleries.

ST IVES IN WARTIME
The conclusion of the Second World War marks the beginning of the art colony in St Ives as part of the Modern Movement. Some, including the most important, were already here. St Ives in wartime was isolated from the rest of Britain. Local travel was restricted. Even Newlyn and Mousehole became remote. In the St Ives Home Guard Leonard Fuller was the commanding officer, Borlase Smart was the intelligence officer with Private Bernard Leach in the squad. Ben Nicholson joined the ARP. There were others in St Ives whose presence gave support and encouragement to the embattled 'moderns'.

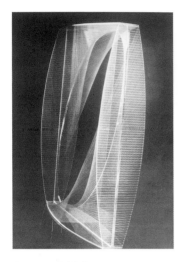

NAUM GABO
'Linear Construction No 1'
1942-43
perspex, 349x349x89cm
Tate Gallery

Naum Gabo (1890-1977). Naum and Miriam Gabo had arrived in Carbis Bay, close to St Ives, in mid September 1939 and were there throughout the war. Engineer and artist, mathematician and poet; he had experienced the terrors of the Russian Revolution and had participated in the European *avant-garde*.

Born in Briansk in 1890, the family name was Pevsner. He took his mother's maiden name, Gabo, to distinguish himself from his brother Antoine four years older and also a sculptor. Naum Gabo was trained in medicine, physics and later in engineering. He worked as an artist in Russia throughout the Revolution and then in Paris and Berlin. He came to Hampstead in 1935.

He described his work as the 'Constructive Idea, a principle for the future.' It was his alternative to the horror and pain that he saw around him. His studio was a craftsman's studio, tools well laid out in an orderly manner. His method of working relied not on calculation but on the assembly of freely formed shapes, defined by drawing in order to find those that he knew to be intuitively right.

His work is a direct response to the observation of nature. When asked where he found his forms he replied:

I find them everywhere around me, where and when I want to see them. I see them, in a torn piece of cloud carried away by the wind, I see them in the green thicket of leaves and trees. I can find them in the naked stones on hills and roads. I may discern them in the steamy trail of smoke from a passing train or on the surface of a shabby wall.

In 1946 Naum Gabo left for the USA and lived there until his death in 1977.

BERNARD LEACH AND THE ST IVES POTTERY

Bernard Leach came to St Ives from Japan in 1920 in response to an offer from Frances Horne, who had set up a handicraft guild for textiles and had advertised for a potter.

He had known Japan as a child and, after training at the Slade School, in 1909 he went to Japan to teach etching, although this was of little interest to the Japanese. Leach was introduced to pottery at a raku party and turned his whole attention to making ceramics. In St Ives, with the help of his friend from Japan, Hamada Shoji, they built a three chambered climbing kiln, fired by wood. St Ives was not ideal for pottery, no clay, no suitable fuel and most importantly no audience at that time for studio pottery. In his work Leach combined the ideals and standards of Chinese ceramics with those of traditional English country pottery.

By 1930 his son David was largely in charge of the pottery while Bernard taught at Dartington, travelled, wrote and experimented. It was David who organised the production of stoneware, earthenware and standard ware which made the pottery commercially viable and kept it going throughout the war. In 1940 Bernard Leach published *A Potters Book* which claimed a new position for the

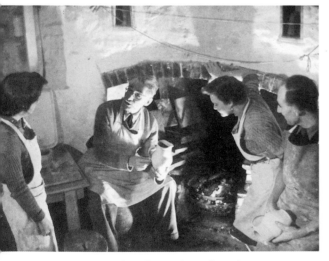

Bernard and David Leach with Apprentices
From Denys val Baker's, Britain's Art Colony by the
Sea

artist-craftsman and which elevated the craft of studio pottery to an art form. His presence in St Ives during the war years gave major support for the position taken by the group in Carbis Bay. In the post-war period Bernard Leach stood uniquely as an artist potter with an international reputation and the highest standards of craftsmanship.

NICHOLSON POST-WAR

In the 1950s Nicholson's work became even more elegant and precise. Forms were linear, freely orchestrated curves with vertical structuring, the references to still-life wholly absorbed into severely disciplined drawings, with the occasional note of defining colour and subtle separation between the lightly textured areas.

Nicholson's work made a triumphant progress across Europe and America. In 1952 he received the first prize for painting in the International Exhibition (the thirty-ninth) at the Carnegie Institute. In the following year, retrospective exhibitions were held for him at the Detroit Institute of Art in Dallas, and at the Walker Art Centre in Minneapolis. In 1954 he received the Belgian Critics' Prize and a retrospective exhibition at the 27th Biennale in Venice for which he was awarded the Ulissi prize.

A large-scale retrospective exhibition of Nicholson's work was held at the Tate Gallery in June 1955. It drew very considerable attention and praise, perhaps best summed up by John Russell: 'This is Ben Nicholson's hour.'

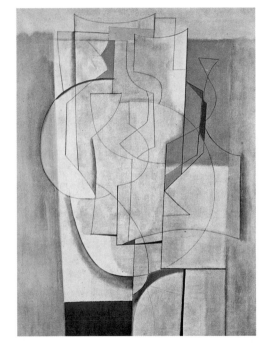

BEN NICHOLSON
'August 11–53, Meridian'
oil on canvas

A few months later he left St Ives. After his marriage to Felicitas Vogler in 1957, he returned to live in that area of Switzerland nearest the Italian frontier, Ticino, where he had painted in the early 1920s, in a house high up on the mountains overlooking Lake Maggiore. Living in the centre of Europe, its ancient cities and treasures were open to him by frequent travel. His international reputation was now assured and his work developed in a series of large still-lifes and abstract reliefs, including many of monumental size. It was this environment that detached Nicholson from England and St Ives. Throughout the late 1960s and 1970s his work was shown internationally in North and South America, Japan and in many one man exhibitions in Europe, and sold by, most particularly, the Galerie Lainhard in Zurich and his London dealers Gimpel Fils, in London, and later at the Marlborough New London Gallery.

A retrospective exhibition at the Tate Gallery, London, in 1969 was an important milestone in this world-wide progress. Another major distinction is the Order of Merit (OM) bestowed on him by the Queen in the previous year, the most prestigious honour awarded in the arts, and limited to the number of those who may hold it at any one time.

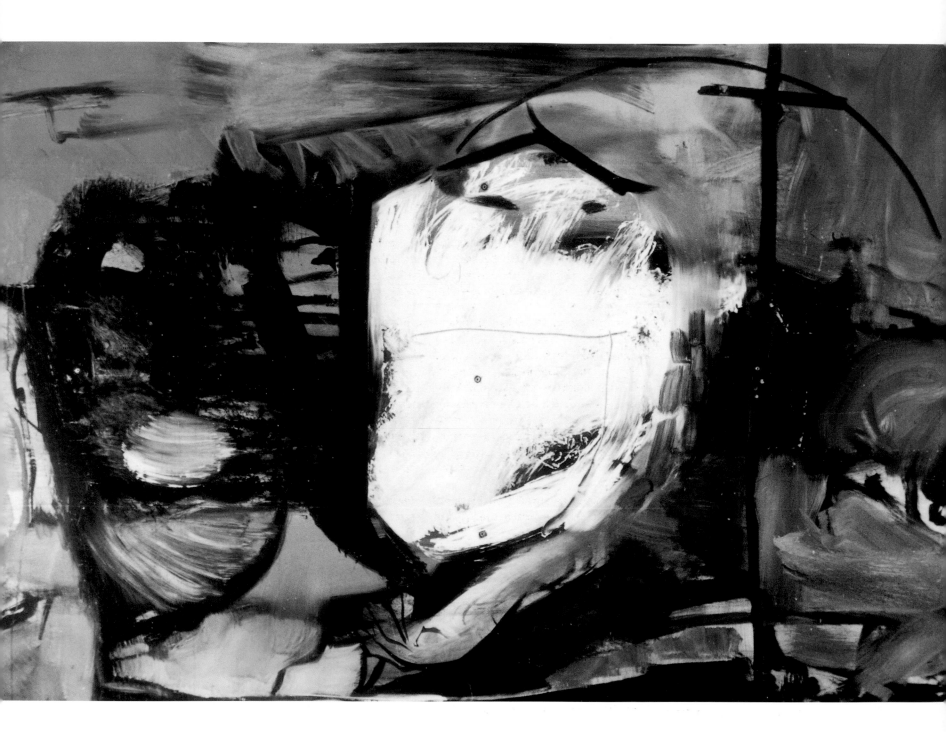

THE ST IVES INHERITANCE

PETER LANYON (1918–1964)

The artist who most forcibly brought St Ives into the second half of the twentieth century was Peter Lanyon. In appearance he was typically English, tall, blond-haired, outgoing and friendly, but there was a deeper Celtic streak that derived from his Cornish background and his detailed knowledge of every rock, cliff and mineshaft in West Cornwall. His imagination had a vaulting exuberance and humour and in his painting this lead to a multitude of images, richly superimposed.

Peter Lanyon was born in St Ives in 1918, the son of Herbert and Lillian Lanyon, a family of Cornish stock with interests in music, painting and photography. He was educated in St Ives, where his friend Patrick Heron was a fellow pupil and later at Clifton College, Bristol. At the age of eighteen he took lessons in painting from Borlase Smart, the St Ives landscape artist, who taught him the value of working directly from nature. It was the writer Adrian Stokes, newly arrived in St Ives, that introduced him to ideas of modernism in art and who suggested that he attend the Euston Road School in London. For four months he was taught by William Coldstream, Claude Rogers and Victor Pasmore. Stokes also gave Lanyon an introduction to Ben Nicholson who agreed to give private art tuition to the young man and they met over several months in Lanyon's studio at the Redhouse in St Ives. Lanyon also met and was greatly impressed by the working attitude of Naum Gabo.

In March 1940 Lanyon joined the RAF and was trained as an aero-engineer fitter. He refused a commission and served in the Western Desert. In 1940, as a corporal in the Western Desert he wrote:

I couldn't see my county as if from outside... but I had an intensity from the war, from street fighting and being under fire, which made me find a strength in myself. The strength was, I think, the granite strength of my own county.

With the resumption of his painting Lanyon was now strongly influenced by Gabo, but with the scraped-down spareness of Nicholson. His descriptions of landscape are non-figurative, yet they are particular to the places that he knows. They reveal an intimate knowledge of cove, hill or cliff and they are, without exception, Cornish. Further changes occurred after 1950, with the scraped rock-like forms of *'Yellow Runner'* and the *'Generator'* series. Within a short time Lanyon had found a new and original way of describing the elements of landscape. From cubism he took the ability to look at an object from all sides rather than from one viewpoint. The sea can ride up the side of a composition,

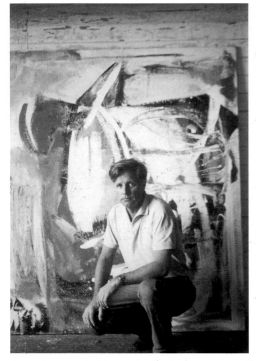

Peter Lanyon in his studio
courtesy: Sheila Lanyon

Opposite page:
PETER LANYON
'Sunday', 1962
oil on aluminium, 122x183cm
courtesy: Andrew Lanyon

the rounded hill can become transparent and may reveal elemental forms. The geometry of the abstract artists of the 1920s and 1930s, including that of Nicholson, is left behind and it is replaced by a new personal freedom of brushwork. Paint is used vigorously to find an equivalent for the rough sea, windswept moorland and ragged hedges of West Penwith. In the swift movement of a well-filled brush he finds a believable equivalent to the forces of nature. Gestural and abstract, they describe the sensation of a particular landscape, the experience of being there.

Patrick Heron wrote of Lanyon's discovery as a 'parallelism', which he described as:

...the key to everything in art. Suddenly, in the line which the movement of a fishing boat across St Ives harbour describes, Lanyon will see the abstract figure, the abstract line, which he has just drawn with a large black brush over a rough white, or pale blue ground, closeted with his canvases, up in his studio overlooking the town. ('Peter Lanyon' by Patrick Heron, Arts New York, February 1956).

In 1946 Lanyon married Sheila St John Browne and in the following year the first of six children was born. This was a time of great activity in St Ives, with the formation of the Crypt Group, in which Lanyon was a prominent member, and which in 1949 was subsumed into the Penwith Society of Artists. For Lanyon it also included a period of travel in Italy and his first one-man exhibition at the Lefevre Gallery, London. As a result of this successful exhibition he was invited to make a large painting for the Arts Council's contribution to the Festival of Britain '60 Paintings for '51'. He exhibited 'Porthleven' for which he had made many drawings and six constructions, as he explained; 'to develop an image in my mind and to explore an actual space before painting it.' The final painting was completed in about six hours. It was purchased by the Contemporary Arts Society and later presented to the Tate Gallery.

In 1950 Peter Lanyon had a public falling out with Ben Nicholson and Barbara Hepworth over the 'A, B & C' rule of the Penwith Society, which divided the work of members into figurative, abstract and craft groups, a separation which Lanyon regarded as destructive. He wrote:

There will be no art in St Ives soon if this idiotic division continues... Modern art, traditional art, primitive art, big and little art, may one day be able to bump around in a jolly manner again and bless St Ives for its ignorance about the fine points of art politics. (Letter to St Ives Times, 7 August 1951).

As a consequence of this dispute Peter Lanyon transferred his considerable energies to the Newlyn Gallery and from 1959 he played an important part in its affairs and attracted many artists from London to exhibit there. In 1959 he became Chairman of the Newlyn Society of Artists.

By the beginning of the 1950s Lanyon's work had reached its maturity, and in 1952 he had the first of five one-man exhibitions at Gimpel Fils Gallery in London. His work was now seen in an international context. He made extended visits to Italy which he considered to be his second home and took

Peter Lanyon grinding powder-colour for paint, c.1954

courtesy: Andrew Lanyon

an interest in the painting of the New York artists. In 1957 he made his first visit to New York for a one-man exhibition at the Catherine Viviano Gallery – the first of five such exhibitions. On this visit he met many of the American artists such as de Kooning and Motherwell. Many became personal friends. In 1958 Mark Rothko visited St Ives with his wife and child and stayed with the Lanyons for a week. With Lanyon they looked for a chapel in West Penwith that Rothko might decorate, but without success. This contact with the United States continued until Lanyon's death.

Lanyon was assiduous in the preparation for a painting. Visits to a site would produce many drawings in charcoal and, as the pictorial idea unfolded in his mind, he would create additional studies in collage and sculpture. He would build elaborate and sometimes large constructions using materials that had been found on the beach or in the studio. These were not intended for exhibition, they were usually a composite of painted wood and metal that provided a support for fragments of glass, perspex and other transparent materials. They have the same freedom as his paintings and they can be looked at from all sides.

During the 1950s his work is most closely allied to his native Cornwall. Such paintings as 'Bojewyan Farms' of 1951–52, 'Silent Coast' 1957 and 'Gunwalloe' 1959, are direct records of the experience of the landscape of Cornwall, from walking and underwater swimming 'Where solids and fluids meet... Its rocks were my own bones'. In 1958 he was awarded the Critics Prize of the British Section of the International Association of Art Critics. In spite of such success he was still commercially unsure and in the following year he set up an art school in St Peter's Loft, St Ives, with Peter Redgrave and Terry Frost, a summer venture which continued until 1955. Also in 1955 he moved to the house in Carbis Bay, 'Little Park Owles' that had previously been occupied by Adrian Stokes.

Lanyon had been denied the opportunity to fly whilst he was in the RAF but in 1959 he began gliding and joined the Cornish Gliding Club. This new experience gave an added dimension to his understanding of landscape and had a direct influence on paintings such as 'Soaring Flight' 1960. The soft curtains of blue with darker brush strokes showing through have the quality of cloud and landscape, seen from the air. In many of these paintings the red streak of the glider is seen penetrating the sheets of colour. 1961 was his most productive year, with a succession of his paintings to do with flight.

In the last two years of his life a new direction emerges. He makes further visits to the United States and for four months he became a visiting painter in the Art Institute of San Antonio. His work is changing again at this time, possibly in response to the developments that are occurring with the younger generations of artists that were being shown in the United States. He continued to teach at Corsham Court and briefly at Falmouth School of Art and in 1964 he was working with a group of students from the West of England College of Art. The drawings, photographs and paintings that he made of the Victorian pier at Clevedon incorporate a variety of found objects, loosely assembled and they are his last group of work. He had plans for more teaching in the United States and a visit to Australia for which he had been sponsored by the British Council, but on the 31 August he died in the Taunton Hospital, following a gliding accident received a few days earlier.

PETER LANYON
'Long Moor', *1960*
oil on canvas, 52x52cm
private collection
courtesy: Andrew Lanyon

PETER LANYON
'Clevedon Bandstand', *1964*
oil on canvas, 48x72cm
courtesy: Sheila Lanyon

THE CRYPT GROUP

In St Ives a small group of young artists were trying to clarify their position in relation to the art of their time. They were lead by Peter Lanyon and included John Wells, Sven Berlin, Bryan Wynter and Guido Morris the printer, Wilhelmina Barns-Graham and later Patrick Heron. Between 1946 and 1949 they arranged a series of exhibitions with the title 'The Crypt Group', exhibiting work that was not acceptable to the more traditional members of the St Ives Society of Artists. For this reason they were only allowed to exhibit their work in the crypt of The Society's gallery. This form of banishment became a mark of pride.

Their first exhibition took place in September 1946 and received strong and unfavourable comment, from some of the traditional artists in St Ives. The most outspoken was Harry Rowntree, a painter, illustrator and caricaturist whose best known work was a series of advertisements for 'Cherry Blossom' boot polish. In a letter to the *Western Echo* (21.9.46) Rowntree stated: 'Fifty years I have been a professional artist and I see nothing original in these modern alleged modern ideas... This modern racket started in France; it rotted French art in France it is now dead. Young men drop it get back to work and sweet sanity'. (*St Ives 1939–64* op.cit. p 104). These sentiments coincide exactly with those of Alfred Munnings, then President of the Royal Academy, who also became President of the St Ives Society of Artists in 1948. On the occasion of the Royal Academy Dinner of 1949, the first time such an event was broadcast, he launched into a wholly intemperate attack on 'this so-called modern art'. He produced a catalogue of rejections, including the School of Paris, Picasso, Matisse, Henry Moore and others. He opened the widest breach between those artists who were responsive to the art of their time and established art organisations, of which the Royal Academy was the summit.

In spite of this strenuous opposition many were aware that by the late 1950s and early 1960s St Ives was the most creative place in England. The presence of Ben Nicholson and Barbara Hepworth, and the example of Naum Gabo was reinforced by many others. Herbert Read was very much involved with the Penwith Galleries and came down often. John Wells met Max Ernst in Newlyn and Peggy Guggenheim in St Ives. Francis Bacon took a studio in St Ives for a time

By the late 1950s Ben Nicholson, who had become an international figure, had left St Ives. The death of Peter Lanyon and Ben's departure seemed to mark the end of a chapter. The group had narrowed to include Denis Mitchell, John Wells, Alex Mackenzie and a few others. It was a struggle to keep things going. For those who remained the whole scene had become more London based, a younger group tried to sustain things in St Ives but it was very tough going.

JOHN WELLS (1907–2000)

At his death at the age of 93 in July 2000, John Wells was the most senior of that group of artists that had seen the remarkable changes that affected the artists of Cornwall before and after the Second World War. He had been an active participant, yet one who preferred to work within the coterie of St Ives rather than to seek the wider recognition of the London dealers.

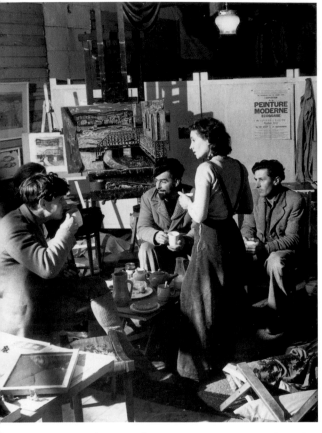

Left to right: Peter Lanyon, Sven Berlin, Wilhelmina Barns-Graham, John Wells, Guido Morris; members of The Crypt Group.

photo: Central Office of Information

Opposite page:
JOHN WELLS
'Sea Bird Forms', 1951

oil on board, 43x49.5cm
Tate Gallery

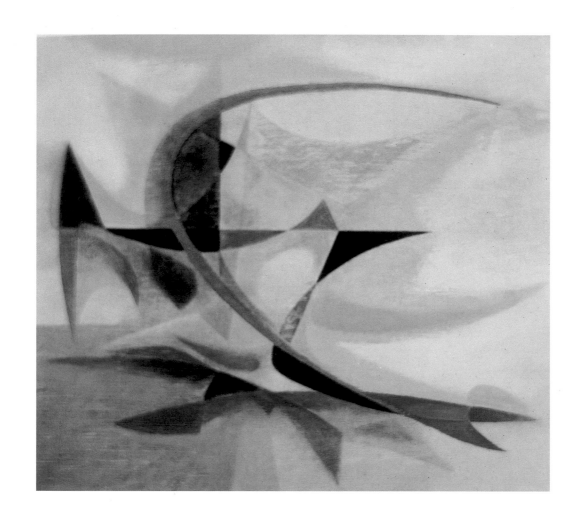

John Wells

courtesy: Dr Roger Slack

John Clayton Wells was born in London in 1907. He had known Cornwall all his life. His mother was Cornish, from St Mary near Padstow, and since his earliest childhood he had come for summers to North Cornwall. His father was a doctor with a small private practice who was also a researcher at St Mary's hospital, Kent, a colleague of Alexander Fleming. The death of his father, when John was two years old, was a direct result of his father's research into glanders, a disease of horses. The family moved to Ditchling in Sussex. In this artists' village, with such awesome figures as the sculptor Eric Gill, Edward Johnston, the great calligrapher, and the painter Frank Brangwyn, John was under the influence of art from an early age.

In the summer of 1928 the young John Wells was holidaying with a cousin, Norman Williams, at Feock, near Falmouth. Neighbours were Marcus and Irene Brumwell who knew of John's interest in art and asked if he would like to meet some 'real' artists. They proved to be Ben and Winifred Nicholson and their friend Christopher Wood, who were staying with the Brumwells. The young John was greatly impressed by their purposeful manner, although he could make little of their art. He remembered Ben with his large sketchbook, and Winifred carrying on with her own work, very aloof. He found Christopher Wood, who was nearer to his own age, more relaxed company. They fished and sailed together. On one occasion they tore the peak of their mainsail and had to put into Falmouth for repairs. Wood, who was French speaking, spoke to the crew of a French fishing boat which could not come ashore because they could not pay customs dues. Wood's purchase of a lobster from them settled this matter. Later on during this visit to Cornwall Nicholson and Wood made their historic visit to St Ives and the discovery of Alfred Wallis. These meetings were very important to John Wells and he kept a correspondence with Ben and with Christopher Wood, that only terminated with Wood's tragic death.

Out of respect for his father's memory, John started his medical training at University College, London, but he also managed to attend St Martin's School of Art for two or three evenings a week over two years. This was the limit of his art training. In 1930 he qualified MB, BsC (Lond), MRCS, MRCP, all in the same year. He had not intended to enter general practice, but with the illness of his mother there was no choice. From 1930 to 1936 he worked as a low-paid intern in Norwich and in 1936 he was able to buy a practice in St Mary's in the Scillies. As the only doctor in the islands, his practice covered an area of more than one hundred square miles. He travelled between the islands, often sailing his own boat. With local help he started a small hospital – one male and one female ward with an operating theatre. In wartime he became a Medical Officer to the Royal Navy, known as the 'Admiralty Surgeon and Agent' attending to a military garrison, a naval base and a seaplane base. This was a busy life but without much evidence of war in the early days. However with the fall of France a large number of refugees came in small boats from Brittany in terrible conditions. It was John's job to give what help he could to the ill and the injured, friend or enemy.

During these years Wells made occasional visits to Cornwall and was in touch with Ben Nicholson, now living in Carbis Bay, and Naum Gabo. Wells took naturally to the *avant-garde* work that he saw. His scientific training made him receptive to the abstract thinking and the evidence of geometry allied to feeling. Gabo did not talk much about art and made little effort to exhibit his work in St Ives but John

remembered one phrase: 'how nature was always striving for the perfect form and always prevented by the accident of life in general, an ideal to which it was always reaching out and never achieving.'

John Wells had earlier formed the intention to paint full-time but events delayed this for nine years. He had a body of work dating back as far as 1930 and many paintings of the Scillies, together with studies of crystals and shell forms and constructions for paintings. With encouragement from Ben Nicholson, he found enough for a London exhibition, at the Lefevre Gallery in April 1946, shared with Winifred Nicholson. The catalogue introduction by Eric Newton spoke of 'work that is new to us – now we have to make up our mind whether we like it or not.'

In 1947, with one thousand pounds saved, which he reckoned would last him for about five years, John was able to buy the large wooden studio in 'The Meadow' in Newlyn, built for Stanhope Forbes many years before. Later, in 1965, he bought the granite building nearby which became his working studio, shared with Denis Mitchell. This had also been built for Forbes in about 1886 and made into a school in 1900.

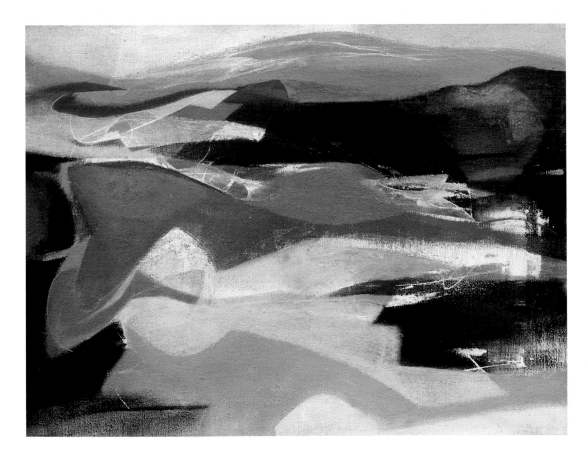

JOHN WELLS
'Journey' (memory of a journey with Peter Lanyon), 1955
oil on canvas, 46x61cm
private collection

John Wells with Peter Lanyon
courtesy: Sheila Lanyon

In the first years of peace much of Wells' work was totally abstract and very formal rectilinear paintings and constructions, sometimes in relief or built up with wire or plastic surfaces. His work shares the constructive geometry of Naum Gabo, both had a scientific training allied to a speculative imagination, a link between the precise and the mystical. Wells shared with Gabo a delight in pure curves and geometric shapes, which he saw as the structural basis of nature. To his death Wells' studio contained fragments of cut metal and plastic which were souvenirs of his earlier friendship with Gabo. He also acknowledges his debt to Nicholson, and his fascination with Paul Klee. Yet his work as a whole has its own distinct quality, quite discrete from these. He also made many landscape paintings which refer to specific places, mostly in West Penwith. Other paintings of free-flowing curvilinear forms resembling seed pods, thistledown and other plant structures, fuse the elements of abstraction and observation.

Although living in Newlyn, Wells was a regular visitor to St Ives. He went over a great deal on his bicycle or on the train – 1/9d return. St Ives was a place where one saw friends, they met in the Castle Hotel, owned by Denis Mitchell's brother Endell. They exhibited there in the back room and discussed the art politics of the growing community. The older artists were generally antagonistic and very much against the younger group. Notable exceptions were Borlase Smart and John Park who were sympathetic and friendly. After exhibiting in all of the exhibitions of the Crypt Group, Wells was a founder member of the Penwith Society of Artists and a regular contributor to its exhibitions.

John Wells was a close friend of Peter Lanyon. They shared a natural and intuitive acceptance of abstraction, but each had a different point of view. They went on many trips together, to Porthleven, long walks on the Lizard, and a memorable visit underground to Geevor mine, Peter drawing all the time. John would not draw, it was for him too private an activity, but later, paintings would come out of this shared experience.

Wells chose subjects for which no visual forms exist, the flight of birds, the sensation of sunlight, the sense of union with the most minute forms of nature. In the imaginary world that he created he searches for equivalents of these sensations. He uses geometry and systems of proportion, the circle and ellipse, rectangles, radiating lines, triangles and rubbed, scratched and diluted colour. He admitted that he found plain white canvas intimidating. His method of painting was to work on the surface of board, scraping or rubbing to create a textured space. Divisions of the areas are made, perhaps based on sevenths or the golden proportion. Slowly the painting emerges .

In a letter to Sven Berlin, written while sitting in the sunshine on a rock, John Wells described the strong feelings that he tried to capture:

so all around the morning air and the sea's blue light, with points of diamond, and the gorse incandescent beyond the trees, countless rocks ragged or round and of every colour; birds resting or flying, and the sense of a multitude of creatures living out their minute lives... All this is part of one's life and I want desperately to express it; not just what I see, but what I feel about it... but how can one paint the warmth of the sun, the sound of the sea, the journey of a beetle across a

rock, or thoughts of one's own whence and whither? That's one argument for abstraction. One absorbs all these feelings and ideas; if one is lucky they undergo an alchemistic transformation into gold and that is creative work. (Painting the Warmth of the Sun: St Ives Artists 1939–1975. Tom Cross, Halsgrove, 1997).

In the 1950s and 1960s Wells exhibited regularly, he had several exhibitions at the Waddington Gallery in London, and in New York with the Durlacher Gallery in 1952 and 1958. His work was also toured by the British Council to the USA and Canada. However he did not visit the United States and gradually withdrew from the international circuit. It was a time of change for many artists working in Britain but the work of John Wells changed little. It continued to move between landscape forms and total abstraction. In this he was following the example of Ben Nicholson who saw the two ways of working as expressing two sides of the same personality. In 1958 Wells received the Critics Prize Open Recommendation.

At the age of fifty John lost the sight of his right eye. At his London exhibition In 1964 he found that his larger abstracts were less well received. He did not exhibit in London for some time after this, but continued to show at the Penwith Gallery in St Ives and in other exhibitions in Cornwall.

John Wells remained a bachelor and was noted for the simplicity of his life. He was naturally withdrawn and in later years he travelled little and remained within the circle of his artist friends. A visit to London in November 1977 in connection with the New Art Centre exhibition 'British Artists who Worked in Cornwall 1945–1955' was his first visit to London in nine years. The revived interest in earlier St Ives painting and sculpture that occurred in the 1970s and 1980s came somewhat too late for him. His later exhibitions were mostly shared with friends, such as that in February 1975 with Alex Mackenzie and Denis Mitchell at the City Art Gallery, Plymouth. Later that year he showed again with Alex Mackenzie and George Dannatt at the Orion Gallery, Penzance. In his later years his work was exhibited at the Wills Lane Gallery, St Ives. A major retrospective exhibition to commemorate his 80th birthday took place in this gallery in 1987. His 91st birthday was marked by a retrospective exhibition at the Tate Gallery, St Ives. John Wells died on 27 July 2000, the day after his 93rd birthday.

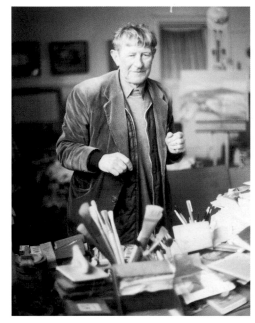

John Wells in the studio, 1983
author's collection

ROGER HILTON (1911–1975)

Roger Hilton came from a background that was part German, Jewish and English. The family name Hildesheim was changed to Hilton in 1916, when Roger was five years old, because of anti-German feeling. He was brought up in Northwood where his father was a prosperous and successful doctor, who helped to found the Northwood and Pinner Hospitals. It was against this middle-class professional background that Roger sought to find his direction in art, helped and encouraged by his mother, Louisa Sampson, who trained at the Slade School.

As an alternative to the medical training that his doctor father had planned, in 1929, the last year of Henry Tonks' long professorship, Roger entered the Slade School. Between leaving the Slade in the

summer of 1931 and the outbreak of the Second World War, Roger divided his time between London and Paris. With the help of an income from his parents of £150 a year, he could, as he said 'Live like a prince'. In Paris he attended the Acadèmie Ranson and the most important influence was that of Roger Bissière, an artist whose work had developed from Cubism to his own form of decorative abstraction. It was the strength of Bissière's personality and his use of an emotionality-based language of abstract painting that impressed Hilton. In all Roger Hilton had about ten months under Bissière's tuition and won his master's respect. Bissière's testimonial describes Hilton as 'among the most gifted young men I have ever met'.

At this time Hilton was described by a friend, the sculptor F. E. McWilliam, as 'a mild eternal student.' But the gentle character was to change with the experience of war. For one who was self-absorbed and a rebel against authority, the army seemed inappropriate, Hilton's war-time career was distinguished but brief. He enlisted in the Royal Army Service Corps and was trained as a driver but volunteered to a commando unit – having it would seem, little knowledge of what it would entail. By 1942 he was attached to No.3 Commando and took part in the raid on Dieppe, in preparation for the D-Day invasion. Hilton was captured and spent the remainder of the war in various prisoner-of-war camps in Silesia, on the German-Polish border. The last part of the war brought his most gruelling experiences, as the Germans, with their prisoners, retreated before the advancing Russians. Eventually Hilton was freed and returned home four days before VE Day.

On demobilisation, unsettled and with little direction, Hilton taught for two terms at Bryanston School in Dorset. He even worked for a time on the Continental Telephone Exchange where his excellent French was an asset. In June 1947 he married Ruth David, a violinist. His first exhibition was of twenty-four paintings shown alongside sculpture by Lynn Chadwick at Gimpel Fils Gallery in London. Patrick Heron was much impressed, he wrote:

> Roger Hilton is a natural painter. That is to say, he cannot put brush to canvas without creating a splotch, smear, streak, stain or smudge (in other words, a 'brushstroke') that is not charged with expressive quality... Indeed, Hilton begins and ends with paint... (New Statesman and Nation 28.6.52).

This highly flattering review lead to a close friendship with Heron and meetings with other artists, including Peter Lanyon and Bryan Wynter, who Patrick had also championed. Hilton was included in the anthology exhibition 'Space in Colour' arranged by Patrick Heron in July 1953.

Increasingly drawn towards abstraction, Hilton was much affected by his meeting in 1953 with the Dutch abstract artist Constant Nienwenhuys, who with Corneille (Cornelis van Beverloo) and Karel Appel was involved in the Experimental Dutch Group and CoBA (a group which took its name from the initial letters of Copenhagen, Brussels and Amsterdam). Constant was resident in London and in February 1953 Roger and he travelled to Amsterdam to see the Mondrians at the Hague. In 1954 Hilton was included in the seminal publication *Nine Abstract Artists* with an introductory essay by Lawrence Alloway. Hilton claimed an heroic place for the abstract artist, he stated:

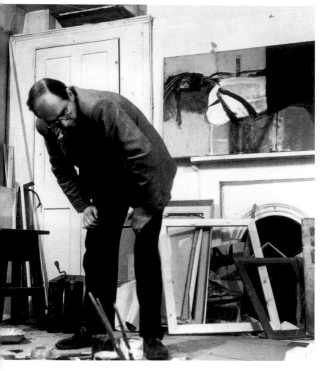

Roger Hilton, 1956

The abstract painter submits himself entirely to the unknown. He believes that today, the true language of colour and form is obscured and rendered ineffective by being put to the service of representation. Thus he is like a man swinging out into the void; his only props his colours, his shapes and their space-creating powers...

Roger Hilton had visited Cornwall on holiday with his family in August 1952. In 1956 he spent Christmas with Patrick and Delia Heron at their newly acquired home, 'Eagles Nest' in Zennor and from this time his visits to St Ives and Newlyn were frequent. His love-hate relationship with Cornwall developed 'What is this Cornwall' he would say testily. Nevertheless his paintings begin to contain references to the world of the sea, boats, rocks, figures and to the human body – always female – suspended in water. Increasingly Hilton was seen as part of that group of post war abstract painters whose success was increasing and who were attracted to Cornwall. In 1956 he bought Croft Pool, a cottage on the moors of West Penwith behind Nancledra.

The success that came to Hilton in the mid-1950s and the financial improvement of a teaching job at the Central School of Arts and Crafts, London, had the effect of unsettling him. His sometimes abhorrent behaviour disturbed his friends and he displayed a strong alien streak that made him critical of other artists' work.

His third and last exhibition at Gimpel Fils Gallery took place in April 1955. His work was no longer the floating abstraction of earlier years, but was described by him as 'semi-figurative expressionism'. In common with many others he felt himself to be under the shadow of the American Abstract Expressionists, a powerful force that would change the direction of many British artists. Hilton's response was characteristically perverse. He grew increasingly away from the abstract image and the forms of landscape and the figure came more frequently into his work. He wrote, 'Abstraction in itself is nothing. It is only a step towards a new sort of figuration, that is, one that is more true'. (From the catalogue of an exhibition at Galerie Charles Lienhard, Zurich 1961). The type of figuration that he developed was loose, scratchy, clumsy, soft rounded shapes of hills, breasts or buttocks, suggested not stated. Sombre earth colours, browns and yellows or simply black and white, with one strong colour. But the expressive mark never fails, the free handling of paint, richly applied, that invites the viewer to share the drama of the painting.

Hilton came to popular attention when he received first prize at the John Moores Liverpool Exhibition in November 1963, with a large and freely gestural painting in cobalt and white. The panel of judges included Peter Lanyon.

Roger Hilton had his most important retrospective exhibition, at the Serpentine Gallery, London in March 1974. By this time he was sixty-three years old and desperately ill. At the private view in the gallery a frail and emaciated figure sat beneath one of his most provocative paintings 'Oi, Yoi, Yoi' clutching his whisky bottle. As his physical condition deteriorated, brought on by his addiction to alcohol, he was less able to paint, and drawing became a central activity, supplemented by cheeky and provocative gouaches. By 1972 he was confined to bed and his bedroom on the ground floor of

ROGER HILTON
'January', 1964

oil on canvas, 127x152.5cm

ROGER HILTON
'March', *1954*

oil on canvas, 152.5x127cm

the cottage became studio, living room and meeting place, where he could work when and as he liked. He was surrounded by the detritus of his life – paints, brushes and a low table he worked on beside his bed, discarded plates of food, letters, books and inevitably a bottle of whisky. Naturally left-handed, he worked leaning on his right elbow. However this became so painful he had to lie on the other side and taught himself to use his right hand.

Following his exhibition at the Serpentine Gallery he appeared to rally his strength, and in the following August arranged for a small private plane to fly him with his wife Rose, his two children Bo and Fergus to the South of France. From Cannes he went on to Antibes and was taken around the town and port by wheelchair. Here he was able to work on new gouaches, his subjects were sailing boats, seabirds and sun-worshippers. However this was the last occasion that he was able to leave his bed. In Cornwall, six months later, after a minor stroke, he died.

In March 1980 five years after his death, Roger Hilton's *Night Letters* were published by the Newlyn Orion Gallery. These were a collection of writings and drawing made in the late years of his life and at a time when he was bed ridden and suffering from peripheral neuritis, aggravated by an irritating skin condition. In these drawings and letters he deals with the essentials of his confined life. Written in the long hours when sleep was not possible, they talk of food, of the art world and its injustices, most particularly the lack of interest in his own work. He talks of pens, – he is always looking for a more perfect writing instrument. He talks of friends and enemies. He gives instructions to his wife Rose about the domestic necessities that she is to find in Penzance – envelopes, stamps, tomatoes, tangerines, milk and above all his regular supply of whisky.

Drawings decorate almost all of the letters, mostly of female nudes in provocative poses, sensual, sometimes erotic. In their intensity they demonstrate an extraordinary creative talent and justify the place he sought to occupy within the hierarchy of 20th century artists. He felt himself related to Miro, Calder, Dufy and 'of course Matisse, Henri Rousseau and on a smaller scale our Wallis'. (*Studio International* March 1974). These are personal and disturbing documents, made during a period of increasing physical deterioration of a remarkable creative individual.

BRYAN WYNTER (1915–1975)

Bryan Wynter was a countryman, with a fondness for wild places. In the summer of 1945 he arrived in Cornwall and camped on a hillside above St Ives. He wrote to a friend of his first impressions of that western facing coast, the rounded hills and granite boulders of the moorland the ancient field patterns and the sea beyond. He described the broken chimneystacks of long-abandoned mines and the 'horrible black wells' of the mineshafts that threaded this ancient landscape. All of these, plus the birds and beasts, the farms and cottages were to become subjects for the work that he would do in the next few years.

On the Carn, a hill overlooking Zennor, crowned by wind-eroded rocks, he found a remote cottage with eight acres of gorse and bracken which he was able to rent. It was without piped water or

electricity and so it remained. With the minimum of repair to the cottage and to the cowshed, which he used as a studio, Wynter lived in rural seclusion. Some six months after his arrival he met and later married Susan Lethbridge, a toy maker, whose shop in St Ives 'The Toy Trumpet' built up a national reputation for hand-made toys. Bryan Wynter lived on the Carn for twenty years. He later described his remote environment:

The landscape I live among is bare of houses, trees, people; is dominated by winds, by swift changes of weather, by the moods of the sea; sometimes it is devastated and blackened by fire. These elemental forces enter the paintings and lend their qualities without becoming motifs. ('Notes on my Painting' Catalogue to an exhibition at the Leinhard Gallery, Zurich 1962)

Bryan Wynter was born in 1915 into a prosperous family in Hertford which had interests in farming and also in a large laundry business – the Times Laundry Company. As the elder of two brothers, Bryan was expected to join the family business and he worked as a reluctant trainee for five years. Eventually, in 1938, he was able to go to the Slade School, London, which two years later was evacuated to Oxford. As a conscientious objector he was exempt from military service and dug ditches and worked as a market gardener. With two friends from the Slade he went to look after laboratory animals in the Department of Human Anatomy, run by Professor Solly Zuckerman, in Oxford University. It was menial work, cleaning the animal's cages and preparing them for experiment, and the animals – monkeys, cats, rats and mice – were subjected to cruel techniques including vivisection. Although he approved of the objectives, which included the study of synthetic hormones, he found the work frustrating. At the first opportunity and even before his official release, he fled to Cornwall, which he had known from holidays, abandoning his place at the Slade School.

Bryan Wynter, 1974
photo: Jacob Wynter

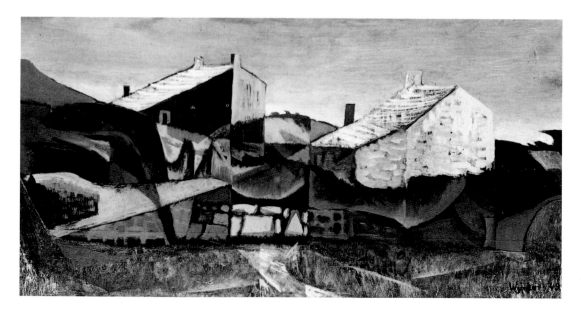

BRYAN WYNTER
'Two Cottages', *1949*
gouache on paper
collection: the artist's family.

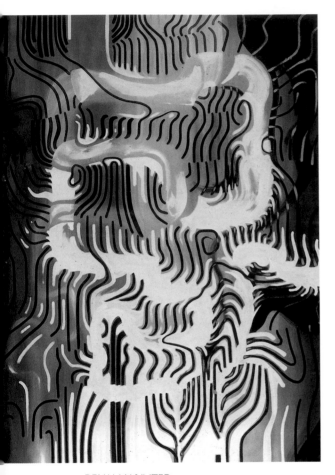

BRYAN WYNTER
'Confluence', 1967

213x168cm
collection: the artist's family.

Bryan Wynter's early gouaches demonstrate his passionate attachment for that exposed centre of West Penwith. The moors, cliffs and bays, animals and birds became subjects for continuous re-interpretation in which the structure of landscape or the wheeling path of a bird in flight is searchingly explored. These drawings which established his early reputation were shown in six exhibitions at the Redfern Gallery, London, between 1947–57.

If Cornwall represented seclusion there was another side to Wynter in which London and the artistic life of Soho played a part. Through his friendship with the poet W. S. Graham, who was living nearby, Wynter was introduced to several London-based artists and writers who were part of the 'Neo Romantic' group, then occupying a central place in post-war British art. They included John Minton, Robert Colquhoun and Robert Macbryde. Others, including Lucien Freud, John Craxton and the surrealist Ithell Colquhoun, all visited St Ives. Wynter's work, which had strong elements of surrealism, was broadly allied to theirs at this time.

There was a pause in Wynter's work in the early 1950s. There were several reasons for this, some of them personal, due to the break up of his marriage, and also to the fact that part of his time was spent teaching at Bath Academy of Art, Corsham Court. Also the artistic climate was changing rapidly. The supremacy of France was being questioned by the American painters whose work became prominent in the mid 1950s. This posed a problem for many artists of Wynter's generation. To emulate the discoveries of Pollock, Motherwell or Rothko would be to give a lie to their own work. For Wynter and others in Cornwall the response was to develop their own achievements to the point at which it was equally valid, yet different.

For Wynter the point of change became apparent in 1956, the year in which the American exhibition at the Tate Gallery, entitled 'Modern Art in the United States' gave major exposure to the new American painting. In that year, working in London, Wynter produced two disturbing paintings 'Interior' and 'Prison', both of which reflect an unsettled mind. Another important influence was the studio paintings of Braque which assisted him in his search for a personal iconography of abstract form which allowed him a far greater range of expression. In these and later paintings, individual brushmarks create a free calligraphy, described by Patrick Heron as 'bead curtains', which create a sense of space and transparency. Although abstract they still refer to natural events and places, each painting giving tangible existence to particular circumstances experienced by the artist.

The process is refined and clarified in a later series called 'Sandspoor'. Wynter describes this as 'a generic title of a series partly descriptive (traces left by water, wind, etc., on sand), but mainly concerned with the spoor as a record of action'. The paintings have a sense of being imaginative reconstructions based upon clues and past traces. The 'spoor' is the evidence of the artist's progress as the paintings are slowly completed. As an example he quotes a passage from Wilfred Thesiger's *Arabian Sands*, where a tracker, having examined tracks in the desert is able to say correctly: 'they were Awamir. There are six of them. They have raided Junuba on the southern coast and have taken three of their camels. They have come here from Sahma and watered at Mughshin. They passed here ten days ago.'

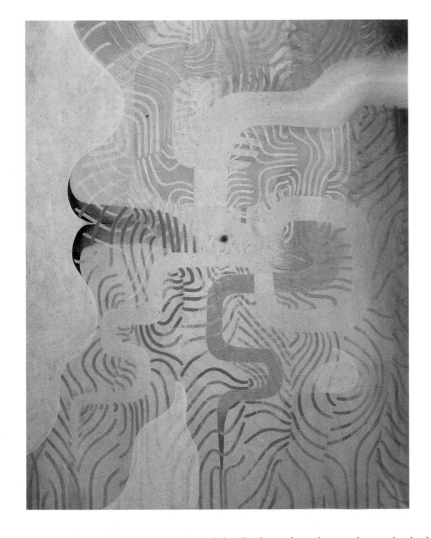

BRYAN WYNTER
'Saja', 1969
oil on canvas, 213x168cm
Tate Gallery

Important to Bryan Wynter was the inventive mind that he brought to his work. He had a love of the mechanical and he had earlier invented drawing machines, but the most important of these visual experiments were in the form of constructions he called IMOOS, *'Images Moving Out Onto Space'*. These kinetic works date from 1960 until the time of his death. In front of a large parabolic mirror, originally manufactured for wartime searchlights, he hung balanced pairs of painted shapes cut from card. Each was free to rotate, moved by air currents in the room. As they moved, their reflections, reversed and greatly enlarged, appeared to mix and to move in opposite directions. These constructions refer back to the 'veiled' paintings of the late 1950s, with their overlapping systems of images. The first group of six were shown at the Waddington Galleries in 1965 and all were acquired by British public collections.

In 1961 he suffered his first heart attack. Now married to Monica and with his young son he moved from the Carn to Treverven, a large granite house on the coast near St Buryan, in 1964.

Bryan Wynter enjoyed pitting his skills against demanding circumstances, physical activity became an experience from which painting was made. Throughout his life he had enjoyed underwater swimming and in later years white water canoeing. From 1966 onwards he produced a series of calligraphic drawings in Pentel pen in which he examines the flow and turbulence of water. These drawings lead directly to new simplifications in his painting. With clear colour, and closely defined shape, a group of large paintings known as the 'Meander' series with titles such as 'Deva' and 'Red Stream' are all to do with the flow and flux of water. 'Deva' is a river in Spain which Bryan Wynter and his family explored by canoe. Through a series of overlapping grids and related sets of curving shapes he creates a new structure to parallel this experience.

In 1975 Bryan Wynter had his last and fatal heart attack. He died in Penzance Hospital aged fifty-nine.

Terry Frost in his studio

photo: Andrew Dunkley, courtesy Tate Gallery

TERRY FROST (b.1915)

Terry Frost is no purist, he works from his feelings and the love of the people and places around him. The language of his work is colour; saturated colour used at full strength in bold simple shapes. For him painting is to do with the courage and the confidence to make a mark first time and to stand by it. But there is also discipline here. Since his return to Cornwall in 1974, Terry Frost's paintings have taken on a new degree of control, for example he has made a number of large-scale collage paintings, which examine the full extent and range of one colour. 'Through Blues' of 1979 repeats a dancing shape which creates a rhythm against the blue background. He says:

I'm now free from copying anything: the shape is not related to a woman's bottom, it's not related to boats, it's my personal shape and it's free. I can do anything I want, I can make it faster or slower, the canvas thicker or thinner, and I can paint it any colour I want within the range that I am doing and then I get the magic of all the shapes in between. (Terry Frost, 'Six Decades' Royal Academy of Arts, October – November 2000).

There is a close relationship between the abstract shapes that he works with and the familiar environment of his home in Newlyn. When he was filmed for *Painting the Warmth of the Sun* sitting on the harbour wall at Newlyn, in 1983, he talked about the scene in front of him, the boats, with their mooring ropes dipping into the water, the crescents of hulls nosing into each other, the brightly coloured floats. In his painting these become curved and straight lines of particular weight and density, pools or shapes of colour of specific area and dominated by a black sun. He is not a landscape painter in disguise but within the abstract nature of the paintings, the character of Newlyn Harbour can clearly be seen.

At the age of eighty-six he is as productive as ever. Terry has always travelled a lot and has had

Terry Frost at work in his studio
photo: the author

exhibition after exhibition, and this continues. He has spent a lot of time in the Mediterranean, in France and Spain, and from 1977 onwards he has made regular teaching visits to Cyprus. The hot colours of the Mediterranean and the image of the sun have entered many of his recent paintings.

In 1998 Terry Frost was awarded a knighthood in the Labour Government's first New Year's Honours List. This came as a surprise to him. He is not very much in London and his older friends in the Labour Party, such as Tony Crossman and Fred Mulally were no longer alive, but he knew a lot of people were writing in support of him and his name often came up in memoirs and published diaries.

Printmaking has taken up much of his time. Working mostly with Hugh Stoneman, the master printer, more than two hundred different editions of prints have been produced. He has also experimented in new forms, for example collage and sculpture have always been a preoccupation. In recent years he has made several visits to Venice to work with the glassworkers in Murano, directing them through his drawings. He found the tradition fascinating. Terry worked closely with the glassmakers, with three sets of kilns working and the maestro controlling the shape, it was like watching a ballet. The result was a series of glass plates and dishes decorated with the creative insignia that he has made his own.

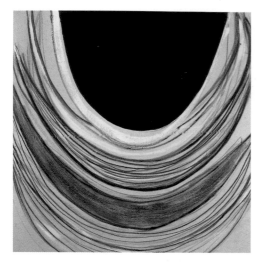

TERRY FROST
'Black Collage on Grey', *2000*

photo: Steve Tanner

Opposite page:
TERRY FROST
'October 12, Lizard Sunrise', *1999*

photo: Steve Tanner

Terry Frost was born in Leamington Spa in 1915. After his parents separated he was brought up by his grandmother. At school he showed an early ability for drawing and for writing, but circumstances prevented him going on to higher education. He later wrote 'I left school at fourteen and went to work, which is the natural thing to do in the Midlands, you go to work. That's what it is all about.' (Interview with Dave Lee, 1993).

Work meant a variety of jobs, about seven of them, as varied as working in Curry's cycle shop to putting the jam and cream into doughnuts, 'this was a bit arty,' he said. At the outbreak of war in 1939 he was a member of the territorials and among the first to be called into the army. He was posted to France with the Warwickshire Regiment and then to Palestine and the Lebanon. He then vounteered to join the 52nd Middle East Commando regiment and saw action in the Sudan and in Crete. It was during the evacuation of Crete in 1941 that his unit was overcome and for the remainder of the war he was a prisoner, initially in Salonica and then in the huge Stalag 383 in Hohenfals, Bavaria.

The army reinforced his strength and determination and gave him the courage to survive. His decision to become an artist was formed during these wartime experiences and his earliest efforts were caricature-like drawings of fellow prisoners of war, made in exchange for the trivial possessions that passed for currency in the camp. By 1944 he was able to send, via the YMCA, twenty-three works, mostly portraits, for exhibition in Leamington. It was a chance meeting with a fellow prisoner of war, Adrian Heath, that introduced him to the idea of pursuing art as a career. Heath had trained at the Slade School in London, and for a short time he attended Stanhope Forbes' School in Newlyn. Forbes was then over eighty, and the school was about to close; for a time Heath was the only student. It was Heath, who by his advice and example helped Frost on the first stages of his artistic career. Terry Frost later remembered these years in the POW camps for their moments of revelation. The activity of painting brought colour to his grey world, and the heightened perception brought about by starvation awakened his senses.

In 1945 he met and married Kathleen Clarke and in preference to living with her parents, and remembering the advice of Heath, they set off for Cornwall. He knew that artists had made St Ives their home, but he had little knowledge of who they were and none whatsoever of those called 'modernists'. With Kathleen they worked in a guesthouse, living in a caravan in Carbis Bay, then moved to 12 Quay Street, in the centre of St Ives where the first of his large family of five boys and a girl were born. Already Frost considered himself an artist and attended the St Ives School of Painting in the mornings and had the use of a shared studio.

St Ives was re-forming as an artistic centre and it was the more traditional artists such as Leonard Fuller and Borlase Smart that first attracted Frost. He remembered the kindness of Sven Berlin and that of John Park, who would not only buy him half a pint of beer in The Sloop, but who would slip half a crown and a packet of Woodbines in his pocket. Harry Rowntree, whom he described as a 'snappy bloke' and who designed posters for 'Cherry Blossom' Boot Polish was opposed to Frost's interest in abstraction. Others in St Ives, more of his own age and experience, were returning from the war. It

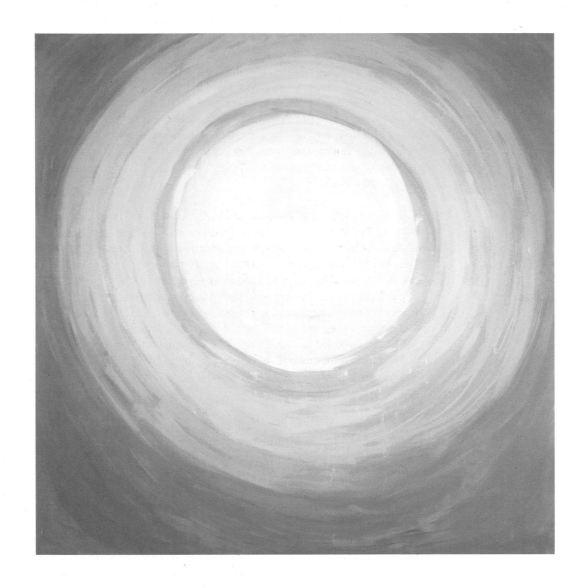

was difficult to see a common purpose in their work, but there was a friendship and trust between individuals, and optimism for the future.

A successful exhibition at Downings Bookshop in 1947, entitled 'Paintings with Knife and Brush by Terry Frost' brought good sales. With prices between £5 and £10, he sold £80 worth of work. He also learnt, at about this time, that as an ex-serviceman he was eligible for a training grant. He was given a place at Camberwell School of Art in London, which had become an enclave for that group of Slade-trained painters who had formed the Euston Road Group before the war, lead by William Coldstream. Most importantly for Frost, it also included Victor Pasmore, who Frost later referred to as his 'God'. Although Frost accepted the discipline of observed drawing and painting, it was the more formally constructed work of Pasmore that appealed to him. For three years, from 1947 to 1950, Frost spent the term time in London, living in Chelsea and the summers working in the Sunset Bar, St Ives.

TERRY FROST
'Exclamation Mark', *2000*

photo: Steve Tanner

He painted abstracts for a summer show at Camberwell but the move from Euston Road figurative painting to abstraction was slow, difficult and often confusing. He began to exhibit with the newly formed Penwith Society of Artists, which was then attracting considerable attention and gaining support from the Arts Council, who described it as 'one of its most distant yet brilliant stars'. He was able to develop his relationship with Ben Nicholson, well on his way to consolidating his major international reputation. It was Nicholson who supported Frost's application for one of the much sought-after Porthmeor studios – No.4 next to his own. It is also said that he persuaded the publisher E.C. Gregory to pay the rent in exchange for paintings. Nicholson commented that the repertoire of forms that Frost used – semicircles and quadrants, chevrons and arcs, would last him for the remainder of his life. Frost found this difficult to understand at the time, but later observed it to be true.

Another move in the direction of abstraction was the opportunity to work with Barbara Hepworth, who had been commissioned to produce a large sculpture for the Festival of Britain. This massive two piece sculpture, entitled 'Contrapuntal Forms', some ten feet high, was carved from blue limestone by a team lead by Hepworth and including Frost, John Wells and Denis Mitchell. For Frost, carving and shaping the form, as opposed to creating the illusion of form in painting, was a revelation. He found a parallel in his own work by the use of collage, a working method that he would later develop. In addition to the support that he received from fellow artists in St Ives, Terry Frost was also in touch with another group in London, based around the studio of his friend, Adrian Heath, in Charlotte Street. These included some of the most rigorous of abstract artists such as Victor Pasmore, Anthony Hill, Kenneth Martin and Robert Adams, along with Adrian Heath.

By 1950 Frost was settled in St Ives and his work had reached a point of total abstraction. He was using systems of proportion, division into fifths or sevenths and the golden section. He used these measurements intuitively and allied them to his own feelings and sensations. A seminal painting of this period was 'Walk Along the Quay' in which divisions of a vertical canvas are reflected in the daily sensation of walking with his young children along the quay in St Ives. He wrote:

I was not portraying the boats, the sand, the horizon or any other subject matter, but concentrating

on the emotion engendered by what I saw. The subject matter is in fact the sensation evoked by the movements and the colours in the harbour. What I have painted is an arrangement of form and colour which evokes for me the similar feeling. (Quoted in Nine Abstract Artists *ed. Lawrence Alloway, London 1954).*

In 1954, with a large and growing family, Terry Frost arrived in Leeds to take up the Gregory Fellowship at the University. This Fellowship, established by Peter Gregory in 1950, with advice from Herbert Read, had brought a remarkable group of poets, painters, and sculptors to the University. Many were young, most later won fame. They included the sculptors Reg Butler, Hubert Dalwood and Kenneth Armitage and among the painters Terry Frost, Alan Davie and Trevor Bell. For Terry these years in Yorkshire gave him support at a critical time in his career. For three years he was free to interpret the landscape of Yorkshire in winter and in summer in a series of vividly experimental large and exuberant paintings. He called this 'the true experience of black and white in Yorkshire'.

In Leeds he also played an important part in the new attitudes in art education that were developing at Leeds College of Art under the direction of Harry Thubron, strongly supported by others such as Victor Pasmore and Herbert Read. It was a highly inventive course based on the students' own exploration and discovery. Frost's contribution was a vigorous commitment to abstraction illuminated by his enthusiasm and positive view of the world.

TERRY FROST
'Dawn Blue, Newlyn Quay', *2002*

photo: Steve Tanner

In 1957 Terry and Kathleen Frost and their family returned to St Ives, which as an artists' colony was entering its most successful period. By now Frost had experienced a long period of success. Between 1952 and 1958 he had three well-received exhibitions at the Leicester Galleries, London. In 1958 he exhibited for the second time at the Carnegie International in Pittsburgh and in 1960 he had his first one-man exhibition in New York at the Bertha Schaeffer Gallery. On this occasion he met many of the American abstract artists whose work was attracting worldwide attention, including Willem de Kooning, Mark Rothko, Barnett Newman, Robert Motherwell and Larry Rivers. One man exhibitions were held at the Waddington Galleries in London in 1963, 1966 and 1969, and throughout the 1960s and 1970s he was represented in the major exhibitions toured by the British Council in the United States, Europe and Canada. A summer teaching at the University of California introduced him to the vastness of America and the hot dry colours of the southern deserts.

In spite of these successes there was a feeling that events were moving on. Talking of St Ives he said 'the steam had slightly run out for me'. In 1963 he left Cornwall and returned to Banbury, where he could be in touch with the London galleries and also find some part time teaching. This he did, first at Coventry School of Art and then from 1965 at Reading University, where he remained until he retired as Professor in 1981.

Cornwall had remained his spiritual home and during the years in which he was living elsewhere he always wanted to come back. When he finally decided to return in 1974, it was during a period of economic stringency in the country and the sales of paintings were noticeably affected. In addition he no longer had support from the Waddington Gallery and had to fend for himself. However he

wanted to get out of full time teaching and characteristically he gave up his post at Reading University because he thought he would be corrupted, waiting for a pension. With exhibitions in the United States and galleries in England he continued to find success. In retrospect he views this period, which threatened to be disastrous, as the best thing that happened to him.

A rebellious abstract artist like Terry Frost would appear to be an unlikely member of the Royal Academy but in 1992 he was elected as a member. In the past he had been a critic of the Academy but he got on well with the President, Roger de Grey, who invited him to become a Senior Academician. Terry's response was to recruit his support for the Fine art Department at Reading University which was very badly housed, in temporary buildings, and with little support from the University authorities. Terry asked the President to assist by giving a lunch to a few wealthy industrialists in an effort to find major financial backing for a new building in Reading. He has since found his membership of the Academy productive but he does not get involved in the social side.

In October 2000 the Royal Academy arranged a retrospective exhibition under the title 'Terry Frost, Six Decades'. Philip King, now the President, spoke of the nature of Frost's painting: 'The triumph of Frost's art is that, through colour and shape it transmits an extraordinary joy that no viewer can fail to respond to.' (President's Foreword op cit).

Abstraction, delight in the sensations of nature and above all joy, are the ingredients of Terry Frost's work.

PATRICK HERON (1920–1999)

Patrick Heron had a close and continuous association with Cornwall. He was born in 1920 in Leeds, one of four children. When Patrick was five his father was invited to join a company making fine colour printing on silk, formed by an artist and designer Alex Walker. The business, under the name 'Crysede' operated from a row of cottages on Newlyn Hill. As it expanded it moved to a substantial factory converted from fish lofts on 'The Island' in St Ives. The young Patrick Heron was educated mostly in St Ives, a fellow pupil of Peter Lanyon. In 1929 Tom Heron left the company and established his own highly successful business 'Cresta Silks' in Welwyn Garden City, and it was there that Patrick Heron completed his education.

From 1937 to 1939 Patrick was a student at the Slade School. Other students there at the time included Paul Feiler, Bryan Wynter and Adrian Heath. In common with other contemporaries in wartime he became a conscientious objector and spent time digging ditches in the Cambridgeshire fens, but illness prevented him from continuing this manual work. In the latter part of the war he travelled to St Ives and became an assistant at the Leach Pottery, then producing utility tableware. He was in St Ives for fourteen months and there made the acquaintance of Nicholson, Gabo and Stokes.

In addition to being a committed painter he also had an unusual talent as a writer and became one of the most expressive and articulate commentators on the contemporary art scene. From 1945 onwards he wrote articles for the *New English Weekly* and from 1950 he was art critic for the *New*

Patrick Heron
author's collection

Statesman and Nation. He wrote on those artists – English as well as French – whose work contained pronounced elements of abstraction. Picasso, Leger, Matisse, Rouault, Vlaminck, Bonnard and Braque. He wrote from the point of view of the practising artist and he was unusually alert to the flow of paint, the elements of abstraction and pictorial space. He was least interested in the literary or descriptive forms of painting that characterised much of post-war British art.

Heron was deeply impressed by the large exhibition of Georges Braque's paintings of the war years, shown at the Tate Gallery in 1946. He wrote of it as 'a new development of an immensely powerful art.' As late as 1955 he wrote: 'the power of Paris is undiminished. I believe it is the best in the world; it still holds the centre of the stage. Indeed it is the stage.' This admiration for the intensity of Braque's vision was reinforced, when in July 1949 he visited the master in his studio. Braque's influence is clearly reflected in Heron's painting of these years.

Patrick and Delia Heron had married in 1945 and their regular visits to Cornwall date from 1947, spending summers in St Ives. Patrick began a long series of articles about the artists working in St Ives, with important early assessments of Peter Lanyon (*New Statesman and Nation*, 1949), Bernard Leach (*New English Weekly*, 1946), Bryan Wynter (*The Changing Forms of Art*, 1955), Ben Nicholson (*New English Weekly*, 1945), Roger Hilton (*New Statesman and Nation*, 1950) and John Wells (*The Changing Forms of Art*, 1950). Heron became closely identified with that group of artists that he was writing about, and many became close friends. His articles showed sympathy with their intentions and an understanding of the new attitudes to abstraction that were developing in this post-war period.

Colour was and remained a preoccupation, but he also spoke at length about pictorial space, which he defined as their main achievement. It became clear that in some of his articles he was outdistancing his audience and, in 1950, he was sacked from the post as Art Critic for the *New Statesman*. There was an interval of five years before he began again to write, this time for an American audience, through *Art Digest* in New York (later to become *Arts*). As the London correspondent, for three important years he discussed the artistic landscape of Britain, and particularly the work of his own contemporaries and associates, including Lanyon (February 1956), Frost and Wynter (October 1956) and Hilton (May 1958}. It was during this period that the work of the American painters was seen in London and the rate of change was accelerated.

Patrick showed his painting in the third exhibition of the Crypt Group and from 1947 to 1958 he had an important series of one-man exhibitions at the Redfern Gallery in London. The large painting he exhibited in the Arts Council's Festival of Britain exhibition '60 Paintings for '51' consolidated his reputation as a painter. In a post-cubist style, reminiscent of Georges Braque, he painted a large-scale domestic interior with his wife and their young children. A characteristic of all his work is its fluency. In this painting and in later paintings there is little evidence of struggle or change; directness of execution is always apparent.

As one who was familiar with the art scene in London and keen to promote his own point of view, Patrick Heron devised and selected an exhibition 'Space in Colour' presented at the Hanover Gallery

Patrick Heron, 1983

author's collection

PATRICK HERON
'Autumn Garden', 1956

oil on canvas, 183x91.5cm
collection: family of the artist

in July and August 1953. Ten artists, mostly associated with St Ives, exhibited, and in his introduction to the catalogue, he described the duality of illusion:

On the one hand there is the illusion, indeed the sensation of depth, and on the other there is the physical reality of the flat picture surface. Good painting creates an experience which contains both.

His own work and indeed his own life were going through many changes at this time. In 1956 he made the decision to move to Cornwall and purchased 'Eagle's Nest', the house above Zennor with its vast coastal panorama. Patrick and Delia, with their young family moved there in April 1956. By the early 1960s the artistic landscape in England had changed radically – the principal clearances were made in 1956 when the exhibition 'Modern Art in the United States' was shown at the Tate Gallery. For the first time London saw major work by the Abstract Expressionists, including Jackson Pollock, Willem de Kooning, Mark Rothko and others. Patrick Heron, who was then writing for an American audience, was 'elated by the size, originality, economy and inventive daring of many of the paintings...'

In 1956 and now working in St Ives, Patrick Heron produced a series of experimental paintings using simple organisations, first vertical stripes and then horizontal stripes of colour, drawing on the colour of the landscape that surrounded him. They have a distinctly 'tachiste' feeling, freely applied strokes of thin paint varied in intensity and breadth The colour is from the experience of the flowering azaleas in the spring in Heron's newly acquired garden. This work was exhibited in 1957 at the Redfern Gallery, London, in an exhibition called 'Metavisual, Tachiste and Abstract Painting in England Today'. This work was considered radical at the time and it was an opportunity for Heron to exhibit totally non-figurative work much of which at the time was in advance of work being produced in the United States. It was however commercially unattractive and was not well supported by the gallery.

By 1957 Patrick Heron was plotting out a programme for his own use, writing on the 1957 Guggenheim Selection at the Tate Gallery he stated:

Painting must return to its fullest range: non-figurative painting must flower into richness and subtlety. Out of its strident freedoms must now grow structures of classical weight and beauty; the profoundly considered must now be permitted to glow where only the rawness of 'the sponta-neous' has been allowed, 'spontaneity' has become a disease!

Within the next two years, after a series of experimental paintings, Patrick Heron found a form, which he was to follow for many years. His paintings were non-figurative and they referred to the classical components of the square and the circle superimposed, but this was not geometry, the shapes were wobbly, eroded, sometimes flowing into each other as if the Cornish sea was eroding a coastline. Colour was strong and personal, applied carefully with small brushes in order to maximise its transparency. He used the range of reds, purples, occasionally brown, orange, strong yellows and blues, usually straight from the tube. He had established a personal and singular method of work. After long contemplation of the canvas, a linear drawing, done in seconds with a Pentel pen, divides the

canvas into areas of rectangular or roughly circular shape. Then over a long process, the different areas would be painted in strong, often unmixed colour applied with fine Japanese brushes, allowing a spread of oil paint of maximum saturation and intensity. Colour became a total preoccupation. He wrote:

Colour is both the subject and the means, the content, the image and the meaning in my painting today... It is obvious that colour is now the only direction which painting can travel... (Leinhard Gallery, Zurich January 1963).

This prescription for a new direction in his work was celebrated when he was awarded the grand prize in the second John Moore's Liverpool Exhibition in 1959. Also in that year, and more ominously, the Waddington Gallery arranged an exhibition under the title 'Four Middle Generation Painters – the work of Frost, Hilton, Wynter and Heron'. In his introduction to the catalogue Patrick Heron wrote of the group who had lost valuable time in the war and who had since been laboriously building something out of the remnants of modern art left in Europe in the late 1940s. Although this was an attempt to find a new direction, it also had the feeling that the work of these artists was being relegated to the past, a feeling reinforced by the range of American painting that was being shown in many London galleries. In the following year the exhibition 'Situation' exhibited paintings by young British artists who had been affected by the American experience. The work was to be large and non-figurative, and although this prescription fitted the St Ives artists, none were included.

PATRICK HERON
'4–5 September', *1995*

oil on canvas
collection: family of the artist

PATRICK HERON
'Manganese of Deep Violet', *1967.*

oil on canvas
collection: J. Walter Thompson

In his mature years his paintings are composed of the same irregular shapes in strong colours, often of considerable size. They have a powerful effect through their size and the intensity of their colour. The realities of Cornwall are only suggested, the roughly circular shapes on wind-eroded rocks behind his house, the horizontal division of the horizon in which a blue sea meets a purple sky and the strength of reds and yellows of the flowering azaleas against the dull green blues of bracken and heather. They remake Cornwall through the artist's eyes and they give us shapes and colours that we should see, we will see.

Patrick Heron had considerable personal success. From 1949 his work was shown at the Waddington Galleries in London, in a succession of one-man exhibitions of paintings and prints. He was also toured to New York, with exhibitions at the Bertha Schaeffer Gallery, and to Montreal and Toronto in Canada, and Australia. In 1965 he was awarded the Silver Medal at the VIIth Biennale in San Paulo. His lecture tours in Australia proved highly popular and in 1977 he was created Commander of the British Empire for his services to the arts.

From 1963 onwards the work became freer, he returned to drawing with a meandering swinging charcoal line, which became a frontier between areas of strong colour. As always, after long contemplation, the work is done swiftly and instinctively, retaining the greatest freedom of expression.

The sudden and unexpected death of his wife Delia in 1979 gave a pause to his work and for sometime he did little painting. However when he did return it was to a series of paintings based on his garden, which have many similarities to those of the mid-1950s, the period in which he and Delia first took 'Eagles Nest'. Across some thirty years the same colours appear, acid yellows, crimson and a darker more congealed red. The mark-making has the same splashy touch, an indifference to the runs and dribbles that come from the loaded brush. There are important differences however. The canvases of the 1950s are densely worked veils of paint which form a screen of colour, as fruitful as the new spring growth of azaleas and camellias of Patrick's garden in Zennor. In the later paintings, the structure of the middle period work appears, square shapes on which a wobbly circle rests and divisions of the painting into four or five areas, strongly differentiated in colour.

In the 1990s Patrick Heron continued to produce a number of large and important works. He also began to draw again, line drawings from places he liked very much, such as his own garden in Zennor, the Dordogne in France, the Lake District and Japan. This last had been visited in 1989 when he went to Tokyo to give a lecture in connection with the exhibition 'St Ives', after its showing in London. From Japan he went on to Australia to become artist in residence at the Art Gallery of New South Wales. For this he had a studio in the gallery and a daily walk through the Sydney Botanical Gardens which reminded him of his own garden in Cornwall. From this visit he produced forty-six large gouaches and six large paintings which were exhibited as part of an exhibition at the Art Gallery of New South Wales. Patrick Heron continued painting, exhibiting and writing until his death at 'Eagle's Nest' in March 1999.

Opposite page:
PATRICK HERON
'Red Garden', *1985*

oil on canvas
collection: family of the artist

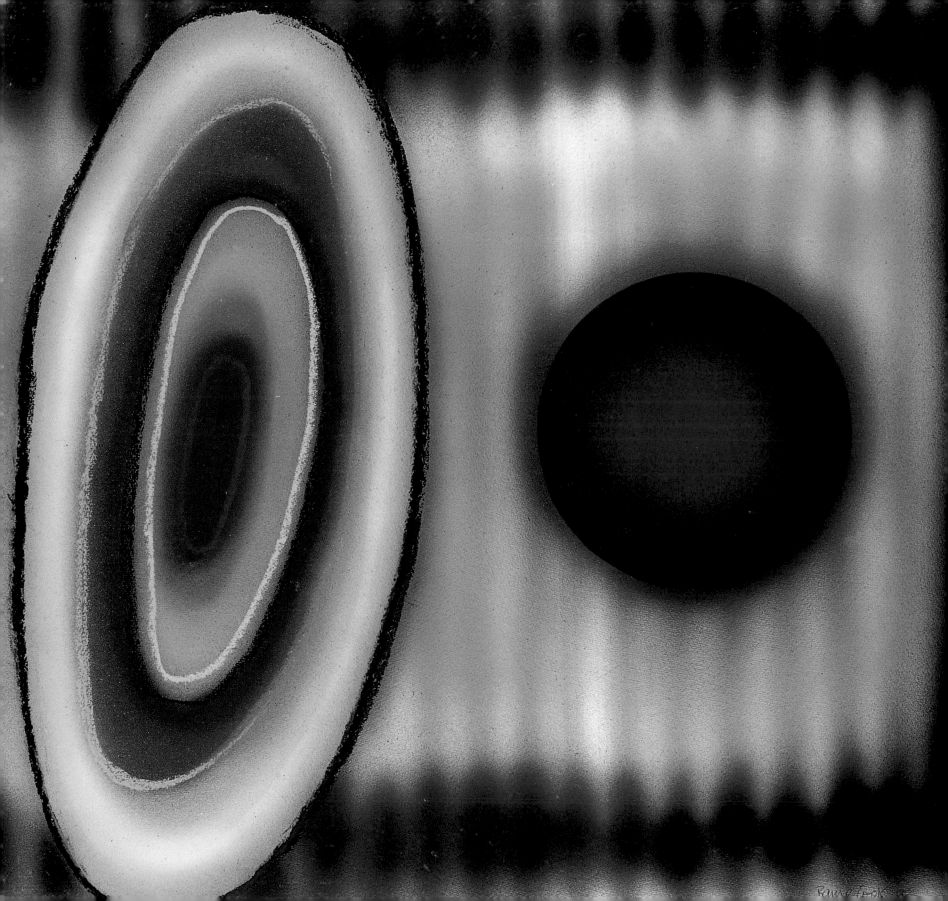

3

FORMS OF ABSTRACTION

The idea of abstraction had been central to the art of painting since the early years of the 20th century. Cubism had appeared in Paris by 1910, and by the outbreak of the First World War it was already well established among many of the younger artists. In the years between the wars a number of those artists took part in the various manifestations of abstraction: 'Purism' – a more theoretical form of cubism; Futurism – which lived and died during the period of the first world war, followed by its somewhat half-hearted British cousin 'Vorticism'. In these earlier movements the chief characteristic was a simplification of the object depicted, allowing for heightened colour and clarity of form. The components of shape, colour and tone were detached from the appearance of places and people, and have a life of their own. A further step in the process is that of 'non-objective art' in which the painting or sculpture is totally separated from natural appearances and becomes an object in its own right. The viewer does not search for what the art object represents, but rather what it is, as they would to music or architecture.

In England in the years up to 1939, these experimental ideas had fallen on bitter ground. The separation from Europe in the First World War and again in the next, the Russian Revolution that by 1924 had turned into opposition of progressive art, and the rise of Hitler in Germany, by 1933 persuaded many of these artists to move to the West – the route was Paris, London and for many, finally New York.

WILHELMINA BARNS-GRAHAM (b.1912)

As a young woman Wilhelmina Barns-Graham (Willie) entered fully into the artistic activities of St Ives. She arrived there in 1940 and was drawn into the St Ives Society of Artists and, although its atmosphere was far from progressive, she exhibited her early landscapes and portraits in its wartime exhibitions. She was instrumental in getting Ben Nicholson to exhibit with the Society. Her early drawings and paintings describe her first responses to the little town of St Ives, the life of its harbour and the brilliant light reflected from the sea. She began increasingly to work in an abstract idiom but she was diffident in showing it. In the mid 1940s she came up against the problem of a young artist, trained as a representational draftsman, but faced at first hand with abstraction. She respected the traditional approach practised by her friend Borlase Smart as well as the extreme modernism of Nicholson and Hepworth. This dilemma was resolved by Barns-Graham through the medium of drawing, a skill that she retains in all of her work.

Opposite page:
BARRIE COOK
'Dendrology with Sphere I', 2000
acrylic and pastel on paper, 69x69cm

Wilhelmina Barns-Graham
© RJ Photo

Wilhelmina Barns-Graham was born at St Andrews in Fife, in 1912. She went to school in Edinburgh and trained at the Edinburgh College of Art. Although her family had interests in the arts, there was family opposition to her becoming a professional artist particularly from her patriarchal father. However, by the age of twenty-four she had her own studio in Edinburgh. At the end of her training a post-graduate scholarship allowed her to leave Scotland. Hubert Wellington, Principal of the Edinburgh College, advised her to visit St Ives, partly for her health and also because he knew it to be the recent retreat of Ben Nicholson and Barbara Hepworth whose work she had already seen in the copy of *Circle* that she possessed. In addition, her friend Margaret Mellis, recently married to Adrian Stokes, was now living in St Ives.

Within a few days of her arrival she was introduced to Borlase Smart who helped her to find a studio (No.3 Porthmeor Studios), which she had for many years. He remained a great friend and supporter. She soon came to know both the older group of St Ives artists and the 'moderns', that little coterie of recent arrivals in Carbis Bay – Nicholson, Hepworth, Gabo, and the writers that Stokes attracted such as Stephen Spender, John Summerson and others. In the exhibitions of the St Ives Society of Artists she was one of the rebellious group of 'moderns' who became known as 'the exhibitors around the

WILHELMINA BARNS-GRAHAM
'Gaia Series (Mars)', 2000

acrylic on canvas, 122x168cm
collection: W. Barns-Graham
photo: Bob Berry

font', and later 'the Crypt Group'. She was in Scotland when the first of the Crypt Group exhibitions took place in 1946, but she exhibited in the following two.

In the last months of 1948 she met a young writer, David Lewis. They were married in October 1949. Earlier in the same year she visited Switzerland with friends and during this visit she produced a number of drawings and gouaches of the Grindelwald glaciers. A simpler, more sculptural approach is apparent in these drawings. The pressure and movements of the ice-mass become a series of vertical freestanding forms on the picture surface, a re-creation of nature in motion. Her exhibition at the Redfern Gallery, London, in 1952, entitled 'Recent Paintings and Glacier Constructions' was most successful; work was bought by the Arts Council and the British Council.

In 1949 she was much involved with the exciting events that lead to the breakaway of the younger members of the St Ives Society of Artists, and the formation of the Penwith Society of Artists. She attended the meetings in the Castle Inn and felt the shared feeling of elation, a sense of building something new. 'This was a new society and we are going to get it going.' She became a founder member of the Penwith Society of Artists and exhibited at their first exhibition. Since that time she has been a strong supporter of the Penwith and much involved in its affairs. The years 1949–1958 had urgency about them. New horizons were opening. Lewis became curator of the Penwith and also acted as an unofficial agent for the British Council, introducing visitors from overseas to artist members.

Her studio in St Ives was a few doors away from the cottage which had been lived in by Alfred Wallis. She remembers that 'the greys and greens of his paintings spoke to her because she found them true'. Her early landscape paintings are softly coloured descriptions of the sea and the freely-placed cottages and boats, sharing something of Wallis' colour.

Throughout her life as an artist her work has been an unusual combination of analysis and emotion. She describes this as 'left hand and right hand', a union of opposites. The left hand is intuitive, expressive of feeling and emotion. The right hand is logical and reasoning. In her work she is able to weld these two dissimilar approaches together into a delightful, lyrical and satisfying whole. Barns-Graham is also ambidextrous and can paint and draw with right or left hand equally. As a demonstration she can write simultaneously with both hands, the right hand writes normally, from left to right, the left hand moves to the left and writes in mirror writing.

The 1950s was a most productive time for her. Without losing any of her impressive skill as a draughtsman, she carried her work to pure abstraction, with a repertoire of form derived from the square and the circle. In 1951 as part of the Festival of Britain celebrations in St Ives, she was awarded a prize for her painting 'Porthleven'. The other prize-winners were Barbara Hepworth and Bernard Leach. In the same year she travelled to Italy and visited Rome, Venice, Florence and other parts of Tuscany. The drawings she made of the hills and cities of Italy were the inspiration for the more abstracted work she produced on her return. Her love of Italy was further advanced when, in 1955, she was awarded an Italian Government travelling scholarship, which took her back to Tuscany. In the following year she showed a large number of drawings of Italy in a one-man exhibition at the Scottish

WILHELMINA BARNS-GRAHAM
'Volcanic Wind', *1994*

oil on canvas, 122x167.5cm
Collection: W. Barns-Graham
photo: Bob Berry

Gallery in Edinburgh. In 1949 she had her first one-man exhibition at the Redfern Gallery followed by another in 1952. Two years later she had a one-man exhibition at the Roland, Browse and Delbanco Gallery in London. By the mid-1950s, Barns-Graham was showing her work regularly in London, Paris and the United States. Her work is in many public collections.

The year 1956 marked a turning point in her life and in her work. Her husband David Lewis, then a writer, finally decided to train as an architect at Leeds School of Architecture – a brave decision for a mature man. Willie found a teaching post at Leeds School of Art, however there was a breakdown in their marriage and she returned to St Ives; they were divorced in 1963. After two years working in London she returned to St Ives to the new studio block 'Barnaloft' on the site of the old Barnaloft Studios, overlooking Porthmeor beach.

This unsettled period was further complicated by the legacy from an aunt of a large house in St Andrews. The establishment there of a new studio and a new way of life, re-united her to her childhood home. Since that time she has spent part of each year in St Andrews, yet her main place of work remains St Ives.

She has exhibited in Scotland at the Scottish Gallery in Edinburgh and in 1968 at the Richard Demarco Gallery, Edinburgh. At her second exhibition at the Scottish Gallery in 1960 she showed abstract drawings and gouaches inspired by her recent visit to Spain. In his introduction to the catalogue Alan Bowness remarked upon the new sense of scale, the bold shape, bright colour and exhilarating rhythms: 'an affirmation of vigour, joy and the beauty of the world'.

In the 1970s there arrived a new firmness and formality in her work. She frequently works in series and they are described by their colour, *'Lime and Flame, Red Painting'*, or by private names such as *'Orange and Black'* (*'Geoff and Scruffy Series'*); formal relationships, such as 'Order and Disorder of Things of a Kind' was a theme she investigated through abstract imagery. She also examines organic forms, the rhythm of waves, the flight of birds and the microscopic structure of leaves, raindrops and other phenomena.

In 1980 she painted a series of large canvases under the titles of *'Expanding Forms'* and *'Touch Point'*. Her drawings remain as strong as ever, she continued to work directly from landscape – in Orkney in 1982, in the Scilly Isles, and each year in a search for early sun in Lanzarote. The particular mixture of formality and free invention is also well-suited to print making. She has considerable skill as a graphic artist and has made a great many prints and monotypes.

The Crawford Art Centre, St Andrews, invited her in 1988 to exhibit in the aptly named exhibition 'Freeing the Spirit, Contemporary Scottish Abstraction'. Her statement for the exhibition expresses her search for a positive way of working as an abstract painter:

the freedom of choice of medium, space, texture, colour: the challenge of feeling out the truth of an idea, a process of inner perception and harmony of thought on a high level... Abstraction is

WILHELMINA BARNS-GRAHAM
'Yellow and Blue', 2000

acrylic on canvas, 122x152.5cm
collection: W. Barns-Graham
photo: Bob Berry

a refinement and greater discipline to the idea: truth to the medium perfects the idea. (Artist's statement).

In the year 2001 she was awarded the CBE for her services to the Arts and a year later her gallery Art First, London, celebrated her ninetieth birthday with an exhibition covering the previous ten years of her work. She was quoted:

Now I am at the stage of urgency. My theme is celebration of life, joy, the importance of colour, form, space and texture. Brushstrokes that can be happy, risky, thin, fat, fluid and textured. Having a positive mind and constantly being aware and hopefully being allowed to live longer to increase this celebration. (John McEwan, *Sunday Telegraph* 25 March 2001).

PAUL FEILER (b.1918)

The recent paintings of Paul Feiler contain a mystery, a void, to do with time, with self and with the universe, three elements, which cannot be grasped. He describes his search for this as an anxiety, even a neurosis. His paintings are objects for contemplation, symmetrical, orderly and regular, composed of primary forms which are universal yet non-referential, the square and series of concentric squares, the circle set in the square.

His feelings for remoteness and infinite space go back to early childhood, living in snow-capped mountains. These experiences and a lifetime of painting have lead him towards the big imponderables, to ask unanswerable questions: Who are you? What are you? Where are you? For him painting is the practical way of exploring these feelings. He looks to produce a sensation of calm but he is aware that calm can only be produced if you have had experience of chaos.

Paul Feiler was born in Frankfurt am Main in 1918, the son of a doctor. To escape the pressures of Germany in the 1930s Paul went to school for a time in Holland and then, at the age of 15, to Canford School in Dorset. His father supported his wish to train as an art student and for two years he attended the Slade School of Art, London. With the outbreak of war, the Slade was evacuated to the Ruskin School in Oxford and Paul went with them. However as the war continued, and without British nationality, Paul was unable to continue his studies and was interned in Canada.

He remembers this as a period that was to be a formative influence upon his life. His release in 1941 was due to the intervention of the Slade Professor, Randolph Schwarbe, who made a case to the authorities because of Paul's unusual artistic talent. He was doubly fortunate in being offered a job teaching painting in the combined schools of Radley and Eastbourne. In 1946 he joined the painting staff of the West of England College of Art in Bristol where he later became Head of Painting. Bristol brought him into contact with contemporary art activities and he became friends with a number of artists teaching at the nearby Corsham Court, many of whom had close connections with Cornwall. Paul began to make regular visits to Cornwall and many Cornish subjects began to appear in his work. It was these paintings of Mousehole, Lamorna and Falmouth that were shown in his first one-man

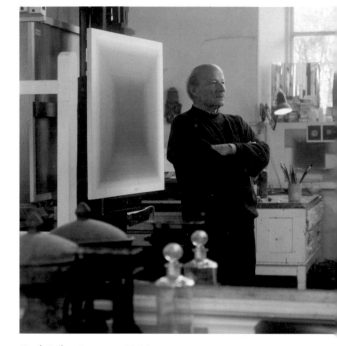

Paul Feiler, January 1998
photo: Bob Berry

exhibition at the Redfern Gallery, London, in 1953. The success of this first exhibition enabled him to buy the chapel at Kerris which has been his base since that time, although for a number of years he remained in Bristol where his young family were at school. Throughout the 1950s his work was included in many of the seminal exhibitions that described the role of abstract painting in Britain.

Although abstract, Paul Feiler's paintings of the late 1950s and early 1960s have specific landscape connections. They are free and gestural. Many have Cornish subjects such as 'Porthleven', 'Nanjidsal', 'Botallack'. The clear colours of the Cornish landscape prevail, predominantly white, a light atmospheric blue, slate grey, bracken brown and green.

Paul Feiler parallels his early experiences of mountains and snow to the forms of land and the sea in Cornwall. In a statement made in 1956 he described his position:

I have always enjoyed writing down with paint what I felt the world around me looked like. This has been a limited world; a world of open spaces, with snow and ice-covered mountains; later, the sea and rocks seen from a height. This had led me to try to communicate a universal aspect of forms in space; where the scale of shapes to each other and their tonal relationship convey their physical nearness to the spectator and where the overall colour and its texture supplies the emotional overtones of the personality of 'the place'. (Interview with the author 1983).

Further gradual changes occurred. In December 1968 Paul Feiler's imagination was captured by the American Apollo 8 space craft, which returned to earth after making ten orbits of the moon. In July of the following year the first moon landing took place, in which Neil Armstrong, Commander of Apollo 11, watched by millions of television viewers around the world, stepped off the ladder of the lunar module on to the moon. He spoke the historic words: 'that's one small step for man, one giant leap for mankind'. There was an immediate response to these events in Paul Feiler's work. He produced a series of paintings with titles such as 'Lunatis' and 'Orbis' in which circular forms float on a white ground.

In 1975 Paul took on the studio 'Trewarveneth', on the edge of Newlyn, previously used by Bryan Wynter. This historic studio had been built for Stanhope Forbes and occupied by him and Elizabeth Forbes until their new house and studio at Higher Faugan was completed. In an article in the *Studio* magazine of October 1896, Elizabeth is pictured in this same studio. In his studio arrangements Paul Feiler is meticulous. It is simply and efficiently laid out, with a single painting in progress on the studio easel. Paints and brushes are carefully arranged for use; for oil paintings he would initially mix a sequence of colours – forty of them – in fairly large quantities. As the painting progresses, changes are made, colour overlaid with colour. Objects in the studio show his interest in ways of looking, large concave mirrors, polished glass spheres and other optical equipment.

Of recent years the paintings have become more formal and less dependent on the observed world. Nevertheless there are certain visual preoccupations that link the earlier work to the most recent. For many years he has used a square format which detaches the painting from the associations of the

PAUL FEILER
'Janicon XLIV', 2001

silver/gold leaf on canvas, 61x61cm
photo: Bob Berry

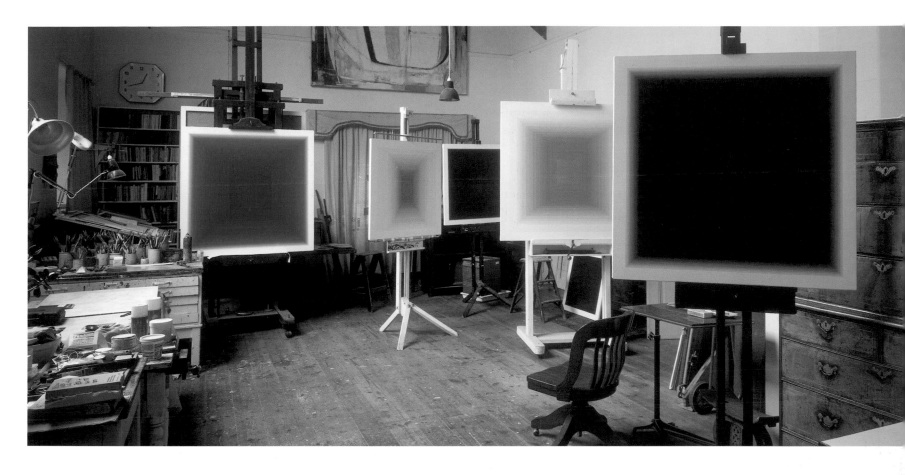

vertical (portrait) or the horizontal (landscape). The square is neutral, it does not have other associations. In his own words:

I make no concessions to being mysterious as far as the procedure of painting is concerned. I hope that the mystery lies out of the way of doing it, so that it has nothing to do with the making of the thing. I always have a square, I always have a rectangle, I always have straight lines, I always have a range of warm and cool tones. I never vary any of these because my aim is to present the end result as opposed to the procedure. Although people may understand how it is done, they are mystified by the fact that this does not explain their emotional reaction to the painting. (Interview with the author 1983).

The titles given to the paintings of 1970s and 1980s are strongly evocative. '*Adytum*' '*Aduton*' and '*Ambit*' are from the Greek or Latin to describe a shrine or sacred place, the experience of mystery, the confines of a sacred enclosure. More recently the use of '*Janus*' as a title is derived from the

Paul Feiler's studio at 'Trewarveneth', Newlyn, built by Stanhope Forbes and later used by Bryan Wynter.

photo: Bob Berry

53

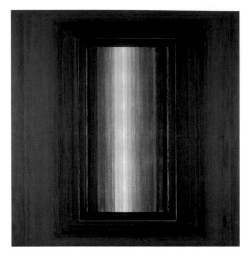

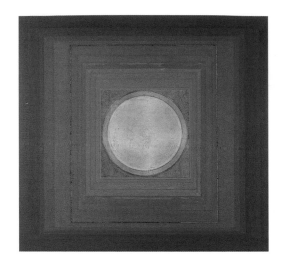

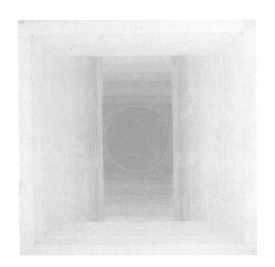

Above:
PAUL FEILER
'Janicon XLV', 2001
silver/gold leaf on canvas, 142x142cm
photo: Bob Berry

Above centre:
PAUL FEILER
'Janicon XLVI', 2001.
silver/gold leaf on canvas, 102x102cms
photo: Bob Berry

Above right:
'Aduton LXI', 1991
silver/gold leaf on canvas, 20x20cm
photo: Bob Berry

Roman god with two faces, one in front and one behind, who guarded the gates of Heaven. These paintings have an emphasis upon symmetry, but there is never an exact mirror image, there are always subtle differences. His most recent paintings contain slow spatial movements, investigations of the same problem, whittled down to something more fundamental,

One of the striking features of the last four or five years has been the use of gold and silver in his paintings. Several years ago he bought a large quantity of gold and silver leaf at auction. This sat around in the studio for many years before he decided to use it. These metallic surfaces are in a sense 'non colours', they draw the eye and they reflect the outside world. The title '*Icon*', is suggestive of an object for contemplation, and even veneration. The use of the gold also emphasises the aged quality of the painting. But Paul is not illustrating a story, religious or otherwise. The narrative in his work, what he describes as the 'anxiety' of meaning, is there to be looked at in silence. If the painting can provide an opportunity for contemplation, then he feels he has achieved something.

ALEXANDER MACKENZIE (1923–2002)
Alexander Mackenzie is one of that small group of artists in Cornwall who strongly supported abstraction in the early 1950s and have been continuously true to this over the years. His position can be judged by the friendships that he made. Mackenzie was somewhat in awe of Ben Nicholson, but they discussed the progress of their work and exchanged criticism. On one occasion Mackenzie admired a painting that Nicholson was working on but pointed out that it was weak in one area. Nicholson's short reply was 'that's what Frost said' and the painting was quickly turned to the wall. With Peter Lanyon, Mackenzie shared a love of landscape and wild places and the most ancient aspects of the land are often discernable in the work of both artists.

By far the strongest and most long lasting friendship that he had was with John Wells. Their work had a natural affinity and many shared qualities. Both of them formed their ideas in the face of nature rock and the strata of the land, the sea and its movement, the transparency of atmosphere, and they shared a strong love of music that is built into their work. The process of their painting is similar, a painting is allowed to grow slowly in the studio, starting on board with a painted surface, filmed with soft colour, scraped down and retextured many times. When transparency is achieved linear drawing and painted shapes begin to bring out the subject. Wells was drawn to the minute forms of shell structure, of crystals and the forms of constructivism; Mackenzie looks to older, pre-historic or mythological examples, the material of myth and legend.

Alexander Mackenzie

Alexander Mackenzie was born in Broadgreen, Liverpool, in 1923 and educated in Yorkshire. He received an early impression of the power of great art when his school was evacuated to Newburgh Priory, a great house filled with painting, sculpture and tapestries. In 1941, at the age of 18, he joined the army and saw action in the invasion of Europe. His drawings done at this time later gained him a place at Liverpool School of Art. At the end of four years of art training, he was now a mature man of 28 and impatient to discover his place in the world of art.

Mackenzie's decision to move to Cornwall in 1951 was not made because of the artists there, he knew nothing of them at this time, but he was attracted to Cornwall which he knew from childhood holidays. He taught at Penzance School of Art and later became Head of Fine Art at Plymouth College of Art.

From 1953 he lived in Newlyn. It was John Wells who helped him to find a house and studio, near to his own, in the middle of the town. He was an early member of the Penwith Society and shared the stimulating enthusiasms of that period when the work of the St Ives artists was first seen in the London galleries. With support from many of the younger members he wrote to the Chairman, then John Crowther, alleging that its affairs were 'too much dominated by a small group of influential members.' This was clearly aimed at Barbara Hepworth and lead to her withdrawing her work from the current exhibition. However she remained a member of the Society and continued to support it. Mackenzie's work was shown in many of the group exhibitions of that time and in London and overseas touring exhibitions, arranged by the British Council.

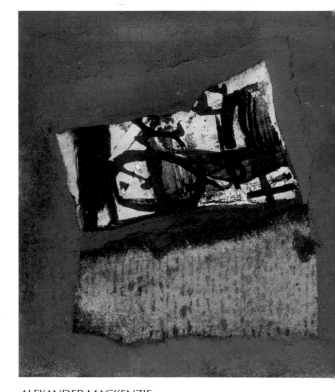

ALEXANDER MACKENZIE
'Fossil', *1995*

mixed media, 13.5cmx12.5cm

In 1959 he had the first of three one man exhibitions at the Waddington Gallery, London, and in 1960 and 1962, one man exhibitions at the Durlacher Gallery, New York. This succession of solo and mixed exhibitions continued into the mid-1960s, but with the increasing demands of his teaching, together with the general cooling of interest in the work of Cornish-based artists in London, his exhibition commitment diminished. In 1964 he moved to Trefrize in East Cornwall and four years later to Saltash, to be nearer to his teaching in Plymouth.

An exhibition in 1975 with his old friends John Wells and Denis Mitchell at the Plymouth City Art Gallery, marked a return to a new development in his work and throughout the 1980s and into the 1990s, his work has been shown regularly.

ALEXANDER MACKENZIE
'The Acropolis, Rhodes', *1998*

mixed media with collage on board, 13.5cmx34cm

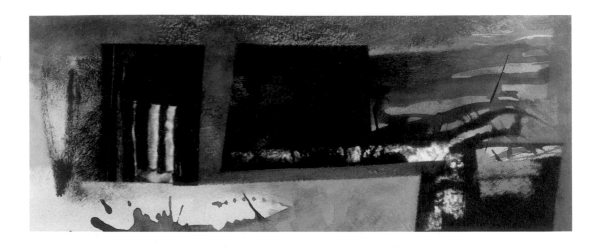

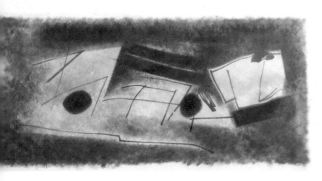

ALEXANDER MACKENZIE
'Dunkery Beacon, Exmoor', *1998*

oil and pencil on board, 36cmx77cm

The painting entitled '*October/November 1960*', shown in the Tate Gallery's definitive exhibition 'St Ives 1939–64' gives a good example of Mackenzie's working process. It is a large oil painting, 29 inches high by 72 inches long. In some respects it has the classicism of Nicholson, a series of carefully proportioned overlapping rectangles, pierced with small circles and cut with a few sharp lines. The painting was commissioned by John Crowther, a Truro architect, who specified that the painting should be of Cornwall. The artist wrote:

I considered the Penwith peninsula, detached, yet remaining part of the mainland... a composition developed, which seemed to describe this detachment, the colour, texture, and scoring represented the worked granite land mass of Penwith and the holes symbolised the hut circles and the burial mounds of the ancient areas, the white surrounding areas represented sea and sky. ('St Ives 1939–64,' p.203).

Mackenzie has a strong sense of place, whether he is painting West Penwith or the Sacred Spring at Delphi in Greece. But these are not casually arrived at, they are places that have a particular attachment for him and he explores these associations. He does this through texture – of lichen-covered walls or granite rock face, of field pattern and pathways. He sees the landscape as from high above, flattened like a map, as Peter Lanyon sometimes did. He takes his subjects from Cornwall and Dartmoor, the Yorkshire Dales and more recently the ancient sites of Greece. Many of the paintings have a textured, atmospheric space, glimpsed as if through a window .

Mackenzie has noted the considerable interest in the Cornish-based artists since the time of the Tate exhibition in 1985. In his own case his recent work has been included in numerous mixed exhibitions in London and at the Royal Academy. A major solo exhibition of paintings, collages and drawings took place at Austin Desmond Fine Art, London, in May-June 1999.

SANDRA BLOW (b.1925)

Sandra Blow returned to Cornwall in 1994, after thirty years of working in her studio in Sydney Close, Chelsea, in one of the great Victorian studio blocks in which John Sergeant had worked, and alongside other painters including Rodrigo Moynihan, Robert Buhler and Michael Andrews. When she moved in the rent of the studio was £3 a week. It later became hugely expensive and badly in need of repair and so she decided it was time to move out of London.

For an artist a studio is a very special place. It is not only a workroom and laboratory; it is a place for private contemplation, a retreat, and from time to time, a place of relaxation with friends. Sandra had previously lived in Cornwall, and talked to friends about the possibility of returning and it was Rose Phipps (later Rose Hilton) who helped Sandra to find somewhere to live near to St Ives. She was later able to acquire one of the Porthmeor Studios, No.9, previously worked in by Karl Weschke. But even this was inadequate for the storage of her largest works and for a time she rented industrial premises, which she described 'As big as an aircraft hanger' at Penbeagle. She was then offered premises in St Ives, previously used as a commercial showroom and store for the Geoffrey Knights Company.

SANDRA BLOW
'Reeling Water', *2001*

acrylic, mixed media and collage on canvas, 259x260cm
shown in Tate Gallery, St Ives, Dec–March 2001–2002

Sandra Blow in her studio at St Ives
'Brown & White', *1978*

acrylic on canvas collage, 366x366cm

It required a major effort of rebuilding to convert this near-derelict building into the present working and living arrangements; a suite of rooms set around a courtyard with a vast and beautifully-lit studio. Although close to the centre of St Ives it is a wonderfully private place.

Cornwall has long associations for Sandra. She first came in 1957 with Roger Hilton, a close friend, who suggested that she visit Cornwall, and she was included in an invitation to stay with Patrick and Delia Heron in Zennor. After a few days she found that Trevor Bell had just moved out of Tregerthen, one of three cottages in Zennor, below 'Eagle's Nest', and she was able to take it. In the 1914-18 war this had been a tempestuous and short-lived artists' colony, where D.H. Lawrence and his wife Frieda had lived, alongside Middleton Murray and Katherine Mansfield. Sandra came at Easter and stayed just for one year to see the four seasons through, painting in the fields and on the cliffs.

This was a critical time in her development. She had recently made a visit to the United States where she met many of the leading artists and exhibited her work at the Seidenburg Gallery. She described meeting 'The full tide of Abstract Expressionism in its breathtaking expansiveness and simplicity.' (Artists Statement from *Exhibition Road, Painters at the Royal College of Art,* ed. Paul Huxley. 1988). This visit took place very shortly before the work of leading New York artists burst upon a London public.

In St Ives she was not drawn into the politics of the artists' colony. She went in on her bicycle for shopping but otherwise saw more of the friends who lived nearby. It seemed that everyone was in their prime, it was a free and expansive time with open house and parties. Bryan Wynter in Carn, Patrick and Delia Heron nearby at 'Eagle's Nest', Karl Weschke also at Tregerthen and Roger Hilton an occasional visitor. The Tinner's Arms was their meeting place, where the poet-coastguard Sydney Graham was a regular. Sandra made a further visit to Cornwall in 1980, following a serious illness, and came to Falmouth for a time to recuperate and to paint.

Sandra Blow was born in Hackney, London in 1925 and trained at St Martin's School of Art. She went to the Royal Academy Schools, London, and after one year she decided to go to Italy for a holiday. In her first week in Rome she met the Italian painter Alberto Burri, who was about ten years older. He had studied medicine before the war and served as an officer in the Italian Army in North Africa; for two years he was a prisoner of war in Texas. After his long and hard war he was now rising to considerable international fame. He introduced her to the younger Italian painters of the time, Guttuso and others. Another important meeting was with Nicolas Carone, a former American GI who was well acquainted with New York painters and who had been a pupil of Hans Hoffman, the influential colourist. These were artists who became close friends and mentors and who would affect the direction of abstract painting in the next few years. Under their guidance Sandra began to understand the spatial meaning of abstract painting. She discovered that abstraction is not a style in art, it is a language which allows many differences of approach. It has a vocabulary as rich and as varied as that of representational painting, and for her at that time it was far more relevant. Rome was like it was at the time of the Romans, with no motor cars; she stayed for a year and remembers this as the most wonderful year of her life.

SANDRA BLOW
'Selva Obscura' 1993

acrylic and collage on canvas, 259x260cm
photo: the artist

Opposite page:
SANDRA BLOW
'Resounding' (12 part work) 2001
acrylic on canvas, 456.8x340.1cm
photo: the artist

It was then back to live in London, but with long summers spent in European countries. She was beginning to be noticed as one of the up-and-coming stars. By 1951 she exhibited at Gimpel Fils Gallery in London; Roger Hilton and Peter Lanyon each had their first one-man exhibitions there in the following year. In the years that followed she exhibited regularly at Gimpel Fils and in many of the major exhibitions toured abroad by the British Council, and in England by the Arts Council. In 1961 she was the second prizewinner (to Henry Mundy) at the John Moore's Exhibition in Liverpool.

She defined the spirit of the time, an existentialist position in which the individual has pre-eminence and his or her rights to self-discovery are paramount. During the 1950s her paintings were rough scarred canvases and boards, paint is replaced or extended by the materials of the earth, grit, ash, broken plaster, sacking. When paint is used it is in thick impasto, usually in dark tones. These paintings are spontaneous and uncompromising, yet their scraped down surfaces have a natural elegance.

From 1960 onwards she taught part-time at the Royal College of Art. Carel Weight, who was Head of Painting, brought Sandra into the College as 'the wind of change'. She had some extraordinary students who found early success, including David Hockney, Alan Jones, Peter Phillips, Ron Kitaj and Derek Boshier. When she joined the staff of the Royal College she found that nearly all her colleagues were Royal Academicians, Ruskin Spear, Carel Weight, Colin Hayes and others, and she was invited by them to exhibit at the Academy. In 1971 she was elected as an Associate of the Royal Academy and became a Royal Academician in 1978. Her work was shown in major exhibitions at the Royal Academy in 1979 and again in 1994.

Sandra Blow exhibited her recent work at the Tate St Ives in December 2001, paintings which show the great variety of abstract forms in her work. Most are very large, often more than two metres In length. The rough shapes of hessian or plaster and the jagged charcoal lines of earlier times have been replaced by more disciplined areas of colour. The vocabulary of shape varies considerably, some may contain rectangular areas, with perhaps an unexpected change from positive to negative, others are an explosion of coloured fragments, set in motion by broad and splashy brush strokes. Chevrons, stripes, lattice systems and circular shapes are all used and they have a powerful effect upon the viewer. She is able to direct this circus of shape and pattern entirely to her own purpose and all of the paintings remain distinctly her own.

Although in earlier times Sandra frequently painted out of doors, the recent paintings do not directly refer to landscape. There are no horizons and the forms are not landscape forms. Yet the influence of the Cornish landscape is there and she likes to take her paintings out into the countryside to assess them and to feel some sense of unity. Another area of interest is architectural space, she talks of her admiration for Mies van der Rohe, and uses architectural components such as networks, systems of proportion, symmetry, repetition and other structural forms. Her talent as a designer is also apparent in the exquisite design of her studio. Another influence, perhaps unexpected, is African art. She is fascinated by the imbalance of form and the savagery of its expression. She is similarly affected by early medieval art with its asymmetrical arrangements.

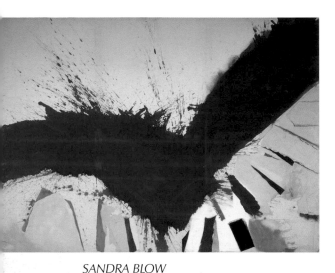

SANDRA BLOW
'Glad Ocean' *1989*

acrylic and collage on canvas, 260x366cm
photo: the artist

She uses acrylic paint because of its speed in drying and the opportunity to over-paint, although she admits that she hates the rubberised surface that sometimes results. Her paintings are worked up from broad, simple statements to more complex arrangements. She often uses paper collage to test colour and balance and to weigh effects. These collage pieces may then be replaced by paint or may remain and be fixed to the canvas itself. Another technique is to take Polaroid photographs of her work in progress. She uses the camera like a notebook sometimes producing a great many photos of the work as it progresses. This helps her to see it at a reduced scale and to understand it from all sides, a difficult undertaking with a 12x8 foot painting.

Her work is a precise meeting of opposites, the controlled and the spontaneous. In a recent interview (with Sarah O'Brien Twohig) she talks of a painting 'Vivace', a free flung, risky painting in which she wanted to be more daring. However even with such an extraordinary liberated painting she insists that there must always be a balance of space, colour and shape, it has to be held in a pictorial structure; which is only got by very hard work.

BARRIE COOK (b.1929)

Barrie Cook sees his paintings as inspiring meditation and contemplation, a form of spiritual discipline. They need time to work and should be enjoyed slowly. The paintings are formal, geometric and often contain linear elements arranged in a repetitive manner, a light background overlaid with vertical bars, soft or hard, behind which are other divisions of the picture surface. His paintings are to do with the illusion of space; the ground can be free and open or it can be blocked, shapes recede or advance.

Barrie Cook in his studio at Ruan Minor

The paintings are essentially abstract and non-figurative but they contain a mystery. They are often of monumental size, eight or ten feet is not unusual, large enough to fill the area of vision. At this scale they become part of the natural world, as trees reflected in water, grasses disturbed by the wind. He does not normally use references to the natural world to place his ideas, but he will make analogies. He may talk about a particular painting as representing raindrops falling out of a cloud, but what he really wants is that forceful punch of colour coming through the retina and working on the brain.

He works mostly with a spray gun, a semi-industrial process that he has mastered to an extraordinarily high degree and uses with great subtlety. Acrylic paint applied by spray has its own qualities. The edges of the forms may be soft and hazy or knife sharp. Colour may be built up to maximum intensity and may produce sensations of dazzle or even painful optical sensations. These paintings do not come easily, they may require many changes of colour and many hundred applications of spray paint

The essentially private and meditative world of such an abstract painter is in contrast to the earliest years of his life. Barrie Cook was born in 1929 in Hockley, a tough inner-city area of Birmingham. It was not an academic environment, from an early age he was streetwise and his education, or lack of it, was not important to him at that time. As an only child he had to be tough, you either hit or you were hit, there was no other way. The idea of recreation for some of his older contemporaries was to be bussed down to London for a fight with a London gang, and then to return to Birmingham.

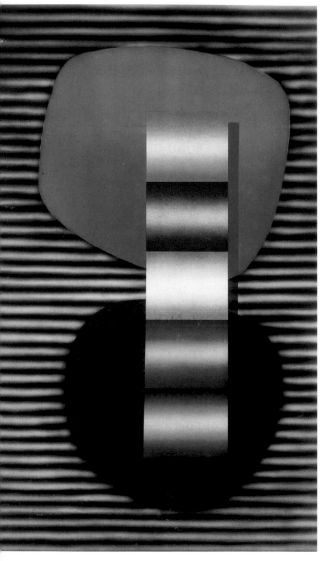

BARRIE COOK
'Painter's Games', 2001

acrylic on canvas, 274x168cm

He left secondary school at the age of fourteen and got a job with the Joseph Lucas factory, which made motor parts and batteries. Working in the personnel department, he was described as 'a page boy', escorting visitors around the vast complex of workshops. In his spare moments he was seen doodling in the office, and this resulted in him being given some training as a commercial artist in the advertising department, where his job description was improved to 'making the tea'. Any artistic ideas that he came into contact with was to do with the life and manners of the society in which he found himself

In 1947 Britain was still under emergency regulations for military call-up and at the age of eighteen Barrie entered the RAF. During his time in the Forces his view of life altered. He developed leanings towards pacifism, a conviction that has strengthened throughout his life. Upon demobilisation, he became a full-time student at Birmingham College of Art. He took a four year course leading to the National Diploma in Design (Painting Special Level) a stringent academic course which tested him, but the experience was valuable and he worked hard at it. He was one of only twelve students selected for entry to the painting school and he was doubly fortunate in having as his tutor the Royal Academician, Bernard Fleetwood Walker (1893–1965) who treated his students in a slightly bullying manner, but instilled in them the basics of professional practice. Barrie remembers the series of advertisements that Fleetwood Walker did for Aero chocolates entitled 'Something Special...', he also admired the portraits of the female students that Walker would paint quickly but making each of them very beautiful.

Much of Cook's life has been concerned with teaching. After completing a teacher-training course he taught in a boys' secondary school in Birmingham. This was a time when great changes were taking place in the art schools. A new attitude to art training embodied in the idea of a 'basic course' in art and design was taking hold. The basic design course had its origins in the Bauhaus, in Germany in the 1930s, with the pedagogic work of Klee and Kandinsky and the teaching programme of Joannes Itten. The course was centred upon the individual student and stimulated a spirit of enquiry into the visible facts of nature and the exploration of materials and colour. In England this influence was first seen in the summer schools for secondary school teachers that Victor Pasmore directed in Scarborough from 1955 to 1957, working with Harry Thubron and Tom Hudson. Other centres were at Leeds College of Art, and Newcastle University, where Richard Hamilton later worked with Victor Pasmore.

Cook took the idea of the basic course to heart; he was aware of the need to extend his own creativity and he was greatly helped by his meeting with Harry Thubron on a summer course in Leeds. The directness of his approach had a message that Barrie Cook took into his own teaching. He gained enormously from these short courses but they were very demanding, every day of the holiday breaks was filled. By this time he was married, but his wife Mary understood these demands, then as now. He also met, and became firm friends with Terry Frost, Roger Hilton and Trevor Bell who at different times were in Leeds on Gregory Fellowships.

Cook was very much part of that renaissance in art teaching that took place in Britain in the 1960s and 1970s. In 1961 he was offered a part-time job at Coventry College of Art, a post that soon

became full time. He was then living on the fringe of Birmingham in the Licky Hills, three miles from Bromsgrove, with a studio in an old mill, above a wine warehouse in Blackwell – more famous for its golf course. By this time his paintings were abstract and large scale, painted in reds and blacks, and he had already developed what he refers to as a 'crutch' of using verticals.

Up to this time Cook's work and his life had been wholly within the industrial Midlands, a hardworking landscape, but one in which art and design has played an emphatic part. In art, as in industry, Birmingham was not backward looking; it kept abreast of developments internationally. Cook's paintings of this time have a distinctly international approach, in common with the American painters of the New York School such as Kenneth Nolan, Maurice Lewis and Frank Stella, whose work was being shown in London in the mid 1960s.

After a period of experiment in various techniques, Barrie Cook began to use a commercial spray gun to apply the paint. He had been introduced to the use of spray in the advertising department of the John Lucas factory, and for a time he shared his studio in Blackwell with the painter John Walker (who later won the John Moore's competition), and they both used spray guns in their work. With the additional strength of pure sprayed colour, Barrie Cook's paintings of the early 1970s became even more expressive. The scale and assertive qualities of these paintings sacrifice illusion and texture in favour of a strong pictorial structure.

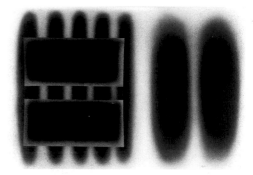

BARRIE COOK
'Temple with Spirits', *2001*
acrylic on canvas, 102x153cm

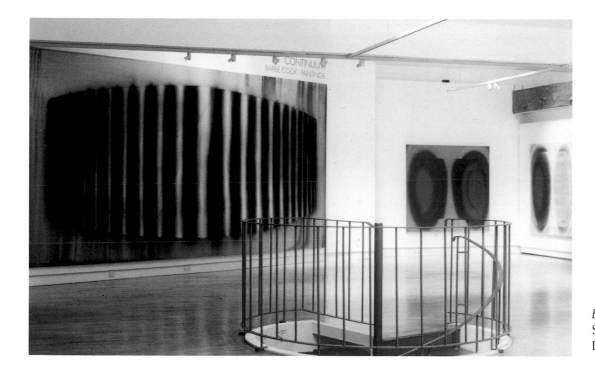

BARRIE COOK
Solo exhibition – installation photograph,
Dean Clough Gallery, Halifax, *1999*

In 1974 Cook became the senior Fellow in Fine Art at Cardiff College of Art. This gave him the use of an experimental studio with no specific teaching requirements and an opportunity to develop his work at a scale not previously possible. An impressive showing at the Whitechapel Art Gallery, London, in 1975 entitled 'Large Paintings from Black to White' included several of considerable size, as much as ten feet high by eighteen feet wide, formed of sprayed vertical bars. The freedom of the strokes and the slight variation of line and gradation of tone impart shimmer and tremble to the surface. For some eighteen years his working base was in Wales, first at Cardiff College of Art and then as Gregynog Fellow in the University of Wales. Later as Head of Fine Art at Birmingham Polytechnic, he retained a studio in Cardiff. During these years he was exhibiting widely in London in a series of one-man exhibitions.

In 1992 Barrie and his wife Mary decided to move to Cornwall which they had known from earlier holidays. They made a series of visits and by chance he came across the Old Methodist Hall in Ruan Minor, on the Lizard in Cornwall, a large and high studio room which gave him the space and facilities that his semi-industrial techniques require. Cornwall has produced changes in his work, most particularly in the direction of colour which is stronger and more vibrant. The use of the vertical has diminished and a series of circular and elliptical forms appear in the paintings.

He continues to think deeply about the basis of his work and he is conscious that his paintings are there to probe into the unseen and the intangible. For an exhibition in Cardiff in 1994 the starting point for a recent series was a radio talk given by Karen Armstrong. He referred to her book *A History of God* in which she introduced the idea of God as female, one who brings calm and nourishment to the psychic space. Cook found this an inspiring thought which lead him to a series of paintings under the general title 'Silence Alone is Appropriate' painted in 1993, which formed the centrepiece of his exhibition at the Concourse Gallery at the Barbican Centre, London, in January and February 1995. In addition to exhibiting frequently beyond Cornwall, he has recently had a series of exhibitions at the Lemon Street Gallery in Truro.

TREVOR BELL (b.1930)

Trevor Bell has had several lives. In the 1950s he lived and worked in London and then in St Ives. He spent many years in Tallahassee, Florida, USA and had major exhibitions in different parts of the United States. Then in 1996 it was back to Cornwall, where he set up his large studio on the outskirts of Penzance and is now engaged in work which draws on all of these experiences.

Trevor Bell was born in Leeds in 1930 and trained at Leeds College of Art, then in the hands of the much-respected principal, Edward Pullee. The head of painting was Maurice de Sausmarez, an innovative educator. While other students were painting gritty northern scenes, Bell painted self-portraits of surprising sophistication, in which he portrayed himself wearing a bow tie. After his Fine Art course he took a teaching qualification and worked as a labourer, and for a time taught evening classes at the Harrogate Art School.

Trevor Bell, 2000

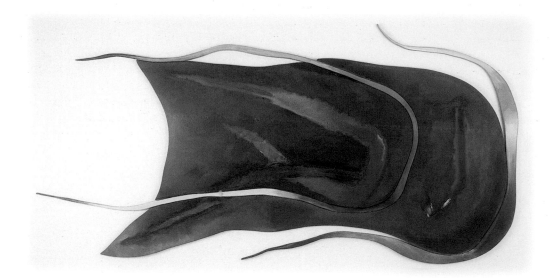

TREVOR BELL
'Night Voyage', *1994*

acrylic on shaped canvas, 518.5x424cm

Commission: Dept of Transport HQ,
Fort Lauderdale, Florida

Trevor Bell is naturally analytical and enquiring. His subjects at this time were close to social realism, the townscape of northern industrial cities. But this part of his early career was also a period of unlearning naturalistic painting and he was making a personal examination of the progress of modern art, examining the methods of Cubism, the double vision of Picasso and the way that children look at the world.

It was during this period that Bell met Terry Frost, then working in Leeds on a Gregory Fellowship. Two memories remain; in discussing Bell's paintings Terry pointed to a small area in the middle of one of them and said 'that he was starting to paint just there,' a remark Bell found very difficult to understand at the time. Later he was better able to appreciate the colour qualities that Frost was referring to. The other important piece of advice was that he should go to St Ives, to 'learn some language'. As a direct result of this, in 1955, with few possessions, he came to St Ives, on an old Indian motorbike, with his first wife Dee, riding pillion.

They arrived In St Ives with introductions to Denis Mitchell and others and obtained the usual odd jobs, washing up, painting and decorating, that many young artists survived on. They lived at Tregerthen, just above Zennor, where Patrick Heron had recently bought 'Eagles Nest' the house that he would live in for the remainder of his life. Trevor Bell helped Frank, the builder, to renovate the house for Patrick; he removed the old Edwardian decorations, sanded the floors and painted all the walls white. He is sure that he painted the conservatory three times. Conversations during lunch on the lawn were inspirational and often included such visiting eminencies as Ben Nicholson, Alan Davie or Bryan Wynter, who happened to drop by.

During those times of serious economic difficulty Trevor Bell and Brian Wall shared a damp basement studio under the Seamen's Mission in St Ives. Later he was fortunate in getting one of the much prized Porthmeor Studios, No.8. By this time he was showing regularly with the Penwith Society, whose exhibitions in the Public Hall in Fore Street were attracting a great deal of attention. London dealers frequently came down to see the talent emerging in St Ives, along with the well-established stars. Charles Gimpel, the partner of Gimpel Fils, the *avant-garde* London gallery, already committed to showing abstract work, saw Bell's paintings. He suggested that Bell should take some to London, to show to a friend who was going to open a gallery. The friend was Victor Waddington, who was about to launch his gallery in Cork Street. Bell was the first artist that he took on and he was to have four exhibitions there. Later Waddington showed most of the principal St Ives painters including Heron, Hilton, Frost and Wynter.

Bell describes himself as an innocent at this time and certainly his work was still developing. His paintings were increasingly abstract but owed much to the deeply cut and broken landscape of Cornwall, its fissures and folded rocks. Opportunities and recognition came swiftly. His first one-man exhibition at the Waddington Gallery in 1958 was a huge success. It was in the catalogue for this exhibition that Patrick Heron called him 'the best non-figurative painter under thirty in this country'. Following this he was awarded an Italian Government Scholarship, which took him to Anticoli Corrado, the mountain village outside Rome, much used by British painters. He was also awarded

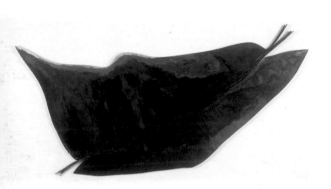

TREVOR BELL
'Black Valley' *(Himalaya Series), 1992*
acrylic on shaped canvas, 284.5x638cm
collection: Polk Museum, Florida

Trevor Bell's Studio at Talahassee, Florida, 1992, during the making of the Himalaya Series.

the Paris Biennale International Painting Prize. He later became a Gregory Fellow in Painting at Leeds University and was subsequently involved in the developments in art education that were happening at this time, teaching part time at Ravensbourne School of Art and as Head of Painting at Winchester School of Art. A major retrospective exhibition of his work, arranged by the Richard Demarco Gallery in Edinburgh, was toured in Ireland and Sheffield in 1970. In 1973 he had a major one-man show at the Whitechapel Gallery in London. The work in that show was all painted in Florida, much of it large scale (up to thirty feet), a response to his experience of the first night-launch at Cape Canaveral (Cape Kennedy).

In 1972, with a solid reputation as a leading abstract artist, he was invited to Florida State University, Tallahassee, to work for one year with post-graduate Master of Fine Arts Students with the extraordinary freedom to organise his own tutorial method of one-to-one teaching. This later turned into a permanent appointment. With excellent studio facilities and the opportunity to paint large-scale paintings, he made a fresh career in the United States. From 1980 until 1998 he had a succession of exhibitions, mostly in the southern cities such as Miami and Atlanta, and also in Chicago where he is still a regular exhibitor. It was here that he was able to show the major works that he was now producing, using shaped canvases and powerful contrasts of colour.

Scale is important to him; size gives his paintings additional presence and definition. They are mostly larger than the reach of a man's outstretched arms, six or eight feet is normal, sometimes more. Bell is very concerned with the way in which a spectator would look at a painting, how they are affected as they walk up to it, first seeing it at an angle. Along the edge of the canvas is written the history of the painting, the changes of colour that have taken place are marked by dribbles of paint, left as a foil to the canvas surface. At other times this edge is physically altered by notching and bevelling and is essential to the pictorial image. As the spectator comes to face the canvas its spread and height has a powerful effect.

He uses shaped canvases, often of considerable complexity. The shape of the canvas plays against the colour, one reinforcing the other. There is an heroic scale about the work which colour emphasises and enhances. Although deeply concerned with visual language he is no theorist and colour is largely an intuitive matter. His preference is for sombre earth colours with strong gestural drawing, simple and roughly stated, with colour to heighten the tension of the painting. On occasions Bell has made very large work indeed. For a bank in Tallahassee he created a painting entitled 'Southern Light' which consisted of 25 panels each 8 feet high and 6 feet wide, covering 125 feet of wall space.

Although the paintings are not descriptive of particular places or events their subjects are implicit. During his years in America he was much affected by the 'Heat Scape' of Florida, that hot tropical light that vibrates and fuses colour. He has also been captivated by his love of India. His teaching in Tallahassee brought him the means to travel in other parts of the world. Trevor and his wife Harriet made seven trips to India between 1980 and 1990, travelling by rail or local bus, and on foot across the Indian Himalayas and Zanskar Mountain ranges into the area known as Little Tibet. These awesome hills and valleys were powerful influences on his work. He writes:

TREVOR BELL
'Pavanne', 1982

acrylic on paper, 457.5x475.5cm
commission: Civic Centre, Talahassee, Florida

TREVOR BELL
'Up Front', *1999*
acrylic on canvas, 229x175cm
collection: Slaughter & May, London

thoughts of the power of land structure and erosion, of ancient monasteries and the utensils to be found there, sacred or functional, have motivated many of these images, the Zanskar source also removed me from the Florida light and colour and so has brought many new possibilities. (Statement by Trevor Bell, September 1990.)

In addition to visiting some exotic parts of the world, Trevor and his wife, Harriet, also made short visits to England throughout their time in the US. Anticipating retirement from his post in Florida State University where Trevor was honoured as Professor Emeritus, they both felt it was time to return home to England. One visit was spent at the 'Poor House', owned by Patrick Heron in Zennor. This period reconnected him with Cornwall, and they came across the farmhouse where they now live.

Throughout his work he has tended to keep 'subject' at arms length, he feels it is too personal, too difficult to describe; he wants the work to be 'purer' in the sense of it being non-referential, totally abstract and contained within the painting. There are subjects however; the same ideas of land erosion and the reverberating presence of ancient man-made artefacts are present in the paintings that he has made since his return to Cornwall. He found that the rocks at Godrevy had the same convoluted strata as those that he had seen in the Himalayas; such examples provided continuity between his past work and the present. He recognises that he is an image-maker; his paintings contain references to water, cliffs and high ground

Bell is a keen sailor and many paintings have a connection with sailing experiences. Memories of the Gulf of Mexico, not very far from his earlier home in Tallahassee, and of sailing in the Solent or through the Bay of Biscay are echoed, as is the sight of well known headlands from the sea, or the experience of coming into port at night. To record these fleeting experiences he makes notes, as he says, in his head. Back in the studio he explores these ideas further with what he calls 'probes', scores of simple drawings, some of which may be amplified into a painting.

Returning to Cornwall has not been easy. Trevor Bell found it difficult to relate to his much earlier life, perhaps because he has had so many lives. It took a while before he recognised how different St Ives now is, in comparison with his earlier memories; in his opinion it has become 'a miniature St Trop'. He now lives an isolated existence in the country, some way from St Ives. He is aware however, that the Tate St Ives has been tremendous for artists such as himself. He has been able to show some large work there, shipped over from America. At a personal level he had a wonderful return to Cornwall and many happy reminders of his earlier association with St Ives.

ANTHONY FROST (b.1951)
Anthony Frost lives in the ancient hamlet of Rosemergy, on the high ground beyond Zennor, looking west to the Atlantic. If you stand at his cottage door looking over the red bracken, with cardboard cut-out clouds, it is an experience as vivid as his painting *'Walking into Red'*. However he keeps away from the Cornish places so much loved by many artists in St Ives. Being a truly abstract artist, he looks for subjects not in the landscape.

Anthony was born in 1951, the second son of Terry and Kathleen Frost; it was a large family, spread over 14 years. Anthony and his brother Adrian grew up in St Ives and he remembers, 'that you only had shoes for schooldays' the other days were spent on the beach. Their father, Terry Frost, was already successful and backed by the Waddington Galleries, London. Anthony remembers these years as a series of vignettes, for example his father returning from America after showing at the Bertha Shaeffer Gallery in New York, with gifts for all the family. Anthony's gift was a Stetson hat. David Hockney would get off the train in a big fur coat and spend an hour or two showing the boys how to make cartoon flip books. Some of the artists were rather intimidating, like Roger Hilton; he is now one of the artists that Anthony most admires. The photographer Roger Mayne was a frequent visitor to the house as was the poet, Sidney Graham. The family moved to a university house in Leeds where Terry was Gregory Fellow, at that time bubbling with creative energy. It was in Leeds that the other sons; Mathew, Stephen and Simon were born. Their only daughter, Kate, was born when the family moved back to St Ives.

Anthony Frost in his studio, Penzance, 2002

For a short time Anthony went to St Mary's Roman Catholic School in Penzance. When he was eleven the family left for Banbury, to a big house where Terry's pictures filled every wall. At his new school Anthony was very embarrassed when the teacher recognised his artistic talent and told the class that his father was a well-known abstract painter. He has never found it difficult to deal with the fact that his father was a famous artist; perhaps it was because he was second in the family and didn't have to carry the main responsibility

At Banbury Technical College Anthony did the two-year basic art course followed by a foundation course. He then went on to Cardiff school of Art. It was a good time to be in Cardiff and Anthony got the best out of it. The dynamic Tom Hudson was the creative director of the School, his energy was infectious, and he was supported by a young and dedicated staff including Alan Wood, Terry Setch and Bill Featherstone. Eric Malthouse was Anthony's personal tutor and it was Eric who taught Anthony about taking a painting as far as possible and not being frightened to change things or 'not let preciousness get in the way'.

It was not because of family connections that Anthony returned to Cornwall, it was simple chance. In 1974 his brother Adrian was living in the Foage Valley near Penzance and there was a nearby cottage available. Anthony came for a visit and immediately afterwards set up a studio in the little room of the cottage. By this time Anthony had met Linda Evans in Cardiff where she was doing an Occupational Therapy course, she loved Cornwall as much as Anthony did and in the following year they were married.

Anthony did not wish to live in St Ives, neither did he originally think of showing in the Penwith Gallery, although he later became a member. Since then he has exhibited his work widely in London and elsewhere, in exhibitions such as 'Viva Blues', which toured in Britain for two years. In London he exhibits with Advanced Graphics and he has just had a show of prints and large paintings called 'Walking into Red', His work is in many collections in Britain and the USA.

ANTHONY FROST
'It's Got A Beat, 2001
acrylic on wynceyette, sailcloth and string
220x525cm

His studio is off the busy shopping centre of Penzance, a narrow building on two levels, linked by precipitous stairs. It is packed with paintings, finished or in progress, work on paper, and a multitude of pots of paint, brushes and drawing materials piled to the ceiling. A lot of the work is made on the floor and he works in an arena lit by the cold clear light of Penzance. He does not use stretched canvas; he prefers surfaces that force him to struggle. In his studio he has a large pile of materials from many sources, canvas, various sorts of ticking and sheeting, pieces of hessian, sacking, rope and string. The paintings are built up from these materials, stapled on to roughly made stretchers. These surfaces give tension and structure, and the different textile materials create a series of areas to which colour is applied. From the local sailmaker he gets heavy sailcloth and the thin, brightly-coloured nylon used for the sails of wind surfers. He does not value these because of their connection with the sea, but because these are locally available, and they are full of stitching and eyelets.

His colour is powerful and used at its maximum intensity. Acrylic paint in primary colours is taken directly from the pot and brushed on broadly. He does not want illusionist space in his painting, there is no trace of a ground or any spatial definition, and if any part looks representational he 'knocks it on the head'. He wants the colour to be there in its own right. He is inspired by colour and he takes ideas from everywhere, from the Marks & Spencer underpants, 'five in the pack', the colour of his T-shirts all lined up, or peeling paint on a bleached wall. But his main inspiration comes from the materials in his studio; he's just as inspired by getting all the pots of Liquitex paint from the dealer and opening them up.

The images that he uses have developed over his painting career. The titles of his paintings were the starting point. When he first came to Cornwall he wrote words or short phrases on his canvases, such as 'King Rocker', 'What do I Get', 'Buck Up'. These come from his love of rock music, combined with private instructions to himself, and give him a provocative foil for shape and colour. He also raided pub games such as darts and dominoes for dot shapes, circles and wedge shapes.

In 1976 he took part in the exhibition 'Deck of Cards' arranged by JPL Fine Arts, London, in which artists were asked to design a painting from a specified playing card. Anthony's card was the ten of Diamonds, this suited him well, and so dominoes gave way to diamonds and produced it's own series of paintings. More recently the diamond has been segmented to give arrow shapes, which carry strong colour across the picture surface. He has established a free repertoire of shapes, moving across and against each other, translated into strong colour.

The titles of his paintings go back to his early days as a student. For example 'What Would You Do' was the last line of a play his brother Steven took him to see. Music of all sorts is always present in the studio and he looks for a title to a painting that sounds like a hit single. Chance remarks provide him with ideas, a current one is 'It's almost believable' or the surreal 'I've no recollection of doing this' said by his friend Roger Mayne.

He has recently been working on a large canvas for the Eden Project, which is a design for planting, shaped to the land. He has been working with horticulturists, planning how his design could be carried out in a planting scheme. This involved working in prescribed colours that were foreign to him but which can be translated into fodder crops, the colours of lucerne, flax, clover, grass and gorse. The resultant 'garden' at the Eden Project will also be an activity area in the sense that people can walk through it, and of course it will change with the seasons. The overall area will be about 550 square metres.

Anthony enjoys talking about his painting and has done a lot of teaching at Falmouth School of Art, and in other schools and Colleges around the country including Canterbury, Cambridge and East Anglia. He is no art historian but in his lecture 'The Stand up Slide Show' he refers to the artists that inspire him. He admires the light structures of Dan Flavin and others seen on his visits to the USA, including the sculpture of Donald Judd, and remembers Judd's comment, 'representation is a kind of noise that gets in the way'.

ANTHONY FROST
'Radar Angel', 2001
*acrylic on sailcloth, sacking cord
and rip stop ties, 107x102cm*

ANTHONY FROST
'Red Cools', 2002
*acrylic on directors chair canvas,
sail cloth, rip stop and string, 46x46cm*

4

THE NEWLYN GALLERY

The art gallery in Newlyn has played a significant part in the development of artistic activity in Cornwall. The gallery was built in 1895 by the Victorian philanthropist John Passmore Edwards, a Cornish born newspaper proprietor with a strong interest in the visual arts. He established some twenty public buildings in Cornwall, and many more in other parts of Britain, including the South London Art Gallery and the Whitechapel Art Gallery. Newlyn was built to provide a showing place for the 'Newliners', that group of artists associated with the town, who, by the 1890s, had gained a national reputation. It provided an all-the-year-round gallery for the display of their work and replaced the old 'show days' in which the public were invited to see paintings displayed in the artists studios, before being dispatched to the Royal Academy for the Summer Exhibition. Stanhope Forbes was the prime mover among the artists, and remained a considerable influence on the gallery for the remainder of his long life. At the age of 87 he was still chairing the annual general meeting of the gallery. He died at the age of 90 in 1947.

The Newlyn Gallery

With the impetus of a new gallery the artists formed 'a fraternal organisation' called the Newlyn Society of Artists. The gallery served the art community well but it did not belong to the Newlyn Society of Artists, and was not run by them. It was in fact the Passmore Edwards Art Gallery with its own trustees and a committee that worked closely with the Newlyn Society. In addition to Forbes, there was Tom Gotch, Walter Langley, Norman Garstin, and those who came later, including Laura and Harold Knight, Henry Rheam, Charles Simpson and others.

There were always financial problems. Although the property was a gift to the artists' group, it had no endowment of funds and for running costs it relied mostly on a small charge for admission plus the subscriptions of twenty-six artist members and some seventy associates. The gallery usually resembled a shop, with a mixture of oil paintings, watercolours and craft exhibits crowded on its walls and arranged in glass cases. There was occasional criticism of the practice of hanging the same pictures 'however good, time after time in successive exhibitions'. (*Diary of a Gallery; 100 years in Newlyn* ed. Melissa Hardie, Patten Press in association with Newlyn Art Gallery, 1995).

Three or four exhibitions of the Newlyn Society of Artists were held each year, and the high spot was the Spring Show Days, usually in March, when the work destined for the Royal Academy was put on the walls for discussion and comment. This was when local reputations were made.

Opposite page:
MICHAEL UPTON
'Lane near Paul, Cornwall'
oil on board, 25x25cm
private collection

73

The Newlyn Gallery and the Stanhope Forbes memorial plaque

It was always the intention that the gallery should be devoted to exhibitions of contemporary art, and for that reason it was never regarded as a museum, and no collection was formed. From time to time special exhibitions were held, as in the summer of 1936, when an impressive collection of past work by Cornwall-based artists, entitled 'Loan Exhibition of Art Treasures of Cornwall' was shown.

During the years of the Second World War the building became sadly neglected and it later required considerable effort to return it to good repair. There had always been an artistic rivalry between St Ives and Newlyn. In earlier days this had been played out on the cricket field, between teams of artists from the two centres. In the 1950s tensions between the traditional and the more advanced styles, which lead to the creation of the Penwith Society, were reflected in Newlyn. But Newlyn was not as extreme as St Ives. As a consequence of the Penwith's advance towards abstraction and the intolerance shown to more traditional forms of painting, an important group of artists, including Hyman Segal, Peter Lanyon and others, left the Penwith and aligned themselves with the Newlyn Society of Artists. Thus at this period St Ives most clearly represented modernism and abstraction, while the Newlyn Gallery was a home for the more traditional painters. To quote Jeremy Le Grice, a trustee of the gallery:

> In the early 1950s the Newlyn Gallery tended to be regarded as a bastion of vague neo-impressionism particularly practised around Lamorna... Due to the (inevitable) accident of Peter Lanyon disagreeing with the ideologies of the youthful Penwith Society, he transferred his considerable energies and enthusiasms to the Newlyn Gallery around 1953. He personally attracted painters to West Cornwall from London and around the country, many of whom exhibited at the gallery in the later 1950s... (op.cit p. 103).

With the appointment in 1956 of Michael Canney as curator, the gallery received a jolt, which brought it firmly into the second half of the twentieth century. Before this the galleries had been manned by volunteers and secretaries. While Michael Canney brought a more professional direction to the gallery, he also possessed a welcome sense of humour. He made considerable improvements to the gallery and the exhibition programme became more varied and ambitious. In 1958 he presented an exhibition of 'The Newlyn School', the first analysis of the work of Newlyn painters from 1880 to 1900. By contrast, in the same year there was a showing of surrealist films, including the long banned 'L'Age d'Or' accompanied by an elaborate display of surrealist images including bowler hat, severed hands and a (stuffed) crocodile.

After eight years as curator Michael Canney left the post to pursue an academic career. Despite limited finances he had transformed the appearance of the gallery and created a varied programme of exhibitions, which brought public attention to a number of artists working in West Cornwall, many of them quite young.

In 1972 John Halkes, recently retired from the Royal Air Force, and his wife Ella opened the Orion Gallery in Morrab Road, Penzance, showing contemporary paintings. One of their first exhibitions was of recent gouache drawings by Roger Hilton, a brave choice considering the irreverent nature of the

drawings and the fact that Hilton had become convinced that he was being neglected. The exhibition brought considerable attention to the painter and to the gallery and was financially successful. The Newlyn Gallery meanwhile was without a director and was being run by members of the society. It was also seriously overdrawn at the bank and the gallery was closed during the winter months. At a time of economic recession it was clear that major changes were required. Following long discussions a new organisation was formed, the Newlyn Orion Galleries, to run the Newlyn Gallery as well as the Orion Gallery in Penzance. The director was John Halkes and the new body became an educational charity. The affairs of the Newlyn Society were separated from those of the gallery, and the Society no longer had the responsibility of running the gallery.

In spite of his best efforts, and with outstanding support from artist members, the following years continued to be financially difficult. In order to concentrate resources the Orion Gallery in Penzance was closed and all efforts centred on Newlyn. The main feature of this time was a series of one-man exhibitions of artists working in and around Newlyn. These gave encouragement to the artist community and greatly increased the size of the audience. It was not until March 1977 that the Treasurer's report could say; 'the Society's financial state is very healthy after many years of anxiety as to whether this Society would survive the running of the Gallery...' (op.cit 145).

ARTISTS OF THE NEWLYN SCHOOL

The most important single exhibition produced during John Halkes' stewardship was the major historical survey 'Artists of the Newlyn School, 1880–1900' which took place during May and June 1979. It gathered together many of the most important paintings by the early Newlyn painters and published a catalogue of considerable scholarship by Caroline Fox and Francis Greenacre. This hugely successful exhibition, seen by no less than 11 000 visitors, allowed the public to see for the first time the full range of the work produced in Newlyn nearly a century before and to understand it as a major movement in the development of nineteenth-century painting, .

A sequel to this was the exhibition 'Painting in Newlyn 1900–1930', which described the work of the next generation of painters in Newlyn and included the artists of the Lamorna Valley. This proved equally successful, and was toured to Plymouth, Birmingham and the Barbican Art Gallery, London. At the last venue the exhibition was expanded to include the earlier Newlyn School.

The record of John Halkes' time at Newlyn is truly impressive. In his sixteen years as director he created a new role for the gallery in terms of education and access to the public. He arranged some 200 exhibitions, including a number of important solo shows, and opened a second gallery in conjunction with the National Trust at Trelissick near Truro. He retired from the Newlyn Orion early in 1991. 'I feel it is time for a change', he said. He had decided to enter the Church and to take Orders, he was ordained a Deacon in Truro Cathedral in June 1990.

The Newlyn Gallery was again without leadership until the appointment of Gerald Deslandes, whose period as director lasted only eighteen months. He was succeeded, in 1993, by Emily Ash, a

graduate from Goldsmith's College, London. She was the first woman director of the gallery and the first practising artist to hold the position. At the age of twenty-six, she was also the youngest gallery director in the country. She was naturally anxious to bring the gallery into the new age. In spite of falling attendance and crises in the membership she brought a very different approach to the gallery, with a programme that included conceptual and environmental art projects. Her main achievement was to obtain funding for the gallery for major building improvements, She oversaw an ambitious scheme for upgrading and modernising the interior of the gallery, to a total cost of £165 000. A further long battle with local planners for the extension of the gallery was lost because of planning restrictions, and a lottery grant of £1 million that she had secured could not in the end be taken up.

Whilst alterations took place a temporary gallery was created in a disused shop in Market Jew Street, Penzance. The Newlyn gallery was re-opened in May 1994 with an exhibition 'Sea and Boats' by the sculptor David Mach, in which a large part of the newly formed upper gallery was partly fitted with a 'sea' of ten tons of newspaper on which a group of canoes floated. Des Hannigan, who wrote in the *Peninsula Voice*, observed: 'Passmore Edwards, the old journalist that he was, would have relished the irony.' In 1995, at the time of the centenary of the gallery, the name Newlyn Orion was dropped and the gallery became once again the Newlyn Art Gallery.

Elizabeth Knowles was appointed as director in September 2000. She had trained in sculpture at St Albans School of Art, which she remembers as very small and old fashioned and fantastically good. She then worked at the Victoria and Albert Museum at shop-floor level in the department that was responsible for arranging travelling exhibitions. She then went to the print collection at the Tate Gallery.

She was married to the painter Stuart Knowles, a Cornishman. Whilst on holiday in Cornwall they decided on impulse to move there as soon as possible. They came in a VW campervan, full up to the brim with their possessions, and bought a derelict barn. She began to do freelance work with the Newlyn Gallery, the best of which was an exhibition 'Terry Frost; Painting in the 80s'. Later she worked for him on the production of a book about his work in which she tried to relfect his personality. She also worked on a number of exhibitions, such as Christopher Wood, Dod Proctor, Roger Hilton and many others. The most ambitious was in 1989 when she worked jointly with John and Ella Halkes on 'A Century of Art in Cornwall' which was exhibited in Truro.

Since she came as director the programme has included a number of experimental pieces, for example Lyndal Jones presented images and scenes from many sources dealing with '*The Facts of Life*' (February to March 2000). In September and October of the same year a group of four Japanese artists created work for the gallery under the title '*Mono – ha*' (School of Things) the 'things' being the natural materials from which the work is made – oil, clay, glass, wood and earth. The resulting installation had much in common with '*Arte Povera*'. The gallery has also continued to show the work of the Newlyn Society of Artists three times a year, the spring showing always being 'Critics Choice'.

KEN SYMONDS (b.1927)

Ken Symonds is a self-confessed traditionalist. He writes:

My world is a visual one and each day brings a fresh challenge. I try to paint most days. I have a model twice a week and I also take out a group 'en plein air' it is important for me to have a routine for working... I have chosen to live in Cornwall for several reasons. It has an enormous variety of painting subjects, the sea, the cliffs, beaches, its moorland, its valleys, its legacies of old mine buildings, fishing ports and quota of ancient monuments in which this part of Cornwall known as Penwith is so rich. (From *The Gallery Scene* Autumn/Winter 1999).

Ken Symonds

Ken Symond's father was born and brought up in Penzance, although Ken was born in 1927 in Swindon, Wiltshire. His father was a railway man, and Swindon was all GWR in those days and everyone went into the factory. After grammar school Ken became an apprentice fitter and turner in the Great Western Railway works in Swindon. He started painting at this time and at the end of his apprenticeship was awarded the first grant by Swindon Borough to attend art school in London.

He went to the Regent Street Polytechnic on the National Diploma in Design Course, where he was to be taught by the Royal Academician Norman Blamey, whom he considered to be one of the foremost draughtsmen of his time. It was a form of teaching based on observation, the study of perspective and the expression of form through light and colour, that went back to the masters of earlier centuries. It was also at the Regent Street Polytechnic that he met his wife, Jane. From there he went on to London University on the Art Teachers Diploma Course, and for two years taught at the Queen Elizabeth Grammar School in Barnet. At this time he was also building a career in freelance illustration and the design of book jackets. Working for an American publisher, book illustration gradually took over from teaching and he decided in 1960 that he could work as well from Cornwall as London.

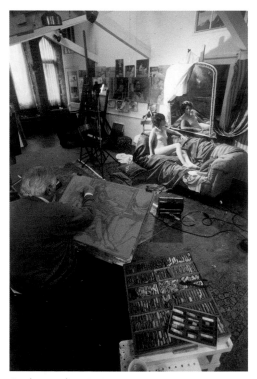

In 1961 Ken Symonds set up a studio in St Erth, near St Ives, still working for the publishers, Longmans. During this time, researching for information for educational books, he visited Nigeria, Ghana and later Kenya. He did not know the artists in Cornwall when he first arrived, the one exception was Anthony Benjamin who had been a fellow student at the Regent Street Polytechnic. He soon came to know many of the St Ives and Newlyn painters. St Ives was then the more active centre and he became a member of the Penwith Society and the Newlyn Society. He tried to steer his own path in his own paintings, neither abstract nor fully representational. He sent the more abstract work to the Penwith.

For the first twenty years in Cornwall he lived in the St Erth valley. His considerable skills in drawing and painting in a variety of techniques are based on close observation of the light and character of Cornwall and a discovery of the coastal structure. He painted more the rugged aspects of the wilder north coast, dotted with mine buildings, legacies of Cornwall's tin-mining past. The engine houses and ventilation chimneys and the strange colours of the waste tips have all been subjects that he has

In the studio, 1998

KEN SYMONDS
'Penwith Panorama', *1978*

oil on canvas, 91x440cm

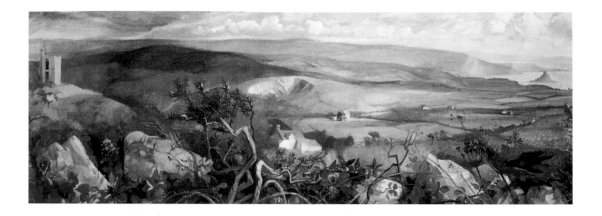

painted. He would make sketches on the spot and return to the studio to compose the cliff and field shapes in paintings that were more or less abstract, but never lost the link with landscape.

Certain features had a special attraction for him; he was absorbed by the rock formations of the coast, for example, the natural arch at Nanjizal, a single cleft through the cliff. Seen in late afternoon, the light from the arch is reflected in the shallow water and forms a long vertical. At other times a lively sea obliterates the gap with boiling surf and spray, and an angled shaft of light can obscure the interior of the cavern, all of these lead to series of paintings. Another series was of Pendeen Lighthouse with its overlapping headlands jutting into a viridian sea. Perhaps the ultimate in drama is the cragginess of Land's End with its castle-like towers of rock. Much of this work, including the largest paintings, was painted out of doors.

In 1980 Ken and Jane Symonds moved from St Erth to Newlyn, to the spacious church on the waterfront, which they refitted to make excellent studio spaces. On the upper floor, where the gallery would have been, is his large painting studio, high and light. It is set out for painting from the model and large enough to accommodate a group of students. In 1982 he made his first visit to the United States to exhibit his work in several galleries in Ohio.

After his move to Newlyn he became closely involved with the Newlyn Gallery. As a member of the Management Committee he witnessed the succession of curators following Michael Canney. Ken Symonds was chairman for five years at the time of the amalgamation with the Orion Gallery, which he saw as a measure of survival in a period of recession. He now has less to do with the gallery and feels distant from the work of the younger artists, some of whom have become prominent members, and feels equally distant from art movements in London.

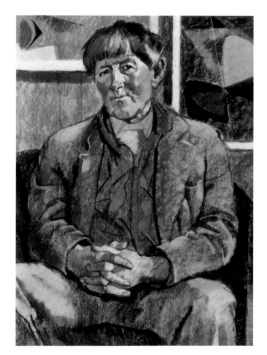

KEN SYMONDS
'John Wells', *1986*

pastel, 74x53cm

After exhibiting at the Pastel Society in London he was invited to become a member and has exhibited regularly ever since. Paintings of the figure, executed in pastel, have come to occupy a major part of his work. He says, 'the flicker of individual life is what I try to capture in pastel'.

BERNARD EVANS (b.1929)

Another senior member of the Newlyn Society of Artists is Bernard Evans who works in a large and handsome granite house at the top of Newlyn Hill overlooking Mount's Bay. It is his home, his studio, and his school. Below is the fishing port of Newlyn with its multitude of boats and scenes of continuous activity. On the high ground behind his house is 'Higher Faugan' the mansion that Stanhope and Elizabeth Forbes built in 1901. The port and its activity provide a continuing subject for Bernard Evans and the memory of the realist painters of the previous century still acts as an inspiration for his work.

Bernard Evans was born in 1929 in Toxteth, Liverpool, and brought up in Dovecot, five miles away. After National Service he went to Liverpool School of Art for two years, and later spent three years at Camberwell School of Art in London, which was then going through one of its many changes. There was a move towards abstraction although the Euston Road School influence was still strong. For Bernard Evans the chief influence was that of the German-Jewish painter Martin Bloch, a refugee from Nazi persecution of the pre-war years. After his training at Camberwell, Evans took a teaching diploma at the London Institute of Education where he also met his wife Audrey, who was a student on the same course.

Bernard Evans painting Newlyn Harbour

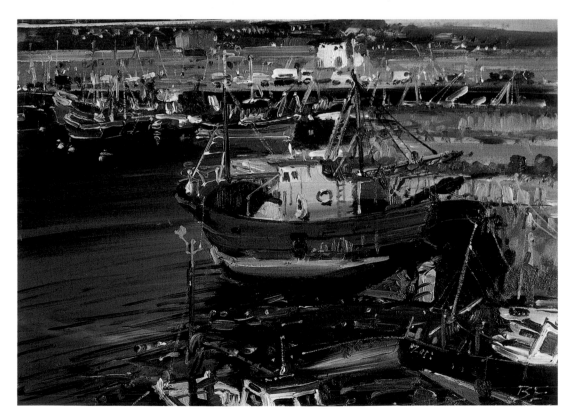

BERNARD EVANS
'Newlyn Old Quay', *1995*

oil on canvas, 305x427cm

BERNARD EVANS
'Newlyn Fish Market', 1995

oil on canvas, 152x214cm

In 1955 he returned to the North of England to teach in Bootle and then in Darlington After spending some ten years in school teaching he became Head of Department at Nottingham College of Education. It was the dramatic news that the college, although successful, was to close for demographic reasons that made Bernard Evans consider his future direction. He was now married with a family of five children and it was a brave move that took him to Cornwall. In 1976 he came to Newlyn to set up the 'Mounts Bay Arts Centre', a residential school devoted to outdoor painting which operated for ten students each week during the summer months. It was a family business; the teaching and the domestic work were shared between Bernard and his wife, Audrey, also a painter who had trained at the Thanet School of Art. After many years they decided that the year 2001 would be the last in which the school operated.

It was initially the light and the landscape of Cornwall that attracted him rather than the presence of other artists, but gradually he came to know his near neighbours such as Denis Mitchell, the sculptor, and John Wells the painter, and others in the Newlyn and St Ives groups. He became an active member of the Newlyn Gallery and was closely associated with many of the changes and improvements that have taken place over the years; until 1999 he was Chairman of the Newlyn Society of Artists.

Bernard Evans has a large and spacious studio; exotic plants and work in progress struggle for space. His work is bold and strongly coloured. Much of his work is painted to completion out of doors. In his studies of buildings there is often a predominance of blue, against which the golden colours of buildings seen in late sunlight shine. At other times he makes large drawings, as much as five or six feet in length, also made out of doors and over several visits. These may remain as drawings in their own right or may be the basis for paintings. He finds many of his subjects close to his home, such as the fish market in Newlyn lying below his windows, which he has painted many times.

Recently, over several months, Bernard has been working on a series of large paintings of the River Thames and the Houses of Parliament, and other London scenes, seen at various times of day and night. One of Bernard's sons, Peter, works for Shell and has an office on the twenty-second floor of the Shell Building in London overlooking the Thames. He obtained permission for Bernard to paint from windows in the hospitality suite. This is directly painted work, accurately rendered and obedient to the laws of perspective. He captures the atmosphere and mood of London at different moments and he feels that he is following the same tradition of observed painting that brought Monet to London in the 1890s. Other paintings have been done from the 'London Eye' of the panorama of London seen from the great height of this slowly moving wheel. Working from a moving vehicle he can only make sketches, amplified by photographs which serve as a basis for painting. It is unusual for him to work from photographs, although for this project there was no other way.

Bernard Evans' studio

GILL WATKISS (b.1938)

Gill Watkiss has a particular and personal view of Cornwall. She enters into the life of those who live on that central spinal ridge, away from the sun-flashed beaches and National Trust cottages. She has written:

my paintings are mostly about the very animated life of this far West Penwith peninsula of Cornwall. I am stimulated by the braveness and colour of the mining, fishing, and farming communities who make up the main part of the population. (Catalogue to the exhibition 'A Sense of Place' arranged by the Newlyn Art Gallery in 1979).

Gill Watkiss is a Londoner born in 1938, in Hackney, within the sound of Bow Bells. On leaving school she was advised to take a course in English, with a view to becoming a teacher, and she went to South West Essex Technical College. Once there she realised that part of the college included Walthamstow School of Art and she immediately re-directed her course towards Fine Art. Although she found working with people around her difficult, she needed to know the craft of her art and benefited from the help that the school gave her. She worked hard and was offered a place at the Slade School, London. Unfortunately her family circumstances made it impossible for her to take this up, which was a great disappointment to her.

At the age of twenty-one she came to West Cornwall. By this time she was married to Reg Watkiss, also a painter and photographer, who had trained at the Royal Academy Schools. He already knew Cornwall and had won a painting prize at the Academy, which enabled them to make Cornwall their home. With the help of Betty John, the daughter of Augustus John, they were able to find a flat in Mousehole.

Gill Watkiss

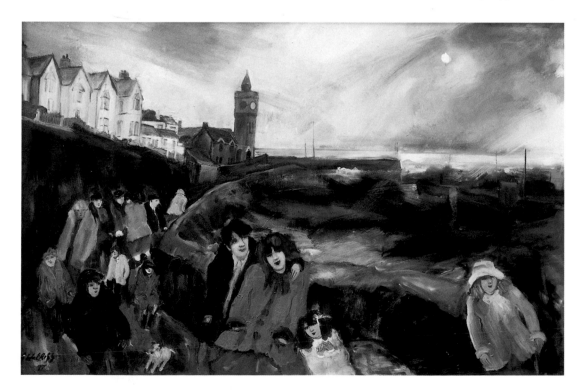

GILL WATKISS
'Watching the Storm, Porthleven', *1997*
oil on board, 92x64cm

81

Gill found it extremely hard to come to terms with Cornwall; it was difficult to deal with the enormous space. In London she had been taught by Ed Middleditch, one of the 'Kitchen Sink' painters and her painting had been low-toned social-realist subjects, city scenes, football crowds, Sickert-like cinema queues. In Cornwall she could not find an equivalent for them.

For a time she and her husband lived near the coast at Zennor and then in nearby Tremedda, at the end of 1969 they moved to St Just-in-Penwith, the last town on the Penwith peninsula. This was then a dying, tin-mining town, a workaday place that drew few summer visitors on their way to Land's End. For much of the year it is remote, exposed to the prevailing winds from the west. Nearby is Botallack Mine, which descends for a mile under the sea, now flooded and abandoned.

By now they had a large family of five girls, and Gill admits to being quite ruthless about her painting time, and each day would go to her painting room. Her daily routine included taking the children to school, walking through the park, where she would see other mothers with their children playing on the slides and swings. This became her subject. She did not like to draw the mothers who were waiting outside the school, she thought it might be intrusive, but kept looking until she knew the colour of somebody's face or their action as they turned. These were not portraits, but she came close to the feel of them as a person. Then working from small drawings and sketches done surreptitiously she began to paint them. Nobody in St Just knew she was a painter while she was living there.

Gill Watkiss did not come to Cornwall because of the presence of other artists, she did not seek their company and rarely went to private views. She admits to being obsessive about her painting and thinks about it all the time from getting up in the morning; but she is cautious about the word 'obsessive' because she feels that it could mean shutting oneself off from people.

GILL WATKISS
'The Bathers, Perranuthnoe Beach', *1993*

oil on canvas, 60x76cm

Her paintings are begun with acrylic paints, which dry quickly, and then completed in oil paint. The studio is not large, a room at the rear of her house with one small well-lit area; for larger work she has to use the floor.

Gill works with a repertoire of figures, more women than men, going about their daily business in and around Penzance, St Just-in-Penwith and other parts of the extreme South West. It always seems to be autumn or early winter, they dress for bad weather with warm jackets and wellington boots. Their bodies lean into the wind as they toil up the steep hills. Young women with their boyfriends walk with arms around each other's shoulders. Mothers wait patiently for children to come out of school; their clothing makes bright splashes against a darkened landscape. The characters in her paintings fit into well-defined types, many of them have what Gill Watkiss describes as a 'Cornish' face, rather wide with dark eyes, pale and slightly distracted. This look, which characterises many of her paintings, came from portraits she painted in Zennor.

Occasionally she has found subjects further afield. When her retrospective exhibition, held at the Newlyn Gallery in 1990, was toured to Plymouth and to Wales, she was struck by the similarity between West Penwith and parts of North Wales. Her work has been shown at the Tabernacle Gallery

and Art Centre in Machynlleth, and she has painted in Blaenau Ffestiniog. This is in addition to the many solo exhibitions that she has had in Cornwall and the West of England. Her exhibition in 2002 at the Great Atlantic Map Works Gallery, St Just-in-Penwith, is her third at this gallery.

From 1971 onwards, for the next eight years, she mainly featured the mining town of St Just-in-Penwith in her work, but in 1975 she and her husband moved to Newlyn and there she began to paint a series of boats, small neat cottages, quayside stalls and market activity. She says: 'the landscape is used by me rather as a backdrop for the portraits of those fashioned by its very elemental character'.

The figures in her most recent paintings continue to battle bravely against the weather. Her families of figures fly, 'Chagall-like', down the steep lanes and across the windy squares. Women with one or two children, dressed in bright clothes, struggle up the hill together. They live in villages of nineteenth century cottages set in a dark landscape under scudding clouds. In spite of the difficult circumstances in which they live the figures are undefeated and purposeful. As they plod up a rain-soaked road one feels that soon they will be inside a warm cottage preparing for their tea.

MICHAEL UPTON (1938–2002)

Michael Upton worked in that margin between realism and abstraction That is to say that his subjects were those he found around him, but he searched out their essential qualities in terms of colour and structure, a sort of personal cubism.

For the last six years of his life he lived and worked in Mousehole, near Penzance, and many of his paintings were based on Mousehole, Newlyn and Lamorna. He accepted the subjects that have intrigued artists for more than a hundred years; the working life of these ports and the changing light of landscape. However he structured his paintings so that some of his large paintings of Newlyn Harbour become a scaffold of line and movement, suggestive of the active work that goes on in the port and giving a framework for colour and shape. He also created many small studies from which larger versions could be made. The richness and the variety in his work was commented upon when he exhibited at the Newlyn Art Gallery in June 1987:

> The paintings of Michael Upton remind us that important work can still be done on a very small scale; each piece could be seen to relate to another in quiet, deliberate, cross-referencing, loaded with social, political and personal implications and intimations... (Mel Gooding in Art Monthly, June 1987).

Michael Upton was born in Birmingham in 1938 and studied at Birmingham College of Art and at the Royal Academy Schools. He had a long association with Royal Academy, exhibiting in their summer exhibitions from 1990, and more recently had been teaching post-graduate painting in the Royal Academy Schools. He had a number of awards including a Leverhulme Scholarship from the Royal Academy Schools in 1960 and the Abbey Scholarship to the British School at Rome in 1962. His exhibitions have included the Yale Centre for British Art, Connecticut, in 1987 and the Anthony

Michael Upton in the Old Chapel Studio, Mousehole, 2001

Ralph Gallery, New York in 1987, and in London at the Anne Berthoud Gallery and the Richard Demarco Gallery in Edinburgh. Most recently he had shown at the Great Atlantic Map Works in St Just-in-Penwith, Cornwall. He had also shown regularly with the Newlyn Society of Artists.

Though teaching and working alongside such artists as David Hockney and Colin Self in the 1960s, Upton went his own way, painting with a determined formality and studied technique. His work throughout the 1970s and 1980s reveals a variety of subject and style far removed from the traditions of art associated with Cornwall, and which appear to have their origin in his urban roots. Later, with his wife Susie and their young children living in rural Dorset, he painted the landscape around their home, but his major work from this period was done away from the countryside. Throughout, his genuine enthusiasm for new ideas generated by the young artists he taught, particularly his interest in conceptual and performance art, kept him from the mainstream.

While his superb drawing skills provided many early paintings with an architectural presence, often containing elements of industry, brick walls and chimneys, and a series of important works from the 1970s repeated the same scene, in different light and in sombre tones, his arrival at the Old Chapel Studio in Mousehole (owned by his friend Sally Fleetwood) signalled a more extravagent use of colour. Those who knew Upton and his work before his arrival in Cornwall watched with some interest how he would approach, or circumvent, the traditions of painting there. As it turned out he fell easily into painting the landscapes in and around Newlyn, strong paintings in oil and delicate watercolours which bore his unmistakable stamp, while yet saluting tradition.

Diabetes had led to serious illness over a prolonged period and, eventually to amputation of both legs. It was while in hospital in Redruth, early in 2002, that Upton was visited by friends:

We arrived to find Michael in his hospital room surrounded by watercolours which formed a frieze around the walls. Bereft of any other subject he had painted and repainted the scene from his window – the dreary hospital grounds, the rooftops of the town, and the countryside beyond reaching towards a brighter horizon – all now pinned up in an orderly panorama. Though in pain and surely fearful of surviving the trauma of the operation, Michael worked with a zest and determination. He could not wait, he said, for someone in the adjacent room to get better, in order that he could move in and continue painting the scene 'just around the corner'.

Michael Upton died in September 2002.

DAPHNE MCCLURE

Daphne McClure was born in Helston, Cornwall and studied at Redruth Art School. She was later at Hornsey School of Art in London under John Platt and completed her training at the Central School of Art, also in London. For a time she worked at the Royal Opera House, Covent Garden, which she found a wonderful experience: 'It was here that my eyes became very aware of being able to carry and remember tones of colours; an invaluable asset, especially when one works from a studio.'

Daphne McClure in the studio, 2000

After twenty-five years away from Cornwall she returned in 1976 to live in Porthleven. Her paintings have almost all been derived from Cornwall with different series being based on such local sites as Hayle, Levant Mine and Penzance.

I go to my studio every day and the paintings have to be as 'right' as I can get them; that is the balance of form and colour. This is very important and difficult to achieve. My colour is, of course, a very personal mix; a schematic range of quirky greys to a boisterous exuberance of colours, especially as I have recently started a new series on field patterns and changed my palette.

She is a member of the Newlyn and Penwith Societies of Artists and regularly shows with these. In the past ten years her paintings have been shown in the exhibition 'A Century of Art in Cornwall 1889 –1999' in Truro and in a number of mixed exhibitions in London. Currently she shows her work with Thomson's and Cadogan Galleries, and Wilson Stephens Fine Art in London. On two occasions she has been a Critic's Choice prizewinner in the Newlyn Contemporaries Exhibitions.

DAPHNE McCLURE
'Levant Mine', 1996
mixed media, 40.5x35.5cm

DAPHNE McCLURE
'Rough Seas in June', 2000
mixed media, 51x40.5cm

5

THE PENWITH SOCIETY

In the years after the Second World War there was a new climate of optimism and creative activity. It was in such a mood that the Penwith Society was created and it was the artists that provided the energy and resourcefulness that was needed.

For three years the Crypt Group had kept the banner of modernism flying in St Ives. This small group of younger artists, who were members of the St Ives Society of Artists, had their work banished to the crypt of the Mariners Chapel, which lead to a separation between those who considered themselves to be *avant-garde* and those who were traditional. In February 1948 the more conservative members of the St Ives Society of Artists called a meeting at which they criticised the inclusion of the 'modernists' in their exhibitions. The result of this was the resignation of twenty-four artists, mostly from the 'modernist' group but including the Chairman, Leonard Fuller, and several committee members including Peter Lanyon. Three days later, at a meeting in the Castle Hotel St Ives, the Penwith Society of Artists was formed, with nineteen founder members. Leonard Fuller was elected Chairman and David Cox Secretary – the same positions that they had filled in the older Society. It was also agreed that the Penwith Society be founded as a tribute to Borlase Smart who had died a few months earlier and who was respected by artists of all persuasions.

The next few years were a struggle for the new group. The first exhibition was held in the St Ives Public Hall in Fore Street, rented from the Labour Party, from 18 June to 17 September 1949. By this time the number of members had grown and Herbert Read had accepted the title of President. Following the first exhibition a more permanent gallery was found at 18 Fore Street, in spacious rooms above the Castle Inn. Peter Lanyon was very active, acting as liaison officer with the press. There followed a multitude of stormy meetings, mainly centred around the balance between work in a traditional genre and that of a contemporary style. The minuted resolution was that 'The Society be a catholic one, wishing to present the best in all schools of thought'. In the following winter the discussions of 'representational' versus 'abstract' was resolved by creating a hanging committee to consist of three groups,'A representational, B abstract and C crafts'. This expedient caused much resentment and several resignations took place. At this time of its greatest success, Sven Berlin, Peter Lanyon, Isobel Heath and others resigned from the Penwith. Throughout the year arguments on the A and B rule continued, in which the case for abstraction was pressed by a determined front of Ben Nicholson, Barbara Hepworth and their supporters. The outcome was a turbulent tie, relieved by carnivals, parties and dances. For the moment the attention of members was redirected

Opposite page:
SHEILA OLINER
'Two Hats', 1997/98

oil on canvas, 76cmx76cm
private collection

to planning for the Festival of Britain, for which the Penwith Society produced no less than three exhibitions.

It was a climate of serious endeavour, the Penwith at that time was very strong and their shows were quite outstanding. St Ives had attracted a group of young artists who were determined and serious in their intention to pursue their work and to build on their shared experience. The gallery in Fore Street represented a longed-for opportunity to exhibit their work in a professional manner, and for it to be seen by the increasing number of collectors, critics and visiting artists who were becoming aware of St Ives as a centre of Modernism. For almost ten years the great barn-like gallery remained the Society's exhibition area, with exhibitions that became increasingly ambitious and distinguished.

By 1957, fearing that the lease of the Fore Street gallery was to be terminated, the members agreed to a proposal made by Barbara Hepworth that they take nearby premises on the ground floor of 36 Fore Street, although this was half the area with a higher rent. This lead to considerable criticism, when shortly afterwards Barbara Hepworth took over 18 Fore Street as a studio for herself. The turmoil over the 'traditional' versus 'modern' was finally concluded in 1959, when the A, B and C rule was simplified to three groups – painters, sculptors and craftsmen. By that time Ben Nicholson had left St Ives.

Some two years later the Penwith Society was forced to move again, as the lease on the gallery had ended and the property was sold. After much searching and exploration of various properties, the Society acquired its present premises in an old pilchard-packing factory in Back Road West, in the centre of Downalong, a conservation area. With financial help from the St Ives Borough Council, the County Council and from the Gulbenkian Foundation, the building was bought for £4300. This triangular space was originally an open yard with a surrounding roof carried on rough granite pillars. With the minimum of alterations this made a spacious light-filled viewing area, some sixty-five feet long, divided by the granite pillars into natural viewing areas. Above the gallery four studios were created. The Society moved in and on 23 September 1961 Sir Herbert Read officially opened the new Penwith Gallery.

John Crowther, the Truro architect, became Chairman in 1964. The complex was smartened up and further improvements were made. A sculpture court, entering from the gallery, was constructed and a small second gallery was provided. New lighting and heating were installed, the rough walls lined. A small exhibition area and a sculpture courtyard were created and the old pilchard-packing factory became one of the best fine art galleries in the country. It was a time of growth and of celebration. In 1967 Leonard Williams became Chairman and Kathy Watkins came as full-time curator. The following year Barbara Hepworth and Bernard Leach received the Freedom of the Borough of St Ives. The Penwith put on a major exhibition during the Arts Festival in which Hepworth, Leach and Ben Nicholson were exhibited in the gallery and in the Guildhall. The year 1968 saw the news of Sir Herbert Read's death; he had been a considerable friend to the gallery and President of the Penwith Society. Norman Reid, Director of the Tate Gallery, London, took his position.

In 1971 the premises next door to the gallery became available, and under the chairmanship of Marcus Brumwell, an old friend of Ben Nicholson and Barbara Hepworth, another group of buildings was acquired. This consisted of an open space, recently used for car parking, and a terrace of six cottages, over a large pilchard-packing factory (another). The St Ives architect H.C. Gilbert, converted this into a further gallery – ninety by thirty feet wide, with a series of niches along one side suitable for sculpture or pottery, supported by granite pillars. At the same time a 'permanent collection' was established, a loan selection of paintings, sculpture and pottery, which included work by many of the most prominent artists connected with the Penwith, past and present. The premises were opened on 10 April 1976.

However the creation of these splendid premises had lead to considerable expense. At this time the Society still had support from the Arts Council, but the cost of the new property was high. It was a precarious edifice that depended upon the influence and financial support of Barbara Hepworth. With her active help it was reasonably certain that substantial grants would be forthcoming from the various trusts and charities, and continued support from the Arts Council and other national bodies could be expected. But Barbara Hepworth died in 1975. With the sudden removal of her energy and direction, the members of the Penwith found themselves in considerable debt. After long, and at times difficult, negotiations with the Arts Council a grant was agreed for a further two-year period. This was on condition that the Penwith Galleries Limited take on the premises under its charitable status, and that a post of director be created, and also that the Society show a wider range of exhibitions created outside West Cornwall.

Hugh Scrutton was appointed as director in February 1977. He had previously been Director of the National Museum of Scotland, the Walker Art Gallery, Liverpool, and the Whitechapel Gallery, London, and an enhanced series of exhibitions were held. In a short space of time a number of emergency measures, including the sale of some of the cottage property, took place. The 'permanent' collection proved to be far from permanent, insurance costs were high and the collection was returned to artists and lenders.

It became known that the Penwith was in serious trouble and a press campaign was conducted by Patrick Heron and others, with such emotive headlines as 'Penwith in Peril' (The *Observer*, September 1977) and 'Crisis at St Ives' (*Guardian* 30 April 1977). Comparison was made between the Penwith and the Newlyn Gallery. As the Arts Council grant to Newlyn rose (it was almost £20 000 in 1977) the grant to the Penwith was severely reduced.

Matters came to a head in December 1980 when, during the Christmas period, it was announced that the Penwith was to lose the whole of its Arts Council grant. This was one of the cuts, which affected forty-two institutions in the country, made for reasons of economy. The two previous years, during which the Penwith had received Arts Council support, had been years of progress. The exhibition programme had included one-man exhibitions by such members and late members as Peter Lanyon, Terry Frost, Kenneth Martin, Alan Davie, Adrian Heath, Anthony Gross, Bernard Leach, Winifred Nicholson and Keith Vaughan. Special exhibitions were also arranged; for example 'Two

Impressionists – Father and Daughter' displayed for the first time together, the work of Norman and Alethea Garstin, whose works spanned a century of landscape painting centred on Cornwall. A retrospective exhibition of the work of the artist Alan Lowndes was held; he had lived mostly in St Ives from the early 1950s until his death in 1978. Peter Dietz, who became Director of the Galleries in April 1982, created a number of these exhibitions. He was a distinguished educationalist recently retired from control of army education services in Western Germany, and with wide interests in education and the arts.

The Arts Council decision to withdraw support turned a period of development into one of financial crisis. It was not possible to renew the contract of the director. However during this difficult period of retrenchment, the Galleries remained open and continued to show the work of members of the Penwith Society. A further *Portfolio of Prints* by members was published and a retrospective exhibition of work by the St Ives painter Borlase Smart was arranged, with the support and enthusiastic assistance of his daughter-in-law Martha Smart. This exhibition proved to be of the most successful and best attended for many years.

This response of the Penwith was not to search for alternative public funding but to continue on the basis of reduced expenditure. The curator, Kathleen Watkins, has carried the burden of running the gallery and she has been unstinting in her support for the members. Up to the present, the gallery has contained its debt and has continued to serve its members with a regular programme of exhibitions. The rear gallery has been used as a rented area for members' exhibitions. With it's complex of cottages, galleries and studios the Penwith remains an incomparable artistic resource.

At the time of writing the Penwith Society of Artists has forty-one full members. Those who are discussed here are only a small selection from this larger number.

BOB CROSSLEY (b.1912)

At the age of ninety Bob Crossley remains lean, tough and bearded. In earlier days he was something of a fitness freak, then it was cycle racing and pace bowling for the St Ives Cricket team (Terry Frost was captain). In later years it was skiing which took him to the Alps each year. He is planning a further skiing trip for the beginning of 2003.

Bob Crossley is a dedicated painter from the North of England who has made St Ives his home for more than forty years. He was born in Northwich in 1911, an industrial town where his father was an engine fitter, as was his grandfather and all uncles and cousins. Bob attended Heybrook Council School and the family lived near the cotton mill. He saw the General Strike and remembered the period when his father was without work and his mother had to work in the cotton mill. At the age of fourteen he left school and took various jobs while attending Rochdale School of Art for evening classes. He ended up working as a poster writer with a wish to become an illustrator, but events caught up with him. He was now married with his first child, a daughter, and with war threatening he was called up to the RAF. By this time he was the manager of his own sign business and studying

Bob Crossley

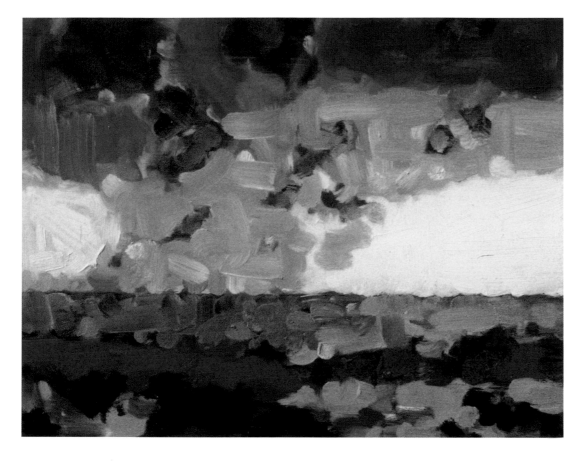

BOB CROSSLEY
'Landscape', *1989*

oil, 40.5x32cm

BOB CROSSLEY
'Landscape', *1991*

acrylic, 101.5x127cm

book and magazine illustration, but by 1941 he was training at Padgate in the RAF. During the war years he made a large number of portrait sketches and cartoons of colleagues in the RAF and also ran an art class in the education department. His first introduction to contemporary art was during leave in London, when in the National Gallery he saw work by the current war artists Edward Ardizzone, Paul Nash, Anthony Gross and others. Shortly afterwards he was in a field in Sicily attempting the same sort of thing. His drawing of General Montgomery at a thanksgiving service was made a short time later.

After demobilisation he re-established his sign business and became a part-time painter until the 1950s. He joined in with the very active art scene that was then in Manchester. He became a member of the Mid Day Studio Club where he met Margot Ingham and Ned Owen, and he came to know L.S. Lowry. He was invited to join the Manchester Academy and his first one-man exhibition was in Manchester in 1958 at the Crane Gallery run by André Kalman. At about this time he made a holiday visit to St Ives and, at Porthgwidden Beach, he noticed builders at work on a corner shop

and cottage. He discovered that this property was for sale and after much hesitation he decided to run it as a seasonal shop selling confectionary, ice cream, buckets and spades. To his surprise it was quite successful, it brought him in a reasonable income and he was able to have a studio above. One of the first artists that he met in St Ives was Terry Frost, who lived nearby, and who suggested that Bob join the Penwith Society, which was then in Fore Street.

Bob's first London exhibition took place in 1960 at the Reid Gallery, the same gallery that showed the work of L.S. Lowry who bought one of the paintings from the exhibition. Bob now had eight months of the year in which to paint and, being a naturally swift painter, his work began to grow. The move to St Ives brought many changes in his paintings. Always expressive and colourful, they took on a new scale and fluidity, and drew increasingly toward a powerful form of mark making. The succession of figure studies and abstracted heads, gave way to large-scale landscape studies. He would start each picture in the same way, random colours brushed on to the canvas without plan, followed by a pause to contemplate the result. When an image appeared, perhaps a memory of something seen, he would pursue it in paint, until completion.

For some years in the 1960s he lived in Wimbledon and then in Putney whilst retaining the shop in St Ives. He had further exhibitions at the Reid Gallery in 1964 and 1966, and at the Curwen Gallery in 1972. He also exhibited in Spain. He began a series of experiments with silkscreen printing using both dense and transparent colour in rectangular and overlapping areas. He found that the optical mix of colour produced a new sense of space, and he followed the same line of enquiry in small acrylic paintings.

He eventually returned to live in St Ives and took No.7 Porthmeor Studios. In this larger space he was able to increase the scale of his work and the small acrylic paintings became the model for further exploration. His attitude towards painting had not changed; he continued to work freely, each paint layer swiftly applied in fluid broad gestures using opaque or translucent paint. For several years he has worked with acrylic paint which gives him great freedom to change the shape or size of the image at will. His work has gradually moved towards landscape subjects, and colour plays a more important role. His large acrylic paintings were shown at the Penwith Gallery in 1979 and in a one-man exhibition at the Bristol Art Centre in 1980. His last solo exhibition was a retrospective exhibition at the Penwith Gallery in 1987.

BRYAN PEARCE (b.1929)

Bryan Pearce has painted the town he was born in, St Ives, in magnificent detail. He paints the harbour and the boats which he can see from his flat overlooking Porthmeor Beach, he paints the St Ives School of Painting that he attended for three years as a student or the interior of the church of St Ia where he worships each Sunday. Each house, each stone is given its own special character. If houses are laid out around the edge of the painting, those at the bottom may be painted upside down and they form an integral part of the design. His eye selects what is central to his knowledge of familiar places. He may use the style of an early mapmaker or the decorative method of an ancient wall

Bryan Pearce in his studio

painting. Buildings may have the flattened perspective of Roman mosaics; Ravenna and Siena are brought to St Ives to celebrate the little town.

Peter Lanyon said of him, 'It is necessary to accept these works as the labour of a man who has to communicate this way, because there is no other' (Catalogue to the exhibition at the Wills Lane Gallery, April 1977). Pearce paints what is before him, his methods are simple. Out of doors he will make a fine line drawing on a prepared board and then in the studio it is more clearly defined with a firm pencil. He goes over each line again, outlining it in yellow ochre if it is stonework and green if there are trees, it must be all outlined before colour is applied carefully, from a limited palette.

In 1953 Bryan Pearce attended the St Ives School of Painting in Back Road West, which was then under the direction of its founder Leonard Fuller. There was an understanding that he should be left undisturbed to take part in such activities as he chose, which for Bryan mostly meant painting from still-life groups. At times he would paint out of doors in the streets of St Ives with other students from the School. The opportunity to concentrate his attention on drawing and painting was an important first step for him. He was able to continue his professional career by becoming an Associate Member of the Penwith Society, due to the generous support of the Chairman, Denis Mitchell, a sculptor, who

BRYAN PEARCE
'St Ives Harbour All Round With New Lifeboat House', *1994*
oil on board, 56x71cm

BRYAN PEARCE
'Newlyn All Round With Six Boats', *2000*
conté drawing, 44.5x62cm

was especially helpful to those, who like himself, had no formal art training. In October 1957 Bryan exhibited his work for the first time in the Penwith Gallery. The correspondent of the *St Ives Echo* commented, 'One genuine primitive is showing – Bryan Pearce...' The description of primitive has been a burden that he has had to bear, other tags have been folk artist or child artist, all of them a long way from the truth. Bryan Pearce chooses his own subjects and paints them in his own manner. It has been said that other painters, Matisse for example, influence him, but he does not know Matisse. There is no influence here, but there is a shared talent, for Pearce can place shape and colour with an authority that can be Matisse-like.

Bryan Pearce was born in St Ives in July 1929. His father was a butcher and his grandfather had been Mayor of St Ives. He is inarticulate and illiterate, yet his paintings have a remarkable confidence. It was not until 1963 that Bryan's mother Mary was prepared to divulge the medical condition that her son had suffered from, this was a rare congenital condition phenylketonuria, which had retarded Bryan's mental development. At the time of his childhood the condition had not been recognised and could not be treated. From the age of ten to sixteen he was away from home at a special school and it was confirmed by several medical practitioners that he was incapable of living a normal life.

It was his mother Mary who sheltered and guided him through the years in which he grew to manhood, and who suggested that he paint. She was a talented painter of portraits and still-life and she created her own studio in the house in Market Place, St Ives, above the butcher's shop run by her husband. She continued to show her own paintings up to the early 1960s at the Penwith Galleries and in Newlyn. By 1963 however it was clear that Bryan's work was attracting public attention. He was regularly included in exhibitions and his paintings were finding buyers. Mary Pearce put her own career aside in order to act as his manager and mentor. In this she had help from two St Ives artists Shearer Armstrong and Misomé Peile, both founder members of the Penwith Society. With their assistance, from 1959 onwards Bryan Pearce had had an impressive number of one-man exhibitions starting with the Newlyn Gallery in 1959 and followed by exhibitions at the New Art Centre in London in 1966, 1968, 1971 and 1973. He has had regular showings at the Wills Lane Gallery, St Ives, and has taken part in many group exhibitions. In 1962 he was a subject of a television programme 'View' which showed him at work, with a commentary by the Cornish poet, Charles Causley.

In 1967 the family moved from Market Place, St Ives to a Piazza flat overlooking Porthmeor Beach, which gave him the spectacle of St Ives Bay and a new range of subjects. His mother died at the age of 91 in 1997, but with help from a dedicated group of carers he has been able to continue painting. A retrospective exhibition of his work took place at the Royal Cornwall Museum and Art Gallery in Truro in 2000. For this last exhibition, Janet Axten, who also organises his artistic life, produced a major book *Bryan Pearce – The Artist and His Work*.

There is a clear sense of delight in Bryan Pearce's work, everything conforms to a perfect idea, the sea is usually clear and blue, untroubled by waves or wind. The waterside buildings and quays are firmly placed and composed of granite blocks, constructed as he knows them to be, as with a child's building set. He paints simply, directly, the size of a building is altered to fit the picture surface and a

BRYAN PEARCE
'Wild Flowers in a Glass', *1997*

conté drawing, 32x24cm

more important building may be enlarged. Surfaces are seen in a flat, even light, a dozen bricks might indicate a wall. There is no attempt at light or shade, everything is seen in a clear cool light.

JOHN EMANUEL (b.1930)

John Emanuel is a St Ives painter whose feeling for paint is related to his earlier training as a painter and decorator, a tradition more often seen in Europe than in England, and most nobly demonstrated by Georges Braque, whose father was a painter and decorator, and who used his father's tools and skills of commercial decoration in his own work.

John sees painting as an extension of living. The figure and the figure in landscape are his chosen subjects and over the last twenty years he has done a great deal of life drawing both in charcoal and pen, ink and gouache. He finds that the one-to-one relationship with his subject, usually an art student earning money for materials, gives meaning to the drawing. In working from the figure he searches for what he calls the 'classical' form for the work, looking for simplicity within the figure and a clear contour. He is very aware of the relationship between the figure and its backgrounds, usually a simple horizon dividing sky and sea.

His workshop is one of the barn-like Porthmeor studios, intensely lit from the long windows that overlook Porthmeor beach. His working area is a mine of paintings in various stages of completion, stacks of half-finished pictures, mountains of paper. In preparing a painting he usually works first on a hand-made paper; drawing with thin wiry lines into a white gesso ground with charcoal. Then the paper will be mounted on board and the painting will be built up in a series of glazes, giving depth to the dark-toned colours. He deliberately does not take the painting to a conclusion at this stage; he prefers the unfinished work to remain in the studio for some time, perhaps years, before it is completed, as the painting grows with his knowledge of it.

John Emanuel was born in Bury Lancashire in 1930. The family moved to Barrow-in-Furness when he was nine and he went on to the Barrow Technical College. He had no formal art training but music played an important part in his earlier life. As a young man, he and two friends were invited to join the local operatic society. He much enjoyed the musical experience and later joined a madrigal society and a male voice choir. Then National Service came along and that was the end of his singing phase. But he had already met people with artistic interests and, around 1957, he joined the Barrow Artists Society. An early memory is attending a lecture on Cézanne, which moved him considerably. Another is meeting Harry Thubron, the charismatic artist, then teaching at Leeds School of Art. On an outdoor expedition to the Lake District, Thubron picked up a clod of earth and indicating the background of hills, he said 'don't look at that, always look at the particular'.

Emanuel's facility with paint developed when he served an apprenticeship as a decorator and sign-writer, and he began to draw and paint in his own time. In 1963, with a friend from the North of England, he came down to St Ives on a visit; not because he knew it was connected with artists, but because his friend believed that there were the most fabulous parties.

John Emanuel in his Porthmeor studio, 1998
photo: Emma Brown

JOHN EMANUEL
'Figure and Skyline – Porthmeor', 2000
paper on board, 66x127cm
photo: Ron Sutherland

In 1964 John and his wife Judith decided to move to Cornwall, and they lived just outside St Ives, in Nancledra and later in Halsetown. For many years, first working with a builder and then with a sign writer, he gained a basic income which gave him time to pursue his painting. For the first ten years he painted during the evenings and at weekends in a room in his house, but in the late 1970s he was able to acquire a Penwith Studio for £2 a week. After the break-up of his marriage in the early 1980s, he moved into St Ives and made a new start in which painting had a central place. At the same time he was able to take over a Porthmeor studio which had once belonged to the sculptor John Milne.

During these years he made close friendships with many artists who have affected the way he has thought about painting, the first being the St Ives artist Dick Gilbert. Perhaps of greatest importance was the late John Wells, with whom he spent a lot of time, although he did not want to follow him into the path of Constructivism. He had great respect too for both the sculptor Denis Mitchell and the painter Alex Mackenzie, and in recent years he came to know Patrick Heron well and they had many talks about the meaning of drawing. He found Heron's chapter on distortion in the *'Changing Forms of Art'* (1955) tied in with his earlier thoughts on Cézanne.

The person who gave him the most practical help was Patrick Hughes, who for a few years was working in one of the large Porthmeor Studios. Hughes was very supportive and became a catalyst among the artists – he made things happen. In particular he created gallery and exhibition opportunities in London. It was at this time that John started to show regularly with Bernice Sandleson at the Montpelier Studios, in Knightsbridge.

Now, with Janet Axten since 1985, John has worked out his own economy, showing both in London and provincial galleries, as well as in in St Ives itself. For many years he has been a member of the Penwith Society of Artists and the Newlyn Society of Artists, taking on the role of Chairman of the Newlyn Society for twelve months in the early 1980s.

Opposite page:
JOHN EMANUEL
'Headland Figure – The Gurnard's Head',
1999
paper on board, 97x97cm
photo: Ron Sutherland

Roy Conn

ROY CONN (b.1931)

Roy Conn was born in London in 1931. His early training was in structural engineering but by his mid-twenties he was painting seriously and he was aware of the developments that were happening in British abstract art. He showed with the London Group in common with Victor Pasmore, Kenneth and Mary Martin, and others. In the 1950s he was painting large abstract paintings and exhibited in several of the John Moore's exhibitions in Liverpool.

When he came to St Ives in 1959 he already knew the work of many of the artists there and this affected the direction of his own work. Shortly after his arrival he was elected as a member of the Penwith Society of Artists and in 1963 he was able to take on No.1 Porthmeor Studios, an historic studio originally owned by Borlase Smart and later occupied by Wilhelmina Barns-Graham.

Roy Conn has consistently followed his own direction in abstract painting. The paintings are large, and somewhat severe; they are about space and colour. They are mostly composed of large elliptical shapes contrasting with solid areas of strong colour. They have a simplicity and purity about them and, to that extent, they might be described as classical. In the 1960s his work had simple descriptive titles

ROY CONN
'White Hill'. *1992*
oil on canvas, 66x91.5cm

such as 'Black and Green', then, as they became more complex, paintings such as 'Cone of Silence' and 'Pinnacle' combined more three-dimensional forms with flat areas of colour. A recent title is 'Blue Ellipse' in which colour plays an even more important part.

He has been very much part of the St Ives community and a supporter of the Penwith Society. He also had a short period of teaching at Falmouth School of Art. He has had one-man exhibitions at the Rowan Gallery in London and the Arnolfini Gallery in Bristol. In the forty years that he has been in St Ives he has seen many changes, he witnessed the upsurge of enthusiasm in the 1960s and the withdrawal of interest that occurred in the 1970s. He welcomes the considerable revival of recent years but he feels there are too many people working in St Ives.

Roy Conn in the studio

MARGO MAECKELBERGHE (b.1932)

In his seminal book *Britain's Art Colony by the Sea* the talented writer and champion of Cornwall, Denys val Baker, wrote of the artists who lived and worked in West Cornwall. He explained that the reasons for their presence were complex:

> it is a mixture of material and mystical, facts and fantasies, all equally important. The climate, the brilliant light the almost Mediterranean blue of the sea, fascinating formations of rocks and cliffs, hills and valleys, sand and pebbled shores.

The features that he describes are those which are evident in the paintings of Margo Maeckelberghe and it is significant that in later books such as *The Timeless Land* and *The Creative Spirit of Cornwall*, Denys val Baker chose paintings by Margo Maeckelberghe for their covers.

It is this intimacy of experience with the landscape of Cornwall that gives Margo her subject. She was born in Penzance, née Try, and brought up there. Her first training was at the Penzance Art School, then directed by the draughtsman and engraver Bouverie Hoyton, with John Tunnard and Bernard Leach as teachers. After this she was offered places both at the Slade School, London, and the Bath Academy of Art, then at Corsham Court. It is said that she appalled Bouverie Hoyton by choosing to go to Corsham, but in fact the choice was well founded, for there she found herself working under William Scott, who was Head of Painting, and with Peter Lanyon, Bryan Wynter, Kenneth Armitage as teachers.

She was offered an extra year at Bath Academy of Art as studio assistant to William Scott, which was a singular honour. It allowed her to paint with him and belong to his small select class of students. William Scott encouraged her to appreciate supreme simplicity – a small frying pan could look so satisfying. She also did sculpture under Kenneth Armitage and created two remarkable life-sized bulls in welded metal, inspired by Goya's drawings of fighting bulls. These were much admired.

A great deal has been said about the close links between Corsham and St Ives, and Margo Maeckelberghe had the experience of both, with the benefit of close acquaintance with the leading

Margo Maeckelberghe, 2002

artists of St Ives. After Corsham she taught art in London for two years and in 1954 she married a Belgian doctor, Willy Maeckelberghe, who was later commissioned in the Royal Army Medical Corps and was posted to Gibraltar for two years. This was a decisive period for her painting, although she was married and had a child, she never stopped painting, she found time and a resident maid helped. The rugged landscape appealed to her and when she returned she began to see Cornwall with different eyes. Gibraltar also gave her the opportunity paint in Spain, Portugal, North Africa, Italy and Greece, usually travelling overland with a small child in the back of the car. These journeys had a strong effect on her work, changing and lightening her palette tremendously.

Margo and Willy returned to Cornwall, to a fine William and Mary house outside Penzance, with a distant view of Mount's Bay, which is where she now has her studio. Her work was soon seen as making an important contribution among those younger artists advancing the reputation of the Penwith Society of Artists and the Newlyn Society of Artists. John Wells and Barbara Hepworth encouraged her to join the Penwith Society of Artists in 1960.

She is proud of her Cornish heritage, she writes:

Artists are drawn to Cornwall, partly because of this clear crystal light. It gives everything a new meaning, the form and structure of the landscape is defined and enlarged by it. The landscape itself is very interesting, but the light does something to it. I have painted abroad a good deal but have not found this matching brilliance in the light except in the Peleponese area of Greece and in India. Then, of course, there is this timeless and magical quality about Cornwall. Through my painting I have come to understand that landscape is not only a visual experience but also something we live and work above and below, an Ancient Land. The most important thing to me is the mysterious 'x' an artist must feel about a place in order to paint it.

She described her subjects as 'Skies, light, atmosphere, the shimmering of pale bleached grasses, surging, half seen rocks, mist, rain, storm and sun on moor and headland, weight, water and pull of tide'. (Catalogue of her exhibition at Lanegan Fine Art, London, 1990). She has found these in Cornwall, particularly the rocks and beaches of West Penwith and the rocky spine of the peninsula. She has however a special affection for the Scilly Isles and the structure of that more skeletal rounded coast has been the basis of many of her finest paintings.

She draws boldly in paint and emphasises the solid forms of nature, the rocks, hills and declivities of landscape. She is also sensitive to the more intangible features that shape the landscape, the tide and flow of water, the penetrating force of wind and the glow of atmospheric colour. The sea plays an important part in the shaping of the Cornish landscape and is never far from her work. The light she depicts has a particular quality; it is seldom bright sun, more usually late in the day when shadows are beginning to form, yet the land retains the colour of daylight. The paintings often have an autumnal feel and a visionary quality. Colour dominates, blue and sea greens, yellow for gorse and khaki, ochres and grey for moorland landscapes. She has taken this romantic content further through paintings that specifically link landscape with the human figure. One such series of paintings

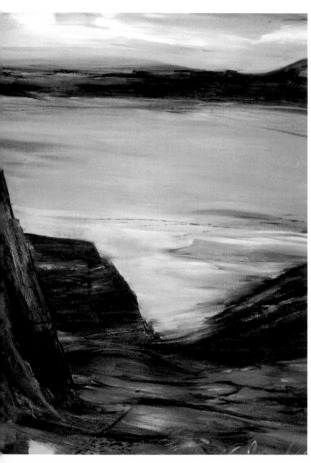

MARGO MAECKELBERGHE
'Sea Bound', *1994*

oil, 102x76cm

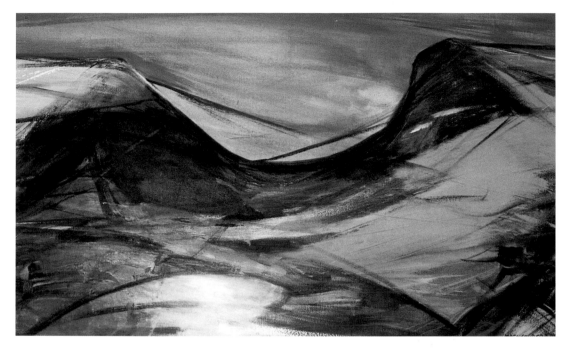

MARGO MAECKELBERGHE
'Atlanta Reclining', 1970
oil, 102x61cm

called 'Atlanta', was made over a long period. The story is derived from Celtic mythology in which the kingdom of the King of Atlantis was engulfed by a tidal wave. His daughter was rescued by a dolphin and taken to the far shore of Cornwall. Here the gods took pity on her and turned her into part of the Celtic landscape where she can still be seen, in the thrusting headlands, rocky cliffs and coves – the female land and the male sea – a constant embrace and encroachment between the two.

Forty years ago she and her husband bought Bryan Wynter's cottage and studio at Carn, perched high up above Zennor on the North Coast. It has unparalleled views of endless moors and sky, and vistas of the North and South Costs which proved a great inspiration for her and played a very important part in many of her paintings. She carries a sketchbook with her and draws and sketches in situ and makes detailed notes, which she then works up in the studio. That is where the painting takes over and often, despite all she has done beforehand, the composition moves in a totally different direction to the one she originally anticipated

She has exhibited her work widely, in Cornwall, in London and other parts of the British Isles, Europe, and the USA with solo exhibitions almost every year from 1960 onwards. In addition to her paintings she has given a great deal of her time to Cornwall in a variety of ways. She is currently Chairman of the Penwith Society of Artists, she was previously a member of the BBC Advisory Council for the South West, and in 1997 she was elected a Cornish Bard for her contribution to the arts in Cornwall.

MARGO MAECKELBERGHE
'Kernow Gold', 1998
oil, 76x61cm

101

Roy Walker.

courtesy: Marion Whybrow

ROY WALKER (1936–2002)

Roy Walker was an articulate artist who was always prepared to engage in discussion and analysis of his own work. He described the paintings that he was doing in the 1980s, following his exhibition in the United States and an eight-week visit to Manhattan:

The art has become much freer and saturated with colour. I work intuitively, allowing my hand to resurrect distilled memories of things seen, silly machines, rusting farm implements, birds, suns and moons and probably some bits of that disgusting factory, trying to get them to cohabit the same space. I have introduced all kinds of bits and pieces into the work, old envelopes, paper scraps, almost anything that has been discarded, to perhaps precipitate new revelations and transcend their uselessness. (exhibition at the Salthouse Gallery, St Ives, 1987)

These 'silly' machines were shown at the Penwith Gallery, St Ives, in October 1986. Inspired by a 1930s cigarette card he produced a bizarre, toy-like wall hanging entitled *'Autogyro'*. It was a large brightly coloured construction in shiny red aluminium, spattered with paint, with a goggle-eyed pilot suspended within it.

ROY WALKER
'Disused Quarry, Lamorna', 1972

etching, 55x42cm

Roy Walker was fascinated by the more ridiculous aspects of modern technology, what he described as 'the madness of the machine'. However these crazy constructions are in contrast to the bulk of his work. His reputation is based on skilful printmaking, most particularly large scale and complex etchings, and the brightly coloured collages that he has made over many years.

Roy Walker was born in Kent and started at Gravesend School of Art from the age of fifteen. After three years in the RAF he was managing to paint fairly consistently and enrolled at the Central School of Art in London as a part-time student. The 'disgusting factory' that he refers to as the worst period of his life, was three years as a production worker on the line at Ford in Dagenham. Shortly after that, and now married, he moved to St Ives and, to his surprise, the first paintings that he found himself doing were a series of images of factory workers and factory-scapes. He was able to take a Porthmeor Studio and became a member of the Penwith Society of Artists and his work was beginning to find success. He took part in a group exhibition at the Marlborough Gallery, London, the Victoria and Albert Museum bought his prints, and the BBC made a film about a year in his life which was screened on television in 1975.

In the following year he was the chief driving force in starting the Penwith Print Workshop, which became a facility for many of the St Ives artists.

An important aspect of Roy Walker's character was his involvement with people in St Ives, both artists and members of the public. This lead him to take part in a number of art events, but not always with great success. One of these was 'A Quality of Light', held at the Tate Gallery, St Ives and in other centres, as part of the Penwith International Festival in 1997. Roy had designed and built a sculpture 'Sky Light I', constructed from square sheets of tin and placed on the Island to act as reflectors of the sky. It was intended to be viewed from the roof-top café of the Tate. Unfortunately there were local objections to this site-specific piece and litigation was threatened. Another piece, entitled 'Sky Light II' was placed in the Trewyn sub-tropical gardens, close to the Barbara Hepworth Museum. It lasted only nine hours before being totally wrecked by vandals.

Roy was undeterred by these setbacks and continued to act as an important liaison between the artists of St Ives and the Tate Gallery until his early death at the age of sixty-six in 2002.

ROY WALKER
'Neglected Greenhouse', *c.1972*
etching, 49x35cm

SHEILA OLINER

Sheila Oliner is best known as a printmaker. There is an oriental quality to her work, reflected in the fact that five of her solo exhibitions have taken place in Japan. Her connection with Japanese art has had considerable influence on her work. Her paintings and her prints show the free flowing line, clearly stated silhouette and the decorative arrangement of figure and ground. Her favoured medium is oil paint on canvas but she also works in the more delicate media of watercolour, and she enjoys the soft range of colour that these produce. Etching and woodblock printing have also been shown in her Japanese exhibitions.

Sheila Oliner in her Penwith studio, 2001

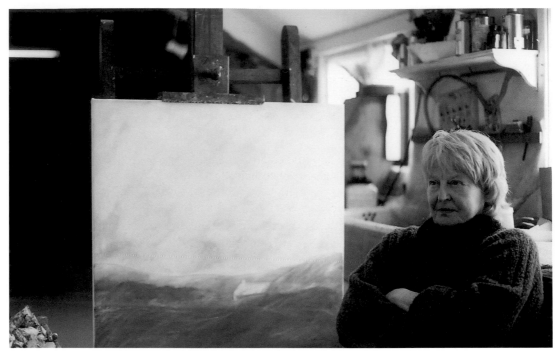

SHEILA OLINER
'Moments That Have Passed II', *1997*

oil on canvas, 76cmx76cm.
Private collection

Sheila Oliner was born and brought up in London. Her art education was at the City and Guilds Schools and at the Slade School during the last part of Randolph Schwarbe's Professorship. For many years she lived in Hampstead and became a prolific exhibitor in London and elsewhere. After painting for some years she became interested in printmaking and studied with Dorothea White of Studio Prints. Subsequently she had fifteen solo exhibitions of her work. Her prints were toured by the Arts Council and exhibited on a number of occasions in the Royal Academy.

For some years the landscape around Zennor has come into her work. Currently she is working on a large group of oils based on this area, which she thinks of as attempting to convey time and place. She has also produced etchings and woodblock prints on a similar theme.

In St Ives in 1990 she was one of a small group of artists who formed the Porthmeor Printmakers; others included Stephen Dove, John Emanuel and Roy Ray. By working together in one of the Penwith Studios, they were able to provide the equipment needed for a professional print workshop. They were also able to offer a service to other artists interested in printmaking, and to arrange printmaking courses in mono-printing, intaglio and etching. They have produced three fund-raising portfolios of prints, plus several collections for sale in the Penwith Galleries. These have proved to be most popular and their sales have helped the Penwith. They have also given financial support to the education room at the Tate St Ives.

STEVE DOVE (b.1949)

Steve Dove's painting is inspired by the figure and by landscape, but it is essentially work that is constructed in the studio. He works very largely on paper, with a strong swinging line and boldly blocked areas of tone. Colour is set within these dark areas, often producing contrasts of stained-glass intensity. Increasingly the work is more abstract, recognisable elements have been replaced by a moving system of line and shape, providing the sensation of movement as in water over rocks, or the progress of a figure through a landscape. Shapes are strongly contrasted, positive and negative, which give them a three-dimensional feeling. These are essentially formal paintings.

Stephen Dove was born in Leicester in 1949 and studied art at the Lanchester Polytechnic, Coventry, and Hull College of Art and later at the Birmingham Polytechnic. In 1976 he moved to Cornwall and lived in Zennor, in rooms in The Poorhouse, a handsome Edwardian villa overlooking Zennor, owned by Patrick Heron. At that time the house was occupied by Alethea Garstin (1894–1978) the daughter and pupil of the Newlyn artist Norman Garstin (1855–1926). In her long painting life she had travelled to many colourful parts of the world, painting in Morocco, the West Indies and elsewhere. Her paintings of exotic subjects have a 'fauve' intensity of colour, and the patchwork of

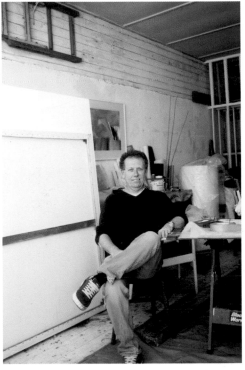

Steve Dove

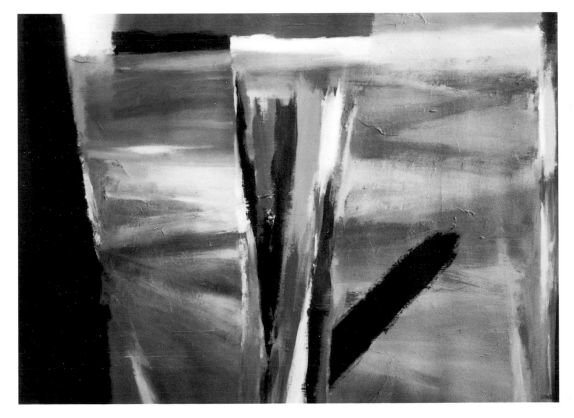

STEVE DOVE
'Near and Far – Porthmeor', 1996
acrylic on paper, 56x76cm
Private collection

light, which lead Patrick Heron to describe her as 'England's leading impressionist painter'. When Steve got to know her she was then an old lady and he remembers taking tea with her each Friday afternoon.

For much of his painting life Steve Dove has worked in that area between realism and abstraction. He mostly uses the recognisable forms of the still-life and less frequently the figure, but these are arranged and displayed upon the flat canvas in that limited space used by the cubists, essentially that of Georges Braque. His use of black and other strongly contrasted colours echo that preference. There is strong tonal separation of the elements, but very little modelling. Occasionally in a still-life he will introduce the real description of fruit, jar or foliage, to form a harmonious part of the whole group.

Steve Dove has exhibited frequently in the West of England. In 1980 he was given a South West Arts Award and a major exhibition of his work at the Plymouth Art Centre. In an exhibition at the Salthouse Gallery in 1981 Patrick Hughes, then resident in St Ives, wrote 'it is a marvellous moment in Dove's development that we are at, where all the visual modes are working together, both harmoniously and in energetic contradiction'. (Patrick Hughes, June 1981). Hughes is referring to the range of representation that Steve Dove uses in each picture. The colours of fruit and fish are displayed tonally, but there are occasions when plant forms and shadows are given equal prominence and became abstract designs in which colour plays a major part. The white of the paper or canvas is often allowed to remain, helping to set off tone against tone, colour against colour, bringing the eye back to the flat surface.

These different visual modes may be related to different areas of Steve Dove's development. When he first came to Cornwall he became a friend of Patrick Heron. Heron had been a prominent champion of Braque's paintings and wrote of Braques exhibition at the Tate Gallery in 1946 as 'a new development of an immensely powerful art'. By 1969 his views had moved to the central importance of colour, he wrote, 'Colour is both the subject and the means; the form, and the content, the image and the meaning in my painting today...'. (Patrick Heron 'A Note on My Painting' catalogue to the exhibition at the Leinhard Gallery, Zurich January 1963). This influence is not specific, Heron and Dove are very different artists, but broadly there has been this direction in Dove's work.

Steve Dove is something of an intellectual; that is no criticism, he makes intelligent paintings and he is very alert to the elements of colour, shape and spatial division in his painting. He is aware of the bridge on which he travels, spanning abstraction and representation. He says:

The subject matter of certain paintings may remain quite obvious whilst with others it is only alluded to. The human form and the landscape are sources that may be referred to directly or else merely hinted at. Because of this varying degree of definition, I would hope to place a greater attention to the formal qualities of the work; the paint itself, colour, tone, shape and space; and with these real and physical properties, convey my vision and feelings as a painter.

For Steve Dove these positive and single-minded views are balanced by his teaching, initially at the St Ives School of Painting where he taught life drawing, and currently at the Richard Lander School in Truro. He finds that in some direct way he is able to give back his own ideas to his students.

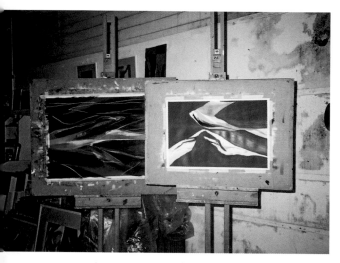

Steve Dove, work in progress

Opposite page:
STEVE DOVE
'Aquatic Light', 1999
acrylic on paper, 56x76cm
David Tovey

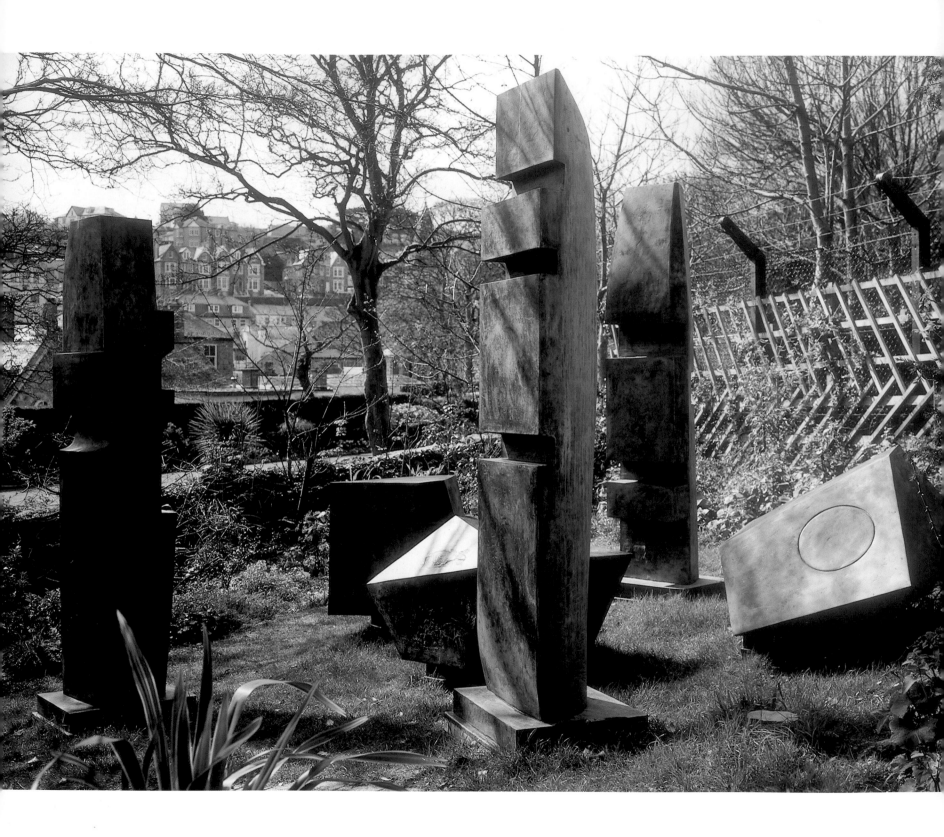

6

TWO AND THREE DIMENSIONS

BARBARA HEPWORTH AND THE TREWYN STUDIO

In Cornwall Barbara Hepworth found a way of working that satisfied her feeling for perfection of form, fine finish, proportion and scale. Yet her sculpture also had a savageness, an energy that crossed centuries, an ancient quality found in the un-worked stones and wind-eroded rocks. Sculpture is a journey to the centre of the block of stone or wood, to discover a form. It requires the strength to shape the block and the finest of judgement to know when to stop, craftsmanship of the highest order. Hepworth drew on the sources of the twentieth century. She was much affected by her early astonished visits to the crowded studios of Brancusi and Arp, by her long association with Henry Moore, and by the spiritual journey that she shared with Naum Gabo; but the life within the work, that transforms the chiselled block into an object of contemplation, is all her own.

Barbara Hepworth was born in 1903 in Wakefield. Her father was Chief Surveyor to the West Riding of Yorkshire, road management was his chief responsibility. At Leeds School of Art, which she entered in 1920, drawing was her main study, sculpture was limited to modelling, carving was taught as a craft subject and was not considered as part of Fine Art training. She then went to The Royal College of Art in London. At this time it was a small and backward-looking institution, still at an early state of change from a teacher training school to an advanced art school, but even here, carving was a marginal study.

In 1924 she competed for the Rome Prize in Sculpture but was unsuccessful, the two year scholarship went to the sculptor John Skeaping. However Hepworth was awarded a West Riding Scholarship and chose to go to Rome. It was here that she came to know John Skeaping well and they were married in May 1925. His skills and enthusiasm for carving in stone and wood were transmitted to Hepworth, reinforced by the skills gained from the Italian craftsmen. On their return to England the couple lived at various addresses in St Johns Wood and found friends and clients among the museum-based connoisseurs and scholars of the British Museum and the Victoria and Albert Museum. In 1928 Barbara and John Skeaping found a studio in Belsize Park, London, one of a block called 'The Mall Studios'.

In 1931 Barbara formed a relationship with the painter Ben Nicholson and they became part of a small group of progressive artists affected by the European art movements. They both identified with the European *avant-garde* and they showed their work in a number of important international exhibitions

Barbara Hepworth
Photo: Louis Stanley

Opposite page:
BARBARA HEPWORTH
'Conversation With Magic Stones', *1973*
Bronze
Barbara Hepworth Museum and
Sculpture Garden, St Ives.
Courtesy the Tate Gallery, St Ives.

alongside such artists as Calder, Miro, Gabo, Giacometti and Mondrian. Within a small but dedicated circle of artists and writers living in and around Parkhill Road, Hampstead, Nicholson and Hepworth felt themselves to be part of a new and optimistic future. As Hepworth remembered: 'Suddenly England seemed alive, and rich – the centre of an international movement in architecture and art. We all seemed to be carried on the crest of this robust and inspiring wave of imagination and creative energy ...' From 1932 onwards Ben Nicholson and Barbara Hepworth pursued parallel paths that lead towards total abstraction. In October 1934 triplets were born to Barbara and Ben.

The decision to come to Cornwall was made against the background of impending war. Following the Munich Agreement it was clear that war was inevitable. In London there was much talk of the evacuation of children. As Barbara Hepworth records: 'a glass-roofed studio in London was no place for them'. Adrian Stokes, a long time friend of the Nicholsons, had recently purchased a fine house in Carbis Bay, a short distance along the coast from St Ives, and suggested that this would give shelter to the Nicholson family. Barbara was opposed to the move, nevertheless the decision was finally made in the last days of August 1939. After the long journey by car the family arrived on 25 August, with three very weary children, together with a nanny and a cook, in pouring rain. They were to remain as guests of Adrian Stokes and his wife Margaret Mellis for four months. There was a feeling of

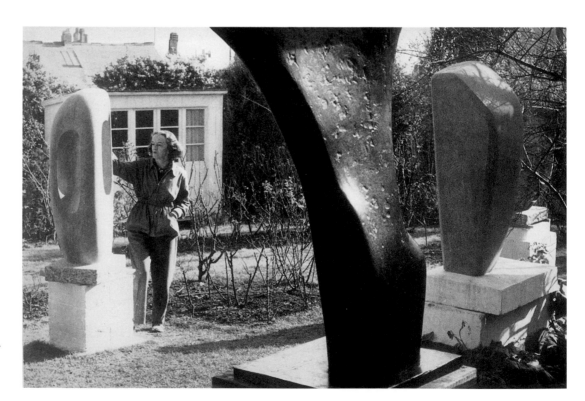

Barbara Hepworth in her garden at Trewyn, c.1958.

author's collection

finality about this departure from London. Hepworth wrote: 'The last person we saw in August was Mondrian and we begged him to come with us in our battered old car (which we bought for £17) so that we could look after him. But he would not.' (*Pictorial Biography* p.41).

In spite of all of the practical difficulties of leaving home and friends and of finding herself in unfamiliar surroundings , Hepworth still placed her work at the forefront of her mind. She wrote: 'At the most difficult moment of this period, I did the maquette for the first sculpture with colour, and when I took the children to Cornwall, five days before war was declared, I took the maquette with me, also my hammer and a minimum of stone-carving tools.' (*Barbara Hepworth, Carvings and Drawings* introduction by Herbert Read, London 1952). At the end of December 1939, Hepworth, Nicholson and the children moved from 'Little Park Owles' to a nearby house, 'Dunluce' in Carbis Bay.

The war years were difficult, and, in common with others, the Nicholsons shared the times of privation. Barbara's days were taken up with running a nursery school and 'double cropping a tiny garden for food'. In the evening she drew, forming ideas for sculpture which refined and developed the pieces that she had worked on in London a few months before, but which she did not have the facilities to realise. Her drawings were of crystalline forms, geometric and regular, within a simple outline, converging lines explore the inner form. As soon as carving became a possibility she began to explore the internal space of the block by carving deeply into it and using threads to emphasise the inner tensions. Crystalline geometry gives way to more organic shapes, reminiscent of pebbles, shells, seed pods, containers.

By 1943 the family had moved again, this time to a large and shabby old house in Carbis Bay, rough but roomy for a growing family '... our work began to flow again... inspired by the view from the house in Carbis Bay, the ocean captured by the arms of land to left and right.' Her sculpture had a precise relationship to the coastal environment of wave, cliff and cloud and a remarkable response to materials. She wrote of this period, between 1940 and 1943:

> It was during this time that I discovered the remarkable pagan landscape which lies between St Ives, Penzance and Lands End; developing all my ideas about the relationship of the human figure in landscape... and the essential quality of light in relation to sculpture, which induced a new way of piercing the forms to contain colour.'

The geometric abstraction of the pre-war years was replaced by a renewed interest in the human figure. In carvings of wood and stone, these were formal pillars, subtly contoured, in which the upright figure is suggested rather than stated. She made many direct drawing of the figure. In 1947, returning to an earlier theme, she began using ballet dancers as models, allowing them to move freely about the studio and drawing swiftly on panels previously prepared with gesso, searching for a line of movement or a contour. In spite of wartime restrictions, Hepworth continued to exhibit her work, in 1943 with Paul Nash at Temple Newsome, Leeds, and in the following year in her home town, Wakefield. She had exhibitions in London in 1946 and 1948 with Alex, Reid and Lefevre, and in New York with Durlacher Bros in 1949.

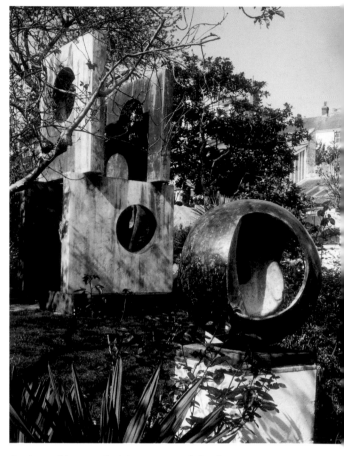

Barbara Hepworth Museum and Sculpture Garden, St Ives.

Tate St Ives.

Barbara Hepworth at Trewyn Studio
Courtesy Dr Roger Slack

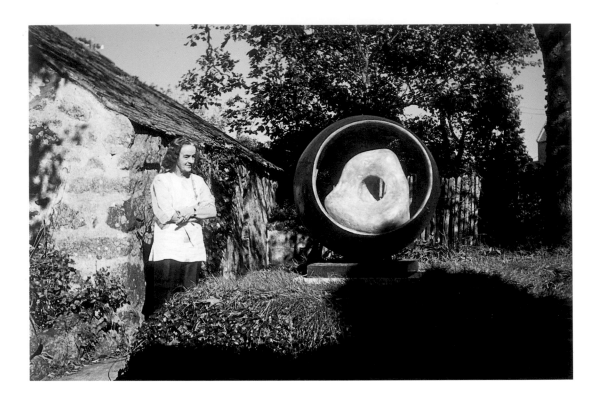

In 1949 she found Trewyn studio with its workshops and garden. This small house was to have the most creative effect upon Hepworth's work and upon the town of St Ives. The property was in the centre of St Ives, a short distance from the Market Place and the Paris Church of St Ia. It had originally formed part of a large estate, laid out in the eighteenth century by a local solicitor and mine-owner called James Halse. The mansion that he built, Halse's Court, became a local landmark, surrounded by fields that descended toward the harbour. At the end of the nineteenth century, now in the possession of the Trewella family, it was given the name 'Trewyn' meaning 'the fair place' or 'place of innocence'.

In the early years of the twentieth century, as part of extensive alterations, a high retaining wall and a small house were erected at the bottom of the estate. It was this that became Barbara Hepworth's house and studio. The house was simple. It consisted of a large room on the ground floor, which became a combined living and bedroom, and an equally large room above, used as an indoor studio. The greatest attraction was the large walled garden with workshops – a private world at the centre of the busy small town. The garden gave her the opportunity to work out of doors and to display her largest sculpture. Great care was taken over a planting scheme which served as background to the sculpture, designed and planted with help from her friend, the composer and amateur gardener, Priaulx Rainier.

However the cycle of creative activity between two equally driven artists put great strain on their marriage. By 1949 Hepworth and Nicholson were living apart. In February 1951, after twenty years of family life, they divorced.

During the 1950s Hepworth consolidated her international career. In 1950 her work occupied a major position in the British Pavilion at the Venice Biennale, exhibiting with John Constable and Matthew Smith. Two major sculptures were commissioned for the Festival of Britain in 1951. In the same year she created a stage set for Michael St Denis' production of 'Electra' at the Old Vic and in the following year her work found an even larger public audience for her sculpture with the film 'Figure in a Landscape' produced by Dudley Shaw Ashton for BBC Television. Drawings of the figure continued to be a central discipline during these years. Towards the end of 1952 she showed her work at the Lefevre Gallery – thirty drawings and paintings and fifteen sculptures. Many of the drawings, made in the evenings after a full day's work in the carving studio, were of the model Lisa, with her mane of dark brown hair.

In the New Year's Honours List of 1958, Barbara Hepworth was created Commander of the Order of the British Empire, and in September 1959 she was awarded the Grand Prix at the International Biennale Exhibition at Sao Paulo, Brazil, on the basis of sculptures and drawings executed over the previous twenty years. From her studio in St Ives, large casts and carvings were regularly dispatched to exhibitions and galleries all over the world. A major retrospective exhibition of Hepworth's work took place at the Whitechapel Art Gallery in 1962. This exhibition, which had enormous popular success, set a final seal of approval on Hepworth's career, if more were needed.

Barbara Hepworth died in a fire in her studio in 1975. Throughout her long years of creative endeavour she continued to be refreshed by the experience of Cornwall.

The interior of the Hepworth Museum, Trewyn Studio

Courtesy Dr Roger Slack

THE TREWYN STUDIO

From her purchase in August 1949 of Trewyn studio it became a place of continuous activity. At last Barbara Hepworth had the space and the workshop accommodation to work on a large scale, and she felt immediately that it was a place to pursue her ideas. She said, 'The atmosphere was so ideal that I started a new carving the morning after I moved in – in spite of the difficulties of the move's involving six tons of tools and materials of all kinds.'

Hepworth had long wished to work on a large scale, but for many years circumstances had prevented this. She wrote in 1969 to Ben Nicholson:

You never liked arrogant sculpture or fierce forms – but I do. I have deliberately studied the photos of my early dreams of large works done in 1938–39 in maquette form... it has taken 25 years to find the space, time, and money, and meanwhile those dreams have matured and so have my abilities.'

Trewyn studio allowed these dreams to be realised and when she started to work in bronze from 1956 onwards, she was able to provide large-scale work for public sites. The studio and garden of Trewyn were of first importance in creating the work and showing it to potential clients.

Hepworth was highly aware of her position as an abstract artist at the forefront of modernism and at the same time a woman artist. She had a strong sense of direction. She felt that her work carried an important social message – a spiritual link between the artist and society. One of her largest and most important commissions was made at Trewyn very soon after her arrival. In June 1949 Hepworth had been invited by the Arts Council to produce a large sculpture for the Festival of Britain. In expressing to Philip James, Director of the Arts , pleasure in the invitation to work for the Festival of Britain, she said:

We have all worked 25 years breaking new ground and fighting battles for both architecture and the arts – and to associate ourselves together on a Festival job is the first natural flowering of our generation. The natural reward for 25 years fight! (Arts Council of Great Britain, 15 December 1949).

There are many photographs of Hepworth in her Trewyn garden at work on the Festival sculptures 'Contrapuntal Forms'. She is pictured high on scaffolding or illuminated by floodlight. There are very few, however, in which her assistants appear, for with the improved accommodation of Trewyn, and the opportunity to work on a monumental scale, assistants were a necessity. The first of these was Denis Mitchell, who had worked with her in Carbis Bay.

DENIS MITCHELL (1912–1993)

In the early days Barbara Hepworth would employ help for a few days at a time to prepare for exhibitions. Peter Lanyon and John Wells both worked in this way. At Trewyn Studio many of the younger artists helped with the heavier work, roughing out blocks of stone and wood to Hepworth's specifications, and with the multitude of physically demanding tasks that are an everyday part of the sculptor's workshop. Terry Frost spent several months in the studio and assisted in the carving of the large, two-piece Festival sculpture 'Contrapuntal Forms'. Later assistants included Roger Leigh, John Milne, Keith Leonard and Brian Wall, all of whom were to establish their own reputations as sculptors. The one who worked for Barbara Hepworth for the longest period – eleven years – and who later went on to make his own contribution as an artist was Denis Mitchell.

Mitchell began to work for Barbara Hepworth in 1949 and became her chief assistant. At first he worked with her on the same piece, following her design and assisting with all the stages of carving and finishing. In later years he became an extension of her hands, able to translate her intentions exactly, but still under her continuous scrutiny and working to her exacting requirements. He remembers the close attention she always gave to the work:

Barbara had a fantastic eye for purity of forms. Time was no object to her until she was absolutely satisfied with the final shape. It was from this I learned that even on a very large-scale carving, less than a hair's breadth rubbed off with emery paper could alter the whole sculpture.

Denis Mitchell
Courtesy: Dr Roger Slack

Denis Mitchell's work at The Studio,
Newlyn, 1983
author's collection

Denis Mitchell, 1983.
author's collection

From the experience of working with Barbara he acquired the ability to work and concentrate on his own sculpture for eight hours a day 'a rare achievement'.

Denis Mitchell had grown up in Swansea. His parents had parted early in his life. His father, who booked variety acts for the music hall, left the family home at Wealdstone, Middlesex, shortly after Denis' birth in 1912. His mother took her daughter and two sons, Denis and Endell, the elder by six years, to live with her brother in Mumbles, South Wales. The Mitchell boys came to Cornwall in 1930. An aunt had bought a derelict cottage about two miles from St Ives; the brothers offered to complete its repair, and stayed on to earn a living, growing vegetables and flowers and keeping a few chickens on the land.

Part of the fascination of St Ives was its reputation as an artists' colony. Denis had always longed to be an artist, but it was not easy for a young man who had first to find a living. He began to paint landscapes, but he did not regard himself as a professional artist, and did not exhibit before the war. In 1939, still trying to find time for his painting, Denis Mitchell married a local girl, Jane Stevens of St Ives. Instead of the army he took the option of working in the mines, for it enabled him to keep the market garden and even to employ some help. He was a face worker for two and a half years in the tin mine at Geevor, near St Just, where lodes run deep under the sea. The comradeship of mining and the

DENIS MITCHELL
'Thrust II', *1992*

bronze, 123.2x28.5x21cm

Photo: Adrian Flowers

physical satisfaction of working underground brought a wealth of experience that he later translated into his sculpture. For a time he also ran a small fishing boat for mackerel in the inshore waters around St Ives.

In 1949, when he was working regularly for Barbara Hepworth, he and his wife Jane and their three young daughters moved into St Ives. Denis Mitchell began to work as an independent sculptor at this time, carving in wood in his little lean-to studio in the evenings. The forms he used in sculpture were abstract, although his paintings had almost all been representational. He admits the influence of Hepworth, but as his work developed from carving in wood to small bronzes he began to find his own range of form

His working repertoire is seen in his sketchbooks and drawings – the oval standing form, flattened and pierced; abstracted flying forms of fish or bird, or those shapes associated with man-made implements; the handle of a well-used tool or a shaped bridle piece. He uses engineered shapes derived from screws, spiral, hook, ratchet and holed block, and forms suggestive of the tools and lifting gear used in the sculptor's workshop, or the blocks and tackle of a sailing boat. His chief enjoyment is in carving, where his inventive ability to work as a craftsman comes fully into play; deeply cut shapes of wood reminiscent of the female form, or laminations of slate with incised drawing.

When he started to work in bronze he could not afford to have his work cast by the traditional lost wax process. He used instead a simpler method of casting which requires much finishing by hand. The discipline of polishing and texturing the rough cast gave each sculpture its own unique purity. His most typical sculpture is a vertical polished bronze, tall and spiky with a dull, ribbed open centre.

Denis Mitchell was a founder member of the Penwith Society and its Chairman from 1955 to 1957, at a time when the members were beginning to earn international respect and attention for their work. He exhibited in all of the early Penwith Society exhibitions and in the three innovative exhibitions arranged by Adrian Heath in Fitzroy Street, London, in 1951, 1952 and 1953. His first one-man exhibition was at the AIA (Artists International Association) Galleries in London in 1959, and his first major success came with a one-man exhibition at the Waddington Galleries in 1961, followed by exhibitions in the United States in 1962 and 1963. Since then his work has been shown regularly in London and in travelling exhibitions abroad.

PAUL MOUNT (b.1922)

There are two important influences in Paul Mount's work which have shaped his approach to sculpture. The first is a strong interest in architecture, which developed from his work as a design consultant. The second is a deep knowledge of African art, which he came to know well during the decisive seven years he spent in Nigeria. His work has an animated presence. The standing figure, in abstract form is an important feature, often in the form of a pillar built up from a series of related shapes.

He is essentially a constructor with a natural tendency to build with component pieces. This method of working has allowed him to make pieces of great size, large enough to cover the face of a building.

For such commissions he has usually designed a small number of modular pieces that can be arranged in different ways, to provide changing relationships. There is something of the mathematician in these elegant and formal permutations.

Paul Mount is a Devonshire man, born in 1922 in Newton Abbot and educated there. His initial training at Paignton School of Art was followed by two years training as a painter at the Royal College of Art, during its wartime evacuation in Ambleside. He particularly remembers Percy Horton who taught him drawing at the College. In the later years of the war, as a conscientious objector, he served in the Friends Ambulance Unit as a driver to the second French Armoured Division. At the end of the war he was able to return to the Royal College of Art, to continue with his training, for a further two years.

From 1948 to 1955 he was a lecturer at Winchester School of Art. Then he went to Nigeria where he started and directed the art department in Yaba College of Technology. He made a considerable reputation in West Africa as a design consultant, working with architects, Fry Drew Atkinson, and in England with John Crowther and Sir Frederick Gibberd. The first major sculpture he designed was a screen twenty-four metres long in cast concrete, constructed by a team of his students, for what later

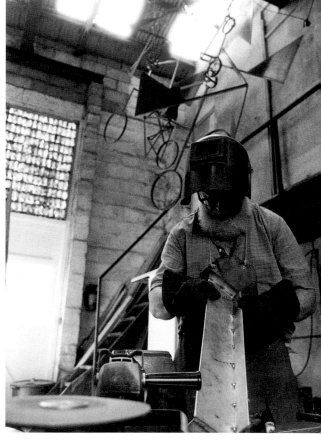

Paul Mount, August 1987
Mobile 'Gymnopedie' is in the background

PAUL MOUNT
'Wall Sculpture', 2000
corten steel, 205cm wide

117

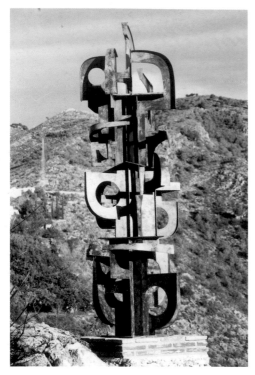

PAUL MOUNT
'Il Commendatore', 1997.

welded bronze, 310cm.

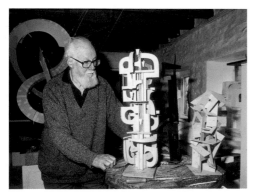

Cardboard model for 'Il Commendatore'.

Photo: Simon Cook

became the Swiss Embassy in Ikoyi, Nigeria. There were many other large and complex pieces of sculpture, usually commissioned for buildings and with a strong African quality. At this time he was working in close collaboration with African sculptors and craftsmen, some of whom were his students.

In 1962 he returned to England. It was a search for studio accommodation that brought him to Cornwall. He found a small building on the edge of St Just-in-Penwith. He has extended it over the years to form a complex of workshops and studios, shared with his wife, the painter June Miles. Since that time his work has been shown widely in London and elsewhere, most particularly at the New Art Centre, London, and Roche Court, the Beaux Art Gallery in London and Bath, and the Penwith Gallery, St Ives. He has also exhibited in art fairs in London, Chicago, Madrid and Basle.

Paul Mount works in a variety of materials but his preferences are for the most intractable, iron and stainless steel. In the studio the work is first constructed in simple materials such as polystyrene, which can easily be cut, glued and assembled in complex shapes. Other materials such as wax and plaster can be similarly used to build up models for casting. This maquette is then set in a container of fine damp sand and molten metal is poured into it. The heat of the metal, which fills the space left, burns out the polystyrene. It is a process similar to the traditional lost wax method of sculpture. After the cast has been made the heavy work begins. The rough casting in iron or bronze requires a great deal of finishing and patination. Most of the work of cutting the steel, welding and finishing is done entirely by himself.

A further form of construction, which he has used most recently, is to fabricate models in cardboard, simple shapes, curved or rectilinear, glued or taped together. These are then taken apart to form patterns from which a metalworker, Michael Werbicki, will cut the shapes in stainless steel sheet and the seams will be welded. With modern technology, if required each shape can be enlarged proportionately, so a cardboard model of, say, one metre high can become a finished sculpture of three metres or more. Paul Mount insists on a high finish in his work, and there is the laborious work of finishing and polishing the final piece.

Although totally abstract, Paul Mount's work has musical associations: 'Saraband', 'Allegro' or 'Rhapsody', have the feeling of a dancing figures. Others are more robust. Strongly assertive pieces such as 'Il Commendatore' and 'el Conjurador', set on a Spanish hillside, have a watchful presence. The hammer-like forms of cast iron and bronze penetrate and encircle one another. Other pieces, made of stainless steel, have a suppressed violence in the spiky shape of trident or the blunt curve of an axe head. The bulky roughened forms of cast iron might relate to the wind-eroded granite rocks in the hills behind St Just, where he lives. The spiky needle-like shapes may be seen in the thorny growth of the hillsides.

A natural extension of these solid pieces has been his use of the mobile, a major feature in Mount's work since the mid-1970s. This usually takes the form of a single rod upon which curved shapes spin. One spinning shape may serve as a fulcrum for others and become animated in the finely wrought stainless steel.

PETER WARD (b.1932)

Peter Ward is a practical man, a sculptor who was first trained in industry as a pattern maker. This rigorous apprenticeship gave him the skills to visualise complex mechanical parts, and to make them in three dimensions, a necessary step between the designer's first idea and the final working machine. It is equally important for the sculptor to give form to an idea and to have the craftsmanship to make it. Peter Ward is able to make use of his earlier, hard-won, skills and to adapt them to the more imaginative world of the artist.

Peter Ward was born in London, and went to school in Walton-on-Thames. At the age of fourteen he left school and his father persuaded him into taking an apprenticeship at the Vickers Armstrong aircraft factory, at Brooklands in Surrey, where his father also worked as an engineer. Because he was so young, Peter was a shop boy for two years, followed by a further five years learning to be a pattern maker. The aircraft industry was then moving from wartime production into civil aviation, and he worked on the various aircraft then being produced, the Vikings, the Valettas the Viscounts. In these early years he was also painting and exhibiting locally.

For a time he worked for a printing firm in Surrey and attended part-time classes at Kingston School of Art. Looking to advance his artistic career, in 1962 he came to St Ives, initially for a fortnight's holiday. One of the older St Ives artists, Elena Gaputyte, helped Peter and his wife Lesley and their

PETER WARD
'Towards a Freedom', *1985.*

oil on canvas board, 75cmx55cm

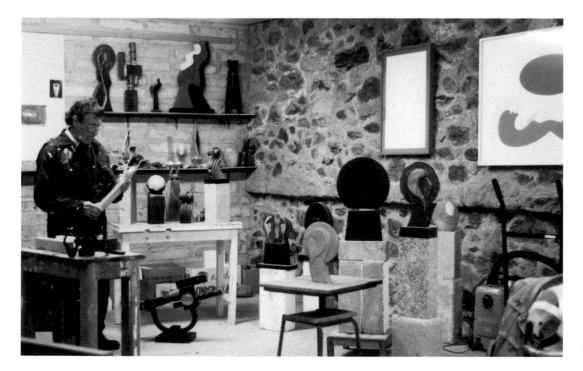

Peter Ward's sculpture workshop, 1999.

119

PETER WARD
'Wave Forms', 1992.
aluminium maquette, 40cm high

two children, to find accommodation and for six months they lived in a caravan at Nancledra, and later moved to St Ives. It was the older artists that he found most helpful, Denis Mitchell was a friend and a constant source of help, as were Terry Frost and latterly Paul Mount.

After this initial visit he returned to Surrey to take a teaching post at Farnham School of Art, where his technical expertise was most useful. By 1983, at the age of fifty, Peter was able to take an early retirement and he and his wife decided to return to St Ives. He was fortunate in acquiring studio space in the Penwith Gallery complex. He has two studios; one is on the ground floor, which he uses as a metal workshop and the other, for lighter materials and drawings, on the upper floor. In the 1980s the Penwith Society was going through a difficult time but Peter Ward found that working beside the galleries re-introduced him to the artists of St Ives and provided a venue for his work.

For the first years after his return Peter Ward mainly produced paintings, which gradually became simpler and more certain, the colour stronger. He remained close to the forms of landscape, the coast and buildings of St Ives, much simplified. Even less tied to appearances are paintings such as 'Freedom, No 1' 1985, where the forms of boat and waves are reduced to intersecting curved lines, framing primary colours. This is abstraction, but the elements of landscape shine through. In the late 1980s Peter Ward moved from painting to sculpture, although for a time these went in parallel.

He had resisted working as a sculptor as he thought this took him back to his engineering training, however he soon discovered that his ability to make patterns in three dimensions was his greatest strength and he began to use these skills in his work.

His sculpture is more emblematic, more formal than his paintings; he works with elemental subjects, the forms of waves or winds, translated into granite and bronze. His early training gave him the ability to see a set of lines as a three-dimensional image and he starts by making profile drawings. It is here that his craftsman's skill unites with a poetic imagination, to give form to the transient movement of wind and water. Much of his present work is that of a constructivist, strong, solid forms cut from sheet or cast metal. Sometimes the forms are more refined and made from curved laminates in wood, cellulosed and worked to a high finish.

Peter Ward is very much part of the current St Ives scene. Since he returned there in 1983 he has exhibited regularly in the Penwith Gallery exhibitions, the New Craftsman Gallery and other St Ives venues.

BREON O'CASEY (b.1928)

Breon O'Casey considers himself primarily to be a painter but he has worked in many other art forms: jewellery, weaving, printmaking and sculpture, and all at the highest level. He believes that in each medium the artists build prisons for themselves from which they cannot escape, but moving to another medium frees the artist and makes it possible to do things that they could not do previously. Not being over-fond of teaching he endeavoured to earn his living as a jeweller, and was eventually

very successful in this. He also tried his hand at weaving and this too came quite easily to him, and for some years he divided his time between gold, wool and paint. His paintings remain the storehouse of ideas that feeds his other work.

His home is a farmhouse below Penzance, close to the sea. A grassed and enclosed garden and granite farm buildings, provide him with three studios for painting, sculpture, and jewellery. He moves between these skills in a highly satisfactory way and his ideas follow the rhythms of his house and home, spare and simple, the three large, crowded workshops contain work in production, work of the past and many ideas for the future. Each is piled with the materials of the various crafts and the tools and equipment required. Breon prefers to work in something of a mess because he believes from this confusion ideas flow.

Breon O'Casey was born in London in 1928. His father, the playwright Sean O'Casey had recently left Ireland for London where his play 'Juno and the Paycock' was in production. On the day that Breon was born came the news that the Abbey Theatre did not want to put on his next play 'Silver Tassie' in Dublin; this affected the family's decision to remain in London. Breon's mother, also Irish, had rebelled against her convent background and she became a chorus girl, who in those days were fêted like models. She had a wide circle of wealthy friends and, as a child, Breon would be taken to stay in castles and grand homes and introduced to Lord this and Lady that. But it was a literary rather than a theatrical world in which Breon was brought up. Shaw was a particular friend of his father, as

Breon O'Casey

BREON O'CASEY
'Theatre', 2002.
acrylic on paper, 38x56cm

121

Breon O'Casey's jewellery workshop

were other Irish writers including Joyce and the painter Augustus John. John painted two portraits of Sean O'Casey. It was a close family of two boys and a girl. Sadly his younger brother died at the age of twenty, an event that shattered his parents. Although Sean O'Casey always intended to return to Ireland he did so only briefly. Another ambition was to move to America, but the war prevented this.

On Bernard Shaw's recommendation the children went to Dartington Hall School, then considered very progressive. As his parents did not want the children to board, the family moved from London to Totnes, in Devon. This was wartime and the junior school was occupied by American troops, it was small and crowded, with an ad hoc group of teachers who could be spared from war service. Dartington had many connections with Cornwall, Bernard Leach had his pottery there, and Breon remembers his first meeting with Barbara Hepworth whose children were at the school. The young O'Casey was up a tree at the time and Barbara looked at him rather coolly and said 'Haven't you anything better to do?' a question that seemed to him rather foolish, but was too polite to say so.

On leaving school Breon was required to join the army as a national serviceman, which he considered to be a waste of two years. For most of the time he was part of a small Royal Artillery battery guarding a deserted D-Day camp outside Rugby, mainly to keep the squatters out. By 1950 he was able to start his art training and chose to go to the Anglo-French Art School in St Johns Wood, London, run by Alfred Rozelair Green, a French artist who came to London to open a school on French lines. Breon admired the painting that was going on in France and thought that this small school was near to his own interests. However the school closed whilst he was still a student and although offered a place at the Slade School, he preferred to work privately in London.

Breon was attracted to Cornwall after seeing a BBC television programme (probably '*Monitor*' – he is not sure) about St Ives, which included a piece on Alfred Wallis and other St Ives' artists. He cannot date his first visit but he can clearly remember seeing Peter Lanyon driving down Fish Street with a passenger that he recognised as the American artist Mark Rothko. This would put the year as 1958, when Rothko spent a week in St Ives, staying with Peter Lanyon.

For Breon being an artist was a natural thing to do and in St Ives he found the company of people similar to himself who intended to make their living from their artistic work. At that time he was aware of the antagonism felt towards 'modern' art and of the time wasted in defending his position. St Ives provided safety in numbers. He obtained one of the old Piazza Studios (now replaced by apartments), below that of the painter Michael Broido. Breon was then beginning to make jewellery and was looking for fittings and it was Broido who introduced him to Denis Mitchell, who was also a jeweller. Their first meeting went well and Breon said half joking on leaving, 'If you ever want an assistant I'm your man'. Denis said, 'I might just take you up on that,' and he did.

Breon O'Casey is naturally sociable; he enjoys conversation and was soon drawn into the Penwith Society of Artists, which was then going through one of its many periods of dispute. At his first meeting he remembers a barrage of criticism from the floor, and number of resignations taking place. He was there and then asked to become vice-chairman and was immediately plunged into the politics of St Ives.

Breon has produced a considerable body of work as a weaver. He was introduced to weaving from a textile factory built beside Dartington School in Devon. Here the lengths of tweed were stretched out of doors on racks, placed in an orchard of cider-apple trees. He associates woven textiles with the Ireland he never saw. He remembers from early days his mother's love of Irish tweeds and with affectionate memory his own jackets that he had made.

His own rugs are woven vertically on the simplest of looms, in the Navajo style, he considers them as paintings and must see the whole of the growing panel, rather than the few inches which disappear into the drum of a horizontal loom. Weaving has its own laws, for example the bird is a symbol he uses frequently in his painting, but he insists it is not the same bird that he would use in a woven rug. If you do a bird in a rug its got to be done in the way weaving makes you do it.

As a painter his subject is still-life, he does not feel that he can handle the landscape, it's too complex. He looks for simplicity, as he once said, 'Not a wood, not a tree, not a branch but a leaf.' He is conscious that if you look carefully at objects, you find a symmetry that can become a pattern. In that sense by painting a leaf you could paint a forest. In his painting and in his prints he uses a repertoire of simple forms, rectangles, dots, semi-circles and sharp triangles. Most recently a stylised bird flies through a forest of spots or across a series of simple shapes. They refer to landscape and still-life by analogy, held together by skill and craftsmanship. The colour of earth or sand often forms the background and holds the sharper shapes of Indian red, blue and ochre yellow

His jewellery has the same unexpected quality as his painting, built on balance, refinement of shape, and the use of formal elements. But it is not painting on a miniature scale. In a heavy necklace each bead has its unique character and becomes part of the whole identity of the piece. Jewellery was a way into sculpture for Breon O'Casey and he has now ceased to make it. On his seventieth birthday he gave himself the present of 'no more jewellery'. It had served him well for thirty years as a means to produce an income, and sculpture has now replaced this.

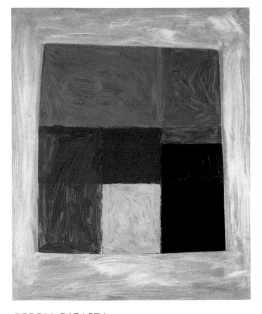

BREON O'CASEY
'Red Centre', 2002.

Relief acrylic on board, 38x30.5cm

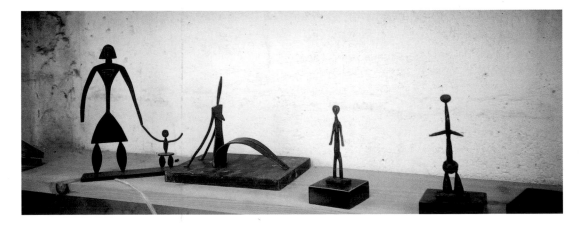

BREON O''CASEY
A corner of the sculpture studio

author's collection

Breon O'Casey with a bronze, 2001

Breon O'Casey worked first as an assistant for Denis Mitchell and then for three years for Barbara Hepworth, mostly cleaning off bronzes from the foundry and giving them a finished surface. He enjoyed working with sculptors and liked the slow rhythm of three-dimensional work and found that this was repeated in the jewellery. Much of his sculpture is very small, only a few inches high. But all of it has recognisable characteristics, mostly human, sometimes animal. They are much more representational than anything that appears in the paintings. In three dimensions Breon cannot help making objects that look like something, they obey the laws of ethnic sculpture, the forms are simplified, and the stance usually symmetrical and highly stylised. A sense of self-identity animates these small figures, the flattened heads, and the emphasis on breasts and genitals. Often the small sculptures are worked in precious metals and they take on an even greater wizardry, images of some ancient cult. He has recently gone beyond these small pieces to larger, more complex sculpture approaching life-size, built in wax and carved, shaped and scraped, before being cast in bronze.

For the sake of a label Breon O'Casey would call himself an abstract artist but he does not really think in those terms. He is not a theorist about art. If he feels the need to pick from an idea from an artist or a period he is quite free to do so. Nor is he doctrinaire in relation to abstract art. He would agree with Kokoschka that all art is abstract. Abstract versus realism is not an issue for him; he deals with the shapes and colours.

However he acknowledges that abstract art seems to be harder for people, though its antecedents are just as respectable, and go back even further. He quotes his friend and artist Tony O'Malley:

> *How can one judge the good from the bad? Rigid rules are very quickly self imposed by the artist; but how does the viewer know what these rules are, and if he doesn't, how can he judge the work? The answer is succinct. It is as difficult for a poet to define a poem as it is for a terrier to define a rat – but he knows one when he sees it.*

JOHN MILNE (1931–1978)

John Milne was an early assistant to Barbara Hepworth, but in a tragically short life, he survived her by only three years. He was born in Eccles, Lancashire in 1931, the youngest of six children. He was educated at the local council school and then went to the Salford Royal Technical College to study electrical engineering, but after a year he persuaded his father to allow him to transfer to the School of Art. He was still a student when, in 1951, he met Cosmo Rodewald, Professor of Classical History at Manchester University. This was the start of a long friendship from which Milne derived many of his early enthusiasms for the antiquities of Greece.

Opposite page:
John Milne with 'Wave Turning', 1976.

Milne began as a working sculptor in the Eccles area and in 1952 he gained a bursary to Paris, working at the Académie de la Grande Chaumière under Emmanuel Auricoste. It was in Paris that he was drawn to the nineteenth century classical sculptures of Rodin and Maillol and the masters of the twentieth century such as Laurens and Brancusi. His first visit to Greece came at about this time and he explored numerous classical sites and the museums at Athens and Delphi.

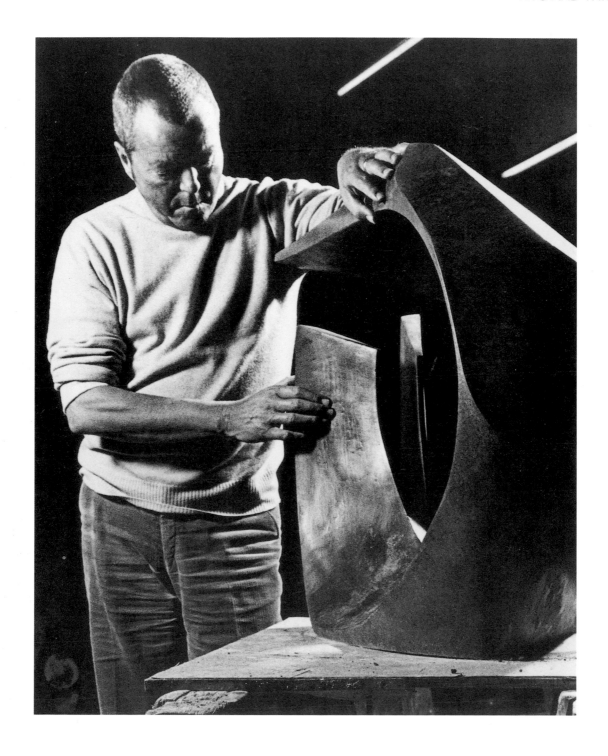

He was still only 21 years old when, in the winter of 1952 he returned to England as an assistant to Barbara Hepworth, working alongside her on direct carving in wood and stone. For several years he rented studios in St Ives. His period of apprenticeship with Hepworth lasted two years, and he was an early member of the Penwith Society of Artists.

In St Ives in the 1950s many property changes were taking place and the ownership of the Trewella estate came up for sale. Part of the old estate was bought by the Town Council to provide a public garden, which joined Richmond Place to Bedford Road. In 1957 Professor Cosmo Rodewald bought the old mansion that had been home to the Trewella family, for the use of John Milne. This was adjacent to the Barbara Hepworth studio, Trewyn, and Milne had a house, studio and workshops in many ways similar to Hepworth's own.

For Milne the next years were a time of intensive work making sculpture in a variety of media, bronze, aluminium and fibreglass. It was also a period of considerable travel abroad. Milne travelled extensively and it was landscape, particularly the landscape of exotic lands, in which he found his inspiration, and which he translated into sculpture. In 1967 he was in Morocco and from there he explored the Sahara Desert and the Atlas Mountains, and in 1971 he travelled across Persia.

In 1970 he had a major one-man exhibition at Plymouth City Art Gallery and he won the sculpture prize in the Westward TV Open Art Exhibition. From her gallery in London, Marjory Parr gave him unfailing encouragement and exhibited impressive groups of his work, bronzes, carvings, drawings and reliefs, which had the commanding style that was his own. Throughout the 1970s he exhibited widely in St Ives and London, and with travelling exhibitions arranged by the Arts Council of Great Britain.

He died suddenly and prematurely in June 1978 at his studio in St Ives. He was at the height of his powers and with an extending reputation and in the process of preparing a second large-scale exhibition for America later in the year.

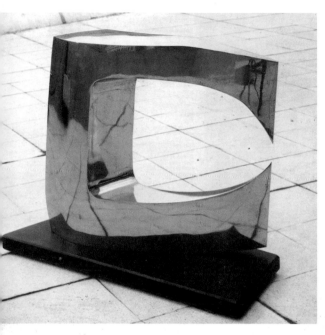

JOHN MILNE
'Gnalthas', 1966.
polished bronze
Tate Gallery

DAVID KEMP (b.1945)

It is not only humour, satire and nostalgia for out-dated technology that drives David Kemp. His work contains a powerful social message and a feeling for the past. From the relics of heavy industry he remembers the men and women that created the machines that transformed the world. It is for this that he scours rubbish dumps and industrial sites looking for cast-offs, and re-constructs demons, gods and goddesses out of rusting machine parts.

David Kemp has lived in Cornwall for thirty years on the exposed western coast between Zennor and Cape Cornwall, an area in which great beauty exists alongside the industrial remains of the tin mining, which had been carried out in this part of the county since medieval times. His working method is to take pieces from the past; fragments rejected or abandoned and give them new life as objects of wonder. He says:

David Kemp with 'The Old Transformers Iron Master', *1989.*

I make things out of things, big things, little things, old things and new things. I like to recycle things, and find new uses for things that have been thrown away. Some things say something about their surroundings, and other things become something else. (Artist's statement January 2002).

The junk in the yard behind his studio has been collected for its visual possibilities and over a period of time it is transformed, by the alchemy of sculpture, into the semblance of a creature, a machine, or a god, and in this process it is given life. Since 1980 when his exhibition 'Public Hanging' was shown at the Penwith Gallery, St Ives, he has had frequent exhibitions and a large number of public commissions. He has also held residencies in a number of centres and worked on theatre and sculpture projects with the Knee High Theatre in Cornwall.

Much of his work is site-specific, as was 'Flexiplant' a series of plastic plants made for the Eden Project in Cornwall. More recently he made 'Tropic Trader' which was also evolved in collaboration with the Eden team. He constructed the bows of a ship to provide an entrance to the Humid Tropics Biome, and to act as a reminder of the long journey from the tropics that the contents have taken to reach our shores. Another commission, from The Lowry, in Salford, Manchester, was for a giant brain to illustrate the processes of creative thinking. Visitors climbed the walkway and explored the interior of this inter-active sculpture. They were able to examine the optic nerves and a whirling brainstorm, and to pit their own brain against the giant sculpture.

DAVID KEMP
'King Coal',
County Durham, 1992

127

An important part of his work is what he describes as 'future archaeology'. He has created 'museums from the future' in which abandoned industrial and mechanical objects are transformed into gods and dragons, kings and warriors. He has invented distant cults the 'Tekniko' and the 'Mekanic' and has created evidence of their civilisation from the debris of industry.

One of his 'transformations' is essentially Cornish and from the sea. He acquired two old Cornish clinker-built punts that had been laid up and beyond repair These were transformed into a wooden whale, commissioned by Glasgow City Art Galleries in 1991.

Many of David Kemp's pieces have been made in the places from which industry has been withdrawn. For example a gigantic head, entitled 'King Coal' was sited on top of a slag heap in the abandoned station yard at Pelton Fell, once a colliery village on the Durham Moor. It was made from masonry from a demolished railway bridge and lime kilns, and included a 15-ton ventilation fan from a coal mine, which made the king's crown. In the commanding position that it occupies, and through its relationship to the industrial landscape, it has a strong social and political message.

DAVID KEMP
'Wooden Whale', *1989*

TIM SHAW
'Dance of the Middle World', *1989–95*

cement, bronze, terracotta and lead,
280cm h x 120cm w x 230cm

TIM SHAW (b.1964)

Tim Shaw was born in 1964, in Belfast, and at the age of twenty had his first exhibition there at the Otter Gallery. This was the year he started his course at Falmouth College of Art where he later took the BA Degree in Fine Art with First Class honours. Since then he has taken part in a great many group exhibitions and has had important solo exhibitions at the Albemarle Gallery and the Duncan Campbell Gallery in London, and the Falmouth Art Gallery, Cornwall.

The sculptures of Tim Shaw are complex creations in which many figures play a part in a timeless world. *'Fragments from the Dance of the Middle World'* was exhibited in June 1995 at the Duncan Campbell Gallery, London. This consisted of more than twenty bronze figures, performing a ritual dance before a cathedral-like façade. This is a complex of pagan rite and Christian symbolism in which each character has a precisely designated psychological role. One is a joker who wears the three-pronged hat of a medieval jester; according to Shaw he lives 'where the moon is recognised and worshipped as a demi-god'. A drummer with a huge head occupies a central position and other figures wear masks, carry knives or are bird-headed acolytes. Each figure is only a few inches high, but the total effect is overwhelming.

'La Corrida – Dreams in Red' is centred on the bullfight, which Shaw perceived as 'brutal, cruel, powerful and beautiful... transcending everyday reality into a world that is charged with heightened pain and energy... a world that exists on a knife edge of life and death.' (Catalogue to the exhibition at Duncan Campbell Contemporary Art, London, September 1997). The piece is part bullfight, part carnival, the athletic figures of the picador and the final acrobatic thrust of the toreador is offset by equally tense and dramatic flamenco figures that form part of the spectacle in the arena. 'It is the world that rages with explosive energy, passion and grace, a world where elements of brutality, sensuality and beauty as merged together... and where the past and present meet on the same level.' Again the figures are small, illuminated by coloured spotlights and by ultra-violet light. Processional

trumpet music plays a part, as do words spoken in Spanish. The whole was inspired during a three-month working residence with the Delfina Studies Trust in Andalusia, Spain, in 1996.

The opportunity to work on a larger scale came in collaboration with the Eden Project, and Shaw produced 'The Rites of Dionysus'. His brief was to interpret a story that was associated with wine growing. This will eventually consist of between fifteen and twenty life-size figures in copper that will stand, dance and writhe among the vines. Dionysus, Greek God of the Vine is depicted as a bull that presides over his followers, the Maenads, who dance ecstatically through the vines. Tim Shaw describes his intentions:

As the newly established vines develop, new shoots will appear twisting and turning on a journey through light and space. As the seasons turn vines will be pruned back making way for new growth. I want my figures to reflect the dance of change, altering, cutting and re-shaping form to reflect the movement of plant growth. I want plant form and sculptured form to merge into one dance.

It is intended that the Bacchanal will be accompanied by a Light and Sound installation.

Tim Shaw working on a figure from 'The Rites of Dionysus' at the Eden Project, Cornwall, 2001

TIM SHAW
Detail from 'La Corrida – Dreams in Red', 1997

resin and pigment, 120cm h x 300 cm w

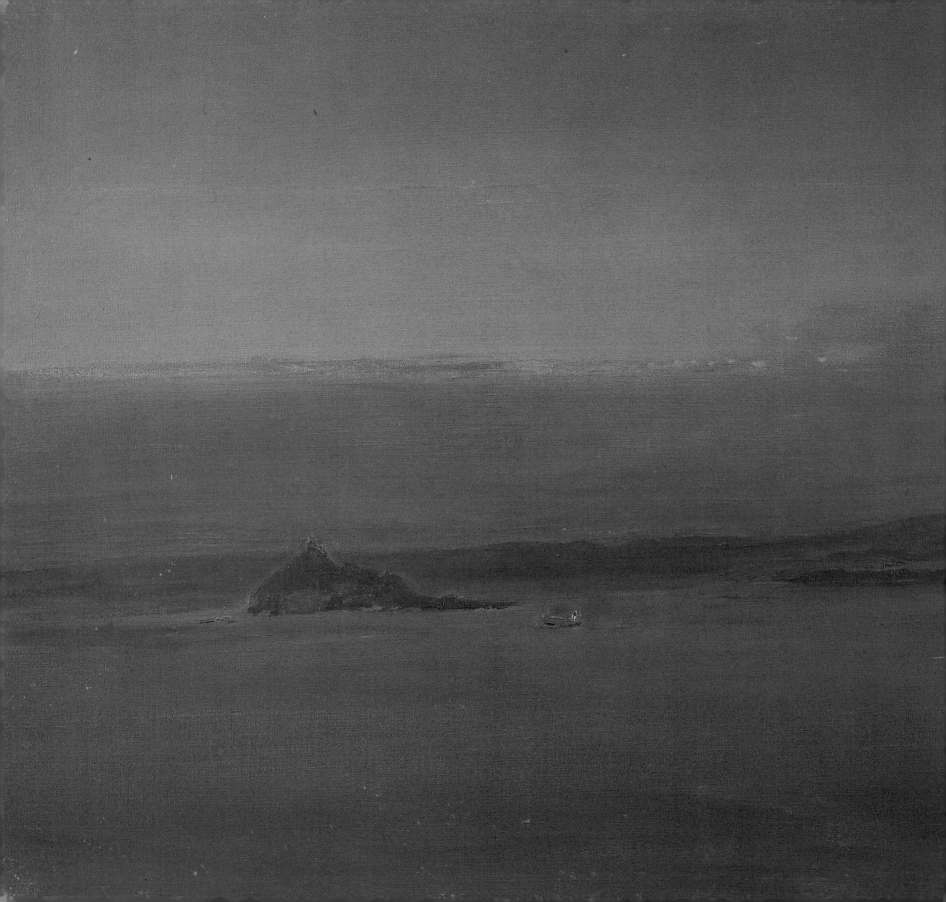

7

LIGHT AND LANDSCAPE

Light is the preoccupation of many of the artists who come to Cornwall. For the painters, both abstract and representational, it is the medium in which they have their existence. Patrick Heron has thought long and hard about the quality of light in the West Penwith Peninsula. As he explained:

at the end of this peninsula, which is the longest tongue of land in Europe, you are miles out into a huge ocean. This ocean is a mirror all round. There are only 8 degrees from this house where land is continuous; otherwise you are out into the sea in no time. All that plane of water is reflecting light upwards into, most of the time, a very humid atmosphere. So the light is then being refracted in all directions. I called this 'multi-directional reflected light', which causes everything in the landscape to be illuminated from all sides. When you look at anything in this landscape, you feel very strongly that light is going round the corners. All objects in this landscape are being approached by light from every side, from every direction. It's the very opposite of light in the middle of a great land-mass, light in the centre of France, for example, which crashes down from one side, with dark shadows on the other. There aren't any dark shadows here at all. Even when the light is full blast the dark shadows are themselves almost cerulean blue. All profiles, whether of hills, houses or headlands rise up towards you, but the light also flattens them, they aren't like a sculpted form. (Patrick Heron interviewed by David Sylvester. Tate Gallery 1995).

JOHN MILLER (1931–2002)

John Miller describes the main ingredients of his painting as 'an exterior response to an interior vision'. He begins with his response to the world around him, particularly the landscape of Cornwall and the Mediterranean countries in which he has worked. His paintings are very specific and are concerned with certain sites and the emotions that they generate. He has tried to paint abstract paintings but he cannot. He does not feel he could paint a picture unless he could identify a horizon or know that the sun was going to be in a certain position. But this 'exterior response' must be balanced by the inward searching and contemplation in which his religious convictions plays a part. He would not claim to be a visionary artist, his work is based on the scrutiny and analysis of his subjects and his methods draw on a long tradition of objective painting. It is in the fusion of these elements that his work has its power. His principal subject is light and for that reason the greatest influence on his work is Turner.

Opposite page:
JOHN MILLER
'Trawler Standing off St Michael's Mount

oil on canvas, 91.5x86cm

John Miller in his studio, 2002

John Miller was born in Streatham in South London in 1931 and was educated at St Josephs College, Beulah Hill. His father was an architect and there was a strong interest in art and design in the family. John attended Croyden School of Art for one term, his only full-time period of education in art. At that time he was strongly attracted to the world of the theatre and joined the Little Theatre in Derby and later the Torch Theatre Club in London, painting and designing sets. He also painted backgrounds for an important historical exhibition at Derby Museum.

At the age of eighteen he was required to do military service and joined the Royal Army Service Corps. He was offered a commission and trained at Aldershot, under the eagle eye of the redoubtable Regimental Sergeant Major Britten. He served in Malta and had quite a lot of time for painting, particularly during a period of convalescence, recovering from serious injuries sustained during training. In spite of this, on the whole he found the army a worthwhile experience and it helped him to find his first steps as an artist.

After the army he returned to London and spent a short time as an actor in the film and television industry and playing small parts on the stage. However he decided that he should find a more stable professional career and decided to study architecture seriously. He attended the Regent Street Polytechnic, part-time, whilst articled to Milner & Craze, Church Architects of London. The study of architecture, with its mixture of the practical and the speculative, he found fascinating. He took the whole seven years training to the RIBA examination, but because he did not engage in professional practice he did not gain membership of the RIBA.

It was architecture that first brought him to Cornwall, to measure the screen at St Buryan Church for an architectural examination. He was greatly attracted by the landscape of Cornwall and felt he could paint it, but he was nearing a period of important change in his life. By this time he was withdrawing from architecture and, increasingly concerned with the spiritual side of his life, he considered entering a religious order. He had also formed a friendship with the potter Michael Truscott which would be long lasting.

These early years in Cornwall were a period of survival. Painting was mixed with the practice of architecture, mostly working for builders or local architects, but painting slowly gained the upper hand. He was helped by Michael Canney, the Director of the Newlyn Gallery, who put him up for membership and also by Peter Lanyon who was concerned with promoting Newlyn and bringing interesting people into it. He remembers advice from Peter Lanyon, who looked at his work and said 'they are not great but they are interesting... you are layering paint over paint – you must make paint move through paint.' By the mid 1960s John Miller became Chairman of the Newlyn Society of Artists, and again from 1967 to 1972. At this time Newlyn was in the process of professionalising its activities and John took a very active part in the affairs of the gallery and used his architectural skills in redesigning the layout of the galleries. The Newlyn versus Penwith rivalry was very evident at this time, one could not be a member of both the Newlyn Society and the Penwith and, following Peter Lanyon's example, John was firmly with Newlyn.

Opposite page:
JOHN MILLER
'Cornish Crabber on the Tide'
oil on canvas, 90x60cm

JOHN MILLER
'Penwith Summer Beach'
oil on canvas,110x105cm

In 1960 John Miller and Michael Truscott opened a guesthouse for artists on the cliffs at Sennen in West Penwith. They later moved to an old house with a large amount of land at Sancreed, which they ran as a community for artists and others. They built chalets in the grounds for people who wished to come and spend time in peaceful contemplation, an enterprise which lasted for thirty-three years. It was not a religious community, but over the years a large number of people have stayed there and found it a very rewarding experience.

The old vicarage of Sancreed, surrounded by mature trees, provided John with a multitude of subjects. He painted the trees in great detail and at different times of the year. He saw them as stage flats, creating a sense of space and drama in the landscape. He then began to look beyond, to the wider landscape of West Penwith and became more aware of the spaces between the enclosing trees. At this time he was painting out of doors as the Newlyn artists of the nineteenth century had done. The colour of his paintings of the mid 1970s was very muted, in greys and browns. Gradually the treatment became more impressionistic and the colour stronger, a first step on the way to the more abstracted and strongly-coloured paintings of the 1980s.

The church has played an important part in his life; John describes himself as a practising Christian but not 'churchy'. John was a Lay Canon, which is an honorary position, at Truro Cathedral. He was also a member of a Franciscan order and, fittingly, he lists his heroes as Van Gogh, St Francis of Assisi and T.E. Lawrence. In 1980 he was asked to do a remarkable commission. Through his architectural work John Miller and Michael Truscott had been assisting in the internal decoration of Truro Cathedral. John was asked if he would make a map of Cornwall showing all the churches of the Diocese; but he found it impossible to do a traditional map. Instead he produced a painting which was a landscape rather than a diagram, showing the whole of Cornwall as if viewed from high above and with the churches positioned. It was entitled '*Cornubia – Land of the Saints*' and the unveiling by Prince Charles brought a great deal of attention.

The 1970s and the 1980s included periods of travel, mostly in and around the Mediterranean. He went to Cyprus in 1973, Venice in 1975, Tuscany in 1976 and Greece in 1980, usually in the company of sympathetic friends. Malta gave him a feeling for the Mediterranean, which he describes as the 'beyondness of the light' which he has sought ever since and which he has also found in Venice and in Cornwall. The paintings that resulted from these trips are a distillation of appearances and they show his ability to select and express the complexities of landscape with great simplicity. By comparison with the Newlyn landscapes which preceded them, these impressions of Venice and Greece have a much greater freedom of colour and brushwork. The experience of painting in the strong light of the Mediterranean inevitably resulted in the use of more intense colour in his paintings of Cornwall. Shape was flattened and abstracted and he found new ways of seeing the Cornish landscape in two dimensions. He describes these as 'impressionist landscapes', painted from 1987 onwards.

John Miller became a prolific artist and he has exhibited widely in Britain and further field. From 1961 onwards he had a large number of exhibitions in Newlyn and other venues in Cornwall. In 1982 he

had his first exhibition at the David Messum Gallery, London, and the gallery represented his work until 1999. In the year 2000 he joined the Portland Gallery in London.

In 1995 he moved from Sancreed to Lelant. Here he was living by the sea and his experiences of early-morning walks on the beach at Porth Kidney or the moon rising over St Ives' Bay gave his work a new symbolism. He saw the sun as a symbol of life and renewal and he associated the moonrise with the death of his mother. For the paintings produced at this time David Messum coined the title 'interior landscapes' which John accepted. It refers to a period after his mother died, following a long illness. During her illness he would go each day to see her, although she was not able to recognise him. He sees these paintings as a memorial to his mother. They portray a tiny figure in a shaft of light, brilliantly coloured against a sombre background. They have a visionary quality, a portrayal of the afterlife. Following a short illness, John Miller died in Penzance in July 2002.

ROSE HILTON (b.1932)

Rose Hilton lives in the same small cottage near to the sea that she came to with Roger Hilton in 1965. It is on the edge of Botallack Moor, near St Just, and exposed to the fierce changes of weather that mark this most southern point of the British Isles. She and Roger had been coming to Cornwall on holiday since 1959, and they had many friends there. For some years after their move to Cornwall, Rose was able to give little of her time to the development of her painting. Her first son, Bo, had been born in London, and her second boy, Fergus in Cornwall. In addition to her family responsibilities she became Roger's helper in the studio and later his nurse. It was only during the last part of his illness, a period of about three years when Roger was bedridden, that she found some time to return to her painting. Loneliness was a besetting difficulty for Roger and he encouraged Rose to work in the same room as himself so that he could have someone to talk to.

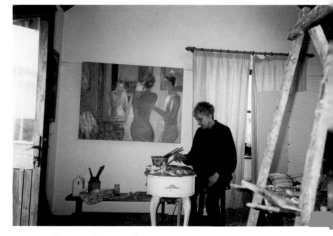

Rose Hilton in her studio, 2002

Rose Hilton wrote:

Whilst not enthusiastic about my being a painter at that time, he [Roger] would encourage me to bring my paints to his room, knowing that there was no surer way of seducing me from other commitments and keeping me there for hours. During this period I painted and drew him and the 'still lives' which paradoxically created and re-created themselves about him – almost continuously, whilst he read aloud from Eliot, P.G. Wodehouse, the Kilvert and Woodford Diaries, or King Lear. [This last named work came to obsess him more and more as time went on]. Wodehouse in particular was more than generous with the great gift of shared laughter and to read him now is a sure path back to many a sunny day spent in Roger's room. (From 'Roger Hilton, Last Paintings' Graves Art Gallery, Sheffield April-May 1980).

A moving, jewel-like painting by Rose hangs in the house. It is of Roger in the last stages of his illness, pictured in the ground floor room, in which he lived and worked.

At the end of this long period, Rose had to remake her artistic career, and to find a new life. After

ROSE HILTON
'Studio in France', *2000.*

oil, 51x61cm

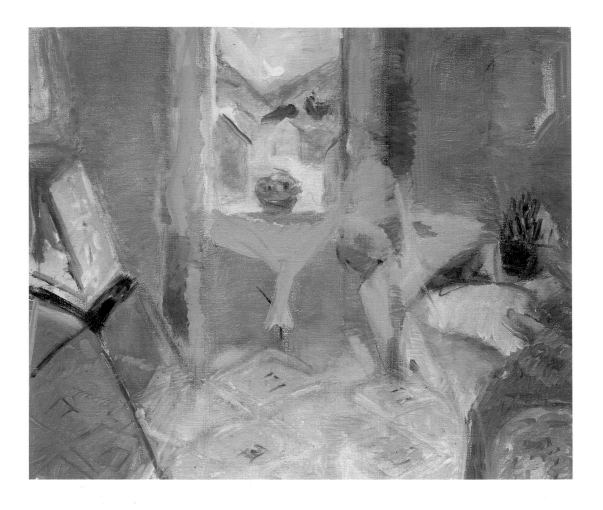

Roger's death, she began again to look around her, at the contents of her cottage, her possessions and her friends. She started by making a series of large, still-life paintings in monochrome, depicting the household objects nearest to hand, plates, cups and dishes on the table. She has continued to work from the places and people that are known to her and has remained a figurative artist. She looks at the world around her, which she finds beautiful, and this beauty is translated with a harmony of colour and form. She likes to have the objects in front of her before commencing a painting, although these are only a starting point. She admits their appearance changes a lot, it is here that her imagination most freely comes into play and usually the work is finished away from the subject.

After several years in Cornwall Rose became aware that she needed a new way of looking at her world. She went to London for the whole winter and found a new direction by taking instruction from the surrealist painter and draftsman Cecil Collins. She joined Cecil Collins' class at the Central School

in London and found him to be an inspiring teacher. He was not interested in whether one was good or not, nor if you were an abstract or realist artist. His instructions were based on the use of materials, how to hold the pen, how to describe the line of the model. He believed that the human figure was the key to everything in art and design and he always had his students working from the model, although the poses might be very short or difficult to hold. On occasions he would have the model dancing. He believed that if you lost yourself in the activity of drawing, 'it' (whatever it was), would come through unconsciously as a spirit. He was rather scornful of skill on the part of his students. He thought that 'correct' drawing, in a traditional manner, got in the way of 'it'. Rose found this approach intriguing; she was there for six months and returned in the following year.

Rose Hilton was born Rose Phipps in 1931 in Kent. Her art education began at Bromley Art School, at the age of fifteen, followed by a period at Beckenham School of Art. From there she went to the Royal College of Art, London, which had recently regained its prominence under the direction of Robin Darwin, and with Carel Weight in charge of the Painting School. Rose found the college a complete liberation. Her background had been strictly religious and she revelled in the excitement and gaiety of London in the 1960s and the many extraordinary personalities that she met at the college. Her time there was interrupted by a period of serious illness, when she was diagnosed as having tuberculosis for which she required extended treatment. Happily she recovered and by 1955 she was able to return to the Royal College where she found herself with a later group of students including Richard Smith and Peter Blake.

She completed her course with distinction and won an Abbey Minor Scholarship to the British School at Rome. As this meant leaving London for a year she advertised her flat in South Kensington for rent. A young painter, Sandra Blow, who answered the advertisement, came to see the flat, accompanied by her friend Roger Hilton, who was introduced to Rose. Almost immediately Rose was on her way to Italy and on her return, a year later, her acquaintance with Roger developed quickly.

In Cornwall the whole house is her studio; she works in the room that Roger used in his last years, overlooking moorland, and in the light-filled studio above, accessed by a ladder. In the garden a newly built granite building is also a studio. Most recently she has built a large conservatory across the back of the cottage, which is a flower-filled environment for her work.

There is an air of quiet domesticity about her painting. She creates a softly coloured place for relaxation in which a group of friends take tea, conversation is made or, in more intimate moments, a woman dresses in front of a mirror, or a nude reclines, oblivious of others. She regularly paints and draws from the model, usually female. She uses her house as Matisse used his studio in Nice, a total environment in which the figure forms a central part. Other obvious comparisons are with the intimate paintings of Vuillard and Bonnard. Rose would admit to all of these. Her drawing however, has a more Northern quality, angular sometimes spiky.

Quiet colour combinations set the mood of the paintings, warm flesh tones surrounded by creamy ochres and strong yellows. Sometimes a more atmospheric range of warm and cold blues fill the

ROSE HILTON
'Pink Nude', *2000.*

oil, 51x61cm

137

room, illuminated by points of ochre and orange. Most particularly beautiful is her use of greys; soft swept colour, thinly applied. Simple objects on a table acquire a spare definition. Her work lies in that interesting and difficult area between representation and abstraction. She has the strong structural feeling of the abstract painter, but essentially she has to follow her instinct.

Rose Hilton began to exhibit her work in the 1980s, first at the Penwith Galleries, St Ives and the Newlyn Gallery. From 1990 she has exhibited regularly at the David Messum Gallery, London, and in many mixed exhibitions.

KEN HOWARD
'Morning Sunlight', c.1990.

oil on canvas, 189x152.5cm

KEN HOWARD (b.1932)

The subjects that Ken Howard paints have always come from his environment. He paints places and people that he loves, whether they are railway sidings, London churches, or friends in his studio. He is an objective painter who only paints things that he can see and stand in front of.

His studio in Cornwall is a large light-filled room with the usual jumble of easels and painting tables, it is his subject as well as his place of work. He feels that every painting is about light. An early riser, he is in the studio by 6.30am in summer, when sunlight floods the room and the backlit figure takes on a statuesque tranquillity. The nude model gives a human focus to the painting and she takes her place in the play of light that envelops the cluttered room. He maps the canvas, defining the structure of window and furniture dissolved by the reflections from the landscape outside. In such paintings one can see that Sickert was a driving inspiration. Some of Ken's subjects were inherited from Sickert; the nude figure seen against the light, figures in darkened rooms, Venice in its many disguises. These are subjects that Ken has also made his own. From 1963 he has painted regularly in Cornwall. Because Cornwall is a peninsula you are never far away from water and its reflections, the quality of light is very special and the only equivalent is the light of Venice.

Ken Howard was born in 1932 in Neasden in West London and educated at Kilburn Grammar School. He then went to Hornsey School of Art. His National Service was spent in Plymouth with the Royal Marines. During the two years that he was in the Marines he was able to go to the Art Centre in Plymouth, to draw from the model, and he had his first exhibition there while he was still a National Serviceman. Plymouth Art Gallery bought ten of the pictures from the exhibition.

Ken Howard's first relationship with Cornwall dates from the early 1950s when his sister was a Land Girl working in Penzance. She met a Mousehole fisherman and they were married. Their parents came down for the wedding and became fascinated with Cornwall and bought a cottage in Mousehole. In the intervening years Ken was a regular visitor and in 1986, on the death of his mother, he bought a studio there, which he has used since. There is another story about the studio, which is worth telling: in 1949 when he was fifteen he cycled from London to Land's End with a friend. On the return journey they came through Mousehole and, going up Mousehole Hill they saw a bearded artistic figure at the door of a studio. Ken later learnt that it was George Lambourne, a painter of Cornish landscapes and coastal subjects. As they pushed their bikes up the hill Ken said to his friend

'I'm going to be an artist like that one day'. The studio that he acquired some twenty years later was the same St Clements Hall, in Mousehole.

Ken knew from a very early age that he wanted to be an artist. He has always painted from observation and his roots are based in France, as were those of Stanhope Forbes and all the Newlyn School. At the Royal College of Art, in the mid 1950s, he was painting places he knew, industrial scenes in London and city landscapes, and his heroes were Sickert and L.S. Lowry. Some members of the staff, such as Ruskin Spear and Carel Weight were encouraging, but the influence of the New York School had begun, and the stars were Richard Smith, Robin Denny, Peter Blake and Joe Tilson.

After the Royal College Ken was awarded a British Council Scholarship to Italy and he lived and painted in Florence for a year. When he returned to England it was a time of the expansion of the art schools and it was easy for him to find some part-time teaching and for fourteen years he taught for two days a week. By this time his work, based firmly on observation, had caught the attention of the

Ken Howard, 2001

KEN HOWARD
'Newlyn Summer Morning', c.1997

oil on canvas, 20x25cm

139

galleries. He has never had a problem selling pictures and his first exhibitions were at Wildenstein's Gallery, London in 1961, 1962 and 1963, and later with the Wibly Gallery. More recently the Bond Street Gallery of Richard Green has represented him.

In these earlier years, in addition to painting he worked as a commercial illustrator, producing drawings for the London Telephone Directory and for Shell and BP in a very direct style. He found it was a good discipline to sit in a street and draw these complex buildings. He was determined not to go into full-time teaching and illustrative work took up quite a lot of his time. Towards the end of 1969 he had an exhibition at the Grafton Gallery and, in 1972, he had a retrospective exhibition at the Plymouth City Art Gallery, twenty-two years after they bought the first group of pictures he had painted as a Marine.

In 1973 he finally decided to give up teaching completely when he was appointed as an official war artist. This was at the height of the troubles in Northern Ireland and he was the first war artist to be commissioned since the Second World War. His title was the 'Official Artist of the Imperial War Museum in Northern Ireland' because technically Northern Ireland was not at war. For ten years he recorded the activities of the army with drawings made on the spot, troops waiting for a helicopter, patrolling the streets of Belfast, training or preparing for action. Occasionally a photograph might be used to capture action, as of a man running, but generally photographs played no part in his work. He quotes Sickert: 'Use photographs as long as you can do without them'. His style of work was well liked and one commission lead to another. With the army he travelled the world, to Germany, Cyprus and the Oman, and as far as Borneo, Hong Kong and Nepal, and with training units in the United States, Canada and Belize. In 1982 he decided to give up the work for the army in order to paint other subjects.

He had shown with the Royal Academy for thirty-four years from the age of eighteen and in 1984 he was elected as a member. Now as a senior Academician he feels rather separate from some of the younger artists. He felt most at home in the year he was elected, when over half the members had voted him to membership: but as new members have joined he realises that he has become part of the Old Guard.

Ken Howard is remarkably prolific. He paints a great deal out of doors, often on the south-facing beaches of Mousehole, Penberth and Porthcurno, near to his home in Cornwall. These paintings are done quickly; an hour or an hour-and-a-half is sufficient because the light will have changed. He paints very directly and in a traditional manner, working in oil on tinted canvases from thin to thick paint. He looks for structure but he has never considered himself to be an abstract painter. In selecting a composition he will move around until he suddenly he see the arrangement of dark and light that touches him.

His connection with Cornwall is through light and he feels part of the earlier tradition of painting in Cornwall, the painters of Newlyn and Lamorna. Although he knows that there are a lot of good things going on in Cornwall, he does not feel that he fits in with West Penwith painting now. He quotes a recent meeting with Terry Frost at the Royal Academy, at which Terry said: 'Ken I don't know what you're on about but I think you are serious about it and therefore I like it.' And Ken said to Terry: 'I don't know what *you're* on about but I think you're serious about it, therefore I like it.'

*Ken Howard's studio,
St Clements, Mousehole, 2001*

JUNE MILES (b.1932)

There is a strong feeling for France evident in much of June Miles' work. The subjects she paints are those of the great landscape artists, the village landscapes of France and of Cornwall. She also paints the objects in her home, a decorative medley of jugs, flowers and fruit on a table and portraiture of her friends. These various subjects are linked by her skills as a draughtsman and an ability to put down in a simple, concise manner the form of the objects. She mostly works out of doors in the French landscape and, whenever possible, in Cornwall, and at other times in the sun-filled painting room of the Nancherrow studio in St Just, West Penwith, which she shares with her husband Paul Mount.

June Miles was born in London but was brought up for the first six years of her life on an island off Hong Kong, called Stonecutters Island, where her father, who was a Royal Marine, was supervising the building of a wireless station. She returned to England to complete her education at Portsmouth High School. In 1941 she went to the Slade School, under Randolph Schwarbe. This was wartime and the Slade was evacuated to Oxford, nevertheless the discipline of carefully-observed drawing, for which the school was

June Miles, 1998

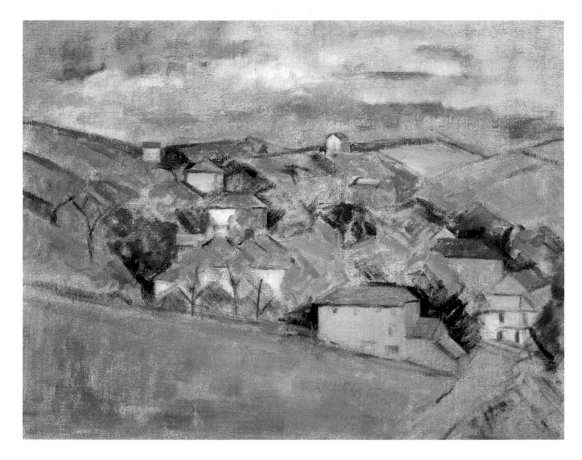

JUNE MILES
'Tregeseal', 1998

oil on canvas, 40x50cm

JUNE MILES
'Begonia', *1999*

oil on canvas, 36x30cm

famous, was strongly upheld. In 1943 she drew maps in an Admiralty drawing office, also in Oxford. This gave her a love of the precise delineation of landscape, which she carried over into her painting.

At the end of the war she married Paul Feiler and they moved to Bristol where he was appointed a lecturer at the West of England College of Art. They lived in Bristol where they brought up three children. It was then that she continued her studies and gained her reputation as a portrait artist. At this time many holiday visits were made to Cornwall and she came to know and paint the Cornish landscape. In 1967, following her divorce from her first husband, she came to live and paint in St Just and combined this with teaching at the Bristol Polytechnic, commuting regularly two days a week. In 1978 she gave up teaching and married the sculptor Paul Mount.

France has been a lure over her lifetime. For the last ten years she and Paul had a house in the Pyrénées Orientales, which was recently sold and exchanged for one at Peyriac de Mer, near Narbonne. She paints this region with the eyes of Cézanne, the tumble of old houses against a background of high hills, the verticals of tall trees contrasting with the horizontals of steep roofs. A high horizon forms a solid background upon which the cubist forms of house, hill and foliage dance gently. She accepts the forms of the mountain scenery and the perched villages and resolves them simply and clearly. There is an emphasis on the structure, the verticals and horizontals of the landscape against the flat patterning of the picture plane.

To see the same characteristics in the landscape of West Cornwall would be dishonest. In her many paintings of the Tregeseal Valley and the areas below St Just, the landscape has a more curvilinear form. The turning shape of road or hill is more solid, the white Cornish light more revealing than the strong contrasts of Mediterranean sunlight. Colour is softer, more earthy.

Her still-life paintings have a more exotic richness and give the greatest range to her imagination. Colour is bright and bold, strong cadmium yellows and oranges, viridian greens contrasted with touches of pure cobalt blue. Flowers in all their variety are a frequent subject; simple arrangements in painted vases set against brightly coloured and patterned fabrics, usually Indian or African. The surface of the paintings, compartmented with a patterning of strong reds, yellows and blue-greens, are controlled with delicate but firm drawing.

JUDY BUXTON (b.1940)

Judy Buxton was born in Sydney, Australia. She had visited England for the first time in 1983 and four years later she returned to train at Falmouth College of Art where she gained a First Class Honours Degree in Fine Art. Cornwall offered her the right experience at that time. At the College her personal tutor was Ray Atkins whose painting she admired. The Port of Falmouth, with that sense of openness, the life of the working harbour and the quality of light, reminded her strongly of Sydney.

After Falmouth she went for three years as a post-graduate student to the Royal Academy Schools, London, then under the Keeper Norman Adams from whom she received huge support. The teaching

at the Schools was broad and the only compulsory period of direct painting was studies in the life room during the first year. This was very much in line with her own direction and she enjoyed her time there.

In 1993 she married the painter Jeremy Annear and a year later she moved to Cornwall where she entered fully into the artistic life of the area. She was elected as a member of the Newlyn Society of Artists and was a visiting lecturer at Falmouth College of Art. In partnership with her husband they established the Chapel House Studio on the Lizard as a teaching centre, with adjacent studios for their own work. Since coming to Cornwall she has had a succession of solo exhibitions in London, Oxford, Bath, Cambridge and St Ives, and has been represented in a large number of mixed exhibitions including the prestigious Hunting Art Prize exhibition at the Royal College of Art in 1997, 1998, 2000, 2002

The Lizard is the last great peninsula of land before Land's End, and the most southerly. It is very different in structure and in appearance to the granite moorland of West Penwith. For the geologist, the Lizard is a remarkable opportunity to examine ancient rocks formed deep below the earth's crust and thrown to the surface by the great pressures that shaped the land. To the north are the wooded slopes of the Helford river and its estuary, to the south and west are the coastal cliffs and rock ridges that have been such a fearsome danger to shipping over the centuries. The centre is a roughly level table of downland, mostly uncultivated and left to gorse and blackthorn. Goonhilly Downs lies at the centre of the peninsula and on the highest point the Post Office have established their satellite tracking centre.

Thomas Hardy knew this part of Cornwall well. Judy Buxton's quotes from *The Return of the Native*:

And the vast tract of unenclosed wild heath embrowned moment by moment... Overhead the hollow stretch of whitish cloud shutting out the sky was a tent which had the whole heath for its floor... The distant rims of the world and of the firmament seemed to be a division in time, no less than a division in matter. (Catalogue to her exhibition 'Silent Spaces' at the New Millennium Gallery, St Ives in May 2002).

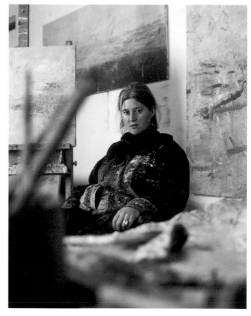

Judy Buxton, 2002
Photo: Steve Tanner

JUDY BUXTON
'Table objects with lilies', *2002*

oil on canvas, 75x180cm

The situation of the southern-facing coast of the Lizard peninsula suits her painting perfectly. Much of Judy's work takes place out of doors. On a daily basis she walks in the nearby Goonhilly Downs and the coastal lands and foreshore around Poltesco. She observes the play of the elements, the wind, rain and sun creating constant change and transformation. 'Through memory, absorption and familiarity of these spaces my painting evolves and condenses into an essential form' she writes. (Catalogue to her exhibition 'Silent Spaces' at the New Millennium Gallery, St Ives in May 2002).

There is a romantic fullness about her paintings. In translating her feelings into paint the studies first done out of doors are painted on a small scale on to board. In the studio she will investigate her experience of the landscape and on large canvases paint is applied freely and directly, working lean to fat, in the tradition of oil painting. As the work progresses this first laying-in becomes a richly textured paint surface. The places she uses are specific, she goes a lot to Poltesco and Goonhilly but she does not see herself as a topographical painter, she does not collect sites. She searches for the experience of places that she loves and to which she cannot help returning.

The Lizard peninsula has an enclosed feel, a largely flat but elevated central plain, cut by deep river valleys at the coast. In her painting Judy Buxton describes this sense of enclosure. There is a lack of focus in the atmosphere, characteristic of the strong light and changing weather, a misty horizon that melts between sky and limitless plain. Scrubland is described by the marks of an over-full brush leaving trails of umber, ochre and a range of greys.

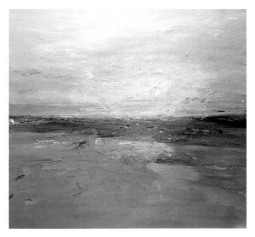

JUDY BUXTON
'Poltesco Drift II', 2001

oil on canvas, 155x170cm

Her observation is coupled with imagination and her sense of wonder at the landscape. Figures do not appear, perhaps she would agree with Jackson Pollock who said, 'I am the figure in the landscape'. She looks at the radio telescopes of Goonhilly and the intrusive space station, and thinks about painting them, but so far she has only recorded them in drawings. She prefers to look away to the vast sky and heath land below.

Her paintings are repeatedly reworked through to a conclusion. She draws quickly and easily in paint, whether it is on a windswept heathland, or a quietly static tabletop arrangement of jugs, jars and flowers. The still-life paintings are an important part of her work; they show a more reflective side of her personality.

In her own words she describes her searching vision of the landscape:

Nature like paint with its own organic mystery, layered... Colours trapped underneath a fragment... remains of what was and what may be replaced by a mark or the sweep of clouds, sometimes it is only the rhythm or weight that is left. A speckling of grass heads, pebbles on the sand, a sprig of gorse against a solid flat band of sienna heath... all colour at the edge... (Judy Buxton 'Reflections on Poltesco and Goonhilly').

RICHARD COOK (b.1947)

Richard Cook was born in Cheltenham although his mother and earlier generations of the family were born in Ceylon, and his first schooling was in that country. As his father was in the RAF the family travelled considerably. For a time Richard returned to Cheltenham, was later in Aden, and from the age of eleven he was at boarding school in Oxford. Richard's art education was at St Martin's School of Art. He found the Head of Painting, Frederick Gore, very supportive, but it was Leon Kossof, who conducted the life class, who made the strongest impression upon him. From 1970 to 1973 Richard was a student in the Painting School at the Royal College of Art, London. However he found that his interests were nearer to Art History and Complementary Studies and he largely avoided the influence of the painting staff. He looks back on these years as a time in which he was discovering his own language as a painter, a search for something to which he could devote his life.

Richard Cook believes that painting takes time to develop. As a mature artist, he feels that his roots are in the English tradition of painting, and his cultural precedents are much more related to Gainsborough, Stubbs, Constable and Turner.

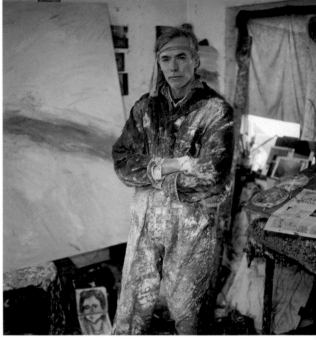

Richard Cook, 2002
Photo: Theo Cook

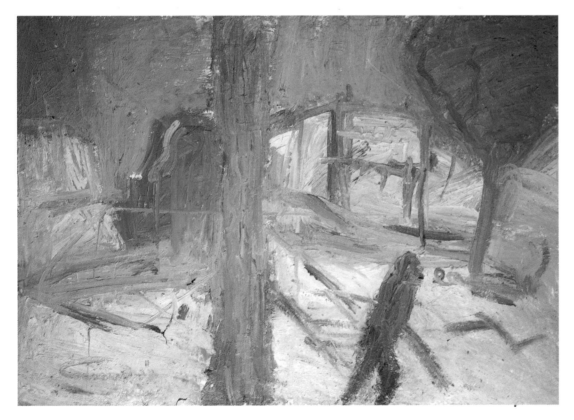

RICHARD COOK
'Alexander Road', *1998*

oil on panel, 122x170cm

145

He remembered Cornwall from earlier holiday visits and he felt that something was pulling a string that drew him back there. His need was to leave London and to resume a greater contact with nature. Finally, in 1985, Richard moved to Cornwall. Now that he has made Cornwall his place of work he finds that it has given him the psychological space that he requires. His studio in Newlyn has a cold northern light, overlooking the working port. His painting room can best be described as a 'cave of paint'. It is a painter's workshop with a ten-year-old accretion of paint. All of the surfaces, walls, ceiling, windows are splashed, and the floor is inches deep in crusted oil paint. If the visitor is invited into the studio, stepping stones of newspaper are laid down first.

Richard Cook works from specific sites which he knows well and visits often. His working studies are vigorous, simple sweeps of wash and watercolour in large sketchbooks. One of his familiar sites is in Lelant on the north coast of Cornwall, overlooking St Ives Bay. He first went there at the age of seventeen and he has returned a great many times since. Another area that he haunts is the promenade between Penzance and Newlyn, but he also visits other landscapes as far afield as Dartmoor and the Scilly Isles. He makes brief but frequent visits to these places and the studies that he makes add to his experience and understanding. He then seeks to resolve these many views of the subject into one coherent whole, by a process of lengthy reworking.

He distils the essential qualities of landscape. The faint and distant horizon, a pale sky reflected in water and the drama of a single figure walking on an empty promenade. They have the atmosphere of Whistler's impressions of the River Thames, and much of their music, although very different in their creamy consistency of paint. Since the early 1980s Richard Cook has shown his work in London in a series of exhibitions at the Austin Desmond Fine Art and most importantly at the Tate St Ives in 2001. He has also been included in many group exhibitions in London and Cornwall.

An important part of his work is to do with the figure. He feels that he could not 'set free' the landscapes if he did not have a confrontation with the figure. He has a regular pattern of activity, working from professional models twice a week. Although many studies are made out of doors, Richard Cook mainly works in the studio on a number of paintings. They may remain for months at different stages before being finished. He is very critical of his paintings; he destroys quite a lot and works over others. It is only when he feels a painting has its own autonomy and he is confident that it will resonate to others, that he will consider putting it on public show.

His exhibition 'Luminous' was shown at the Tate Gallery, St Ives, in January 2001. The works are from locations in Devon and Cornwall, painted from memory, reinforced by studies on the spot. Light is the overriding presence, the pale light of the sun behind cloud. In his catalogue to the exhibition Michael Archer discusses the title:

Cook has called his exhibition 'Luminous' a title that carried us beyond a mere acknowledgement that light is a necessity of the painter's trade towards and understanding that it comes to us largely as atmosphere. We appropriate it through our senses as the dazzle on the water, the warmth of the sand under foot, the radiance of a cloud, the hum of insects, the sparkle of a stream and the

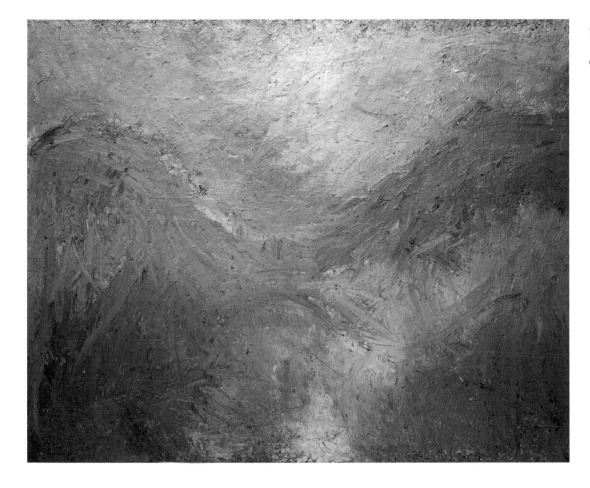

RICHARD COOK
'Dartmoor, near Belstone', *1996.*

oil on panel, 122x152.5cm.

wheel of gulls in air that is moist and heavy with the smell of salt. ('Scapeland and Inscape', the Landscapes of Richard Cook by Michael Archer, Tate St Ives 2000).

Cook paints a world of memory. The crusted surfaces of these large and heavily worked paintings evoke an ancient landscape. It is appropriate that Cook has an interest in archaeology. His collection of arrowheads and scrapers, of lumpen hammerheads and tools of flint are evidence of time long past. Their indestructibility is reflected in the mood of his paintings. The structure of the landscape is shown as landmarks along the edge of the sea. A particular tree or building, the outline of a hill or the convergence of two footpaths evoke more fleeting memories: a figure who might be his son, walking away or turning, the wheeling flights of gulls or the changing patterns of clouds. These give permanence to the past.

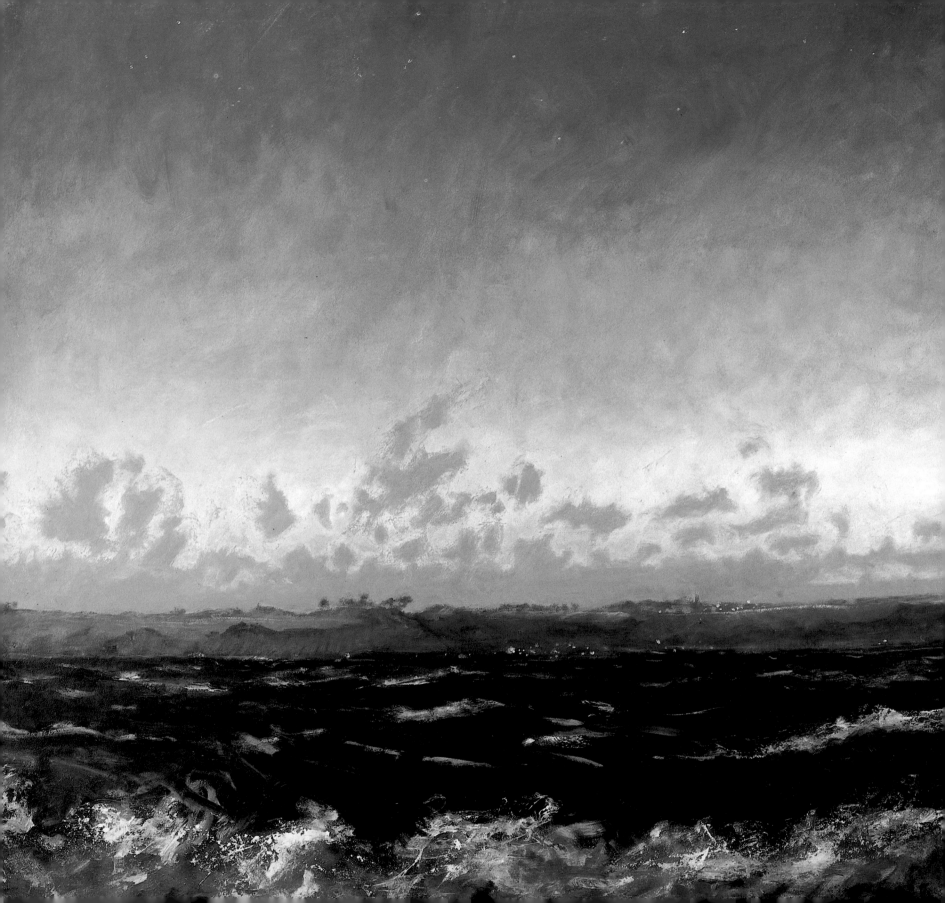

8

PAINTERS OF COAST AND SEA

A COASTAL WALK IN WEST PENWITH

Approaching Penzance along the coastal road from Helston, the new bypass rings behind the town, avoiding Newlyn on its way to Land's End. It is still the same rounded fertile farming country as we leave Penzance, but it is an older road now, twisting and curving, lined with oaks; as the ground rises the trees are left below in the valleys. We pass ancient standing stones at Tresvennack and at Catchall the old road turns off to St Buryan and Porthcurno. We keep to the south, this is now a harsher landscape, the granite is close to the surface. We pass more standing stones at Canopus and, where the road is high, you can see across the undulating country to the church of St Buryan. This has a fortified look with it's high crenellated tower surrounded by a small hamlet of miners cottages, all of granite. It is a landmark for the whole of the peninsula. This is the high spine of West Penwith, the ground falling away to the sea on both sides.

The sun is to our left, reflecting from the sea and bringing a greater intensity of light. The surface of the land appears level but it is cut by deep river valleys that come to the sea. We are coming down one of these at Treen. Now there is a steep rise again as we go to Trethewey.

This coast is plotted by it's churches. The church of St Levan lies at the head of one of the steep valleys that give down to the Holy Well of St Levan and the towering rocks of Porthgwarra. The squared granite rocks of Pedn-men-an-mere and the Vessacks go round to Hella Point on Gwennap Head. The high coastal footpath twists over these stacks of rocks, facetted and balanced into columns and piers, like the ruins of some ancient cathedral. The seams of red earth indicate the copper that lies beneath the surface. It's early in the year and the gorse has only begun to yellow but soon it will emblazon the upper slopes with an impenetrable cloak of colour.

This is a place to which the author came with John Wells, when he was in his mid-seventies, but he remembered his walks from his earlier days in Newlyn and St Ives. It was on this path that John picked up a small piece of bone, probably a skeletal fragment of a seagull. He was delighted to find this precise and marvellous object and he decided it was a construction by Naum Gabo.

There is a Paul Nash-like surrealism about this headland, rounded and barren, but with two precise geometric objects placed near the summit – one pink, one black and white. These are navigational aids for seamen far out in the channel, and they help to provide a safe passage around the fearsome

Opposite page:
ROBERT JONES
'Passing the Coast, Evening'
oil on board, 120x135cm

rocks of Land's End. At Porthgwarra a natural archway through the rocks gives on to a white sandy beach. Here the granite is marked with millions of fossilised shapes, every surface appears textured and catches the points of light.

At the edges of this moor the wind-eroded rocks assume strange shapes, as predatory as the gulls that fly above them, or as swift as the seals below. This place has its own special magic and mystery. Structure has been abandoned in this battle for existence that only the rich mosses and heather can survive. Rough grass has to battle to cling on to the granite-loaded soil. Suddenly climbers appear clambering up from the fierce rocks below, festooned with slings and carabineers and with orange crash helmets and dangling ropes.

KARL WESCHKE (b.1925)

In September 2001 an exhibition entitled 'Karl Weschke, Die Deutsche Retrospektive' took place in the Kunstsammlung Gera Orangerie, a magnificent Baroque building in the town of Gera in Germany. This retrospective exhibition of the work of Karl Weschke consisted of more than forty paintings. It was accompanied by a further exhibition of twenty drawings shown by the Kunstverein Gera e.V, Stadtapotheke, Markt 8/9. These two exhibitions represent a remarkable tribute to Karl Weschke from the town of his birth, which he had not visited since childhood. Most of those intervening years have been spent in Cornwall.

Karl Weschke came from a socially impossible situation, fortunately one from which he has managed to escape. He has experienced poverty and neglect and he knows that it can deprive people of elegance of thought. For him this is far from the case, he is essentially a survivor. The details of his early life have been fully chronicled (see *Karl Weschke, Portrait of a Painter* by Jeremy Lewison 1998). In brief he was born in the village of Taubenpreskeln near Gera, in Thuringen, Germany, the second child of Elsa Weschke, whose three illegitimate children were all fathered by different men. The father of one of his sisters was Jewish and his own father, who Karl met only once, was an anarchist; both later died in the concentration camps. The other they did not even know. Rejected by his mother, he was brought up in a children's home until the age of seven and after that he partly lived the life of a street child.

Karl was finally taken back by his mother, perhaps because he was now old enough to be useful. At the outbreak of war he was fourteen years of age and the Hitler Youth movement absorbed much of his energies. However he pursued his own education, he would go to reading rooms where he read voraciously. It was the kind of childhood that may be exciting in the telling but in reality it is rather horrible. It made him tolerant of life, but very intolerant of evil.

In 1942 he joined the German Air Force. In the last year of the war he was taken prisoner by the Canadian Forces – he thinks – and shipped in a hospital transport to the Law Hospital in Glasgow. After moving through different POW camps Weschke arrived at Camp 180, Radwinter, near Cambridge. There he attended a course of lectures on the Board of Extra Mural Studies and the International Student Service of the University of Cambridge. After a final stint at Wilton Park he was

Karl Weschke
Photo: Ander Gunn

at last civilianised in Hawick, Scotland, and registered as an alien in 1948. During the time at Wilton Park, Weschke had met his future wife, Alison de Vere, then a student at the Royal Academy of Art. Weschke's only experience of formal art education came during the following year when he studied for one term at St Martin's School of Art. However he spent a great deal of time mixing with artists and dancers and looking at works of art in the museums. In 1952 he worked for a season as designer for Berto Pasuka's *Les Ballets Nègres*.

In London he had become acquainted with Bryan Wynter and it was at his suggestion that Weschke came to Cornwall, to live at Tregerthen Cottages in Zennor. Cornwall provided him with subjects whose emotional strength matched his own experience. He painted the sea and the extremes of weather, expressed as abstract images of considerable power. They emphasise that sense of imprisonment that can go with cliff top living and the huge forces of nature that are part of this marine environment. Karl Weschke describes the extreme turbulence of storm and gale in strong abstract

Karl Weschke in his studio painting 'Luxor', 1994–95.

KARL WESCHKE
'Deir el Bahri', 1999.

oil on canvas, 183cmx228.6cm

KARL WESCHKE
'Polandese', 2001

oil on canvas, 183cmx122cm
private collection

images such as *'Sturmfloten (Gale)'* – 1965–66). He also uses allegory; the gathering forces of the wind are portrayed as gods, reminiscent of the marginal drawings in old maps. Their panpipes produce the forces of wind and weather described in bold geometry.

In 1960 he moved from Zennor to the exposed headland of Cape Cornwall, close to Land's End. These precipitous rocks and cliffs have been mined for copper and tin since prehistoric times and they lie above the deep seams of the Wheal Edward Zorn and the mines of Lelant, Geevor and Botallack. To the south are the terrible rocks of The Brissons and the cliffs of Land's End, scenes of many wrecks. Weschke became an experienced diver; sometimes searching for fishermen's lobster pots or nets that had become lodged in the rocks.

His first solo exhibition took place in 1958 at the New Vision Centre in Seymour Place, London. During the 1960s his work was included in many group exhibitions arranged by the Arts Council and by London galleries and he had considerable success. He was not however seen as part of the St Ives' group. His work had references to artists such as Bomberg, whom he had not met, but knew of through his friends Clifford Holden and Dorothy Mead, and also Francis Bacon whom he had come to know during Bacon's brief stay in St Ives. However the core of Weschke's art lies closer to the German Expressionist painters of the first part of the twentieth century: Otto Dix, an artist who knew poverty and rejection and who by chance came from the same town as Weschke, Gera, in Germany, and Max Beckmann who painted images of the coast, and the earlier expressionist Emil Nolde.

In the late 1960s he moved away from Cornwall to Gloucester. However by 1971 he was again back in Cornwall, living on Cape Cornwall and with a studio in St Ives. He later built his own spacious studio in Cape Cornwall. Weschke's work of the 1980s is based wholly on Cornwall; he paints the places and the people that he knows and those friends, human and animal that make up his world. Horses that exercise on the beach and the company of his dog Dankoff, who died in 1976 and lies buried in a cave near to the house. His many figure paintings bear witness to his complex emotional life – married twice and often responsible for bringing up four young children.

In his paintings the sea often threatens. The figures are almost always female. They have the immobility of exhaustion, vulnerable after sex and set in a landscape of strong sexual analogies, the action of water falling over rock, towering verticals of cliff face. There are other persistent images, such as that of the fire-eater whom he saw in a street in Frankfurt, myths such as *'Leda and the Swan'* (1985–86) and *'Europa and the Bull'* (1988–89).

Although he became a member of the Penwith Society and exhibited with the other artists of St Ives, he was naturally a loner and kept apart. If his work appeared abstract it was for a purpose, to better emphasise the power of the sea and the strength of rock. Colour was descriptive and used sparingly, unlike the strongly-coloured abstractions of other St Ives' artists.

In 1990 he made his first visit to Egypt. He believes that Egypt is the cradle of civilisation and he has a detailed knowledge of its early history. For him Egypt had the great sentiment of the clear spaces,

the notion of the noble Bedouin, the sun and the desert. When he arrived the dream he had of the beauty of the buildings was vastly exceeded by the reality. The scale and magnificence of what he saw overwhelmed him. Though he was less impressed by the floods of tourists, the grandeur more than contained them. This experience of the most ancient of civilisations has had a deep impression on him.

He has made an impressive series of paintings of the buildings of Egypt, but his interest is not only because of its architecture, it is rather the fact that in these vast structures man holds himself captive in time. He finds in the art and the architecture of ancient Egypt a symbolism of the subversive world of desire and the manipulation of myth and the subconscious. A number of the large canvases that resulted from these excursions were shown at the Redfern Gallery, London, in 1994. One of them 'The Nile near Kom Ombo' was bought by the Tate Gallery, and was shown in 1996 as part of a group in an Extended Display of Weschke's work at Tate Britain and later at Tate St Ives.

Karl Weschke is a complex man. He is resistant to enquiry yet highly articulate and discursive; similarly his paintings reveal much of his personality but there are much deeper waters yet. With the considerable success that he has had of recent years, the clarity of his work has increased and his work has a lighter clearer touch.

JEREMY LE GRICE (b.1936)

Jeremy Le Grice has had many studios. His present one is some distance from his house, down green and forgotten lanes to a group of ancient buildings. The studio is an old mill complete with the long-disused machinery, set in fields with horses. It is a place in which ideas can germinate and grow. He has always used his studio as a subject; he has painted its proportions and spaces, the strong light falling upon a blank canvas and the darker places below.

Jeremy Le Grice narrowly missed being born in Cornwall. His mother had to break her journey to Cornwall in order to give birth to twins, two months premature and each weighing only two-and-a-half pounds. Jeremy now lives in a portion of the manor house Trereife, his family home on the edge of Penzance. He and his twin sister were born into an old Cornish family, which has occupied the present house since 1799. Before that they came from a line of vicars from Bury St Edmunds that can be traced back to 1120. The son of one of these came as a tutor to Cornwall and married the widow of the house, joining the Nichols family to the Le Grice family. They founded generations of country gentlemen living on their estates, which extended out from Penzance and around Newlyn. It was Charles Day Nicholas Le Grice who gave the land on which the Newlyn Gallery was built in 1895. From that time, as trustees, members of the family have played an important part in the affairs of the gallery. Jeremy's father was killed at Dunkirk, an event which perhaps precipitated him becoming an artist and which subsequently informed and influenced the course of his work. His uncle became almost a second father to him and early on Jeremy spent all school holidays at Trereife.

Educated at Eton and with a strong interest in art, Jeremy found his first training in Cornwall. In 1955, Peter Lanyon, with William Redgrave and Terry Frost, had set up a summer art school in St Peter's Loft,

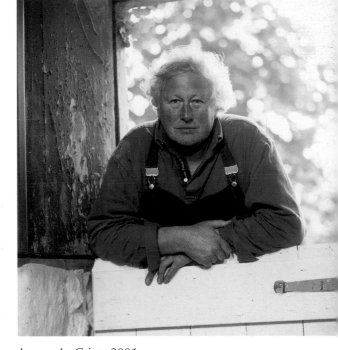

Jeremy Le Grice, 2001

153

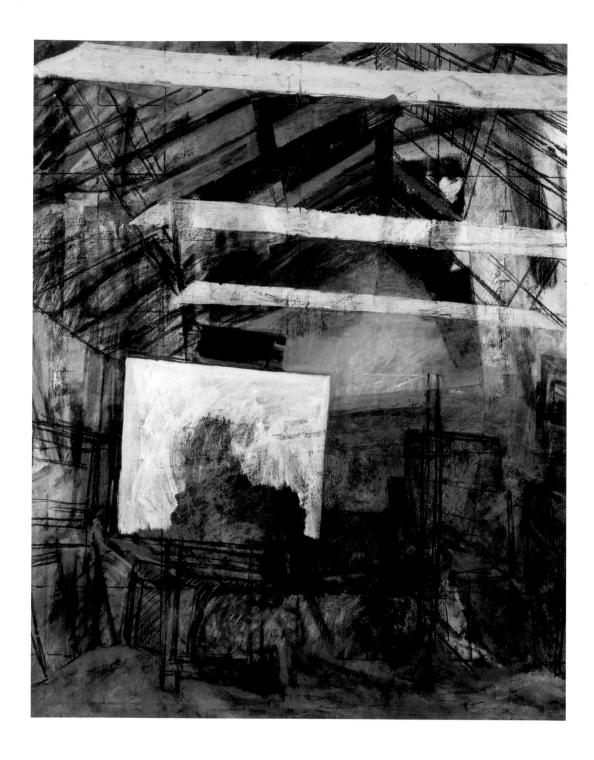

St Ives (now the print studios above the Penwith Galleries). Jeremy had seen a painting by Peter Lanyon 'Harvest Festival' of 1952, which greatly impressed him. Jeremy Le Grice was one of the first students to attend this new school, and for two summers he was a student of Lanyon. At that time there were only six students, four marvellous girls and one other man, Tony O'Malley, looking very much like the bank clerk he then was, with stiff collar and tie, an image that would soon change when he became a dedicated artist. The school was run as a French 'atelier', with classes in painting and drawing from the model. In addition expeditions were made to the cliffs and to the coastal landscape. Peter Lanyon was a painstaking teacher, teaching by example and by inspiration.

In 1957 Jeremy went to the Slade School in London, a total contrast to his previous experience. Under the Professorship of William Coldstream the Slade developed a wide range of interests among the many artist visitors and the students. Jeremy appreciated the discipline of drawing and the generous criticism of such teachers as Keith Vaughan and Frank Auerbach. In the summer of 1961, after four years at the Slade and with his wife to be, fellow student Mary Stork and their young baby, Ann, they came to live in St Just.

After London it was difficult to start painting landscapes again. For a year he found himself painting jugs – three of them, painted repeatedly. In these early years of professional activity he had a deeply-felt commitment to Cornwall, he was still very much influenced by Peter Lanyon and shared his powerful associations with the county. He was aware, however that he was working against a tide; by the late 1950s the art public had seen repeated assaults by the painters of the New York School, and the power of painters from Cornwall to command the prime London audience had waned. However the new neo-American painting did not persuade Jeremy. His subject was in Cornwall, he wanted to get to grips with landscape in an immediate sense; he painted many small, dark paintings of the north coast as a starting point. His 'St Just' period lasted throughout the whole 1960s decade.

He describes the next period, from 1972 to 1984, as twelve disjointed years, in which painting played only a minor part. In 1969 his marriage to Mary Stork ended. With three children it was a difficult time. In 1971 he remarried, to Lynn, herself an artist and designer of distinction, who was then teaching fashion at Bournemouth. She has later become well known as an interior designer. They moved to Gloucestershire, where Jeremy taught on a foundation course in Hereford and at Cheltenham Art College, then back to Cornwall. A large-scale barn conversion took much energy and time. They now had six children between them.

Jeremy's subjects are specific, places special to himself, which he has visited repeatedly over many years. He makes a conscious effort to see them subjectively, avoiding mannerism. He aims to portray as fully as possible the western part of West Penwith from Penzance to Zennor, including Sennen, Newlyn Harbour, St Buryan, Penberth and St Michael's Mount. He searches for the ancient, rather than current topographical descriptions. He does a lot of drawing out of doors and frequently starts paintings in the landscape, but he usually continues them in the studio, and works on them for long periods, weeks and months – and many changes are made. He discovers the direction of a painting by testing his own responses as change follows change. He works in few colours with strong tonal

JEREMY LE GRICE
'Two Jugs', *1963*
oil on board, 36x40cm

Opposite page:
JEREMY LE GRICE
'Alsia Studio', *1996*
oil on canvas, 155x125cm

155

JEREMY LE GRICE
'White Cottage', *1995*
oil on board, 30x30cm

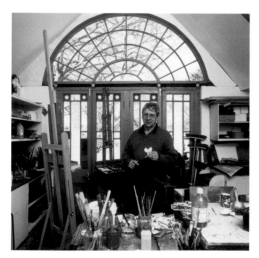

Robert Jones in his studio
Photo: Simon Cook

contrasts. Shapes are boldly delineated, strong and assertive, sea and rock, the hulls of fishing boats, trees seen against the skyline. Sudden intense blues and sharp greens contrast with white and black, used as positive ingredients. He pursues his own direction, little influenced by other artists around him; his own commitment is to Cornwall.

Jeremy plays many parts in local artistic affairs. As a Trustee of the Newlyn Gallery he has been involved in battles over policy and played a part in the discussions over extensions to the Gallery. Although he has painted in other countries, including France, Germany and Mallorca, Cornwall always remains his true subject. He looks for the old, sombre characteristics of Cornwall, particularly the coast, the sea and the weather. His is a powerful and personal vision.

ROBERT JONES (b.1943)

Robert Jones belongs to a long line of sea painters working in Cornwall, a tradition that goes back to the mid-nineteenth century. In the early part of the twentieth century Julius Olsson ran a School in St Ives of 'Sea and Landscape and Painting'. Olsson was himself a sailor who made many long passages in his own boat and taught generations of artists, including many from overseas. Robert Jones has made the sea his subject. He was born in Newquay and he is is one of that small number of artists who were born in Cornwall. His early life contained tragedy. His father, who was a medical attendant in charge of surgical instruments at the Radcliffe Hospital, Oxford, died six months after Robert's birth. In his first year of life Robert contracted an extremely serious stomach ailment and spent three months in hospital. He felt that these early ordeals and the fact that he grew up as an only child in an all-female household contributed to his later decision to become an artist. Visual things fascinated him from his earliest memory.

Growing up in Newquay in the 1940s and 1950s brought with it a great sense of liberty. He lived on the beaches and in the countryside and he had the freedom to wander and roam. Swimming and surfing on improvised boards came naturally. This unconfined life was in contrast to his days at primary school, which he described as brutal. He remembers being caned almost every day for a year, for the most trivial faults of behaviour or inattention. He was still beaten even when he got all his sums right, ten out of ten, because the teacher thought he was cheating. He later felt that this treatment affected his relationship with men, most particularly with his stepfather, Samuel Currah, who became part of the household after his mother's re-marriage. Robert's response was not to rebel but to become a loner, avoiding schooling whenever possible, sometimes by feigning illness in order to draw and paint at home.

After school, whilst working in his uncle's outfitter shop in Newquay, he also began to paint and draw more seriously. Whilst sketching on the cliffs, he had a chance meeting with Ivy Pierce, an artist from Newquay, who admired his drawing. Her interest encouraged him to join an evening class in art. After three nights attending the class he had a dream in which the voice of his teacher asked him 'Robert are you happy in your work?' to which the answer was 'No'. The next question was 'Would you like to go to Art School?' This dream was repeated word for word the next night. The result of

these revelations was that he decided to acquire some academic qualifications and attended Cornwall Technical College for eighteen months and also went to classes at Redruth Art School. He was then able to go to Falmouth School of Art as one of the last students taking the National Diploma in Art and Design. He found this a happy place; it was then an art school with only sixty-five students, run by staff who were painters and sculptors and who treated their students as artists. He was strongly influenced by Francis Hewlett, who was head of painting, and Robert Organ, a lecturer in painting, both of whom became his close friends. This was followed by a year in Cornwall, painting intensively,

ROBERT JONES
'Wrasse', 1984
coloured pencil, 37x40.5cm

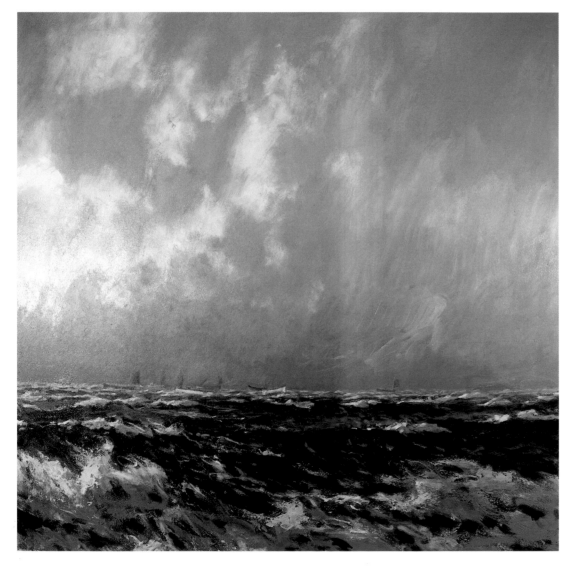

ROBERT JONES
'The Mackerel Fleet', 2002
oil on board, 122x118cm

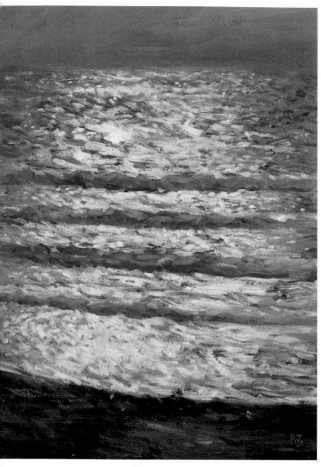

ROBERT JONES
'Light on the Water'

oil on board, 122x118cm

and returning to the sea as his main subject. In 1965 he gained a postgraduate scholarship at Manchester College of Art and worked under Norman Adams, but without a grant he was unable to complete the first year of his course. At the College of Art he met a fellow student, Susie Jackson, and he decided to remain in Manchester, doing a variety of jobs.

Susie came from a Jewish family and, following the death of her father, she and Robert decided to go to Israel to work on a Kibbutz. They were there for seven months, in the period of increasing political tension preceding the Six-Day War. They witnessed exchanges of fire, and were shelled from the Golan Heights, and were eventually advised by the British Embassy to leave the country. They then lived in Brighton where Robert took a teachers' training course at Brighton College of Art. In 1969 they were married. During a visit to Summerhill School in Suffolk, which Susie had attended as a child, Robert discovered that there was a vacancy, teaching art and craft. He was to work there for three years. In this small and free community, under the famous headmaster A.S.Neal, the quality of the children's work produced with Robert was astonishing. It was the children's decision to go to lessons, or not, and Robert saw that the work of the art room had a positive effect upon their development. He also found time for his own work, making many drawings of the pupils. When their first child was born they decided to return to Cornwall to St Columb Major. Robert, with a friend, bought a commercial fishing boat, fishing for crab and lobsters from Newquay, and later from Hayle and Newlyn. This was the first of several boats that he later owned, the largest was the thirty-eight foot ex-French crabber *Michael and David*.

During his time as a fisherman Robert had many adventures and narrow escapes. He experienced extreme conditions at sea, and faced the difficulties of navigating the north coast of Cornwall. On one occasion, in deteriorating weather off Land's End, his fishing boat nearly foundered and they were lucky to get to Penzance. In the early days Robert devised a method of recovering his crab and lobster pots by making drawings of the coastline, with landmarks which provided him with the position of his gear. These views of Cornwall and his experience at sea, had a powerful influence upon his later work.

Robert felt an increasing need to paint. And after seven years working as a fisherman he gave up the sea as a livelihood and combined painting with teaching at Mullion School. His family grew, and there were now five children, three boys and two girls. The sea continued to provide him with subjects, and a great deal of his work at this time was in the form of black and white drawings and etching. His studies of fish are precise and detailed, and these heavily-worked coloured pencil drawings formed his first exhibition at the Wolf at The Door Gallery in Penzance, in 1987. This, and the success of his one-man exhibition at the Newlyn Art Gallery in 1988, led him to make further studies of tidal states, weather and light, working on the stretch of coast that he had known since the family moved to Hayle in 1982, between Godrevy and Portreath. These gouache and coloured pencil studies were a breakthrough for Robert. Colour is very restrained, the sparkle of light upon water and the description of turbulent skies reveal a deep knowledge of the sea and of changing weather.

There is an obsessive quality about these early drawing; a tension increased by his financial struggles and his wish to find a true direction in his painting. The paintings are mostly small; few are more than

ten or twelve inches high. The paintings of the north coast were mostly done from the cliffs early in the morning to capture the effects of sun on water, sometimes they were painted from the back of a fishing boat and were of the sea and men working. Others are done in the studio from memory, or from what he describes as 'messing about', working on paper or board with pencils and paint to discover an image, which is then refined.

By this time his teaching had been reduced to part time lecturing at Penzance School of Art and Falmouth College of Art until an increasing demand for his work enabled him to paint full time.

He frequently works on a series, painting the same subject from different points of view or at different times of day. For years he worked outside, relishing different weathers. A series of studies, painted on New Year's Day 1995, was included in the exhibition at the Tate St Ives, which was entitled 'Porthmeor Beach, a Century of Images'. He has made many painting trips in different parts of the British Isles and as far afield as California and the Greek Islands.

In the 1960s, whilst still a student, Robert Jones had seen an exhibition of the work of Alfred Wallis, the ex-seaman and fisherman who, in his seventies, started to paint his memories and became an important influence on the artists of St Ives. Robert recognised the importance of the features in Wallis' paintings and spent several years researching the sources of Wallis' images. In his recently published book *Alfred Wallis Artist and Mariner* (Halsgrove 2001), Jones identifies the wealth of geographical, historical and nautical knowledge contained in Wallis' paintings.

For several years Robert Jones has been working in oil paint, either on the spot or in the studio. His most recent work is the most ambitious and often large in scale. He continues to be concerned with the conditions of weather and the changing light on sea and land. Many of the works are made in series in which these various components can be closely examined. His colour, too, has become richer. In 2001 his wife and eldest son Joe established a gallery in Camborne to show his own and others' work, and his work can also be seen in several galleries in Cornwall and London.

STUART KNOWLES (b.1948)

The paintings of Stuart Knowles are an instinctive journey towards a form of abstract painting that unifies the description of familiar objects with their more emotive characteristics. He feels very close to the land and has taken as his subjects the strong, simple forms of Cornwall, the standing stones with their prehistoric associations, Celtic crosses, the mine engine-houses and chimneys and the industrial debris of the nineteenth century. Even his choice of colour, slate greys, indigo blues and acid greens, label him as a Celt. Yet in the painter's reconstruction of these subjects a new synthesis appears, and we are taken into a view of Cornwall which includes the artist's feelings and emotions.

Stuart Knowles was born in 1948, in Redruth, Cornwall. His father worked in the aircraft industry and when Stuart was very young the family moved to Amesbury near to Stonehenge. Although he was very young he has clear recollections of this great prehistoric temple made of giant standing stones

Stuart Knowles, 2002

and it is still a recurrent memory for him. A further move took the family to Aldershot and, at the age of sixteen, he went to Farnham School of Art. After a period working for the Forestry Service he went to Winchester School of Art, where he took the Diploma in Art and Design with First Class Honours.

This was followed by two years postgraduate work at the Slade School in London. At that time the Slade had taken space for postgraduate students in St Catherine's Dock, in the City of London, which provided a very stimulating atmosphere in which to work. In this vast, near derelict building, students from different countries were able to work on a large scale. In addition, other artists were also working in the building; Bridget Riley had her studio there, Peter Sedgeley was running a kinetic workshop, Stanley Kubrick filmed there. Stuart had expected the Slade to be much more figurative but he found that it was very wide open, and was largely left to his own devices. At that time he was making what he described as, 'rather strange constructions' but tutors, including Robin Denny and Malcolm Hughes were supportive and helpful.

After the Slade Stuart got a job driving trucks carrying antiques to different parts of Europe. He also made short trips to the United States. Meanwhile he was painting in a SPACE studio in Hackney, London. These early visits to several countries were very important to him. He was able to see work that was being produced, and in a number of cases to get to know artists who were making their way on the international scene.

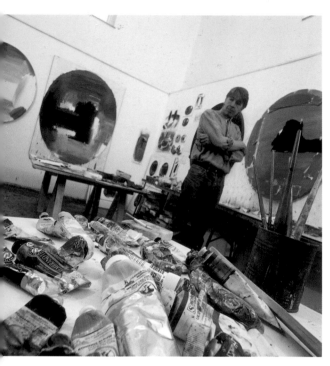

Stuart Knowles in his studio, 2002

Through his interest in Japanese prints he has read extensively about Japanese Kabuki and Noh Theatre and found that the formal masks of the Noh Theatre had a special fascination for him. Such masks are a device for recognition, but they also conceal. Stuart Knowles is by nature somewhat solitary and the disciplines of meditation and contemplation had a great appeal for him. There is also something of a theatrical presence in his work and the form of the mask is strongly echoed in many of his most recent paintings. In 1986 he wrote: 'Mask – enabling one (the Actor) to exceed the limitations of the corporeal self "the distant being", perceptible only far off, flows into our presence through the mask'. (Kerenya, from the artist's workbook).

In London he had married his then wife Elizabeth who was a curator at the Tate Gallery. However they both found that London was becoming increasingly difficult for their work, there was no continuity of tenure for the studio and rents were going up. They both had a strong desire to return to Cornwall and in 1986 they decided to make the break. They found a hill, farm near to Marazion, badly in need of repair where Stuart created his present studio, largely with his own hands. After London, his return to Cornwall was a great help in sorting out his ideas and clarifying new directions. He also taught for short periods at Falmouth School of Art.

Stuart Knowles is not naturally historically minded; he prefers to let matters take their own course and believes that if anything he does has any meaning it will find its place, but he has strong feelings for some of his predecessors. He has a special place for Peter Lanyon. He admires the rawness in his work that appears to be cut out of the landscape itself, and could only have been produced in

Cornwall. He found that passages in Lanyon's painting precisely confirmed his own sensations, and what they had in common was their Cornishness.

Stuart has been exhibiting his work in London and elsewhere from 1967. In 1972 he exhibited at the newly-opened Ikon Gallery in Birmingham. As a member of the Artists International Association, operating from Lisle Street in London, he met artists from Bologna who persuaded him to work in Italy; his first solo exhibition was in Udine, Italy in 1983. His first exhibition in Cornwall was a large solo exhibition in the Newlyn Gallery in 1991, and Cornwall is a central feature. In his notebook of that time he writes:

Cornwall – objects made here cannot be simply records of the land, of nature, naturalistic – here, especially, the manifestation of the past, the moods of nature and all the inherent metaphors encompassed by such changes must be present in an object that purports to be 'of the place... a picture of Cornwall should force the observer to wait on the hidden sun to emerge – or when it is there to expect his visions of colour to be hidden beneath a blanket of cloud and melancholy at any moment. (November 1987).

STUART KNOWLES
'Tin Bay', *20022*
oil on canvas, 33x38cm
collection: the artist

STUART KNOWLES
'Rain on the Land, Rain on the Sea', *1995*
charcoal on paper, 56x84cm
collection: the artist

In 1996 he showed with the Austin Desmond Gallery, London, 'Winter Bay Series' - the first specific essay with direct reference to the Bay and the far West of Cornwall.

His paintings are tied to places, sites that he sees often and revisits, but they are not simple descriptions. He paints more from the general sensation, if he is asked to name any of the places, the only one he would be specific about would be St Michael's Mount which is so prominent and which he sees almost every day. He works slowly, often in series, usually starting as small free paintings in oil on paper, and as the forms become defined, he extends them into small canvases and then perhaps a few larger canvases. These often-rehearsed brush strokes have a symbolism, which relies on instinct and intuition, universal signs, which can be read without knowledge of their explicit meaning. They are not the familiar symbols of the cross or the circle; they are fluid signs made by a few broad strokes of a loaded brush, in which the calculation of colour and tone give a three-dimensional presence on the canvas. This process of selection and search is a highly personal matter and when he feels that he has completely understood it he is able to transfer its power and strength to the onlooker.

His work is essentially emotional. Paint is used liberally and the gesture of the brush stroke and the splatter of the loaded brush are allowed full play. He works freely and expressively, but within a clear structure. Many of his recent pictures are constructed within an ellipse, painted on shaped canvases which can vary in size from about a foot across to five or six feet. The ellipse is a reference to enclosures, habitation, stone circles and Mount's Bay itself – but perhaps more importantly, an 'arena' in which the ritual theatre and confrontation of painter and materials can take place. When he first travelled to Spain he went to a bullfight in Alicante. He found the experience powerful and terrible at the same time, horror and excitement combined. It seemed to satisfy a basic instinct linked to his Celtic roots.

This is free abstraction rooted strongly in the rocks of Cornwall. No specific mark or brush stroke can be read as a standing stone, a Celtic cross or a mineshaft chimney. The ambiguity that is part of the work allows a variety of interpretations; there is a hierarchy of forms, very clearly stated but non-specific. Nevertheless these abstract marks are resonant of Cornwall, a landscape of sun and damp grassland, an atmosphere that exists between the dark silhouettes and the lightened horizon. He wrote:

Whilst we look for metaphor and symbol to feed and corroborate our work, here in the moods of light and weather, in the scarred rawness of landscape, one sometimes glimpses the very origin from which metaphor and symbol are born.

KURT JACKSON (b.1961)

Cornwall has always been part of Kurt Jackson's life. He was born in Blandford, Dorset, but spent a large part of his early life in and out of North Cornwall, near to Boscastle. Both of his parents were visual artists who also taught and travelled in many parts of the world. In some ways he was self-taught, finding his own path, with his artistic direction coming from his parents and contemporaries. He had always juggled his interests between the two wholly dissimilar studies of the natural sciences and the visual arts. At school, which he described as 'a run down comprehensive school in

Kurt Jackson
Photo: Caroline Jackson

Hertfordshire' he showed talent in both areas. He had a strong instinct to refuse further training, but a chance meeting on a beach in Greece, with two Oxford students, gave him an insight into university life, and when he was offered a place at Oxford on a course in Zoology he accepted. He followed the course but it was art that attracted him more than the sciences and he spent much of his time painting and drawing at the Ruskin School of Art in Oxford. It was also in Oxford that he met Caroline, his wife to be.

In 1982 he graduated from St Peter's College, Oxford, with a BA Honours Degree in Zoology. The year following was a further search for direction, travelling extensively in Europe and to Africa, Greece and later to Latin America, painting and drawing every day. It was during this exploratory period that he decided to become a professional artist. Another decision that he made at this time was not to follow his parents' path in teaching. He preferred to do odd jobs in order to survive, he also decided to stay in Cornwall.

Other than a shared love of Cornwall, he does not feel part of any group of artists. He accepts that the character of his work – most of which is painted 'en plein air' and his independent personality, separate him from other painters that work in this south-west corner of England. Amongst the painters that he can relate to is Karl Weschke, who lives and works nearby, and whose paintings have the feeling of being painted out of doors, although he knows they are created in the studio. His heroes include the Spanish painters Antoni Tapies and Miguel Barcelo, and Keiffer in Germany, who he finds are more interesting to him than others in England. However the exhibition 'St Ives' shown at the Tate Gallery, London, in 1985 had a powerful influence upon him, and affected his decision to move west to Cornwall to work, recognising it as a place where art could happen. After a period in Boscastle in the mid 1980s with his young family he moved to the West, partly because of the lack of arts infra-structure in North Cornwall. In 1989 he bought the Victorian Police Station in St Just, which gave him good accommodation and three spacious studios. Kurt Jackson now lives and works in a smallhold-ing on the edge of St Just where he has two studios, one for the larger canvases, and another one for work on paper.

He has always worked out of doors, although the practical difficulties of working on large canvases might require that some work is done in the studio. He is very productive and works fast, although he destroys a lot – perhaps more than he saves. He first studies a subject or location by making copious drawings, sometimes hundreds. In comprehensive notebooks he studies the components of the subject from many points of view.

His 'projects' bubble out of his inner self. He examines the way people work, farmers, fishermen and miners, which gave rise to the series of paintings he made of the underground workings of South Crofty, the Carnsew granite quarry and the Tinners Way. He has a strong ecological interest and many of his paintings are concerned with the landscape of Cornwall, its heritage and the changes that occur. His approach to his painting is analytical, the result of his own natural powers of observation, developed by a scientific training. He follows the seasons and the processes of growth and change.

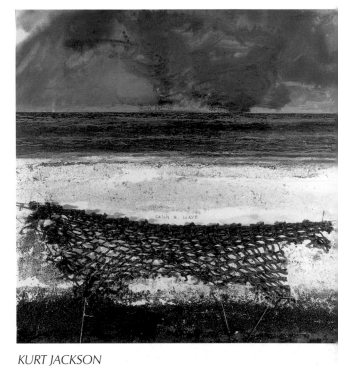

KURT JACKSON
Catch A Wave', 2002

mixed media and collage on canvas, 152x152cm
Photo: Simon Cook

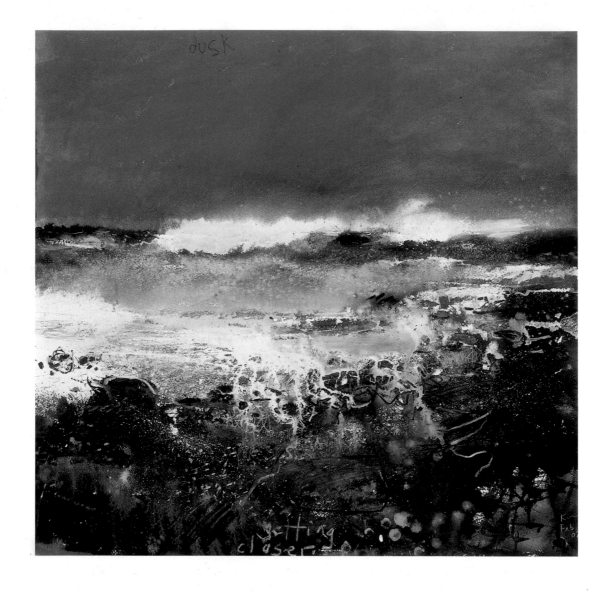

More intimate ideas are also pursued, such as a series of paintings which follow the stream near his house to the sea, painting a small picture every ten paces. Another example was a series of paintings of a lone hawthorn tree, painted from the same place once a week for a year.

Kurt Jackson has a very clear idea of the method by which he works; in his choice of subject he first looks for an 'essence' that is a place or situation that can characterise the strong feelings he has for the subject.

Every painting is an experiment, a large painting can happen in one day, on other occasions it can take months. When he begins a painting there are three factors, all equally important, whether it is a ten-minute sketch or a six-month oil. He first looks for the 'documentation' to capture the character of the place. He has no problems with representation; he accepts the evidence of his eyes and the perspective of the situation in which he finds himself. He then considers what he calls 'the picture of the painting'. This is his mental concept of the scene, as it will appear on his canvas. This leads to the 'painting of the painting', the preparation of the surface, the manual work of mark making and the balance of light and texture that will express the situation, together with the enjoyment of paint for its own sake. As his work is done out of doors there is also the experience of being there, the senses of hearing, smelling, and the general atmosphere of the place which he would like to include in the painting.

He works in oils and acrylic, but with other added media – ink, shellac, and even plaster and collaged items. A memory of a deceased fisherman produced a painting in which the fisherman's oilskins were glued to the canvas. The figure does not often appear in his painting, although occasionally a small figure gives scale. He travels a lot, to places that mean much to him. In Spain he goes regularly to a village where he paints the same olive grove repeatedly.

He tours Cornwall in his travelling studio, a Ford Transit van. He searches for spontaneity, which he finds in rough and rocky places such as the Kenidjack Valley and Carnyorth Common. He paints at Tregeseal and in the Delabole slate quarry. He has currently five places, all within walking distance of his home, which he paints over and over again. One is at Priest Cove, where he can use one of the fishermen's huts to store work. From here he paints the sea on six-foot square canvases, working directly from the beach. A sequence of large paintings of the open sea, 'the last wilderness'. Sky and sea reflect the same colours, blue, indigo and white, broken by warmer browns and ochres. There is a strong horizon; parallel to the liquid graduations of the sea, from deep water to the shallows; the reflections on wave tops and glistening pebbles are pinpoint sharp.

He has exhibited widely in Cornwall, although he is not very keen on mixed exhibitions, and his work has been shown in the public galleries in Truro and Falmouth. Many of these Cornish exhibitions have toured nationally and internationally to other public galleries. A major exhibition is arranged for the Newlyn Gallery in 2003. He also exhibits in several commercial galleries such as the David Messum Gallery in London, the Great Atlantic Map Works in St Just, and the Lemon Street Gallery in Truro.

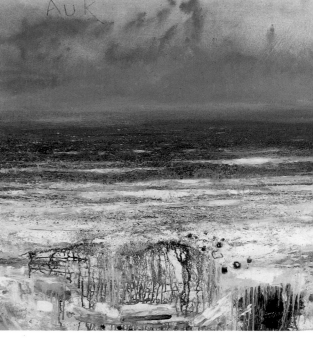

KURT JACKSON
'Auk', 2002
mixed media on canvas, 92x92cm
Photo: Simon Cook

Opposite page:
KURT JACKSON
'Getting Closer, Dusk', 2002
mixed media on paper, 56x59cm
Photo: Simon Cook

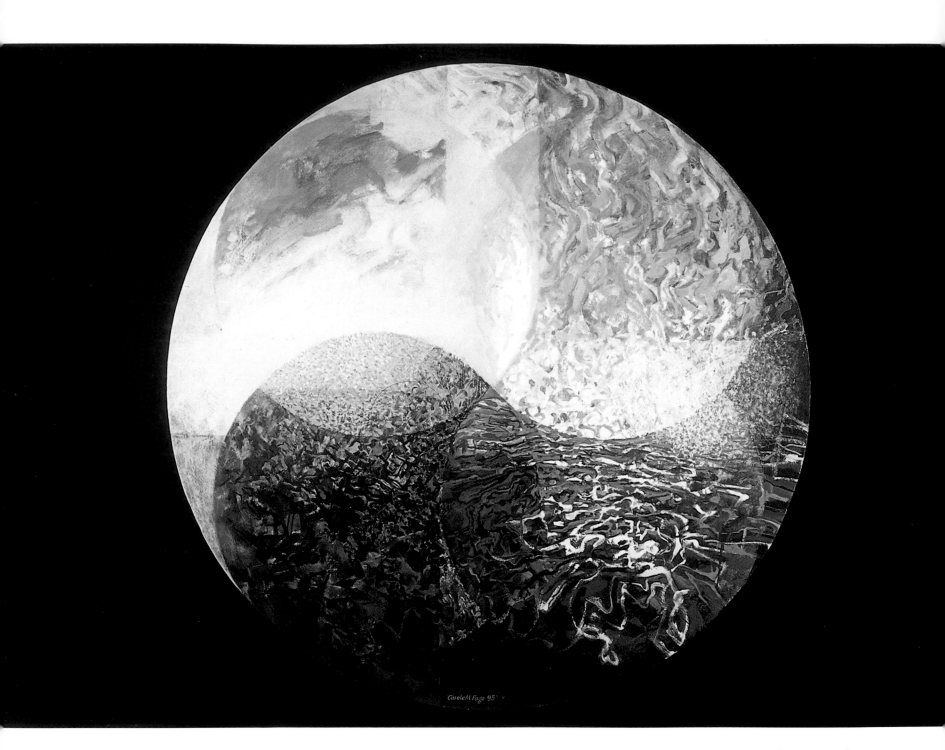

REALISM, IMAGINATION AND FANTASY

I n many ways the artists of Cornwall are echoing the national situation in which no single style or set of ideas dominates. Much that modernism had suppressed has now reasserted itself, an interest in narrative, myths, symbols, expressionism, primitivism and the landscape tradition.

The exposure to the various forms of abstraction in art and the reduction in the role of painting, reflected in the various forms of minimal and conceptual art, produced in some artists a desire to regain the object. A significant number wish to look again at the possibilities of exploring their world in paint and giving their own imaginations full rein. This may at times take them into their own private worlds, but frequently they are prepared to share this world and create a fascinating experience for both artist and viewer.

In reclaiming the art object, these artists may also regain a tradition that had been put aside, or find in the history of art some overlooked treasure. They also recover the pleasure in using the material of paint, with all its wonderful fluid characteristics, and they may again explore the use of fully three-dimensional space in their paintings. In some cases this revival of traditional media is coupled with an enhanced awareness of the need for a more social art, which in turn produces a greater involvement with contemporary life.

BOB BOURNE (b.1931)
There is a sustained tension in Bob Bourne's paintings, a link between the painter and the sitter or the scene, which is the result of an intensity of looking. He has written:

Painting to me is a form of controlled breathing. The act of creation is an endeavour to penetrate to the deepest level of understanding in the inner being. It has always been the truest way to communicate with the mystic soul.

Bob Bourne is extraordinarily single minded about his painting. For him it is a natural activity, yet supremely difficult. Throughout his painting life he has searched for the best way of doing it, first with paintings of landscape, which have lead him naturally to interiors in which the figure occupies a central place. An ideal landscape is seen through a window. There is a dream-like quality about these landscapes, as if they belong to some far off beautiful country, yet many have Cornwall as

Opposite page:
CAROLE PAGE DAVIES
'Elementa 4 in 1', 1995
oil on canvas, 91cm diameter
collection: the artist

Bob Bourne, 2001

BOB BOURNE
'Green Crucifiction', *1971.*

80x90cm

their subject and their sites are quite specific; Botallack is a favourite spot.

Bob Bourne was born in 1931 in Exmouth and brought up in Brighton. His father was a heart specialist and the senior doctor in Brighton Hospital during the war years. As a friend of Aneurin Bevan he played an important part in the formation of the National Health Service. Bob was educated at Brighton College but during the war, with his mother, brother and two sisters, he was evacuated to Bermuda. From the age of eight he lived an active outdoor life, despite a birth injury which made him clumsy and uncommunicative, so although he could sail a boat he was unable to swim. For a time he was diagnosed as spastic and attended a special school, and from early childhood he has suffered from co-ordination problems; painting has been his way of resolving these.

He came back to England three months before D-Day and returned to the prep school in Brighton and then to Brighton College. At the age of eighteen he had a further breakdown in his health and went to a special school in Kent and it was during this period that he started painting. For several years he did any job that came along but he had made a decision to paint and at the age of twenty-one he came to Cornwall on a hitchhiking holiday. When he arrived at Zennor he felt it was a place where he should remain, and he was able to find a cottage on Castel An Dinas. His only formal training in art was a brief period as a student at Bristol School of Art, an experience that turned him away from art schools.

Painting was the one thing he found he could do. To earn a living he worked in hotels in the summer, washing up and waiting at table, and found ways of living on very little. He met other artists in the pubs, and in and around the towns and villages. He believes there is nowhere else in the country where it was so easy to mix with other artists. He felt that not having been to art school put him at a disadvantage, but gradually his work began to be noticed; Peter Lanyon was particularly helpful at this early stage.

In 1973 he had a successful exhibition at Tooth's Gallery, London. At that time he was very much a loner, living in a caravan on the moors. From having absolutely nothing to a one-man exhibition at this prestigious gallery was almost too much for him. Whilst still recovering from this experience, he had met a number of Australian artists through the Poetry Society in Earls Court, London. On the invitation of Brian McKay, an Australian painter, he went to Perth, Western Australia.

Bob felt he had come to the end of something in England and that Australia would offer new opportunities. However he found when he got there that he had made a mistake, the isolation of Perth, more than fifteen hundred miles from the next large town, was too intimidating. He tried to paint in Australia but not very successfully. He had been in Australia for nearly eighteen months when he applied to do a course at the University of Western Australia, but due to a mix up they put him down for shorthand and typing, so he caught the next plane home. He described Australia as 'The disorganised turmoil of the outback.' However this experience brought him back to his roots; the effect upon his painting was that it became almost totally abstract for two years.

On his return to Newlyn he rented Tom Gotch's old studio on Newlyn Hill, a big wooden building

with a couple of rooms. Later he acquired a converted barn in Newlyn in which he worked for many years. From 1983 for six years he showed at the Kalman Gallery in Knightsbridge, London, and in other small galleries. He was then mostly painting landscapes, with the figure as part of the landscape. His friend Peter Thompson, the poet, was of the opinion that that when Bob came back from a summer at Alba-la-Romaine in Provence his work had attained its full weight and maturity.

Bob continues to travel and many of his paintings have a Mediterranean feel. He goes frequently to Crete where he draws and produces paintings on his return. On a later extended visit to the mountains of Crete, the village houses re-awakened his fascination with interiors, and he painted a series of figures in rooms with windows opening on to an ideal landscape.

Many of the figure paintings are connected with events in his life, his feelings and his inadequacies. Although these may be described as story paintings he does not investigate or explain their sources, he feels it is up to the viewers to make these interpretations for themselves. His paintings of figures in a room have affinities with Matisse who is one of the painters he most admires. There is also a surrealist quality, the surrealism of di Chiricho or Magritte. The paintings have a potential for the unexpected, a half-explained problem or the hint of absurdity.

He does not use drawings in preparation for a painting, except in what he describes as 'straight' landscapes, that is a very specific view of a place he knows, even so, by the time he has finished they are totally different to the drawing. Once he starts on a painting he is concerned with the shapes and colours that come on the canvas. In the case of his more recent work he would start with two large abstract shapes, which in the process of painting became a landscape seen through a window.

Bob has been a member of the art societies of Newlyn and Penwith for a period of some thirty years, but he feels that currently there are members who he does not respond to. However he has shown his work widely in Cornwall at the Newlyn Orion Gallery and the Penwith Gallery, St Ives, and in London with Arthur Tooth & Sons and the Crane Kalman Gallery. He has also shown in Western Australia at the Fire Station Gallery and the Lister Gallery in Perth, and exhibited in France, Germany and other galleries in London. He now works in Penzance.

CLIVE BLACKMORE (b.1940)

Clive Blackmore was born in Kingston upon Thames and brought up in Twickenham. He went first to art school in Twickenham land later to Kingston School of Art where he did painting. He remembers little of that time except that he developed a passion for French painting and a preoccupation with traditional New Orleans jazz. He taught himself the trumpet and worked for some years with the Barry Martin Band, which is still playing to this day in America.

Blackmore's musical and artistic interests began to change in his early twenties. On his way back to work at the late night sessions at Studio 51 in Great Newport Street, he would go to a concert at The

BOB BOURNE
'Autumn Landscape', *1986*

105x125cm

Clive Blackmore, 2002

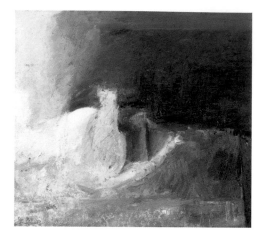

CLIVE BLACKMORE
'Still Life, 3 Objects', *2002*

oil on canvas, 45x50cm

Festival Hall, especially if it was a Bach recital, and realised that his interest in jazz was on the wane. Also, at about this time, he saw the work of Shoji Hamada and Michael Cardew, which fired his interest in studio pottery.

Leaving Old Windsor and the river boat on which he lived (now married), he moved to Falmouth in Cornwall, where his son Matthew was later to go to art school. Blackmore started a pottery in partnership with friends in Helston, where he bought a cottage and lived with his wife and two sons, Theo and Matthew.

The break-up of his marriage brought him, in 1977, to the place where he now lives, an old farm-house overlooking Mount's Bay and the Penwith peninsula. It was here that he and his new partner, Ann, brought up Theo, Matthew and Ann's son, Sebastian, and started a pottery in an old cottage that is part of the property.

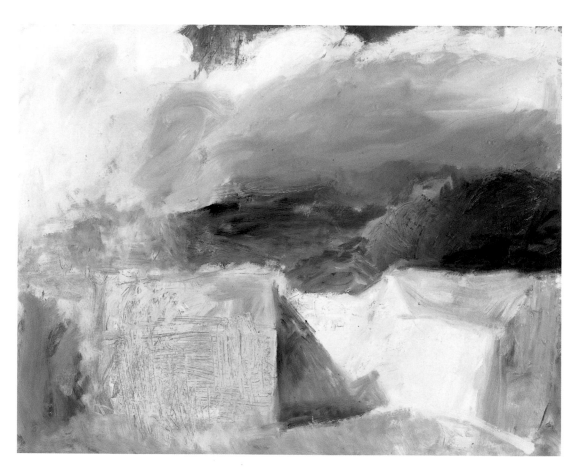

CLIVE BLACKMORE
'Garden Buildings Near the Sea', *2002*

oil on canvas, 60x75cm

Drawing has always been central to Blackmore's artistic practice both as a potter and painter. He never ceased to draw and it was through his drawing that he began to paint again full time in 1985.

The studio is a large room that once housed gas and electric kilns and is filled with the white light of the coast. In one corner is a well-worn upright piano, evidence of his continuing interest in music, this is in addition to the Bechstein grand in the house.

In 1986 he began to exhibit with the New Academy Gallery, London, which was then housed within the Royal Academy of Arts, and he has shown with them regularly ever since, as well as at other galleries.

Blackmore's work is figurative and his subjects are still-life and landscape. He feels that his earlier paintings were dependent to a certain extent on charm, but now the work is more sparse in its realisation of the subject in order to achieve a feeling of stillness and quiet, a quality he admires in Chardin, Morandi and the late gouaches of Rothko. The expression of light in painting and its effect on our emotions is another of his preoccupations. It is not so much the light of the South of France, where he and Ann have a village house in the Vaucluse, but the veiled luminosity of Cornwall in the autumn and spring that affect his work.

Except for sketches and notes made quickly out of doors for his landscape paintings, his work is carried out in the studio. It is not unusual for a canvas to be brought to a finished state only to be scraped right back at the end of the day and restarted the following morning. This process can be repeated for days or weeks until he feels that the image can stand on its own.

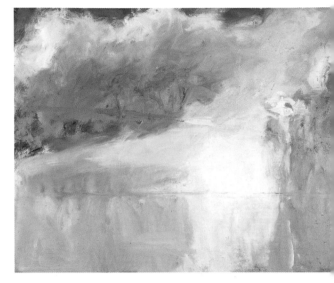

CLIVE BLACKMORE
'Lake, Early Morning', 2002

oil on canvas, 60x75cm

GRAHAM OVENDEN (b.1943)

Graham Ovenden is a bibliophile, a collector and a scholar, but first he is a painter. He paints in oil, working to a high finish and with great precision. Colour is graded and radiant. To apply the paint he uses fine brushes, his fingers or anything to hand, but the finished surfaces are immaculate. In his landscapes colour is strong, often glowing. Many of the landscapes are untenanted, empty and expansive; perhaps the only trace of human habitation is some broken mineshaft chimneys. This is Cornwall abandoned by man. He may picture the late evening, with the sun behind clouds, silhouetting standing stones on a remote hillside as a kind of transfiguration. Although he does not subscribe to the religious views of the Pre-Raphaelites, he retains a great respect for their work and attitudes.

He paints thinly in oil paint and believes that luminosity is an important quality in painting and that if you paint with impasto, which is colour thickened with white, luminosity is destroyed. This can be wonderful if you look at a Constable oil sketch, but it is not for him. He uses a nineteenth-century technique; the grading of colour is achieved by careful under-painting and by transparent glazes of colour. He is not a fast painter; he probably paints seven or eight pictures a year; a big painting might happen every two or three years.

Graham Ovenden
Photo: Chris Bowden

171

GRAHAM OVENDEN
'Peter and Juliet Blake'

oil on canvas, 122cmx92cm
Photo: Peter Nahum

Opposite page:
GRAHAM OVENDEN
'The Great Tree', 1978

oil on board, 46cmx40cm
Photo: Peter Nahum

Ovenden no longer works directly from nature, although he has done so over some forty years, sitting out in the cold with his sketchbook. Now he works out of his head. He does not even refer to his earlier drawings; he feels they get in the way of his vision and he is reassured by the fact that Samuel Palmer worked in a similar manner in the latter part of his life. Essentially he believes that the source material is not too important; it is the work of art that counts. He is very much against the 'grand manner' in art; the assumption that every mark the artist makes is of great consequence. For him it is the whole work of art that matters, the artist is the servant to his art, not the master.

Portraiture is an important part of his work; these are scrupulously correct views of family and friends, less exaggerated but perhaps more intense than the landscapes. The drama of confrontation is enhanced by the soft boundary edge that encloses the figure against a dark background. The eyes of the sitters have an unusually magnetic effect; the same fixation appears in the fictional characters that he paints, such as the mad Ophelia, fading into a background of clouds.

He has worked and still works as photographer, but he keeps this separate from his painting. As a young man he saved for his first camera by doing a paper round, and at the weekends he would take a train into the East End, recording the life around him; working people, children at play, all classes of society going about their normal daily business. Recently, some thirty-five years later, these photographs have been published in America as an important document of their time.

Graham Ovenden was born in Alresford, Hampshire in 1943. He had strong family connections with the West Country and in his early years he was a regular visitor to Dartmoor and Cornwall. He studied at Southampton School of Art from 1960 to 1964, and then at the Royal College of Art, London. His tutor during his last two years was Peter Blake, who later became a great friend and for a time gave Graham a room in his house. Whilst Ovenden was still a student Blake invited him to make illustrations for a new edition of *Alice in Wonderland*. A year later Blake and Ovenden shared an exhibition at the Waddington Gallery, London, of paintings, drawings and screen-prints on the theme of Lewis Carroll's *Alice*. Graham Ovenden's success at this exhibition meant that there was a direct flow from his student days to being a professional painter.

In 1969 Peter and his then wife, Jan Blake, left London to live in a former railway station at Wellow near Bath. By this time Blake was internationally known and his work had been shown in many one-man and group exhibitions in London and abroad. His presence in the West County provided a focus for a small number of artists who shared similar ideas.

In 1974 a group of seven artists decided to give themselves the name 'The Brotherhood of Ruralists', the name chosen to parallel that of the Pre-Raphaelite Brotherhood. In addition to Annie and Graham Ovenden and Peter and Jan Blake, the members of the group were Graham and Ann Arnold and David Inshaw. They spent much time together, and were mutually supportive. This small group wished to look at nature as an important aspect of god's creation and to depict it realistically. In their work they sought clarity and likeness, they refused what they saw as an obsessive specialisation of non-figurative art which often was ornament posing as something greater. They were also against

'experimental' art and it's various manifestations, which dispensed with the painted image and replaced it with performance or cinema, found objects, piles of stones, waste and rubbish from the city streets.

In 1979 the Ruralists as a group were invited to show at the Royal Academy summer exhibition. The President, Sir Hugh Casson and Peter Blake, by then a Royal Academician, had been asked to choose a centrepiece for the exhibition and this seemed an appropriate moment to launch the group. Many saw it as a breath of fresh air; others, and particularly those of the 'older guard' threw up their hands in horror.

At this time a manifesto was produced by the Ruralist Group (which has since been lost). Their work received considerable attention from a general audience and it was shown in a series of exhibitions in the late 1970s and early 1980s. It was Laurie Lee, the writer, who coined the title 'Ruralists', defined as 'someone from the city who moves to the country'. The painters, who regarded Lee as a special-ist on the rural scene, warmly accepted him.

The decision to form The Brotherhood of Ruralists was perhaps taken somewhat light-heartedly but it had a serious intention. The mild-mannered Ovenden can be pugnacious in attacking the establish-ment. He wrote:

We are the avant garde *now. We've inherited the banner of opposition to the prejudice and ignorance of the establishment. We are the successors of Cézanne. People are desperate for good art nowadays and although I don't always want to be going on about the iniquities of the modernists I certainly don't want to be numbered with the bad guys. There are probably about thirty people in this country who hold down important jobs in the arts, in the museums and the art galleries, in the art schools and in the media. They do far more damage to art than any of the supposedly philistines politicians. (The Ruralists an Art and Design Profile edited by Andreas C. Papadakias, Academy Editions, London 1991).*

It was the Cornish landscape that brought the Ovendens to Cornwall, in 1973, to a small farmhouse, 'Barley Splatt' near Bodmin. This is not an invented name, although it might well be. Splatt is Cornish for field, and Barley Splatt can be traced back to the seventeenth century probably built to serve a nearby lead mine. As soon as they arrived the work of reconstruction and extension of the house began. The result can best be described as neo-Gothic, a substantial building in High Victorian taste, largely built with Graham's own hands. The entrance door of the house is a high Gothic arch set with narrow lancet windows, the wall to the side is far from finished but already overgrown with thick moss. As Ovenden says 'you should never hurry good things'.

The house has the air of a museum devoted to the middle and late nineteenth-century, from the Pugin door-fittings, offered to but not accepted by the House of Lords, to the collections of Pre-Raphaelite literature and illustrations. Long dark corridors with the occasional slit window connect the rooms at Barley Splatt, or ghostly electric light from a gothic lantern, faintly illuminates decorated tile-work and carpets in the manner of Pugin's designs for the House of Lords. Furnishings and fittings are from the Morris workshops, Philip Webb, Street and Gilbert Scott.

GRAHAM OVENDEN
'Ophelia', 1979–81

oil on canvas, 87.5cmx65cm
Photo: Peter Nahum

174

These corridors house his bursting collections of early nineteenth-century furniture, books, records, photographs and other artefacts. His love of music is shown in the large number of early acoustic gramophone records and cylinders, which reminds one that before going to the Royal College of Art, Graham Ovenden was a student at the Royal College of Music. Photography is of a central interest and his Victorian collection is wide ranging and of great quality, including photographs by Marcus Adams and Lewis Carroll. His expertise and the assistance he gave in the early auctions of Victorian art at Sothebys and Christies helped to establish the area for collectors. A particular display refers to the steamship *Titanic* and its sister ship the *Olympic*. *Titanic* is photographed many times in the days before commencing its tragic voyage and a remarkable study of the Chief Officers of that vessel shows them in heroic pose, photographed, shortly before their departure

The studio on the upper floor has the air of a nineteenth-century study. A single painting in progress stands on an easel; nearby is a wind-up gramophone. On the ground floor, unexpectedly, there is a large, high and beautifully-lit gallery with long windows, which give on to lawns down to the bubbling river. Two or three times a year exhibitions by Graham and Annie Ovenden take place, together with work by other artists of whom they approve.

Just as the beginnings of the Ruralists are shrouded in a seemingly light-hearted mystery so its end as a movement is indeterminate. Peter Blake's withdrawal from The Brotherhood of Ruralists might be seen to date from the time that he left Wellow to return to London, following the break up of his marriage to Jan. His painting of the late 1990s, 'I may not be a Ruralist any more but I saw a fairy at the bottom of my garden this morning' might mark his withdrawal, but nothing is final. It is certain that Graham and Annie Ovenden see themselves as part of that same group and continue to subscribe wholeheartedly to the attitudes and ideas that they have been so carefully nurtured.

Annie Ovenden
Photo: Edmund Ovenden

ANNIE OVENDEN (b.1945)
Annie Ovenden has been a full participant in the Ruralist Group activities from the group's inception, but she will admit that her day-to-day activities with the house, her children, their friends, the animals and the land which they own, a considerable thirty acres, takes up a great deal of her time. She says that she often gets her ideas for painting whilst going about these domestic tasks:

> *Usually I will be working outside when suddenly I'll see something in the landscape, and then respond to it inside. It is this quality which I've seen the light create, and the feeling I have received from it which I have tried to put into my painting.* (The Ruralist op.cit page 89).

She works in oil and in watercolour and it is perhaps in watercolour that she finds the greater freedom for her work; these are very direct views of familiar landscape, such as a group of beech trees entitled '*Memory of a Friend*' 1990. These are in full foliage straddling a lane, and shown in all their complexity, yet each retains its personality. An oil painting of her son, Edmund Dante Ovenden, painted in 1976, is equally direct with the young boy looking directly at the artist with a gaze as undeviating as that of the painter.

ANNIE OVENDEN
'Edmund Ovenden', *1975*
oil on paper, 35.5x46cm

Annie Ovenden was born in Amersham, Buckinghamshire, in 1945 and studied at High Wycombe School of Art. She worked as a graphic designer for several years before moving to Cornwall. The family took much of her time in the late 1970s and 1980s, but from 1992 to 1999 she taught painting and drawing in the Adult Education Service. In addition to her painting she has produced illustrations for a large number of books. She has also shared the themes which have been used by other members of The Brotherhood of Ruralists such as the *Alice* theme for which she painted a Mad Hatter Tea Party in 1990. A current group of portraits of members of the village community in which she and her family live are telling examinations of the character and social positions of each.

ANNIE OVENDEN
'February Morning in Lanhydrock Park'
oil on canvas, 66x66cm

TONY FOSTER (b.1946)

Tony Foster is an explorer, artist and a traveller who works in many distant parts of the world. Wilderness and conservation are at the centre of his work. His subjects are sublime nature, and the primacy of the extraordinary natural landscapes that he explores has developed his strong ecological interests and reflect his feeling for nature in its most extreme forms. His method is to walk into remote areas until he is far from any indications of civilisation, beyond the roads and the telegraph wire; sometimes he will travel by kayak or canoe. These journeys might take weeks; they may be taken alone or with a small group of like-minded friends, willing to share the hardships of the journey and the special circumstances that Foster requires. These expeditions are carefully planned and researched; experts, scientists and rangers are consulted and, with his travelling companions, a route is planned that will provide subjects for painting.

His paintings are diaries of his travels, a record of his personal and private experiences, and of the extraordinary places that he ventures into. All his personal, camping and painting equipment is carried on his back. He works in watercolour, which is portable and quick drying, on a heavy paper made by Barcham Green. He also makes small collections of objects, sprigs of plants, a feather, and fragments of stone or flint. These, together with maps and his illustrations of bird and insect life, are included on the margins of the drawing. Occasionally he includes drawings of some remarkable specimens that he has observed, such as the nine-foot-long boa constrictor seen in the Costa Rican rainforest, or the six-foot-long iguana, which remained stationary for three days. His work is about 'wilderness and a celebration of the fact that even on this overcrowded planet there exist places of intense beauty without any mark of human interference'. (*Tony Foster a World View*, published by the Frye Art Museum, Seattle 2000).

Tony Foster was born in 1946 in the Lincolnshire Fens, in a tiny hamlet of four houses on a crossroads with the impressive name of New York. When he was ten years old his schoolmaster father took a post in Essex and the family moved there. Tony confesses to a rackety education; art was the only thing he was good at. He left school under a cloud; he sought adventure and for a time lived rough in London.

Tony was now married to Ann (née Partington) who had been studying textile design at Loughborough College of Art. After he had gained a teaching qualification in Birmingham they travelled to the

Tony Foster

Cayman Islands in the West Indies where he had been offered a job. This British Protectorate was building a new secondary school and Tony Foster was one of a party of teachers who were sent out to set it up and then to run it. Soon he was teaching art to students who had never before held a paintbrush. After two years he and Ann decided to come back to Britain. In the Cayman Islands Tony had learnt to scuba dive and he looked for an area where he could continue to do this, and a job at Fowey School attracted him. He soon found that scuba diving in Cornwall was not the same as in the West Indies, but it brought him to Cornwall. Since that time his Georgian house in Tywardreath, near Par in central Cornwall, has been his working studio and his home with Ann.

At 15 500ft, Nevado Sajama, Bolivia, 1997.

Photo © William Vanderbilt

TONY FOSTER
'PU'U'Ō'Ō erupting', *Painted on the night of 4/5 October 1997*

55x60cm and 2.5x15cm

Collection: Ken and Karen Jones, Seattle.

177

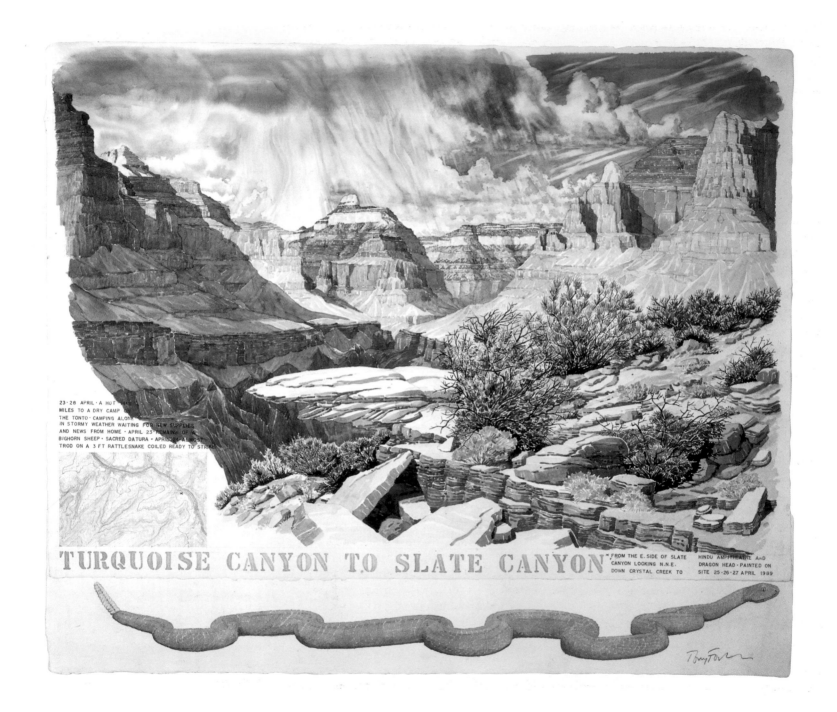

23·28 APRIL · A HOT
MILES TO A DRY CAMP
THE TONTO · CAMPING ALONE
IN STORMY WEATHER WAITING FOR NEW SUPPLIES
AND NEWS FROM HOME · APRIL 23 REMAINS OF A
BIGHORN SHEEP · SACRED DATURA · APRIL 24 ALMOST
TROD ON A 3 FT RATTLESNAKE COILED READY TO STRIKE

TURQUOISE CANYON TO SLATE CANYON FROM THE E. SIDE OF SLATE HINDU AMPITHEATRE AND
CANYON LOOKING N.N.E. DRAGON HEAD · PAINTED ON
DOWN CRYSTAL CREEK TO SITE 25·26·27 APRIL 1989

His break with teaching came when he was thirty years old and he went to Cardiff College of Art to take a Postgraduate Diploma in painting. He describes himself then as a 'pop' artist, his work was about boxing matches and hot rods and American football, illustrated with notes and comments. At the end of the year he had his first solo exhibition, at 'Chapter' in Cardiff. For several years Tony struggled to paint while earning his living as an art administrator, first at Southhill Park in Bracknell, and later as the Regional Art Organiser for South West Arts. However he found this an increasing strain. After working part-time for South West Arts, he was better able to pursue his own work. He finally left paid employment completely in 1985.

Foster had begun to make paintings connected with short journeys on Dartmoor, and he extended this idea with an exhibition entitled 'Travels Without a Donkey in the Cevennes'. This retraced the steps of the nineteenth-century writer, Robert Louis Stevenson, whose book *Travels with a Donkey* recounted his long walk in the French Pyrenees in 1879. Tony Foster and the photographer James Ravillious travelled the same route, also on foot, and recorded their journey. Camping gear, painting and photographic equipment and other necessities were carried on a golf trolley. Later they exhibited twenty-two photographs and twenty-two paintings from this journey, at the Curwen Gallery in London, and at a number of centres in London and Scotland. The show was successful and was written up in the *Observer* colour supplement. Although most of the work was sold, Tony felt that the amount earned was pathetic. For what was basically a year's work, he received less than a month's wages. As he was on the point of becoming solely dependent on his painting for his income, having resigned from South West Arts, he went to the United States to explore the gallery scene there.

He always tries to find a strong conceptual basis for each exhibition. In selecting his sites he needs to have a clear motive. For his next exhibition he chose a theme that was specifically American and which was at the heart of his own ecological beliefs. Foster had painted at Walden Pond, in New England, over a three-day period in June 1984. On his drawing he inscribed the words of the nineteenth-century Ruralist, Henry David Thoreau, 'I went to the woods because I wished to live deliberately, to confront only the essential facts of life'. In the following year this and other drawings were exhibited at the Yale Centre for British Art in New Haven, Connecticut, as 'Thoreau's Country: Walks and Canoe Journeys through New England'. The exhibition was also shown in a number of other galleries in North America.

This success was followed two years later by a 225-mile walk along the Sierra Nevada, and exhibited under the title 'John Muir's High Sierra'. Muir was a Scottish ecologist and climber who went to the United States when he was about nine. He spent many years wandering in the wilderness areas of North America and wrote passionately about the need for their preservation. He became well-known when President Teddy Roosevelt camped with him in the mountains for two nights, a significant meeting which lead to the President setting up the first National Park in North America

Tony Foster has always avoided being typecast; he has no wish to become known as an artist who followed the journeys of others. He began to look for themes that would give him variety and the opportunity to explore the wilderness regions of the world. In October 1987 with two like-minded

TONY FOSTER
'Honduras – Looking North to La Cascada Del Rio Zacate', *2001*

Watercolour, pencil, 55x60cm and 2.5x15cm
Artist's Collection

Opposite page:
TONY FOSTER
'Turquoise Canyon to Slate Canyon', *1989*

Pencil, watercolour, caran d'ache,
printing ink, 35x49cm
Collection: Bill and Peggy Brace, Massachusetts.

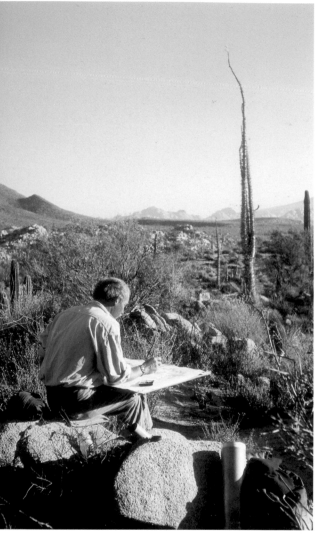

At Kataviña Boulder Field, Sea of Cortez, Mexico, 1995

Photo © Dorie Stolley.

travelling companions, J. Parker Huber, a writer from Vermont, and Bill Brace, a geologist, they set off to explore the Grand Canyon in Arizona. Foster admits to reservations about attempting what could have been a very hackneyed subject. Altogether he made three trips taken over a period of five months, much of which was spent in the bottom of the canyon in temperatures of 103 degrees Fahrenheit or more. He produced a series of watercolours which described in detail the rock strata of this world wonder. Although made in extremely difficult conditions, some of the watercolours are of considerable size; one, entitled 'Twenty One Days on the South Rim', is eighty-eight inches long. These very large watercolours are painted in sections on heavy watercolour paper, which is mounted on a folding drawing board. In addition to the carefully selected views, notes are included, for example he notes that here he was 'drawing for four days, painting for fifteen days from an over-hanging rock two thousand feet above Bright Angel Shale, ravens and swallows fly below...'

In the last few years major exhibitions, followed by a tour, have taken place on a two-yearly basis. In 1992 to 1993 a series entitled 'Rainforest Diaries, Watercolours from Costa Rica' was toured in Bath, Exeter and Harewood House in England, and also in the Montgomery Gallery in San Francisco. Two years later came 'Journeys in the Idaho Rockies and Arid Lands', which were diaries of journeys in deserts, taking him into some of the most inhospitable areas of the United States and Mexico. The most hazardous was a series of visits to those parts of the world in which active volcanoes are found. This was exhibited under the title 'Ice and Fire, Watercolour Diaries of Volcano Journeys' (1998–99).

His work is in the tradition of the great scientific illustrators who accompanied explorers and cartographers to the most remote parts of the world. He paints with controlled accuracy, reminiscent of the studies of natural history by John Ruskin. His subjects are frequently so extraordinary that any exaggeration would be superfluous. These exhibitions are of interest not only to art lovers, but also to ecologists, geologists and travellers. This has been evidenced by Tony Foster's election to the Royal Geographical Society in 1994 and their award, in June 2002, of a medal 'For Artistic Portrayal of the World's Wilderness Areas'.

He accepts whatever conditions prevail; for example, in the deserts watercolour dries almost instantly, whereas in rain forests the paper might never dry. On occasions a little gin has to be mixed with the water to stop it from freezing. His travelling paint box is three inches by four-and-a-half inches and the twenty-four colours that it contains have to suffice for the whole range of his watercolour work. He travels with a camera and some photographs are taken for reference but they are not used for the paintings. He finds them lacking in information compared with the experience of being there. His most recent series called 'Watermarks' is a record of water in all its forms, icebergs, geysers, seas, waterfalls, swamps and includes paintings and drawings done in Greenland.

He has found a receptive audience in the United States for his work and the support of galleries in New York and San Francisco. He also has a group of collectors, about a dozen, who have regularly bought his work. Some of them will accompany him on his journeys. A 'Foster journey' is taken slowly and its members must accept the fact that this Britisher has to stop every two hours for a brew of tea. But these self-set tasks are no holiday. Against such an accusation he points to 'The back-

breaking miles, the countless hours and days working on site, roasting or freezing, soaking or steaming, plagued by insects, holding his drawing board down in a howling gale, or perched on an exposed ridge in a thunderstorm.' (*Worldviews* op sit). But his way of working has allowed him to witness and to record some of the most extraordinary environments on this planet, observed under extremes of heat and cold.

CAROLE PAGE DAVIES (b.1955)

A holiday in Cornwall with friends introduced Carole Page Davies to West Penwith and for three months, at the beginning of 1981, she stayed in a chalet in John Miller's garden, in Sancreed. After two or three winters spent in this way she decided to move to Cornwall and bought a house in New Mill, near Penzance. It was not the presence of other artists that drew her to Cornwall. Although she respects the St Ives' experience and the work that has come out of it, she was not drawn particularly to the St Ives coterie of artists. Rather it was her feeling for the landscape that brought her to Cornwall.

Carole Page Davies was born in 1955, in Hanover, Germany. With her father in the army, she grew up in a number of countries; her strongest memories are of the hot and steamy jungles of the Far East, and the bustling life of Singapore. From the age of six she lived in the Usk Valley in South Wales. She

Carole Page Davies painting in Tuscany 1994

CAROLE PAGE DAVIES
'Bracken After Rain', *1998.*

oil, 60x40cm
Artist's collection

was educated in England and went to school in Newbury and then to Marlborough College, which had recently admitted girls.

In 1973, with a strong interest in art, she went to the Slade School in London. This was a time of change, from the professorship of Sir William Coldstream to that of Lawrence Gowing. The policy of the Slade at that time was very much to let students 'get on with it', and Carole felt that she did not challenge herself enough. But the atmosphere of enquiry kept her looking and drawing.

From the Royal Academy she was awarded the David Murray Studentship in landscape painting; this took her to work in mid-Wales, at Lake Vyrnwy, near to Bala. She had remembered this wooded valley and its great lake from childhood visits. This vast man-made lake, the largest artificial reservoir in Europe, was constructed in the last part of the nineteenth-century to retain the waters of the River Vyrnwy. During the dry summer and the drought of 1976 she painted the drying terrain of this valley, living in a hut on the lakeside for several weeks.

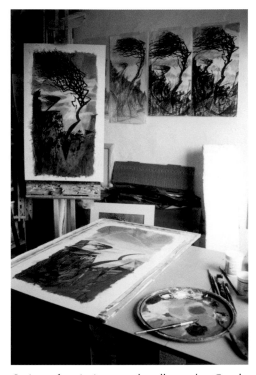

Series of paintings and collages by Carole Page Davies entitled 'Evening Thorn', in the studio at Chyenhal, 2002

After leaving the Slade she stayed in London, working as an illustrator, but she retained a strong wish to work against a more rural background. The work she did when she first came to Cornwall was realist and highly detailed. In a phrase of the time it could be described as 'Magic Realism'. She looked closely at landscape details, and water was often a subject. Her paintings are done in the studio from drawings and photographs, but there is quite a lot of re-working. Montages are often made from photographs. She is very conscious of the rectangle of the canvas, and the need to make an interesting composition. Perspective and aerial perspective play their part.

More recently her observation of places and the forces of weather, growth and decay, which shape the landscape, have been overtaken by what she describes as her 'inner landscape' in which she finds the expression of her emotions through the colour and texture of nature. Most of the sites she works in are in West Cornwall and the Scilly Isles. A later painting entitled '*Still Pool*' is a detail of a stream in Trevaylor Woods.

In her choice of landscape subjects, Carole Page Davies looks for specific places with a high emotional content, which informs the colour and her feeling for time and place. She believes that the four elements and the mandala format are part of ancient beliefs, they appear in Aristotle and were current in medieval and Renaissance thinking. In modern times these same elemental forms have surfaced as a metaphor for the characteristics of the human psyche. Her wish to clarify her responses to certain landscape sensations has led her to make a series of paintings based on the four elements, Earth, Air, Fire and Water.

Her interest in the elements arose from a combination of sources, her reading of Karl Jung and his successors who discussed archetypal psychology, and in poetry, including *The Four Quartets*, by T. S. Eliot, and *Elements* by Lawrence Sail. These different points of view all confirmed her own observation of the cycle of the four elements, which she has tried to capture in a series of paintings, started in 1990.

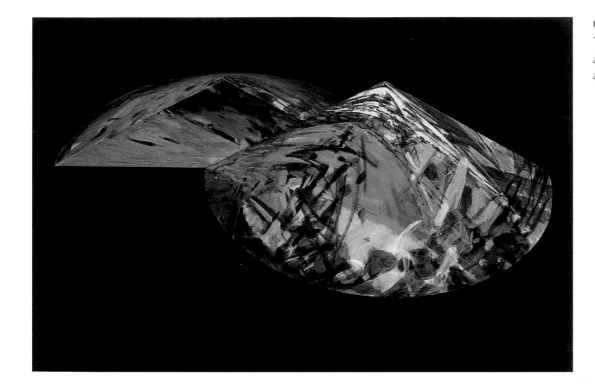

CAROLE PAGE DAVIES
'Sea Pieces' 3-D, one work in two parts, *1987.*
acrylic, 91cm bases
artist's collection

In 1993 she began to work on a series of paintings of the cross within a circle. She is interested in mythology and the background of the Christian faith. She sees the cross as a principle of order as well as a Christian symbol. She also finds that painting helps her to understand her own subconscious. Her paintings have given her an insight into herself and have brought together her various interests, particularly in nature and ecology. She grows organic vegetables and makes plant dyes for knitting. She retains her great interest in poetry.

She regards the way in which she paints as rooted in an earlier period, and believes that craftsmanship in painting has relevance. Her main influences come from the early twentieth-century and the School of Paris.

A series of her paintings has been based on circles, which she regards as representing 'the feminine principal', because they are inclusive and receptive; they do not differentiate and categorise. As they lack the straight lines and hard angles of squares, rectangles and triangles, so conflict and difference are not apparent in them. The circle appears naturally in dances, as movement, or in other contexts as stillness and completeness. The circle usually expresses community and equality rather than individualism. She quotes an anonymous source: 'The nature of God is a circle, of which the centre is everywhere and the circumference is nowhere.'

Partou Zia, 2002
Photo: Theo Cook

PARTOU ZIA
'My Blue Book' *(self portrait), 2001*
oil on panel, 121x92cm

PARTOU ZIA (b.1958)

Partou Zia was born in Tehran, in northern Iran, previously Persia, of Iranian parents. She came to England at the age of eleven. Her early years were spent in London and after her schooling she went to Warwick University where she took a degree in the History of Art, under Professor Julian Gardner. As part of her Degree she spent some months in Venice,

In 1986 she went to the Slade School of Fine Art in London. It was a time of transition, with the outgoing Professor, Patrick George, being replaced by Bernard Cohen. Her tutors at this time were Paula Rego and Bruce Maclean. In her first year Partou painted mostly from the model and her interest in the anatomy of the human figure took her to witnessing dissections at University College Hospital. However she avoided the plumbline techniques of Euan Uglow, also teaching at the Slade, an artist whom she greatly admired, but whose insistence on accurate measured drawing of the figure she found too rigid.

For several years she taught in London. She was also painting in an ACME studio in the old Avon factory in Dalston, in the East End, and had begun to exhibit her paintings in London. Increasingly she found that the restrictions of living in the city were not helping her painting

In 1993 she decided to move to Cornwall. It was a wish to paint that lead her to make this move. She had made visits to Cornwall previously and the rocky coast reminded her of her birthplace in the northern part of Iran. She did not choose Newlyn because of the presence of other artists, nor is she especially interested in the earlier generations that had worked in Newlyn. She saw it as a working town, going about its business, from which she stood apart, carrying on with her work.

Partou Zia belongs to a cultural tradition that goes back to her Middle-Eastern roots. She is very conscious of the character of the objects or places that she paints, and relates this to her early years, as part of a tradition to respect things, even the pots and pans on the table. She sees her painting as a form of phenomenology, an understanding of how things really are. In making a painting, she is looking at objects that have a life and which demand respect. This is not an aspect of formal religion; rather it goes back to the stories she heard as a child.

Her drawing and painting have energy and show vigorous handling. This is painting of discovery, in which thick skeins of paint define the structure of the form. She has recently been producing large landscapes out of doors. The working port of Newlyn, the harbour and the landscape of West Penwith have been the subjects for many of these paintings, recorded in a free and expressionist manner.

Other paintings are to do with her home overlooking the port and the objects in the interior of her studio; a chair, the curtains, and the windows of her room take on an iconic significance. Yet her paintings exhibit an enclosed feeling. She does not display the spectacular landscape of Newlyn that lies outside these windows. She looks internally to the room; a form of self-absorption. She has also made many self-portraits, some of the head, some nude. Before each of these she would make many drawings, detailing the various objects in the room in relation to the figure. When she has reached a

Left:
PARTOU ZIA
'The Red Chair I', 1999
oil on canvas, 140x140cm

Far left:
PARTOU ZIA
'The Old Corona', 2001
oil on panel, 122x122cm

point of understanding, she will paint quickly, working explosively from the centre. She says that painting is a state of chaos, not knowing if the painting is going to work; it is this struggle that creates her affinity with her subjects

A recent series of paintings are of the interior of St Peter's Church, Newlyn. The choice of the church was not for religious reasons; as she explained: 'she was attracted to the mysterious presence of something other than the palpably material – a kind of visual search for the spiritual dimension of places and things, most particularly by the pointed arches of the nave, which reminded her of the arcading of eastern buildings.'

Her paintings are strongly coloured and boldly painted in thick creamy pigment, the product of a great deal of looking and revising. In the church she was very conscious of the atmosphere. She writes:

The chapel is white, cold, shaded, and for an unaccountable moment silence is given as a gift. The crudely designed 'Chalice of Light' stitched carefully into tapestry cushions, nestling on the front pews, takes on a three-dimensional hue. The chapel glows with the sewn threads of gold as light emanates from this mysterious vessel. (Artist's statement, February 1998).

In her paintings the Chapel is mostly deserted, but occasionally figures appear, as do the religious artefacts of candles and crucifix. Sometimes she witnesses the work of the church, as in 'Morning Mass', 1996, 'A Funeral', 1995. This series of paintings were the subject of an exhibition at Newlyn Art Gallery in 1998.

Since 1996 she has had a series of solo exhibitions in Devon, London, Newlyn and Truro. She has also exhibited in a number of group exhibitions. One of her self-portraits has recently been bought by the British Museum. For the past three years she has shown her work at Art Space Gallery, London.

Her painting is based on drawing, which she values because this establishes memory, a territory that is continually being explored. She believes that art is a human journey, which you can't possibly let go.

LISA WRIGHT (b.1965)

Lisa Wright has two children, Max, born in 1993 and Theo, born in 1999, and they are the subjects of much of her recent painting. In their first months of life she drew them many times. She emphasises the value of drawing: 'drawing forms the structure upon which I create a painterly language, without this vital element, the painting is wanting'. These direct and free drawings are carried forward in the form of paintings in which the young child, already a person, displays the pride in his first step and finds confidence in his own abilities. She describes in these softly-coloured paintings the space and occasional drifting shadows in which these young human forms settle, wander and belong.

But these are not sentimental paintings of motherhood. She seeks to illuminate the intimacy and special relationship, but she does this through the medium of painting. The flow and scrape of paint is used boldly to indicate floor and wall, superimposed with a free linear drawing of the young child. She quotes the American abstract painter Philip Guston, 'A moment arrives when the air of the arbitrary vanishes and the paint falls into positions that one feels were destined'. Indeed much of her work has the certainty of Guston or the more open space of Richard Diebenkorn. In her paintings she looks for that moment in which the most dense areas of thickly-painted colour appear to float and settle into a precise definition of the room's width and the form of the wandering child.

In a statement about her work, Lisa Wright writes:

The human presence in painting lures me and continues to remain prominent in my own work. My paintings seek intimacy; they are the realisation of something seen and felt. These images are arrived at through drawings evolved from a process of observation, memory and familiarity. Drawing forms the structure and becomes woven into a painterly language as the image is finally redefined within the substance of the paint itself.

I work constantly with the hope of empowering each painting with an energy for it to speak softly or stand strong but ultimately for it to declare itself whole. (Artist's statement August 2002).

Cornwall has had its effect on her in terms of quality of light in the paintings, the intensity of colour, and her heightened awareness of the dramatic weather changes.

Lisa trained at Maidstone College of Art and at the Royal Academy Schools, London, where she achieved an MA in painting in 1993. Four years later she moved to Cornwall. She has shown her

LISA WRIGHT
'Standing Shadow', 2001

oil on canvas, 142cmx136cm

Lisa Wright, 2001
Photo: Steven Tynan

LISA WRIGHT
'Drifting Shadow', 2002.

oil on canvas, 56cmx56cm

work widely in exhibitions in London and elsewhere, and in solo exhibitions, most recently with the Beardsmore Gallery, London. She has been a regular exhibitor at the Royal Academy since 1991. She is a member of the Newlyn Society of Artists and she lives and works in a former chapel in Helston and teaches part-time at Falmouth College of Art.

NAOMI FREARS (b.1963)

Naomi Frears was born in Leicestershire and studied art in Loughborough and Sunderland. As her courses were in sculpture and printmaking she did no painting at all. After Art College she made a long overland motorcycle trip, which ended by her settling in St Ives in 1989. It was there that she started painting and printmaking. She writes:

St Ives feels like the right place for me. Being surrounded by the town, the sea, the moors, other artists and that big horizon helps me to paint. I'm not sure how, but I have tried working in hilly, forestry and urban environments and it just does not happen.

NAOMI FREARS
'Achy Breaky Heart'
acrylic on paper

NAOMI FREARS
'Self Portrait – Big Blush'
acrylic on paper

I work at least five days a week in a wonderfully quiet and light studio that used to be the St Ives Aquarium. I am very untidy and the walls, plan chest and floor are covered with half-finished drawings and paintings, old rags and unidentifiable 'matter'.

Despite having said that St Ives is the place for her, it does not really appear in her work. She still travels a lot and the landscape, art and architecture always seems to have an effect upon her. Her work develops slowly. She works mostly in acrylic and her paintings develop over months and often years in response to changes of mind. On occasions she will paint a completely new image over another. This process of retrieval is important to her. Sometimes she scrapes and rubs paint off to bring back something that is buried in the painting.

Painting is a process of discovery. Although some may find it hard to believe that a painter does not know what they are aiming at, it is true for her. She just has to hope that she can recognise the moment when a painting is right, and then stop.

Naomi Frears is a member of the Porthmeor Printmakers; she leads various workshops at the Print Workshop, Tate St Ives and the St Ives School of Painting, and exhibits her work in Newlyn and St Ives.

JESSICA COOPER (b.1967)
Jessica Cooper's paintings come from particular experiences and memories. Her work is developed from intense memories and provokes strong emotions in the viewers. She reduces the everyday to an essence, be it landscape, a plate of lemons, a child's tooth mug or a dish of pears on a table. Yet from these sturdy and reassuring shapes she produces an image, sometimes highly simplified, yet containing the essential nature of her subject.

Her drawings are the starting point for her painting. She finds that spontaneity and freedom are important to her work and the drawn line acts as a structure, which often stays on the canvas throughout the process of the painting, contrasting with the many layers of paint. She works in acrylic and pencil on canvas. Ideas come from her sketchbooks, which are full of drawings of landscapes and still-life. She is an emotional painter but one grounded in reality with an unwavering ability to grasp the essential.

Jessica Cooper was born in Bristol in 1967 and moved to Cornwall at the age of three months. She followed the Foundation Course at Falmouth School of Art and then went to Goldsmiths College of Art, London, for the course in Fine Art and Textiles. She now lives near Penzance and has exhibited nationally and within the county. She lives with her husband Ben and two children on the north coast of the peninsula. She is a member of the Newlyn Society of Artists and an Associate Member of the Penwith Society.

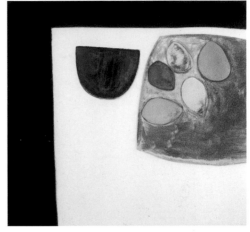

JESSICA COOPER
'Lemons on a Plate', 2002.
acrylic and pencil on canvas, 80x95cm
Photo: Simon Cook

Jessica Cooper
Photo: Simon Cook

JESSICA COOPER
'House Under the Hill', 2002.
acrylic and pencil on canvas, 40x45cm
Photo: Simon Cook

10

THE FALMOUTH PAINTERS

The working port of Falmouth did not become an artist's colony, as did Newlyn and St Ives. However over the years it has provided a home and a working place for a large number of artists, including some of major national reputation. The most senior of these was the Royal Academician Charles Napier Hemy (1841–1917) described as 'the constant and almost life-like illustrator of Cornish scenery, who was at work thereupon before most of the Newliners were born', (*Among the Cornish Painters*, von Knaben 1894). His paintings of the sea were based on deep experience. As a child he had accompanied his parents as they took part in the Australian gold rush. On the sea passage to Australia he had rounded Cape Horn twice, and experienced near shipwreck when the ship was struck by a whale. But his deepest impression was the sea itself. He wrote of his first impression of the open sea from the deck of a ship 'I can remember it entering my soul; it was imprinted in my mind and I can never forget it, I have gone on painting it all my life'. (Manuscript in the Ashmolean Museum, Oxford).

Hemy had trained in Antwerp under Baron Leys and in London he became a close friend of Whistler. A series of paintings of the River Thames were the basis of Hemy's first success. By 1880 he had decided to move to Falmouth, which he preferred to Venice, and which provided him with many subjects: the work of the port, the crabbers, oyster dredgers and the visiting fleets of great sailing boats which he painted from his floating studio in the harbour. His large and sombre paintings emphasised the struggle and harsh advances of the sea. His most successful painting '*Pilchards*' was exhibited at the Royal Academy in 1897 and is now in the Tate Gallery.

The younger artist, William Ayerest Ingram (1855–1913), was also a sailor of considerable experience, painting the sea and shipping on voyages to Australia. He had spent some time in Newlyn and became friendly with Stanhope Forbes, but in 1886 Ingram settled in Falmouth and became, with Henry Tuke, the moving force in establishing the Falmouth Art Gallery at Grove Hill, Falmouth.

After his training at the Slade School in London, and a period of working in Paris and central Italy, Henry Tuke (1858–1929) worked in Newlyn over a period of two years. He produced only six or seven paintings in Newlyn, plus two portraits, but in the months that he was there he was an important member of the Newlyn Group. In 1885 he left Newlyn to return to his childhood home in Falmouth; scenes of his youth which he knew well and for which he had the greatest affection. It held all he wished for, the bustle and activity of a great seaport with the tidal estuaries of the Fal, the

Opposite page:
FRANCIS HEWLETT
'Vertical Lights – Falmouth', *2000.*

oil on canvas, 95x140cm
artist's collection

191

FALMOUTH COLLEGE OF ARTS
Student: Paula Flavell
Course: BA (Hons) Fine Art – Autumn 2000
Title: 'Look Out and be On Your Guard'
Falmouth College of Art

FALMOUTH COLLEGE OF ARTS
Student: Finn C. Notman
Course: BA (Hons) Illustration
Title: '10'
Falmouth College of Art

Helford and Truro rivers. On quiet beaches and sun-filled coves, painting could go on undisturbed without a crowd of Newlyn fishermen and children looking on. In his own words he wished; 'To paint the nude in the open air, here there are quiet beaches, some of them hardly accessible by boat, where one may paint from the life model undisturbed.' ('Henry Scott Tuke', Studio Vol. V, 1895 p.93).

His paintings convey his great love of sailing, and of the new sport of yachting and yacht racing. In 1886 he purchased an unseaworthy French Brigantine, Julie of Nantes, and moored it in Falmouth Harbour as a floating studio. His paintings describe life under sail, the activity of taking a boat out of the harbour, the excitements of racing or the quiet moods of a peaceful voyage home. He achieved considerable success at the Royal Academy, London, in 1889 with 'All Hands to the Pumps', a full-blown figure subject of storm at sea, bought by the Trustees of the Chantry Bequest. When he became an Associate of the Royal Academy in 1900 he was welcomed as 'the best painter of the open-air school which we now have with us'. (FK 'Studio Talk', Studio XIX 1900, p.121).

Tuke remained on good terms with the Newlyn artists, but he was now at the centre of his own group in Falmouth. When asked about this he said; 'No – we consider ourselves quite a distinct branch of the brotherhood, and we are a congenial set too'. (Flora Klickman, 'The Life of a Famous Painter', Windsor Magazine, 1895). He became Royal Academician in 1914, passing the war years in Falmouth and afterwards resuming his earlier travels with friends to France and Italy, and a four-month visit to Jamaica in 1924. But these are years of declining health; in 1929 he died at Swanpool at the age of 72.

Another who was a member of Tuke's 'congenial set' was Hereward Hayes Tresidder (1843–1950), who combined a career as a professional artist with that of manager of the Falmouth Savings Bank, from 1910. After volunteering for the Grenadier Guards, he was wounded in the Somme in 1916 and during his convalescence in a military hospital he painted many portraits. He continued to paint as an amateur artist until his retirement from the bank in 1949.

FALMOUTH SCHOOL OF ART
The presence of a major art school in Falmouth has had a positive effect upon the visual arts in Cornwall. The foundation of Falmouth School of Art goes back to the beginning of the twentieth-century, when the redoubtable Anna Maria Fox, of the well known Quaker family of Falmouth, opened a school of art in Arwenack Avenue. For almost half a century classes in art and design were offered on a non-vocational basis. The school came under Cornwall County Council in 1947 with the appointment of Stanley Wright as Principal. It was then that the school moved to Woodlane and began to develop around the house, Kerris Vean, once the home of the Fox family, set in a splendid sub-tropical garden.

In the 1950s, successive principals, Jack Chalker and Michael Finn, developed a broadly-based school of art and design with an emphasis on the fine art programme, and new buildings were added for painting and sculpture. In 1967, after a long, and at times acrimonious, battle with central education authorities the school was nationally recognised for courses equivalent to degree standard. A major

factor in the recognition of the school was the support given by the professional artists living in Cornwall, notably Barbara Hepworth, Bernard Leach, Patrick Heron and Bryan Wynter

Michael Finn, who was Principal from 1958 to 1972, remembers this as one of the smallest art schools in the country and one of the most remote. The work of the school was firmly centred upon painting, taught in an open and undogmatic manner. Michael Finn believes that the experimental work done at Falmouth School of Art, including photography, film and creative writing, was in line with the attitude of younger artists of today, a kind of revolt against traditional painting. He was anxious to involve as teachers, artists who were very different to him, and he deliberately chose staff who could offer alternative points of view. The policy of employing practising artists as teachers and encouraging them to continue to practise added greatly to the working atmosphere of the school. The late 1960s and early 1970s were years of comparative abundance in art education and this small school continued to prosper. Following the purchase of land adjoining Rosehill Gardens, a major building programme took place, which was completed in 1970.

Tom Cross became Principal in 1976. By this time the days of sudden expansion were over and money was more difficult. Patrick Heron, who was a governor of the school, became deeply involved in the national debate about the future of independent art schools. In a lengthy article entitled 'Murder of the Art Schools' (*Arts Guardian*, October 12 1971) he castigated the forces of the establishment which, in his opinion, were a threat to the hard-won freedom of the art colleges, and expressed his strong disapproval of the move to bring schools of art into the polytechnics.

By the early 1980s the school had changed. It had grown in student numbers and it was to grow further. It was now seen as part of a national pattern, which determined all aspects of the school's working operation, but it retained its character as a Fine Art institution. The school had many friends and contacts over a wide area. The series of Delia Heron Memorial Lectures, established in 1980 to commemorate the name of a loyal governor, had an impressive start, with Lord Bullock, Vice Chancellor of Oxford University, speculating on the use of history. The school also retained its good relationship with Cornwall and the Cornish artists. There was an amusing demonstration of this in 1981, when the second Delia Heron Memorial Lecture was given by Leslie Waddington on the role of the professional and the art world. In the audience there was a line up of all the most prominent artists in Cornwall, including Patrick Heron, Terry Frost, John Wells, Denis Mitchell, Paul Feiler and others. Leslie Waddington lectured to the students on the need to be professional and to have well-arranged slides to show gallery owners. The artists present later reflected bitterly on how they had all, with the exception of Patrick Heron, been excluded from Leslie Waddington's own gallery in favour of internationally more acceptable American and European artists.

In 1984 the continuation of the Degree Course of the school was directly threatened and by September of that year it was clear that a major re-planning of Art and Design education in Cornwall would take place. The pressures continued over the next two years. As part of the campaign to save the school Patrick Heron wrote, 'if Matisse had founded a School of Art in England, he would have chosen Falmouth.' The eventual decision was a positive one for the future of art education in the county. It

FALMOUTH COLLEGE OF ARTS
Student: Katharine Morling
Course: BA (Hons) Studio Ceramics –
Autumn 2001
Title: 'Underwater'
Falmouth College of Art

was to form a new institution of art and design for Cornwall and to centre this in Falmouth. In 1987 the Falmouth School of Art closed, and in its place the Falmouth School of Art and Design was created.

MICHAEL FINN (1921–2002)

Michael Finn's eightieth birthday was marked by two exhibitions between January and March 2001. One was of recent paintings at the Newlyn Art Gallery, and the other of constructions and sculpture, shown at the Falmouth Art Gallery. This display of the totality of his work, showing its range and depth, and the warm reception that was given to it, are an indication of the part that he played in the development of painting in Cornwall.

Michael Finn was born in 1921 in Surrey, at Addlestone in the Thames Valley, close to Weybridge. It was at Brooklands, nearby, where he formed his love of cars and aeroplanes. He was educated at St George's College, a Roman Catholic School on the outskirts of Weybridge and then at Westminster School, London. From here he was able to visit the Tate Gallery and other galleries in London and he fell in love with the idea of painting. An early experience that he remembered was seeing Lynton Lamb's 'Portrait of Lytton Strachey' – the long languid figure, stretched out in a chair before a huge window looking on to an idyllic landscape, was magical.

As a student at Kingston School of Art he watched the Battle of Britain as it was fought in the skies overhead. In his turn he was called into the RAF and, unusually for a conscript, he was trained for flying duties, in Oxford and later in Canada. He flew transport aircraft, towed gliders and later became the squadron's test pilot. At Kingston Art School he had met Cely, a fellow art student, who became his wife in 1943. Their first child was born in 1945. In the following year he left the RAF and returned to his training in art at the Royal College of Art in London. Although the school was in many ways backward-looking in those post-war years, the return to education was a breath of fresh air, and he found great help from visiting teachers such as Victor Pasmore and John Minton.

After some years teaching at Somerset College of Art in Taunton, he was successful in his application for the post of Principal of Falmouth School of Art which he saw grow from the small beginnings described earlier. In 1972 Michael Finn left Cornwall to become Principal of Bath College of Art at Corsham. He remembered that he asked Barbara Hepworth for a reference for the job at Corsham. In giving this she also advised him to give up teaching and paint full-time.

Over his years as a teacher, Michael Finn continued to paint. Already in the 1970s his work was leaning towards abstraction; this was against the grain of the other teachers at Falmouth who were mostly figurative painters. By the early 1980s, Finn was painting wholly abstract fields of colour in earth reds or ochres. The paint is applied vigorously, as on a broken wall or the surface of a sun-bleached door. There is an evident handmade quality with softly-drawn edges of colour.

There is an acknowledged influence of America which dates from his experiences of Canada during the war and his early visits to New York, reinforced at intervals with further visits. The tranquillity and

Michael Finn
Photo: the author

harmony in the work of Mark Rothko and his search for 'the impact of elemental truth' coincided with his own desire to make paintings which are objects of contemplation. Another influential artist was Richard Diebenkorn whose long series of paintings entitled 'Ocean Park' override the distinction between representational and abstract painting.

Finn has taken an independent path. After seven years at Corsham Michael Finn retired. He chose to return to Cornwall because there he could make paintings that said something to him. He was not interested in what he calls 'that landscape thing', he feels no direct connection with landscape, although his choice of colour, soft earth reds, brownish-black and occasional clear cool blue, are essentially of the land. But his colour, like the simple diagonal shapes and textures that he uses are to do with silent feelings; 'It is entirely to do with what I am happy with' he says.

His studio is a small barn with a workshop on the ground floor and an upstairs painting room, entered by a precipitous ladder and a trap-door. Work is done in series, acrylic paint is applied with a creamy consistency and there is considerable over-painting. He is reluctant to discuss the changes he makes in a painting, it is an intuitive process, the slow 'push and pull' of colour, adjusting the relationship between one area and another 'because at that point it is wrong'. This rightness or wrongness is solely a matter for his judgement; there are no external criteria. The painting is finished when he cannot do any more to it. He would like the work to speak for itself; 'within the painting, and for it to contain as little as possible, without being totally bland. I really don't know very much about what I do,' he says.

As the paintings became increasingly abstract and mystical Michael began to work in three dimensions. This gave him practical problems, but importantly, it allowed new directions to emerge for the expression of religious, and specifically Christian, experience. Michael took the crucifix and the crucified figure as his subject. In his early attempts to work in three dimensions he produced simple structures in wood, glued together, reminiscent of the forms that Peter Lanyon had made in his explorations of landscape subjects. The first finished crucifix that he made was a gift to his son Robert, then studying English at Cambridge; Robert later became a Dominican priest. Other early versions were also given to friends.

MICHAEL FINN
Work in progress, summer 2001
Photo: the author

The earlier crucifixes are fully detailed, with carved limbs and features reminiscent of Spanish processional figures or the images of the crucifixion by Georges Roualt. Later they became highly simplified but recognisable within the Christian tradition. The figure is more abstract, subsumed within the cross, the head no more than a squared block, but retaining a piercing frontality. Each crucifix is abstracted and composed of a similar number of simple parts, torso, arm segments and a head. As they became more certain in their proportions, casts of the crucifixes were made in bronze by the skilled caster Michael Werbicki of Bristol. As with the paintings, the three-dimensional work was made in series, usually variations on a narrow theme.

The paintings and the crucifixes were first shown together in an exhibition at the Newlyn Gallery in 1989. Two years later, in February 2001, the double exhibition of his paintings and sculpture was shared between Newlyn and Falmouth Art Galleries. Michael Finn died in his home at No-go-by-Hill on 24 March 2002.

FRANCIS HEWLETT (b.1930)

Francis Hewlett's art is centred upon careful and meticulous drawing, often of people, either sitting for portraiture or engaged in everyday activities. He is working within a tradition that extends deep in Western art, back to the time of Ingres and earlier. In the twentieth century this tradition of observed drawing appears strongly in the drawings of Sickert.

Francis paints in a large room, originally the attic rooms at the top of his house, overlooking Falmouth Harbour. A big window occupies most of one wall and the movement and activity of the docks is a background to his work. In his most recent paintings he has looked back to his inheritance of earlier drawings, some of which he made during his student days in Paris. Currently he is working on a series of four views of the west front of Notre Dame Cathedral in Paris, seen in different lights and at different times of day, the same interest in a repetitive motive that drew Monet to make his many studies of Rouen Cathedral. In the case of Francis his main interest is in the structure of the cathedral as explored in his earlier drawings.

Francis Hewlett was born in Bristol in 1930. He attended Fairfield Grammer School (an earlier pupil of the same school, the young Archie Leach, later found fame in Hollywood as Cary Grant). At the age of seventeen Hewlett gained a scholarship to Bristol School of Art. Just after the war this was filled with ex-servicemen, older men and women who had seen active service. By comparison with these 'old killers', as Francis described them, he and his friends felt very young, almost like children.

The principal teacher at Bristol was George Sweet, a precise and widely cultured man who had been a contemporary of William Coldstream and Claude Rogers at the Slade School in the 1930s, and was later a pupil of Sickert. Under Sweet's influence the course at Bristol was based almost exclusively upon drawing, and he invested his students with a passion for drawing that never seemed to stop. They finished up being able to make objective drawings with great vigour but without a very clear idea of how to use them.

Sickert was still an influence in Bristol. He had died in 1942, whilst living in nearby Bathhampton, and was personally known to members of the staff of the art school. It was this example which lead Francis Hewlett to make a long series of drawings of the theatre, an extended discipline that later proved to be of the greatest importance to him.

The theatre in which he drew was the Empire Theatre, Bristol, a beautiful old building, built for a music hall tradition that was already dying. In a last attempt to keep the theatre open, the management had redecorated the interior and re-gilded all of the baroque architecture. The effect was magnificent, like a brand new Victorian theatre. Each evening after the art school closed, Francis sat in the rear of the stalls and drew. The theatre was usually half-empty but the manager allowed Francis to use any empty seat and over a period of about three years, he produced hundreds of little drawings. The performances were spectacular, bizarre and awful, whole shows of dwarfs, or 'Gang Shows' of ex-servicemen in drag. There were strip shows, carefully monitored by the Lord Chamberlain's regulations, and music hall with Arthur English, Eddie Gray and Max Miller.

Francis Hewlett

The drawings that Hewlett produced were, at this time, an end in themselves and lead to very few paintings.

In spite of the passion and industry that went into the activity of drawing, the course at the Art School was narrowly directed, and in many ways out of step with current art training. Hewlett remembered, as an isolated incident, Patrick Heron coming to give a lecture entitled 'On the Necessity for Distortion in Drawing'. The younger students found this concept absolutely baffling and suddenly realised that there was a whole massive world of art, of which they knew little.

After Bristol, Francis won a scholarship to go to the Slade School of Art in London. During the summer, before he started the course, he entered a national competition for promoting the film 'An American in Paris', which required a painting about Paris. Liz (née Allen) and Francis had been married in 1953 and they went to Paris with their friends Bob Organ and Alan Halliday. Francis produced a painting based on drawings of the Eiffel Tower, he then returned to London to begin his course at the Slade. Before the first term had ended Francis found, to his great surprise, that he had won the first prize in the competition, an astoundingly generous offer of a year in Paris, with all expenses paid. William Coldstream, the Professor of the Slade School, gladly agreed to Francis going and to repeat the first term on his return.

In Paris Francis had a place at the Ecole des Beaux Arts under the teacher Legueult, a fresco painter, and then with a painter called Brianchon who Francis described as 'a tidied up Vuillard'. After a year it was back to the Slade to continue his course for a further two years, and to rejoin his friends from Bristol, Robert Organ and Alan Halliday. At the Slade this small group became known as the 'Bristol Boys' and they were remarkable for their dedication to drawing and for their, sometimes bizarre behaviour. A most famous occasion was during a Slade cabaret when, on stage, they managed to totally destroy a piano, while somehow managing to keep the tune going on the instrument until the very last moment.

On leaving the Slade Francis was still required to do National Service, which had been deferred until the end of his training. He had registered as a conscientious objector and he was allowed to work with the Social Services. For two years Liz and he worked in a home for deprived children in Surrey and for a time they became joint wardens. Many of the children had come from other countries, as refugees from different parts of Europe, and it was a taxing job, but rewarding.

The decision to come to Cornwall was made casually. By the summer of 1957 the period of their social work was drawing to an end and they came to Cornwall on a camping holiday. Knowing there was an art school in Falmouth they called to see if there were any job vacancies. There were none, but Jack Chalker, who was then Principal, happened to hear their enquiry and told them of a part-time job teaching art at Redruth Grammar School, which Francis was able to get and which lead to the offer of a part-time job at Falmouth School of Art. The start of the contract coincided with a period of severe illness for Francis, the first of several such bouts caused by a recurrent intestinal complaint, Crohn's Disease.

By the early 1960s Francis was Head of Painting at Falmouth School of Art, now under a new Principal, Michael Finn, with a small but active staff. This was a time of experiment; Francis tried to make the painting department as wide as possible and supportive of many different styles and directions. His years of teaching made him widen his own interests and new possibilities began to open up in his work. The paintings got thicker and less controlled. He made many drawings done from memory and produced paintings that were made in the shapes of the objects represented; his limit in this direction came when he painted a carpet upon a real carpet. He realised that he was, in fact, moving towards sculpture and for a time he was taken with the idea of chromatic sculpture and experimented with fibreglass and resin. This lead to the use of ceramic and soon he was working on a large scale in ceramic sculpture.

These ceramic sculptures were funky, provocative and funny; huge hands or enormous feet, animated wardrobes and ceramic suitcases decorated with pottery daffodils. With the aid of a large, track-loading kiln at the art school he was able to make individual pieces up to six feet high. The work had a jokey, lavatorial humour, with an end-of-the-pier irreverence. It also had an edge of satirical comment. For a period of some twelve years ceramic sculpture took precedence over painting but he continued to draw and he was also teaching.

In 1976 Francis Hewlett had an exhibition of paintings and ceramic sculpture at the Newlyn Orion Galleries. He was nearing a point of change in his work and he wrote:

'Hand' 1973, with Francis Hewlett in 2001
stoneware, 2 metres high
collection: University of Wales, Gregynog Hall

There is frequently a kind of grossness in the image, which I find alternately humorous, menacing, reassuring... For ten years I have used ceramic as an alternative to paint, it has the advantage of being widely familiar as a substance, direct to use and easily and permanently coloured. (Artist's Statement, Newlyn Orion Exhibition May/June 1976).

His last large ceramic sculptures were made in 1976.

An opportunity to resolve some of the tensions that were pulling his work in different ways, came in 1977, when he was awarded the Gregynog Arts Fellowship of the University of Wales. The large country house, Gregynog, had been a gift to the University of Wales from the remarkable Davis sisters, Margaret and Gwendoline. In the 1920s and 1930s they had formed a noteworthy collection of Old Master and French Impressionist paintings, now in the National Museum of Wales, and at Gregynog they had established a private press, a renowned music festival and conference centre.

The Fellowship gave him a sabbatical year away from teaching, studio facilities in the handsome house in mid Wales and the use of a cottage in the grounds. Initially he had the intention of working on a series of drawings and continuing with his sculpture, however the sight of the wonderful landscape of mid Wales convinced him that it should be tackled by a painter. Within a few days the feeling of the new setting enveloped him and, although it was winter and snow was in the air, he decided to paint directly from the landscape.

At the conclusion of that year the Welsh Arts Council toured an exhibition of his work of forty-eight paintings and drawings, all based on the house and grounds of Gregynog. The paintings follow the changes of the seasons in clear atmospheric colour and demonstrate how he was carried away by the beauty of the house and it's surroundings. This sustained study of landscape also helped him to make the decision to give up teaching, in order to paint full time.

FRANCIS HEWLETT
'The Sisters', *1979*

oil on canvas, 75x75cm
Private Collection

In 1981 and still only at the age of fifty, Francis Hewlett accepted a retirement on grounds of ill health, in respect of his chronic debilitating complaint. Now that he was free to give his undivided attention to his work he turned back to the stack of drawings that he had made years ago in Bristol. They were mostly small, about sight size, that is the drawing, held with an outstretched arm, approximate to the apparent size of the object before him.

Francis had always attached value to his drawings of the Empire Theatre but at the time they were done he did not know how to put them into paint. He approached the problem like a detective, working out a strategy by which this vast collection of drawings could be revitalised into new paintings. After considerable study and analysis, he found that there were five or six major compositions, and to understand their complexity he first painted large monochrome versions before going into colour. Over the next ten years these drawings were pondered over, pieced together and reworked. The resulting six large paintings were shown in 1993 as a group at the London gallery of Browse & Darby, together with many small paintings and drawings.

It was not only the method of constructing the paintings that interested Francis; it was the theatre itself and the excitement of theatrical performance. The finished paintings give us a view of the late and near defunct music hall, at the fag end of a Victorian tradition. They are strongly reminiscent of Sickert, most particularly when they describe the rapt attention of spectators in the boxes illuminated by the reflected light from the stage. He pictures 'Monsewer' Eddie Gray and Arthur English heckling from the stage box. Wilson, Kepple and Betty perform their sand dance, and in another painting a group of half-naked girls shout at the audience, in defiance of the Lord Chamberlain's instructions.

A major retrospective exhibition of Hewlett's work from 1951 to 2000 was organised by Falmouth Art Gallery and shown there in September 2000, and in Plymouth City Art Museum in March 2001. This drew all of the strands of Hewlett's artistic life together in an impressive group of paintings, sculpture and, perhaps most importantly, drawings.

Ray Atkins

Photo: Bonieventure

RAY ATKINS (b.1937)

The principle that has separated the work of Ray Atkins from that of many of his contemporaries is his abiding desire always to paint from the subject. Some years ago he concluded that he needed to face the complexities of the natural world in order to draw from it his own particular vision. This has lead to much criticism and misunderstanding. He wrote, 'one was treated at best as an absurd maverick, more usually a fool, totally out of touch with 'the scene'.' (Catalogue to the exhibition 'Ray Atkins', Royal Cornwall Museum, Truro 20 March to 22 May 1999). The response of some of his critics meant little to him and he was easily able to put it aside, it was more than compensated by the praise of his admirers and the trust that he places in his own judgement.

Ray Atkins is a West Country man, born in 1937 in Exeter and brought up in Sevenoaks, Kent. After school he went on to Bromley College of Art, but his beginnings in the art world were shaky, as he failed to pass the Intermediate Examination in Art and Design. This meant that he could not continue on the course and he was immediately eligible for National Service. He was conscripted into the army and served in Cyprus with the Royal Signals. This was at the time of the Ioka terrorist campaign and his first views of the Mediterranean were with a gun in his hand. During his time in the army painting was not possible, but he thought about it and, as he said 'painted the camps and the extraordinary landscape in his head'. He arranged to be demobilised in Cyprus so that he could travel across Europe, in winter by himself, to give him time to think of his future.

After this period of reflection he found that his resolution to become a painter was even stronger. Returning to London he set his mind on entry to Camberwell School of Art, and he got himself a small room in Camberwell and some part-time work. However he was unable to raise the fees for the school and returned to Bromley. He was still officially suspended from the School of Art but he went there one day and started to work and after a time he was accepted as a returning student.

Although Ray had reached a point of commitment in his work, he was still without a clear direction. At Bromley he met the young Frank Auerbach, then in one of his first teaching jobs, who talked about

Painting on site at Goonvean, 1994

all of the things that Atkins was interested in. It was an amazing meeting of minds and there was no way in which he could avoid being affected. Another influence was the painter Chris Chamberlain, who opened Atkins' eyes to the importance of objective painting. With him, the students went on drawing expeditions and through his eyes they saw the industrial wasteland of South London in terms of fantastic colours, shape and texture. He also taught the value of vigorous charcoal drawing that you could hammer and push around.

After Atkins' earlier experiences with officialdom, entry to the Slade School was surprisingly easy. The Slade School was always independent of examination results and preferred its own judgement of a student's potential. Atkins was accepted, in spite of the fact that he had again failed to satisfy the examiners of the National Diploma in Design. At the Slade Ray was one of several students who were working in a Bomberg tradition, but he deliberately held back on his commitment to this and pulled away from the influence of Frank Auerbach. He was aware of all the exciting changes going on in British painting at that time, abstraction in various forms, pop art, op art etc. The tension between his awareness of new art forms and the intuitive direction that he wanted to follow, meant that for a period his work went downhill.

Ray Atkins' studio, 2001

Towards the end of his training Atkins came to the unfashionable decision that his way in painting lay in working directly from objects. He left the Slade in 1965. After gaining an Abbey Minor Travelling Scholarship he made a tour of Italy and, on his return, he was offered a part-time teaching job at Reading University. Claude Rogers, who had been Ray Atkins' tutor at the Slade, had moved that year

RAY ATKINS
'Scrapyard II', *Summer 1977*
oil on board, 157x245cm
artist's collection

RAY ATKINS
'January Bonfire', *2002*
oil on board, 125x125cm
artist's collection

to Reading University as Professor in Fine Art. Rogers had been a leading member of the Euston Road Group and shared Atkins' interest in objective painting. For six years Atkins worked at Reading University, mainly teaching in the life room and living in London.

There is a savage and dark intensity about the paintings done in London and Reading in the 1960s. They are heroic in size, very large paintings; six or seven feet, perhaps as much as ten feet across, and usually painted on board which, with the thickly crusted paint, make a massive object. These paintings and all that follow are painted in situ creating a number of physical problems. Transportation becomes a major problem, as does finding a site where he can work undisturbed. Then the board must be secured to a spot where it can be supported with bracing and held down by ropes weighted with rocks. Sometimes he can find a shed or barn to store the part-completed painting but most usually he has to carry it back to his studio. Often the paintings, because of their size, were left out on site. On one occasion, working at the entrance to Millwall Docks in London, some local children floated the painting into the river. Ray followed its course downstream, took it back to the original spot, and continued to work on it.

For a period of four years after leaving Reading, he taught at various London art schools. For someone who was dedicated to objective painting and drawing it was a difficult period to get a job, but his public persona was growing and from 1970 onwards Atkins had a series of solo exhibitions, and his

work was shown in many mixed exhibitions. In 1974 he had his most important opportunity, a one-man exhibition at the Whitechapel Art Gallery, London. The work was selected by Frank Auerbach, who chose pictures that did not show his own influence on Ray, mostly recent, and in Atkins' opinion perhaps not always of the best. This exhibition came at a difficult point in his career and did not attract the attention it deserved.

Ray Atkins' move to Falmouth in 1974 brought a new feeling for the light and colour of Cornwall into his work. He translated this in his own terms. He shares little with the abstract artists of St Ives or the coastal painters of holiday Cornwall, and made no concessions in his choice of subjects. His own search for truth and veracity takes him to the rough places, the hedges and ditches of the spine of Cornwall, broken ground, derelict mine workings, abandoned quarries, places where he can work unobserved.

RAY ATKINS
'Left Foot Dancer' *(from yoga series)*, 2002
oil on board, 150x150cm
artist's collection

The action of painting is best performed in private and the evidence of the artist's struggle can be read in the energy of brush stroke upon brush stroke. In the mine workings of South Crofty he sees great beauty in the flaming burst of gorse that holds the centre of the canvas as a crash of cymbols. The working pit of Goon Vean becomes a creamy melange of soft warm colour. The rusting car bodies of a scrapyard create a minor symphony in earth reds and blues. The ambition and dedication in these paintings, and the sheer hard work that goes into their production, can be measured by the great quantity of work produced and its high quality.

Because of his interest in the industrial landscape, Ray Atkins was invited to take part in the 'Broken Ground' project. This was an idea of the composer Paul Hancock who invited two other artists, a poet, Peter Redgrove, and a painter, Ray Atkins, to work with him in the industrial ruin of Wheal Jane. Until it closed in 1998 this had been one of the largest of Cornwall's tin mines. It was now a desecrated landscape wholly created by man, but rapidly returning to briar and bramble and surrounded by great pools of water that had been pumped out of the flooded mine. In a series of strongly-worked paintings Ray Atkins responded to the drama of the site, broken and overgrown buildings and abandoned machinery all described with his own vigorous handling of paint and strong colour. This unusual combination of music, painting and the spoken word was presented as a multi-media event in April 2001.

Although he is naturally drawn towards landscape Ray Atkins brings the same breadth and freedom to his paintings of the figure. He does not wish to divide 'people' from 'places', as he believes that painting is a visionary language which does not have such separations. In 1998 he had a large exhibition in the Royal Cornwall Museum and Art Gallery, Truro, entitled 'Paintings of the Figure' which included work spanning some forty years. One painting, dating from student days, was of the professional model Quentin Crisp, famous as *The Naked Civil Servant*. Atkins paints him as a dark and glowering presence in the corner of a traditional life room. His main model over many years has been himself, and a long series of self-portraits have titles such as 'Nick Spirit', 'The Lamb of God', 'Death's Head', 'Ancient Image' and 'The Energy of Sex', titles which indicate strong private undercurrents of emotion. He has continued to work with the figure in a series of movement and dance projects, which

Philip Hogben

PHILIP HOGBEN
'Divers', 1986

oil on canvas, 245x155cm

developed initially from his teaching. This has lead him to working with professional dancers and to create paintings that share the rhythm and measure of the dancing figure, and portray the dance in a new and unexpected manner.

Essentially the painter works through his own appreciation of the situation. He sees his world in terms of colour and movement and the size of the task. For Atkins painting is a complex and sophisticated language which he finds equally fascinating when working from landscape or the figure. He feels that the possibility of communicating through the medium of paint makes it the most wonderful language of all – 'the dialogue between these fundamental questions and the wonderful sensuous fact of life often seems at its most poignant in paintings of the figure...' (Ray Atkins op.cit).

PHILIP HOGBEN (b.1945)
A characteristic of Philip Hogben's painting is its optimism, seen through colour, light and movement, and explored by strong drawing. His subjects, the landscape and buildings that he knows well, are treated with careful respect. He knew when he first came to painting that he wanted to make paintings about the pleasures of life, and over the years in Cornwall he has described the country places, the gardens and buildings in engaging detail

Philip Hogben was born in 1945 and trained at Derby and Winchester Schools of Art. In 1969 he came to Cornwall to teach at Falmouth School of Art where he is now a Senior Lecturer in Fine Art. A formative introduction to modern painting was seeing an early BBC Omnibus film of Picasso, painting a skull and a candlestick. Philip was greatly impressed by the involvement of the painter and the speed and confidence with which the image was painted, destroyed and re-invented, again and again. He learnt that if the image is to be authentic and strong the painter cannot copy what is there. He must engage his own ideas and feelings in a dialogue between the subject and the evolving painting.

Philip has lived in and around Helston for many years and his work has been largely from the landscape to the north-west of Helston, an area of hills and high ground which remind him of the landscape of his Derbyshire childhood. Although he paints on location he does not attempt to make topographical paintings, but searches for a visual poetry in the objects, houses, buildings, landscapes that he paints. He less frequently paints figures, although this statement is denied by the series of swimming pool paintings that he made in the 1990s.

These paintings of figures in the Helston swimming pool come out of some earlier studies he was doing on the beach. He was looking for an opportunity to paint the figure in a modern and believable setting and by coming to a pool indoors he found that people who are swimming are less self-conscious and have little concern for someone drawing them. In fact people who were interested in what he was doing became an important part of the programme. The paintings were done from small pencil drawings made on the site and then painted to a large scale in the studio. The emerging strange shapes of the immersed figures and the complex reflections of water gave his imagination much to work on.

PHILIP HOGBEN
'Helston Pool'. *1988*

Oil on canvas, 79x104cm

Philip Hogben has exhibited his work widely in Cornwall, and is a member of the Newlyn Society of Artists. He has had many solo exhibitions in Bath and in London, and most particularly at the Gordon Hepworth Gallery in Exeter.

DIANE IBBOTSON (b.1946)

For Diane Ibbotson painting has a special purpose. Her work is part of a process of self-understanding, relating to the the world around her. For her, painting is a continuous struggle, yet it is also a response to the joy that she feels in her surroundings.

From an early age she was aware of her ability to draw and paint. Born in 1946 in Colne, Lancashire, she was brought up in a nearby village and from the age of eight in Barnoldswick, a small country town on the Yorks/Lancs border near to Skipton. She remembers as an eight-year-old girl the wonderful feeling of attracting praise for her drawings. With one sister and a supportive family, art became an important part in her young life. In her school days she admits to being a difficult pupil, sometimes

DIANE IBBOTSON
'Here I Am', *1988-93*

oil on canvas, 105x105cm
artist's collection
Photo: Steve Tanner

emotional and argumentative. Her art teacher, Peter Clarkson, suggested that she should apply to the University art schools, and Reading University offered her a place on the four-year degree course.

The first year at Reading was experimental and ranged widely over contemporary art practise. Parts of the course were structured and students were encouraged to examine their ideas carefully, to question the construction of a painting and try to discover why it should take the form that it did. Other parts of the course were activity based, for example, using chance elements in a free and expressive manner. All of this was integral to forming her own beliefs and questionings.

After Reading she went on to the Royal Academy Schools, London, where she studied for three years. Here she found a traditional approach to teaching, which helped her to understand matters of pictorial language and gain time to establish her own method of painting. After her training she had four years in Preston, teaching in night classes, and in Blackpool, part-time teaching on courses in illustration and photography. In 1975 she got a part-time post at Falmouth School of Art, travelling from Preston.

This was in the 1970s when fashions and ideas in art were being challenged, and for Diane it was a personal struggle and a test of character to survive in painting. She is a strongly imaginative person and painting for her is transitory evidence of her existence. She asks herself many questions. It is a philosophical search and a statement of faith. The Painting 'Up in the night I am, I believe' painted in Preston in 1975–77 sums it up, as do all her titles. Important in this process was the series of self-portraits painted in the North of England. The close scrutiny of herself, made over many months, gave her work considerable strength and assisted her in finding her own style. One self-portrait, which shows her as a lonely figure, has the title 'Here I am'. This was taken from the Bible story in which Samuel wakes, feeling cold, and hears the voice of Elijah calling to him. He replies 'here I am'.

Diana has never stopped painting, combining it with considerable domestic responsibilities. In Falmouth she married Richard Platt, then Senior Lecturer in Painting at Falmouth School of Art and her first child was born. She also inherited two teenage stepchildren and a second son of her own was born in 1983, coinciding with the painting 'All that glitters' (Falmouth 1983–88). She had to make a positive effort to re-engage in the world around her. Painting was the way to do this. A short walk from her home in Falmouth was an unremarkable council estate. She decided to do a painting of the houses on a large canvas and gave it the title 'They were finished in July 1946, that's when I was born'. In order to get the truthfulness she required, and unable to work out of doors on such a scale, she made a succession of small paintings on the spot of different parts of the scene. These were then incorporated in the larger canvas in the studio.

She applies self-made rules to her working process. In several paintings such as 'Here I Am' and 'Drawn Curtains' she examined the rooms in her house, close pictorial records, revealing in their precise detail. Every flower on the curtains and wallpaper is separately recorded. In one, called 'In the Dark' (Falmouth 1995–97) it is evening and a door is standing open; the painting is almost totally dark, just a lightening of tone indicates the shape of the room, yet the painting is charged with mystery and energy.

From her garden she painted views of Falmouth and the harbour, closely observed and rendered in a highly detailed manner. Each of these paintings progresses from small steps, which lead her to making large and complex paintings, painted almost entirely on the spot. With this finely-worked technique goes a surprising innocence, as if these familiar places are seen for the first time.

Diane Ibbotson is a very private person who rarely exhibits her paintings. When she was bringing up her two children she felt she could not cope with the business of exhibiting. For a time she had a patron who bought all her work, and other occasional sales have been made. She is slow in producing paintings and only a few close friends know her considerable output. She paints one picture at a time but there is no interval, one tails into another. A painting might take several years, in the middle of doing it she has no idea what the next painting will be, but another seems to emerge as each is completed.

She has worked from the object for many years, either indoors or out of doors. Recent paintings are made in a small well-lit room at the top of the house; at present she is using photographic evidence. Each painting is done with intensity and each represents an important step in her personal development. She is articulate in talking about the problems she had in their construction. She pursues her work with great dedication and in her conversation she talks as if she views herself from the outside, wryly and with amusement. She possesses a strong North Country spirit and sees humour in her situation. When asked if she has a reverential feeling for her painting she quotes Les Dawson who was interviewed on the radio and asked what he believed in. His reply was 'I am cosmic dust'. This struck her as absurd yet in some way truthful, an unknown and unknowable particle from which something can be made.

DIANE IBBOTSON
'All That Glitters', 1983–88
oil on canvas, 185x150cm
artist's collection
Photo: Steve Tanner

MARY MABBUTT (b.1951)

Mary Mabbutt is a figurative painter who works from her own feelings and from her own environment. Her paintings have their beginnings in an emotion, a feeling or a simple experience. She is able to step outside her world and see it as an observer would for the first time. She describes this sensation:

When I am able to move beyond resemblance into the world of the painting, which has it's own life, I feel as if I've taken the world apart and put it back together again. It's as if I've seen some-thing I've never seen before, as though I've fallen in love with a small part of time and space and celebrated the event in paint. (Artist's statement 1995).

Her subjects are chosen from the most everyday experiences. For example she might be trying on shoes in a Truro shop when she becomes aware of feeling: 'I am inside this moment, I am here, now, doing this'. At another time whilst rocking a baby to sleep she notices that the fading light is making a processional movement across the room. These domestic events are the spark for a painting and they are pursued with all of the persistence of a gifted artist. She continuously enquires into her motives and reviews the means that she has at her disposal:

Mary Mabbutt, 2002

Where do I choose to look? Why? What does my field of vision contain and in which part of it do I focus? What kind of movement occurs in the subject, or in myself? Where does the light come from and what kind of light is it? How do I compose from what is there? How shall I use the paint and what should be the sequence of the marks I make... (Artist's statement 1995).

As a consequence of these testing and difficult questions, she does not respond literally to what she sees, she reconstructs her world in paint.

Mary Mabbutt was born in 1951 in Luton and brought up there, one of four children, two girls and two boys. She found Luton rather a dull place and she did not have happy memories of her comprehensive school; however she escaped to the sixth form college and from there her interest in art gained her an A level. In the family, art was seen as a relaxation or a hobby, it was certainly not regarded as a secure profession. Although her parents were supportive, they were unable to appreciate the value of an art education in economic terms and they persuaded her to follow her sister to the teacher training college in Winchester. However she soon found that this was not what she was looking for and she gave up the course in the second year and successfully applied to Luton School of Art for a foundation course. At this time, Mary doubted her choice of art as a career. However she went on to Loughborough School of Art to take the Diploma Course in Art and Design. Still feeling the pressure to do something useful, she became a social worker and for six months she was a house parent to mentally handicapped children, but this experience, although valuable, only confirmed her choice of art as a career

In 1975 Mary won a place at the Royal Academy Schools, London. She described the teaching as 'non-aggressive'. Teachers such as Anthony Eyton, Michael Saloman and Peter Greenham gave her support, and she found that Roderick Barratt was a most supportive teacher also. The three years that she spent there were the most enjoyable part of her training. At this time her work was more illustrative and her ideas about painting developed into a personal form of enquiry. 'What sort of things could she put into a painting? What was the subject matter to be? And how should it be painted?'

From the Royal Academy Schools she was successful in gaining a Junior Fellowship at Cardiff College of Art, a considerable achievement to be selected from 150 candidates. At last her parents were convinced of her abilities and her achievement. Her father, on hearing the news, could not conceal his delight. He telephoned her and said, 'You've got to take care of your hands now.' The Senior Fellow in Cardiff at that time was the painter Adrian Heath; Mary Mabbut remembers a perceptive remark of his about her painting. He said, 'You've got to sit on it', meaning that she was too tentative and not fully exploring the possibilities in her painting. In spite of this well-meant advice, Mary worked for a year in a large studio in Cardiff and produced only small paintings, none bigger than ten inches, together with reams of sketchbook ideas.

In 1978, having completed the Fellowship at Cardiff, she was offered a short-term teaching appointment at Falmouth School of Art. When she came to Falmouth for the first time she found it a magical place, and meeting Joe Coates, a painter teaching on the degree course, enhanced this first

Opposite page:
MARY MABBUTT
'Red Jacket', 1999

oil on canvas, 150x120cm

MARY MABBUTT
'Large Shoe', *1999*

oil on canvas, 30x30cm

Peter Webster

impression; they were immediately attracted to each other and later they married. For about four years, living in Falmouth, she took up various part-time teaching appointments in a number of colleges Portsmouth, Bristol, Cheltenham and Cardiff. She seemed to be travelling all the time, but by 1987 she was able to return to teaching at Falmouth.

In 1986 she moved into her present home, a large and spacious Georgian house in Woodlane, near to the Art School. One long room at the top of the house is set aside as a painting room and it is no surprise that an illustrated book of Matisse paintings lies open in this studio. The painted figures of Mary Mabbutt occupy a world similar to that of Matisse in the 1930s, enclosed, complete, cut off from their surroundings, capable of exploring a range of emotions through the orchestration of colour and form.

The life of her family and the incidents of everyday life are her subjects, usually painted on a small scale, although she also likes to work on large canvases, squared up from the smaller paintings, and reinforced by drawings. She often paints herself within this familiar environment and pictures herself trying on a coat in a mirror, doing the ironing or dressing in a bedroom, strewn with clothes and shoes. In choosing a viewpoint she will generally accept what is there, but her responses develop in the process of painting. Frequently figures are shown in movement, swinging into a room through an open doorway, or glancing around a room. In these self-portraits she is not very kind to herself, the figures are angular and accusatory, they turn suddenly or struggle into clothing.

Although Mary Mabbutt works from observation, she does not believe that she can paint what she sees. It is rather that seeing is determined by what it is you look for. There are countless answers to this question involving looking, response, emotion, and then there is the question of material. During the process of painting she achieves the freedom to rework her vision and at this point the painting takes on it's own authority. She is absorbed by such things as the texture of the paint, the weight and direction of the brush stroke, the relationship of colours and their placing within the different colour areas. The stylised figures in her paintings have a monumentality, shown frontally within a flattened three-dimensional space, animation that goes beyond representation. As the painting progresses the initial feeling is translated into an organisation of colour relationships and structure, the abstract element takes over and she thinks in terms of colour, shape and proportion.

Since 1980 she has had a succession of solo exhibitions at the New Grafton Gallery, London, and at the Paton Gallery, also in London, and in mixed exhibitions. She has also been invited to exhibit in a number of group exhibitions, particularly those dealing with figurative painting.

PETER WEBSTER (b.1951)
Peter Webster is a Yorkshireman born in Leeds and educated the Jacob Kramer College of Art in Leeds, and Cardiff College of Art, with a Master's Degree from Reading University. From 1976 to 1986 he worked in London with a studio in the Butler's Wharf complex and one was one of the founder members of the Chisenhale Studios in Bow, East London. He did some part-time teaching at Falmouth School of Art in 1984 and moved to Cornwall in 1987. He later became a Course Leader and Senior

Peter Webster
'The Black Circle Society IV', *2001*

oil on linen, 35cmx60cm

Peter Webster
'The Black Circle Society I', *2000*

oil on linen, 35cmx60cm

Lecturer in General Art and Design at Falmouth College of Art. Since 1974 he has shown widely in exhibitions in London and in the major provincial galleries. In a statement made for *Catching the Wave* he describes his work as follows:

Meaning in my work is located in the relationships between different forms of visual language. I try to release ideas by association and prompting rather than direct description.

Organisation of the formal elements of Painting has become a necessary context for this form of visual speculation, especially awareness of the Figure/Ground relationship as a continuum for a diversity of signs, layers and encoding.

In recent Paintings I have attempted to transform diverse visual sources and structures into forms and variations of painterly language. Made and observed elements (signs, gestures, models, fragile motifs) co-exist, the images become mapped between both Surface (skin) and Illusion (recessive, overlapping, variously layered).

The Black Circle Society (paintings) are a gathering of voices murmuring, arguing, sharing, Interrupting, listening – a constant exchange.

11

NEW DIRECTIONS

The international movements in twentieth-century art have been followed in Cornwall, albeit from a distance. American influence during the 1960s and early 1970s brought successive waves of abstract art, abstract expressionism, post-painterly abstraction and minimalism. Painting and sculpture were in danger of being reduced to a point at which art was no longer recognisable.

In an effort to rid itself of the restraints of the gallery system and the limitations of paint, canvas and sculptors' materials, the conceptual movement of the 1970s ran parallel to the interest in minimal painting and sculpture. In the Tate Gallery's exhibition of 1969 'The Art of the Real', contemporary art was presented as independent of ideology, tradition or history. In particular, conceptual art attempted to replace the art object with the idea, so that, for example, written texts would be offered in place of a painting or sculpture, or photographs would be used instead of drawings to describe a certain feat or phenomenon.

This contemporary movement has not been without it's detractors. Who should know better than Malcolm Bradbury the limits of experimental art? He states:

> Years of wandering the frontiers of transgressive post-modern imagination have taught me what its key words mean. 'Conceptual' means: we haven't thought about it much, but we're cool, and something will happen to which we can add the name of art. 'Post modern' means: guess what, we managed to get a corporate sponsor to pay for it. (Malcolm Bradbury, Picador 2000)

There were advantages to this rejection of the art object, an expansion of possibilities in which ideas from politics, sociology and ecology were incorporated within the artistic idea. Under the influence of the conceptual movement sculpture lost its preoccupation with permanence and included a wide range of other possibilities such as environment, happenings and performance art.

A number of these experimental attitudes are reflected among the artists of Cornwall, although in most cases they take a gentler, less aggressive stance than the metropolitan artists. As might be expected many aspects of their work are land-based and much of it is intended to enhance landscape.

Opposite page:
PALP – Gillian Cooper
'Amnesia' (detail), 2002
Chiltern Sculpture Trail, Oxfordshire

Ken Turner

KEN TURNER
'Tuyu'
acrylic on panel, 122cmx151cm

KEN TURNER (b.1926)

Ken Turner would describe himself as a performance artist, but one must see this against a background of painting and environmental art. In London in the late 1960s he founded and directed 'Action Space' a charitable trust funded by the Arts Council, the local authority and private trusts. Its intention was to promote the theory and practice of art in the community (not as community art). This was based first in Kentish Town and then in the Drill Hall off the Tottenham Court Road. During the ten years that he worked with 'Action Space' he held performances and installations in many cities in the United Kingdom and abroad. He took part in many of the international festivals in Berlin, Rotterdam, and Amsterdam.

As a student he was offered entrances to the Slade School and to the Royal College of Art, but John Minton advised him that the courses would spoil his established vision and Minton advised his one-time own school, the Anglo French Art Centre run by Rosela Green, which Ken Turner attended during 1948–51. A Fellow student at the time was Breon O'Casey.

Ken Turner was much involved in art activities in London which included the beginnings of the Institute of Contemporary Art where he exhibited, and in the 1960s he was also exhibiting paintings and constructions in solo shows including Heal's Gallery and the Mansard and Lords galleries in London. He had made an early visit to Cornwall in the 1950s and had good memories of this. In 1954 an important series of drawings were shown at the Beaux Arts Gallery in London.

In 1994 Ken Turner moved to Cornwall. It was not the light or the presence of other artists that brought him, it was the opportunity to work in an environment that he liked. He was able to convert a barn for his use. He now works in a variety of media and techniques in painting and performance. He says:

I feel that I am at the threshold of possibilities to go to forward with ideas, facilitated by computer technology... which means that I am able to go ahead to make art in a multipiicity of disciplines, and to be experimental in combining analytical propositions with conceptual and visual form. That is 'art as idea as art as form in painting and peformance'.

To this end he uses digital images and text in painting, and video projection with camera images linked with drawing and performance; a current work called '*Boots, Legs and Laces*' is a performance/installation/video piece. Painting remains a foundation to his visual research. He is represented in the Arts Council Collection.

JOHN CHARLES CLARK (b1941)

In his approach to his work John Charles Clark has always been considered conceptual. He is more interested in what art can be, and in what it can be about, than in producing consistent product to please galleries or public. He has never considered himself a lover of paint in the traditional painting sense but he will use any materials that are appropriate to what he wishes to make. Yet he is by no means alien to the artistic heritage of Cornwall.

He remembers his first visit to St Ives:

I came down from London to St Ives in August 1964 to visit a painter friend, and during my week's visit I had an invitation to meet Barbara Hepworth. I went to see her at her home and studio at Trewyn and spent a few hours talking sculpture and art in general; my own interest at that time being kinetic sculpture made by a new wave of artists from both Europe and South America. It was a very pleasant afternoon and afterwards I walked over to Porthmeor Beach to watch the surf and to see the rock formations at Enys Head and Clodgy Point.

It was this experience of meeting Hepworth that made me determined to leave London, to live and work in this beautiful area that I had not known existed, and as Barbara Hepworth had shown me, the possibility of living a fully creative life here.

I returned in March 1965 to stay and I am still here. In the intervening years my work has undergone many phases. The first works made were hard edge abstract paintings, which I later returned to in the late 1990s, also kinetic works, visual poems and spray paintings, to name a few. In recent years I have been working with writing texts and making text drawings. (Artist's statement 2002).

John Clark was born in London and studied at Woolwich Art School, Camberwell School of Art and the London School of Printing. Since he moved to St Ives he has shown with the Penwith Society and has had work published in *Poetry St Ives*. He was a major award winner for Sainsbury's 'Images for Today' in 1982. He has taught at Falmouth and Camborne Colleges of Art, and the St Ives School of Painting. He now exhibits with the Belgrave Gallery in St Ives. He was a collaborator on design and selection for the book *Roger Hilton Night Letters and Selected Drawings*, published by the Newlyn Orion Gallery in 1979.

MICHAEL PORTER (b.1948)

Michael Porter was born in 1948 in Derbyshire, in a tiny village called Street Lane. He and his twin brother went to Nottingham College of Art at the age of fifteen, both to study graphic design. After three years of the course Michael decided that this was not for him, and took a year out in order to gain GCE's, needed for entry on a foundation course, which he did in the following year at Derby College of Art. He then went on to Chelsea School of Art, an exciting school at that time, with a young staff, many of whom were making their mark in the London galleries.

In these last years of the 1960s the American influence was all-powerful and Michael Porter was very aware of the work of artists such as Donald Judd, Sol le Wit and Robert Morris. Michael made his own versions from string, glass, wood and paint, and almost anything he could find in skips. These were three-dimensional objects, but made to hang on walls, and he saw himself as a painter. A postgraduate year at Chelsea was followed by a Fellowship at Cheltenham School of Art.

On his return to London he took a SPACE studio in Hackney and an ACME house in Bow, both of

John Charles Clark, 2002
Photo: Richard Clegg

JOHN CHARLES CLARK
'Text Drawing (detail)', 2002
mixed media
Photo: Richard Clegg

215

Michael Porter in his Newlyn Studio
Photo: Alex Porter

Opposite page:
MICHAEL PORTER
'Gwavas Lake (Rocks and Sea)', 2001
PVA oil, pigment on canvas, 140cmx170cm
Purdy / Hicks Gallery

which he had for more than twenty years. In the late 1970s and 1980s he began to show his work regularly in London. He always had an active interest in the history of painting and to further examine his own position he made his own versions of paintings by three artists, El Greco, Giotto and Cezanne, each of whom had a three dimensionality in their work, but achieved it in totally different ways. This discipline went on for about two years during which time he produced a series of relief paintings from laminated wood and objects embedded in paint.

Michael Porter reached maturity as an artist at a time when art was in the process of re-defining its boundaries. Pop Art was giving way to Minimalism, traditional systems of representation had broken down and new forms were sought. There was a rejection of previously agreed artistic values in favour of the supremacy of the object. Michael Porter's response to this changing position was to explore the deceptive balance between the painted illusionary image and the material of paint itself.

In 1983 he was offered a residency at the National Gallery, London, which gave him studio accommodation in the gallery and full and complete access to the collection. Here he was brought face-to-face with painting in of all its forms, an experience which helped him to find his further direction.

He decided to focus on the subject of landscape and took as his subject one particular wood in Derbyshire, Ambergate Woods. Situated by the river Derwent, between Matlock and Belper, an area he had known since boyhood, this location was specifically chosen in order that both memory and observational analysis could be used in a single work. He would visit the woods about once a month and take black and white photographs of the bushes, the brambles, the pathways, as they appeared at various times of the year. From these he would produce large contact prints, searching for line and texture that he could work from. He did not copy these photographs; he analysed them to obtain as much information as possible. Sometimes he would take a particular object; for example he photographed a particular fungus from different distances ranging from thirty yards to close up. The information he obtained was similar in approach to that of Paul Nash or Graham Sutherland, examining minute forms, which echo the landscape.

In 1997, after some twenty years in London and in search of a change, Porter came to Cornwall with his wife, son and daughter. From friends he heard of a house in Newlyn with a large workshop that would make an excellent studio. This had been a boathouse at the turn of the century, and the double doors gave directly on to the old south pier in the Port of Newlyn, overlooking the harbour. It was quite by chance that he now has the same view of the oldest parts of Newlyn that were painted many times by the nineteenth-century painters of the Newlyn Group, but this was not his reason for coming here. His large studio is a combination of drawing studio, photographic workroom, painter's studio and sculptor's workshop.

For the last twenty years he has only painted from areas which have a degree of familiarity to him. When he arrived in Cornwall it seemed logical to examine the areas nearest to his home, which appeared to have a rich potential. His current subjects are of the rocky foreshore near his Newlyn

home and the primeval rocks that make up this broken beach. Rock has a very distinctive surface, in spite of its toughness there are subtle qualities within it. Porter makes explorations with a camera and if a particular section interests him he will make several photographic studies of it. He will then produce large drawings that echo the shadows and breaks in the rocky surfaces. In the studio he first takes a large piece of white paper which he crushes and crumples; pigment rubbed on the paper gives a variety of textures. This is then stretched and glued on to canvas, with the marks and abrasions of the pigment remaining. He also uses many innovative techniques and methods, which echo the tidal flow and current that have shaped the rock. With the photographs as a guide, canvas is stained, paint is dripped and dribbled and allowed to flow, producing textures very similar to the eroded and cracked rocky surfaces.

Another method is to paint on to polythene sheeting with diluted acrylic paint, which forms pools or puddles. This is then blotted on to the paper. When it is dry the polythene can be peeled off and the result is a very fluid-looking surface with a wide variety of textures. The painting will be finished by applying thick oil paint to specific areas. These processes may be repeated in order to get that consistency and density that he requires, resulting in a highly deceptive series of textures that closely resemble the surfaces of rock seen in sunlight.

He goes to great lengths to imitate the subjects of his painting. He insists that his work is not abstract, it is rather a literal interpretation of actual locations. His close inspection of the tidal foreshore produces many associations; at one level it is the broken surface of the beach and its primeval origins. At another level it exists in the world of painting and demonstrates the infinite subtlety that can be achieved through freely expressive flow of paint. As an artist he would like to show people this aspect of the natural world seen in all its density and detail, and he continuously tries to search out different ways of recording these impressions.

In January to March 2001 Michael Porter had an exhibition at the Tate St Ives, entitled 'Gwavas Lake' which is that area of Mount's Bay that lies immediately to the south of Newlyn, once an ancient forest, inundated by the sea. He exhibited a series of six large paintings, each made of two equal parts, one part of which is composed of photographs, the other of paint and mixed media. The photographs, in black and white, are of particular rocky locations viewed from above, taken at eye level of a man stumbling across the rough beach. The painted panels, also in monochrome, echo or amplify the photographs, as a man-made equivalent of the rocky foreshore. These paintings and photographs are intended to be seen as a group and references can be made across the room.

Michael Porter is interested in the magical quality of chance, and he is often not fully aware of what the results will be, but everything is done systematically and according to the qualities of the material. Effects may be achieved that cannot be forecast. It is the use of that unaccountability and the direction it takes which allows the artist the freedom he requires. Like the earth itself the paintings are in a continuous state of flux, until they capture that essence of place which becomes instantly recognisable; a glimpse of reality which relies both on our eyes and our imagination.

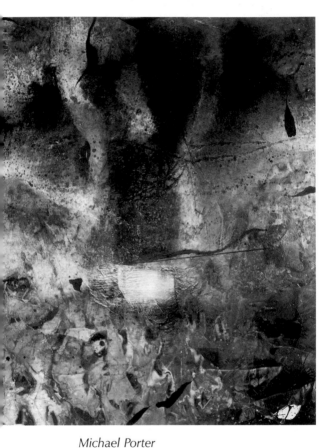

Michael Porter
'Water on Rocks', *1998*

PVA oil, pigment, paper on canvas, 170cmx140cm
Gallerie Brennecke, Berlin

JEREMY ANNEAR (b.1948)

Jeremy Annear is a maker of objects. He uses a variety of materials and stimuli, paint, collage and occasionally found objects. He works in a large white studio, a place of meditation, often enhanced by music. There is a precision about the arrangement of the studio and of the drawing tables, easels and earlier work, and the frieze of small paintings on the wall and work in progress.

There is a spiritual sensibility about his work, a complex link between the rational and the irrational, a sense of belief that there are more than the mere physical components to life. It is the same interest that takes him into psychology. Much of his work is on paper and drawing is an activity that goes on wherever he is, even travelling on aeroplanes or as a passenger in the car. The constantly changing environment of travel comes into his drawings. Drawing is a regular activity, an investigation of ideas that may or may not be used in his painting. There is an automatic approach in his drawing, he employs the surrealist device of emptying the mind and allowing the hand to make what marks it will, a sort of considered surrealism.

He is married to the painter Judy Buxton and they work in a former chapel and Sunday school on The Lizard, each has a studio. They have a shared collection of bottles and jars that serve both of them as subjects for painting. The two studios are very different places. The austerity of Jeremy Annear's studio contrasts with the paint-encrusted surfaces of Judy's studio.

Jeremy Annear was born in Exeter, Devon, in 1949 from a large family, three sisters and one brother. He was educated at Shebbear College, a Bible Christian Boarding School in North Devon. This was a happy time for him and art was greatly encouraged. There was some parental resistance to him attending art school. He spent three years at Exeter College of Art and formed a love-hate relationship with it. This was a time when installation art and other *avant-garde* activities were being promoted, which he found very helpful in the development of his 'modernist' sensibility. After some years painting and doing whatever work was available he took a teacher training diploma at Rolle College in Devon. He taught in the Dyrons Art Centre in Devon, an ideal job, partly directing in art and drama, and partly teaching. He later went on to become a lecturer in foundation studies at the South Devon College and for two years was also the director of Riders Gallery at Dartington College of Art.

At an early age Jeremy had become well acquainted with Cornwall, coming with his family on frequent holiday visits to St Ives and staying in Rinsey. He had always regarded Cornwall as his real home and the early visits had been regular and of long duration. Annear is a Cornish name and particular to that part of Cornwall around Budock Water. He knew Cornwall as a place to which artists came, but at the time he did not recognise their names although he found the whole spirit of the place exciting.

For a period he was a member of the committees of both the Newlyn and the Penwith Societies of Artists. He regarded this as being part of the extended family of artists in Cornwall; however he soon had his fill of committee work.

Jeremy Annear

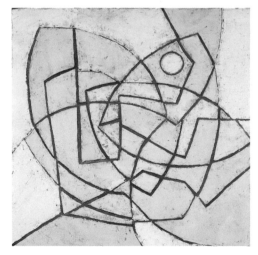

JEREMY ANNEAR
'Light Forms, White', 2000
oil, 71x91cm

219

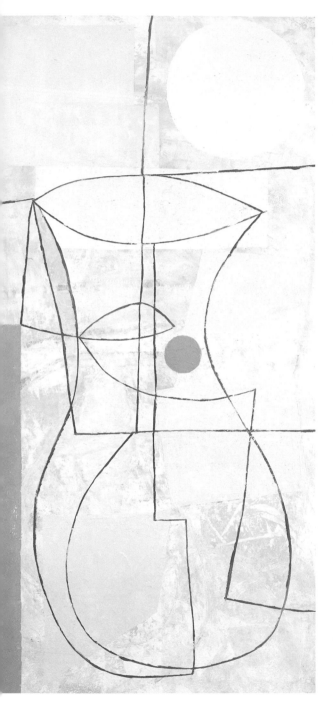

In 1991 he was awarded a Kreissparkasse award from Bremen in Germany and a DAAD (the German Academic Council) Scholarship and became a resident artist to the Atelierhaus Verlag in Worpswede, an international bursary for a year. This brought him directly into contact with the radical new movements that affected the art world in Germany in the 1970s and 1980s and which had a pronounced effect on his work. He had two solo exhibitions in Berlin and one in Leipzig. However the artists he looked at most intently were the obvious ones, Braque (principally), Picasso, Klee and Miro. An early influence was with Klee because Jeremy had spent a lot of time in Switzerland, he had friends there and had exhibited there and had sold work privately in Switzerland. Shortly after his return to Germany he married the painter Judy Buxton.

In 1997 Jeremy Annear had his first solo exhibition at the David Messum Gallery, London. By this time his work was formal and mostly based on the conventions of Cubist still-life painting, jugs, dishes, glasses arranged upon a table. Their linear outlines induce a transparency and overlapping of shape, which serves as a framework for strong colour with black and white. There is a strong influence here of the cubism that Ben Nicholson used in the immediate post-war years. However there are forms in these paintings that Nicholson would never have admitted. Annear will include in his painting references to the earth or to the sea; night and day. Admitting the Cornish influence on this work, he wrote:

> I think sometimes in the past I was a little afraid of colour. I loved Ben Nicholson's slate greys and the Cornish landscape often suggested a more subdued palette to me... more recently I have found almost to my own surprise that I really wanted to explore colour. (Jeremy Annear, 'New Works' exhibition at the David Messum Gallery March to April 1998).

This renewed interest in colour resulted in more complex works, still largely based upon still-life, but with very strong relationships to the Cornish landscape: 'The ribboning of the line between the land and sea, the shapes, forms and colours, all synthesised into abstract form in my paintings...'. (op sit) Colours are earthier, broken white, ochre and brown, and the paintings are paralleled by a series of drawings in which the cubist intention is replaced by very free calligraphy, reminiscent of the drawings of Paul Klee or Joan Miro.

In 1993 Jeremy Annear made the first of several visits to Australia. He was aware of a broad artistic scene much less based on Western tradition and including many influences from the Pacific and the Orient. Most particularly he became interested in the work of the Aboriginal artists, which is now a feature in the major Australian galleries. He always likes to respect the fact that Aboriginal art has a profound spiritual symbolic language that he is largely ignorant of and therefore in his next series of drawings he only takes the superficial graphical elements of the Aboriginal, the dotted lines and the serpentine marks, which give disjointed and superimposed descriptions.

A good example is the drawing 'Line Form V' where a classic silhouette of a jug has imposed over it a dotted outline of a similar yet different jug shape set on an inverted triangle. Through these drawings he has evolved a new and private language, evocative of the various cultural influences he has absorbed in Cornwall, Germany and Australia and, through the notation of the drawings, linked with

his interest in music. Because of their extreme freedom these drawings appear to point in the direction of psychoanalytic art and the viewer is offered a wealth of associations.

Jeremy Annear has shown his work widely in Cornwall and beyond, and in one-man exhibitions at the Messum Gallery in 1998 and 2000. He has continued to work through the medium of still-life. He uses this as a vehicle to refer to nature in a broad sense and particularly the landscape of Cornwall. He is an artist who uses still-life to transport us into the world of abstraction and a free play of pictorial ideas.

Opposite page:
JEREMY ANNEAR
Untitled, *2001*

oil on canvas, 155x75cm

ANDREW LANYON (b.1947)

Andrew Lanyon is a polymath, a writer, photographer, a film-maker, painter, and illustrator and the son of Peter Lanyon. He was born in St Ives in 1947. While at school he received a travel scholarship to take photographs abroad and in 1964 captured scenes of a suicide from the Eiffel Tower in Paris. He worked for the *Daily Express* in Paris; here he met and photographed Man Ray. In 1969 he

Andrew Lanyon filming 'Laughing Gas', 2001

Photo: Rosa Levin.

ANDREW LANYON
'The Sea at St Ives', *c.1986,*
oil, 15x20cm
Andrew Lanyon

221

ANDREW LANYON
'A Useful Novel', *c.1985*
oil, 20x25
Andrew Lanyon

co-organised and produced the catalogue: *The Durham Surrealist Festival*. From 1966 to 1968 he studied at the London School of Film Technique and learnt only that it was essential to have nothing to do with film as a creative medium unless every aspect of it could be controlled. He co-organised 'The Casual Eye', which was about snapshot photography, for Northern Arts in Newcastle and wrote the catalogue.

A surrealist humour runs through all of the different media he explores. For a while he worked in the film industry, including a year with Stanley Kubrick. Later he turned to painting, writing and publishing. He was assistant editor for the poetry magazine *Ambit*; he wrote, filmed and directed a documentary about Exeter Cathedral for television, and has held many solo exhibitions of photography and painting, as well as of 'Hollow Books' (one-off books with moving parts inside worked by opening the cover), including Camden Arts Centre and Liberty in London. He has exhibited at the New Art Centre, London, the Beaux Art Gallery in London, and at Newlyn Orion and the Wills Lane Gallery in St Ives.

The long list of publications to his credit includes the aforementioned *Durham Surrealist Festival Catalogue*, and *Peter Lanyon 1918–1964*, a biography of his father, the late Peter Lanyon. His painting and his books are in public collections including the Museum of Modern Art, New York and the British Council. He built and designed two large travelling shows with accompanying books for the Photographers' Gallery in London; both included paintings and working models. He made the film 'Plot for Sale' with Bill Scott, which won the International Celtic Film Festival Golden Torque Award. At present he is completing 'Laughing Gas', a sixty-minute film set in 1800. It is the second in a series of films about characters that he has developed in nine 'ArtFi' books published over the last twenty years.

HARRIET BELL (b.1950)

Harriet Bell works with materials that she finds in the landscape: dried leaves, flowers, ferns, grasses, foliage, twigs, seeds and other growing things from the hedgerows and fields close to her house on the moors behind Penzance. These are arranged in groups, perhaps assembled to form organic structures on a pyramid of earth or shale. She uses the simplest objects reconstructed to make an ambiguous and organic sculpture. The work is not given titles and the arrangements would change according to the circumstances of the gallery. She likes to make work which does not impinge on the landscape but slightly modifies it in a constant process of recycling where objects are perpetually made and remade.

She was born in Ankara, Turkey. Her father was with the British Council so the family travelled a great deal and she was brought up partly in Jamaica and South America. In 1968 she was in Paris as a student at the Académie Charpentier at the time of the student uprising, and in the following year at Hornsey School of Art, training as a sculptor. This was a time of experimental freedom in the art schools which she used to good advantage, and the work she did then is very similar to what she is doing now. She has shared her husband's travels to India and other parts of the world

Harriet Bell

and the work she made during her many years living in the United states was influenced by these experiences.

In February 2002 she had an exhibition at the Newlyn Art Gallery which consisted of a number of delicate small assemblages, mostly of insect and plant life: forensic examinations of gentle decay. These fragments would be unremarkable in the corner of a barn or the undisturbed roof of an old house, but their setting in a gallery gives them an importance that persuades us to examine them more closely.

There is an air of a botanical museum about her work-room. She sometimes creates books, in which the printed pages are subsumed with leaves, stalks and foliage; an abundance of dried plants. Although the books cannot be read because of the materials that are glued on to each page, she is nevertheless interested in the book's contents. For example she is working on a biography of Billy Bray, the Methodist minister who preached in Gwennap Pit to huge congregations in the nineteenth-century, which she finds a fascinating example of social history.

In the catalogue for the exhibition Michael Bird writes:

> Bell is a collector, but she specialises in things whose material presence is so vulnerable, so un-encumbered that they are hardly 'things' at all. Her work sets these players – pieces of folded textile, paper boats, brittle filaments of dried root, eggshells; discarded, ephemeral and often almost weightless objects – to enact a balancing game: on one side the bereft terror of destitution, on the other the balm of simple completeness. In the choice, placing and construction of objects, the spaces between them and the invisible histories of how they came to be there, Bell implies many layers of action and intention, which often seem, in the final work, to have been sifted through and through to the point where their subtle weave becomes a virtual absence. (From 'The Archaeology of Absence' an essay by Michael Bird, 2002).

There is a sombre side to Bell's work. A group of work produced in Tallahassee in the 1990s appeares to be an examination of a forgotten culture. An air of death pervades, decayed or embalmed figures,

HARRIET BELL
'The Eyes Have It' *2002.*

HARRIET BELL
'The Body The Souls' *2002.*

223

HARRIET BELL
Untitled, 2002.

Newlyn Art Gallery

shrouded and with plaster masks, were laid beside dishes containing desiccated offerings. In 1993 she wrote:

For the past year I have been thinking about the passing of people of no particular importance in life. When I say 'passing' I am not using a euphemism for death. I am interested in a 'passage' similar to that described in the Tibetan Book of the Dead, and familiar from many cultures concerning the journeying of the dead until a final quiet is reached. My visual work is about any traces made, or given, by the living to aid these journeys. (Harriet Bell project description 1993).

She has exhibited her work widely since 1973. Several exhibitions were held in Tallahassee, Florida, between 1981 and 1996 and more recently she showed at the New Millennium Gallery, St Ives in Cornwall. She has taken part in many group exhibitions in the United States and in England, including 'As dark as light', at the Tate, St Ives in 1999.

SUSAN BOAFO

Susan Boafo works through the medium of photography. In a statement she summaries her position:

My photography celebrates the process of hybridity. We have long understood how bringing different plants together to create hybrids increases their variety and produces evermore hardy and perfect specimens. As a mixed race woman, it has been my experience that the idea of hybridity between people from different cultures or races is not looked upon or encouraged as enthusiastically! I suggest that the same vitality and newness that is found to be so beneficial through plant hybridity also occurs when people from different cultures are brought together. My photographs, video installations and sculptures show hybridity as a process through which newness enters the world.

The portrayal of identity as fluid and constantly changing rather than fixed and separate is a key aspect of my relationship with the camera. My subjects are depicted in a continuous state of movement and migration across borders. The camera is often placed so close to the subject that its ability to see and clearly define becomes disrupted. Genetic science now demands that in order to really know our identities we must look beyond surface appearances. The Human Genome Project confirms all humans are 98.8% the same. The remaining difference refers to genetic adaptations, which have occurred since man's migration out of Africa. The family trees of individuals from Japan, Europe, and Africa have all been found to lead back to a single common ancestor. We are all hybrids.

SUSAN BOAFO
'Hybrid Vigour V', 2002.

Photographic Print, 38x38cm

Susan Boafo trained at the University of Plymouth and after receiving the postgraduate diploma in Fine Art went on to an MA in Fine Art. Since then she has had extensive photographic and teaching experience, as a working photographer in London and in Cornwall and as a lecturer at Falmouth College of Art. Since 1995 she has exhibited her work in a number of centres in Cornwall. She took part in the exhibition 'Field of Vision' at Tremenheere sculpture park Penzance in 2002.

SUSAN BOAFO
'Type 55 Hybrid Perpetual', *2001*
Iris print, 21.5x14.5cm

Susan Boafo

PALP

There is a group of artists in West Cornwall who go under the collective name of PALP, Penwith Artist Lead Projects. They act as a collective of artists who wish to see community action as arts-lead not economy or politics lead. They acknowledge that the county of Cornwall is historically famous for its art, but they feel that it is in decline in relation to recent movements in the art world. They therefore wish to link with other artists and collectives in the UK and in Europe to find new ways of working together in different spaces and places to reach new audiences. The group consists of seven members: Susan Bleakley, Gillian Cooper, Tessa Garland, Amanda Lorens, Marion Taylor, Lucy Willow and Rory McDermott, and for some events other artists are invited to participate. They have so far held three showings, one in each year. The first in August 2000 was a site-specific show by a group of like-minded artists and it was held in a number of outbuildings on a farm on the outskirts of Penzance.

Susan Bleakley (b.1945) trained at the Falmouth College of Art in sculpture and an gained MA in sculpture at the Royal College of Art London. She has made work which confronts the capacity for survival and resilience in the Balkans, and she says:

Despite the turmoil in Europe there is always the flickering flame of hope. Yet it is essential to burn out so that new matter can emerge from the ashes and the residue. Sue Bleakley asks, 'What is the

after taste of something that is broken, a broken life a broken country, things may get reduced to ashes and despair but people do fight their way out of angst and this is the fiery moment of resurgence and ephinany.

Since leaving the Royal College in 1997 she has taken part in a number of exhibitions and site-specific installations, in London and in Macedonia and Bulgaria.

Gillian Cooper is an installation artist, using domestic materials such as satin, carpet, feathers, and wire wool. She has created pieces in derelict rooms, disused barns and public sites, even shop windows, public squares and open fields.

For example *'Scission'* 199 consisted of one hundred metres of red satin, which had been cut into small strips and piled on the floors of a deserted warehouse. This material made reference to the body and by its colour to blood. Yet it was a refined and seductive material unexpected in it's position. Since leaving her MA Fine Art Course at the University of Wales Institute, Cardiff, she has taken part in many exhibitions. The piece *'Scission'* was shown in Hanover in Germany. She has had residencies in Germany and Belgium.

Tessa Garland (b.1963) did a degree in Fine Art at Newcastle upon Tyne. Later she took the Certificate in Education at Plymouth University, followed by a Post Graduate Certificate of Education from Exeter University. From 1991 she has been a lecturer in art in Penzance and in the year 2000 at Falmouth College of Arts. She has had many residencies and has taken part in exhibitions with such titles as 'Small Objects of Desire' (the City Gallery in Leicester), 'City of Lights', Royal Cornwall Museum, Truro; 'Window Shopping' (the ex Tesco building, Penzance), and in 2001 'Conceptual Interiors' (The Beatrice Gallery, Southampton). Her installation *'Aquarium'* was sited in two separate rooms: in one room, the viewer was faced with a large tropical fish tank with fish, mounted opposite a plain wall painted in cobalt blue. The audience were filmed through the fish tank as they watched the fish. In the next room a large sheet of opaque glass was hung on to which was projected images from the hidden camera. The interaction of the audience and the movement of the fish produced extraordinary visual and emotional responses.

Amanda Lorens. After training at Winchester School of Art, Amanda Lorens took her MA in Fine Art and Sculpture at Chelsea College of Art, London. Since 1996 she has shown in exhibitions at the Belgrave Gallery, London, the Plymouth Art Centre and her exhibition 'Margherita' was a mobile video installation on a touring pizza van which went to six locations in Cornwall. She took part in PALPITATIONS, site-specific installation at the Exchange, Penzance, by PALP.

Although her work appears cool and calm it makes a series of visual metaphors which relate to the deeper levels of human experience. In a statement about her current work she talks of:

Visceral images of food moving beneath a clean white surface; veiled screens with mouths that appear to be talking while omitting no sound; the familiar sitting room scene, transported into the clammy, claustrophobic, dark space of the coal shed, with the sound of ranging fire, suffocating heat, claustrophobic intensity.

PALP – Gillian Cooper
'The Interior: Chaos into Matter', 2001.

Newlyn Art Gallery
Photo: Dr Valerie Reardon

Marion Taylor (b.1948) works in the multi-disciplinary area of installation art and also as a painter. She has made pieces which are intended to be site-specific and installed in non-gallery spaces in order to bring art closer to 'real life'. For her this alternates with reflective periods of work in two dimensions. She finds that work between the two forms does not conflict, as both feed upon each other. Marion was born in Manchester in 1948 and lived in London whilst raising four children. In 1989 she moved to St Ives and took a degree in Fine Art at Falmouth College of Art in 1998. She has exhibited in the various PALP installation projects and in exhibitions in Newlyn and St Ives.

Lucy Willow (b.1967) is an artist who works partly through drawings done on paper and also on video installation pieces. She says:

I am interested in the idea of capturing things that cannot be caught, an experience, a moment in time, such as the blackness of night or the moment of death when something moves from one state to another.

She creates assemblages in which the individual items, the piece of film, pebbles and bones collected from a beach, scraps of writing, seem to explore a private world of associations. In her two-dimensional work photo-montage heightened by the use of painted images explore this private world further. She was born in 1967 in Whitsable, Kent and took her degree in Fine Art at Falmouth College of Art. She has shown in a number of installation exhibitions in Cornwall.

PALP – Marion Taylor
'Exchange/Connect/Disconnect', 2001.
Exhibition: Palpitations, former BT telephone exchange, Penzance

BELINDA WHITING

Belinda Whiting moved to Cornwall in 1988 having previously lived in London and Spain for several years. At present she is employed as a part-time lecturer in photography at Falmouth College of Art. She has exhibited her work widely in Cornwall and the South West. She writes:

Personal issues have always been an integral part of my work, since they have almost invariably been the starting points of lines of enquiry that seek to explore both internal states and the visible world simultaneously. In recent years the themes of memory, loss and death in particular have been my central concern.

I choose the medium of photography as a tool for exploration because it is so versatile and because its scope and power to communicate constantly excite me. However I continually feel the need to move beyond the straight, chemically-produced image to a more 'hand-crafted', tactile and personally involving method of production. This enables me to develop different qualities in the print surface itself, which are applicable to the subject matter and its treatment. I often use the old process of bromoils where the photographic image is bleached away and brought back with lithography inks and a brush, because of the freedom it affords to interact physically both with the image and within the process itself. My recent work has been concerned with movement and dance, gesture and emotion and has used video and the sequencing of stills taken from video.

BELINDA WHITING
'Obsession', one of a series, 2001
bromoil (photographic process), 22x28cm

IT'S NOT ALL OVER!

Over recent years Cornwall has been in process of renewing itself artistically, with such important developments as the Barbara Hepworth Museum, the Tate St Ives, the Eden Project and a new University for Cornwall. These are taking place on a scale and at a pace that was certainly not dreamt of when that group of artists of the 1950s assembled in St Ives. In this final chapter we look forward to the establishment of these major centres and for the potential for the future that they hold.

THE BARBARA HEPWORTH MUSEUM

Since the separation in 1951 of Barbara Hepworth and Ben Nicholson, Barbara had made Trewyn Studio her permanent home. In 1961 she also acquired the St Ives Palais de Danse across the road from Trewyn Studio, which acted as a store and finishing workshop for her sculpture, and she had the door on to Barnoon Hill enlarged so that her larger sculpture could be put straight into waiting lorries for delivery to exhibitions around the world. It was a scene of considerable activity. Although she continued to be extremely productive until the late 1960s, she was increasingly affected by throat and mouth cancer and a fall affected her mobility. Nevertheless some of her largest and most impressive pieces were constructed in these late years.

Barbara Hepworth died in a fire in her studio in 1975. Trewyn Studio had been her life as well as her workplace and in her will she asked her executors to consider establishing a permanent exhibition of her work in Trewyn Studio and in its garden. This matter was taken up enthusiastically by her family, which included Alan Bowness, her son-in-law through his marriage to Sarah Nicholson. Under his direction the fire-damaged house and the sculpture garden was made into a small museum. It was intended to reconstruct something of a feeling that Trewyn Studio had in the 1950s. Alan Bowness remembers: 'We chose a representative group of work from what was left of the estate, with particular attention to a wide chronological span and from early work to late, and to a good range of different materials.' (*Gasworks to Gallery, the Story of Tate St Ives* by Janet Axten, published by Janet Axten and Colin Orchard, 1995).

The new museum was opened on 10 April 1976. The garden contained about fifteen bronzes and three or four stone carvings and the studio on the upper floor of the house had a group of about twelve works. The workshops were left in the same condition as on the day she had died, unfinished works, tools, assistants' overalls and the date of her death on a wall calendar. On the lower floor a brief archive of her life was displayed.

Opposite page:
Tate Gallery, St Ives.

Courtesy: Tate Gallery

At that time the Tate Gallery was not prepared to take over the financial responsibility for the house and garden, but in anticipation that this would later happen the family decided to open the premises to the public at their own expense. Finally, after long dealings with government, the museum was handed over to the Tate Gallery on 3 October 1980, as a small out-station, three hundred miles from London.

THE CONTRIBUTION OF THE PENWITH SOCIETY

There had long been a general feeling that there should be a gallery in St Ives to mark the achievements of the art colony. In the years between the two world wars the subject came up from time to time in the press, and various possibilities were put forward but none were pursued with sufficient vigour to advance the idea.

When the new gallery was built for the Penwith Society of Artists in 1976 it was intended that it would house a permanent collection of the finest works of art produced by artists in St Ives. With loans from artists, their families and collectors, a group of work was brought together. This was, however, an ad hoc arrangement. For a gallery without professional curatorial help, and subject to the varying views of committee members, it was difficult to establish and curate a representative collection. Some work was borrowed, a few pieces were given; but the collection varied, and sometimes the gallery was used for other purposes.

Following the death of Barbara Hepworth in 1975 the Penwith Galleries found themselves in considerable debt. Over the next few years, after a losing battle with the funding bodies, a number of emergency measures took place; one of these was the disbandment of the 'permanent' collection. In February 1980 the work was returned to artists and lenders. The new gallery at the Penwith was used as a rented area for members' exhibitions.

PAINTING THE WARMTH OF THE SUN – ST IVES ARTISTS 1939–1975

In 1976 the author of this book, Tom Cross, moved to Cornwall to take up his appointment as Principal of Falmouth School of art. He already knew some of the artists living in St Ives personally, and the idea gradually formed in his mind that he would write a book about them, for nothing at that time existed. Cross realised that many artists were still living and working in the area and would have clear recollections of earlier events. He reasoned that now was the time to make a record of what had occurred. He began to make tape recordings of artists such as John Wells, Denis Mitchell, Patrick Heron and Wilhelmina Barns-Graham, which he started to assemble into a book. Progress was slow, but in 1983, whilst on a year's sabbatical in the United States, he received a call from his Cornish-based publisher, Alison Hodge, asking for the book to be completed in three months' time! So *Painting the Warmth of the Sun* was written, published and launched without fanfare in a very short time. (The title was taken from the letter from John Wells to Sven Berlin, quoted earlier in this book). It reached the bookshops in October 1984, a few months before the St Ives' exhibition opened at the Tate Gallery and became an important complement to the show. Republished by Halsgrove in 1995, the book remains, along with its sister publication, *The Shining Sands*, a standard work on the history of art in Cornwall.

The illustrations for the book came about as a result of collaboration with the newly formed regional television company Television South West. When TSW applied for its franchise, it set up a number of advisory committees, one of which covered the arts. Tom Cross was asked to be a member. Each committee put forward projects to be included in the overall franchise bid. Cross suggested a film of his proposed book and the idea was taken up. During the summer of 1983 a film crew, with Kevin Crooks as the producer, and assisted by Jonathan Harvey, TSW's art adviser, shot many hours of film of St Ives' artists and collectors, for which 'off-camera' Tom Cross conducted most of the interviews.

Filming began with a party on the lawn of the Tregenna Castle Hotel for as many of the artists, their spouses and close friends as could be brought together, about two hundred in all. It was a very hot August day, great friendships were resumed immediately, and old arguments and rivalries reappeared. The resulting film, narrated by Tim Piggot-Smith, who had become well known through his appearance in 'The Jewel in the Crown', was screened in three hour-long episodes, on Channel 4, in the early evenings of Easter Sunday, Monday and Tuesday 7, 8 and 9 April, 1985. It was shown at the Tate Gallery on 26, 28 and 29 March., and at various times subsequently.

ST IVES 1939–64

The timing of these publications was partly determined by the decision of the Tate Gallery, London, to present a definitive exhibition of the work of artists associated with St Ives in the 1950s. Between 13 February and the 14 April 1985, the Tate mounted the first survey of the art of St Ives as an exhibition 'St Ives 1939–64, Twenty-five Years of Painting, Sculpture and Pottery'. The work was selected by Dr David Brown, Assistant Keeper in the Modern Collection of the Tate Gallery, in consultation with Alan Bowness. Some 230 paintings, drawings and sculptures, plus forty-one ceramic pieces were shown, with a catalogue prefaced by a personal memoir by David Lewis and a chronology prepared by David Brown. For the first time the public could see the range and depth of work associated with St Ives.

THE TATE ST IVES

These various events had helped to create a climate of expectation for work by the St Ives artists to be shown in the town where it had been created. Realistic moves towards a gallery came from several directions and from the energies of a number of individuals. In 1984 Martin Rewcastle was the recently appointed Director of South West Arts, the government body charged with the regional development of the arts. He had prepared a report *A Survey of the Arts in the South West* which covered all the visual and performing arts. One of the conclusions was that Cornwall had the lowest local authority expenditure on the arts in the country (apart from the Isle of Wight). It had no county policy for the arts and, with the exception of the small Newlyn Gallery, no proper provision for exhibitions. The outspoken criticisms of the report were taken seriously by the Cornwall County Council, particularly by those concerned with planning and economic development. In the following year a second influential report *The Economic Influence of the Arts and Crafts in Cornwall* drew attention to the serious decline of visitors to Cornwall, a situation that was coupled with the erosion of its industrial and agricultural base.

By contrast there was considerable interest in painting and sculpture from Cornwall, as had been demonstrated so recently at the Tate Gallery in London. Building on this imbalance, and with support from elected members and officers of Cornwall County Council, Martin Rewcastle approached Alan Bowness and extracted from him a promise that work from the Tate's collection could be exhibited in Cornwall, provided that a suitable gallery could be built.

In the summer of 1988 there was a firm proposal from the County Council to establish a gallery in St Ives, in conjunction with the Tate Gallery. It was decided to set up a steering group to examine and further this idea. At this point the matter becomes political. A group of elected representatives, under the chairmanship of Richard Carew Pole, met with a selected group of officials and a few invited specialists. The first task of this group was to search for a site for the proposed gallery. A number of possible sites were examined, both in the town and adjacent to it. One of these was the derelict gasworks overlooking Porthmeor Beach, an awkward sloping site, heavily polluted and very exposed to westerly winds. There were also cost implications and problems in terms of car parking. However because of its position the gasworks site had a drama and grandeur that all the other sites lacked. In a brave and far-seeing gesture the final choice was made for the gasworks.

It was now necessary to draw up a brief for the project and to appoint an architect. This was done by limited competition of five invited firms, all with major national and international reputations. The brief that they were offered emphasised the need for the building to be instantly attractive to visitors: '...in the way that the Pompidou Centre and the Lloyds Building do... the building should be stimulating, imaginative and excellent. It should be equally attractive to the art enthusiast and to the family on holiday.' (*Gasworks to Gallery* op.cit p.109). After long and careful consideration the husband-and-wife team of Eldred Evans and David Shalev, already well known in Cornwall from their progressive design for the Crown Courts in Truro, completed in 1988, were appointed as architects.

The process of design took up the first part of 1990. There was however an urgent need to raise the necessary funds for this large project. The combined Local Authorities agreed to give £700 000 for the acquisition of the land and the first part of the architects' fees, but much remained to be found. In its search for private funding and sponsorship the exciting situation and high quality of the planned building was the greatest asset for the steering committee. A major contribution of £250 000 was offered by the Henry Moore Foundation, a charity with substantial funds to distribute, mainly concerned with sculpture and now directed by Sir Alan Bowness. Other major sums were forthcoming from such bodies as the Sainsbury Family Trusts – £100 000, the John S. Cohen Foundation – £50 000, Northcliffe Newspapers, which had interests in the South West – £25 000, and by many other charities, trusts and companies. Grants were secured from the European Community Regional Fund and the Rural Development Fund amounting to £1.2 million.

An important part was played by the St Ives Tate Action Group (STAG) lead by the indefatigable Lady Carol Holland, who co-ordinated local support and fundraising. She marshalled local resources and arranged a succession of events and the staggering sum of £125 000 was raised in these ways. By the time the gallery opened in 1993 the final cost had reached £3.3 million.

Tate Gallery, St Ives
Tate St Ives

In March 1993, as the building of was nearing completion, the large coloured glass window made from Patrick Heron's design was put in place. For the design Heron had returned to an earlier style, reminiscent of the 1970s, and produced a small gouache drawing with eight coloured areas. In order to have the maximum colour impact, he required a stained-glass window to be made without leading so that colour could meet colour precisely along his drawn lines. This difficult technical feat was achieved by a German company who produced a laminated window some 4.6 metres by 4.2 metres, the largest ever made by such a method. When it was placed in the Mall of the Tate it immediately became a major focus of the new building.

The fabrication of the building was a long and complex process, which is described fully in the excellent publication *Gasworks to Gallery, the Story of Tate St Ives*. His Royal Highness the Prince of Wales, Duke of Cornwall, opened the gallery on a sunny but windy morning on Wednesday 23 June 1993.

Some time before the gallery was completed a curator was appointed, Michael Tooby, who took up his position on 25 May 1992. He came from the Mappin Art Gallery in Sheffield and before that, as assistant curator at Kettles Yard in Cambridge, he had been brought into close contact with the fine collection of work by St Ives artists, formed by Jim Eade. Tooby felt strongly that the new gallery should not be seen as marking the close of a period, as it could be: 'now that St Ives has ended here is its museum'. In discussions with Nick Serota, the newly appointed Director of the Tate, it was agreed that a balance should be struck between the story of St Ives and an alive and viable artistic experience. It was also decided that the displays should change regularly. This was not in the original architects' brief, and for that reason there were no exhibition holding areas, or storage rooms in the building (a situation that still persists).

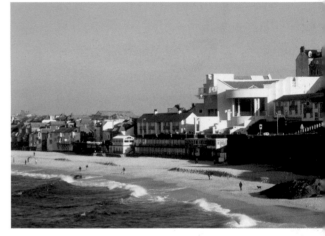

Tate Gallery, St Ives
Tate St Ives

The first few years were experimental, a 'portfolio of possibilities' to flag up the potential for the institution. It was decided to do several things. The first was a wish to augment the Tate's collection, so borrowings took place from the Pier Art Gallery, Kettles Yard, and other collections. Secondly the gallery created small loan exhibitions 'in house'; an example was the Barbara Hepworth drawings of surgical operations. Thirdly, was an intention to involve living artists, not only by giving them exhibitions but helping them in other ways and including artists from outside Cornwall.

It was intended to tie the gallery in St Ives to a definitive list of artists but to extend the range of work that would be shown. For example one of the most interesting exhibitions was that of the work of Mark Rothko. This could be criticised due to the fact that Mark Rothko only spent a few days in St Ives, but the question is why did Mark Rothko go to St Ives in the first place? The gallery also exhibited paintings by Frans Kline, whose mother was from Ludgcome in Cornwall. Michael Tooby noted:

Alex Mackenzie remembers Kline coming to his opening in New York in the early 60s. Later in a bar Kline became very weepy-eyed about Mackenzie's titles, which summoned up the place names in west Cornwall that his mother had talked about.

The gallery has been a notable success. From a projected 75 000 visitors for the first year, The Tate St Ives now attracts about 200 000 each year. Since it's inception the Tate has worked closely with the other galleries in Cornwall: Newlyn, and Falmouth, and with the School of Art in Falmouth and tertiary education in the county. It has also been estimated that the presence of the Tate St Ives has added approximately 5 per cent to the annual economy of Cornwall as a county.

In March 2000 a new Curator, Susan Daniel-McElroy, took up her post, succeeding Michael Tooby. She had been Director, Visual Arts, for the Scottish Arts Council and before that she had worked in Wales. Susan originally trained as a painter and she had extensive experience in arranging exhibitions of modern and contemporary art, many of which toured nationally. Since coming to the Tate St Ives she has further enlarged the original brief of the exhibition programme in order to bring contemporary work by major international figures into the gallery. Recent exhibitions include 'The Garden Paintings of Patrick Heron' (March 2001), a challenging group of sculptural works by Anthony Gormley (June 2001), a retrospective exhibition of work by Bryan Wynter (September 2001), Sandra Blow (December 2001), and work with a maritime theme by the Scottish artist Ian Hamilton Finlay (March 2002).

ANTHONY FROST
Design for planting at the Eden Project, 2001
acrylic and mixed media
Photo:Tom Cross

A UNIVERSITY FOR CORNWALL

Final agreement has been reached and building work has begun on a project to be known as 'The Combined Universities for Cornwall' (CUC), lead by the Falmouth College of the Arts in partnership with the Universities of Plymouth and Exeter. A site in Penryn, near to Falmouth, has been purchased and is already in use by the Falmouth College of the Arts as a centre for design studies. On this large acreage of land further buildings will accommodate a number of teaching units of the Falmouth College of the Arts and various academic departments from the University of Exeter, including the Camborne School of Mines, the Institute of Cornish Studies, and the Department of Life Long Learning.

The Chairman of the CUC executive is Professor Alan Livingston, Principal of the Falmouth College of the Arts. He came to Falmouth in 1987 as principal of the newly constituted School of Art and Design. He had a background in graphic design and had been working in the South Lancashire University as Head of Art and Design. At that time he knew that Falmouth School of Art had a good reputation. It was small by comparison to some of the larger art and design faculties in the polytechnics and it was more specialised in the direction of fine art studies. As a specialist college he would have put it as one of the top three in the country. There were however emerging pressures on higher education to increase the numbers of students and to become more efficient. Over the last decade this has been a major debate in which all of the art schools have been engaged and requiring them to examine practices.

Livingston's arrival in Cornwall coincided with a reorganisation of art and design in which the Art and Design Faculty from Cornwall College in Camborne was linked to Falmouth. It was decided to centre all higher-level work in art and design in Falmouth, and to make Falmouth a major centre of academic learning. Over the years some of the courses were upgraded to a degree programme, and some handed back to Cornwall College as further education courses.

The comparative isolation of Cornwall is always an issue, but it is much less so with development of technology, while isolation can be ameliorated by the activities of the staff. This was reflected in the year 2000 by a teaching quality assessment which gained twenty-four points out of a possible twenty-four, the only college of art in the country to receive such an accolade. To be small, remote and ordinary is a bad combination, so they tried to be less small, never wanting to be big but always somewhat special. At present the college has about fifteen hundred students, which is probably about right. It offers an impressive programme covering foundation studies and degree courses in art, design and media studies and there is currently an emphasis on postgraduate activities. It is closely connected with the various institutions and galleries in the county and beyond, and sees itself as a facilitator in the visual arts in Cornwall.

THE EDEN PROJECT

The great biodomes of the Eden Project have entered into the life of Cornwall. The scale, the ambition and the optimism of this remarkable piece of science-related architecture is a statement of passionate belief for the future. The main purpose is to place science beside conservation, and these beautiful structures, which are an unrivalled stage for the study of the rainforests, Mediterranean lands, and the Spice Islands, are also masterpieces of efficiency in design and engineering. There is another aspect to Eden's work however. In his introduction 'What is Eden all about?' Dr Tony Kendall, the mission director explains:

We wanted to do more that put up signboards of facts and dull explanation, we have tried to use the power of art and of language to conjure images, atmosphere and passions and to explore complex issues. The world-renowned creative community of south-west Britain has risen to the challenge, working in every medium from sculpture, poetry and painting, through textiles, fashion designs and even mechanical automata. Art is not always comfortable, it is not always beautiful – the same is true for the world we are representing. It would be a betrayal of the energy and vision we look for if we kept the artists on safe ground. We hope you also enjoy the exploration with us. (From *Eden Project, The Guide* Eden Project Books 2001)

A number of artists have been mentioned earlier in this book that have worked on the Eden Project, they include Anthony Frost, David Kemp and Tim Shaw. This form of collaboration is the most direct and valuable way of encouraging the arts and providing ways in which they can enter and enhance our life.

IT'S NOT ALL OVER!

It was intended in these pages to show some part of the development of art in Cornwall over the last twenty-five years, produced by a large number of individuals working with passion and dedication in a wide variety of art forms. Our thanks are due to them. Artists take many directions and explore many avenues. Perhaps all that can now be said is that the visual arts in Cornwall are extremely healthy, and perhaps never more so.

DAVID KEMP
'Industrial Flame Plant', *2001.*
Commissioned by the Eden Project, Cornwall.
Photo: Tom Cross

INDEX